Ms. Goeres-Gardner balances the unique and complex history of the Oregon State Hospital with the art of the storyteller. This well-researched history extending from the earliest days of the Oregon State Insane Asylum to the present, although not always a pretty story, is exactly what we need to hear. I applaud this book, which will elevate public awareness of the issues, particularly at this time when a dialogue is desperately needed as we approach the crossroads of mental health.

—Howard W. Baumann, MD
Board Member, Oregon State Hospital Museum of Mental Health

Those who would want a better understanding of the way Oregon has responded to the needs of people with mental health challenges would be well advised to read and ponder the history described in such great detail in this book. Ms. Goeres-Gardner presents a compelling story with historic references that no other book has provided to date. The book's first chapter, "The Case of Charity Lamb," sets the stage for considering both the tragedy of society's response and the compelling efforts at humane treatment. These themes come up time and again and serve as comparisons and contrasts to what we have done since then.

Diane Goeres-Gardner has searched the state archives for reports to the legislature. She has reviewed newspaper articles and many other documents. She has interviewed many key participants in the history of Oregon's state hospital. Her exhaustive research tells the full story of the institution, its troubled and humanitarian past, without passing judgment. That is left to the reader. The book will be a critical resource for historians and storytellers for many years to come.

—Robert E. Nikkel
Director, Oregon Addictions and Mental Health Division (2003–2008)

INSIDE
OREGON STATE
HOSPITAL

A HISTORY OF TRAGEDY AND TRIUMPH

DIANE L. GOERES-GARDNER
FOREWORD BY JOHN TERRY

Charleston · London

THE
History
PRESS

Published by The History Press
Charleston, SC 29403
www.historypress.net

Front cover: Oregon State Hospital, 2009. *Photograph by Laurie Burke.*
Back cover, top: Oregon State Hospital, 2007. *Photograph by Tom Green. Courtesy of the National Register of Historic Places.*
Bottom: Oregon State Hospital, circa 1940. *Courtesy of the Oregon State Library.*

First published 2013

Manufactured in the United States

ISBN 978.1.62619.040.5

Library of Congress CIP data applied for.

Dedicated to the thousands of Oregon's men and women who devoted their hands and hearts to working with persons with mental illness since 1843 when Oregon's provisional government was established.

CONTENTS

CONTENTS

FOREWORD

Throughout its history Oregon State Hospital has frequently ranked as the most misunderstood, maligned, malnourished, even mysterious of all the institutions under the aegis of state government.

The nature of the hospital itself is partly to blame. Of all human maladies that have been cured or at least brought under control in the last century, mental illness remains one of the most elusive to medical science. Breakthroughs in medication have helped some, but the need for someplace to isolate the "crazies" among us persists and probably always will.

I use the term "crazies" advisedly.

Several of my young years were spent in Salem during the 1940s. My friends and I were well aware of the gothic hulk out on Center Street. "That's where they keep the crazies," we told one another. We accepted as gospel rumors of the unbalanced behavior behind those forbidding walls and the physical indignities suffered in the name of restoring sanity. Likely as not, one or the other of us had some family member, or knew of some family member or friend, who had spent time there.

Salem was still a small town. Word got around. And, as it turns out, many of the "treatments" employed at the hospital, viewed in today's bright light, can only be classified as draconian if not out-and-out torture.

Not that, for the most part, the hospital staff were not deeply dedicated to the task at hand. They were diligent both in tending to patients' comfort and in the effort to restore them to a meaningful role on the outside.

Years later, in 1964, as a neophyte reporter for the old *Salem Capital Journal*, I received a lasting lesson in hospital philosophy from its superintendent (1955–1981), Dr. Dean Brooks, whom I described as "the smiling, mild-mannered psychiatrist, superintendent, shepherd, administrator, father confessor and arbitrator responsible for the sprawling institution."

It was springtime. The legislature was in session. Money was short. The hospital was running $100 per day over its drug budget. Disapproving glances emanated from the legislative budget barons.

"Dr. Brooks hastens to assure…[that] although problems do exist, the hospital's total program is not threatened," I reported at the time. "He makes it clear that his concern, and consequently the hospital's, is to heal the patients' minds to a point where they can once again function in society. If a drug will help, fine. If not, better to use another approach."

Thus was it ever at the hospital, virtually from the day in 1883 when the state transferred patients from the privately run Hawthorne Asylum in East Portland to the spanking new Oregon State Insane Asylum in Salem, itself conceived to save the state a bundle of money.

As dynamic and often disturbing as the hospital has been over its 120 years, no one until now undertook to track its history. There have been multitudinous newspaper articles and scholarly studies and papers but nothing comprehensive to lift the veil for the public to see and assess what the hospital has been and is all about.

Diane Goeres-Gardner, whose previous two books dealt with unseemly but intriguing aspects of Oregon history, has accepted that challenge. It was partly by accident, partly by logical progression that she was led to chronicle the hospital.

In the early 2000s she was researching family pioneers who came across the Oregon Trail in 1852 and settled in Tillamook. As she tracked ancestors via microfilms of old newspapers at the University of Oregon Knight Library in Eugene, she kept coming across accounts of public hangings.

Before 1903 when the state took over the task, local sheriffs dutifully dispatched criminals sentenced to death. Those ceremonies tended to attract curious throngs, often taking on a carnival atmosphere with the execution as the climactic feature. Goeres-Gardner stockpiled those stories, which became *Necktie Parties: Legal Executions in Oregon, 1851–1905*, published in 2005.

In the course of that endeavor, Goeres-Gardner also came across stories about women who had run afoul of the state's justice system. In 2009 came *Murder, Morality and Madness: Women Criminals in Early Oregon*.

A variety of those cases led her to the Oregon State Insane Asylum, where female offenders (the state then lacking a women's prison) were commonly incarcerated.

Thence this work, *Inside Oregon State Hospital: A History of Tragedy and Triumph.* It's a story long overdue and begging to be told. It's a saga not only of individuals subjected to the mental health system but of the system itself and the social and therapeutic climates that altered it through the years. Now, at last, she finds a glimmer of hope at the end of the tunnel.

JOHN TERRY

John Terry is a retired journalist whose career, starting in 1963 with the Salem Capital Journal, *spanned fifty years. For fifteen years starting in 1997, he wrote a weekly column on Oregon history for* The Oregonian.

ACKNOWLEDGEMENTS

This book would not have been possible without the help and support of my family. Thank you to my husband, Mike, for his patience when I was typing away in the early morning hours; to my daughter Nicolle Wynia-Eide for proofreading numerous drafts; and most of all to my daughter Dr. Laurie Burke for her wonderful photographs and assistance in understanding the language of psychology.

Special thanks to Patricia Feeny, communication manager for the OSH Replacement Project, for all her time and patience in answering a thousand questions. Thank you to the employees in various state offices who cheerfully assisted me in finding photos and other material for this book.

Thank you to Dr. Howard Baumann, a member of the Museum of Mental Health Board, for his intense and critical review of the entire manuscript. I am deeply appreciative to the members of my critique team for the hours they spent reading and rereading the many drafts. Thank you to B.J. Bassett, Sybilla Avery Cook, Jan Duren, Sarah Schartz, Ann Shorey, and Jo Wanner. Also a heart-felt thank-you to Giuli Sutton for establishing a filing system that finally worked for me.

The last three chapters would have been impossible without the work done by some incredible newspaper reporters, in particular Alan Gustafson of the *Salem Statesman Journal* and Michelle Roberts of the Portland *Oregonian*.

INTRODUCTION

O regon began assuming responsibility for its mentally ill citizens as early as 1843, sixteen years before becoming a state. The provisional government adopted laws and appropriated $500 "for purposes of defraying expenses of keeping lunatic or insane persons in Oregon."[1] The Oregon State Insane Asylum was built in 1883 at the end of an era popularized by the erection of large state asylums all over the United States. These monuments to prosperity and modernity represented the best civilization had to offer. Just as the scientific method offered a cure for physical ailments, the nineteenth-century asylum offered a new and profound insight into the human mind.

In every way imaginable, asylums were the epitome of the patriarchal system. Superintendents were in charge of the patients, father figures with the power typically given to the head of the family in that time period. Just as the superintendent used his authority over the patients, the state used its authority over the superintendents. Unfortunately it left the mentally ill at the bottom of the power structure—hopeless and helpless.

This power structure led ultimately to the Eugenics Movement, in which thousands of Oregon citizens were sterilized ostensibly for their own good and the good of society. Coupled with the various shock treatments and the permanent cure, lobotomy, the mentally ill became part of a great experiment. Everyone except the poor experimental subjects embraced these procedures with remarkable enthusiasm and approval. It wasn't until the 1960s that federal legislation, spurred by President John F. Kennedy, was passed to address some of the legal inequalities facing the mentally ill.

The history of the Oregon State Hospital (OSH) is inevitably the history of the mental health system itself. The great surge of interest in the early 1900s gradually declined to a kind of apathetic cultural disdain in the 1970s. Money dried up, and instead of a sense of responsibility for the mentally ill, the state chose to ignore them. The result was a system full of chaos and huge increases in abuse similar to those last seen in the eighteenth century. Without funds to repair buildings or hire sufficient staff, OSH became a dark and dangerous place.

No one knows for sure why one person becomes schizophrenic and another doesn't. "Nobody is immune."[2] There are many "schools of thought

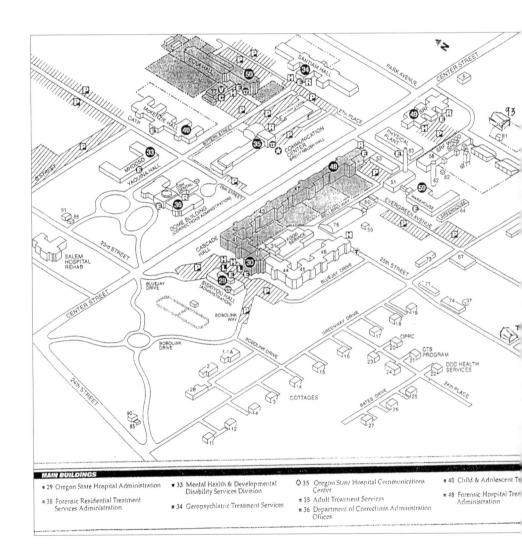

MAIN BUILDINGS

- ■ 29 Oregon State Hospital Administration
- ✱ 30 Forensic Residential Treatment Services Administration
- ■ 33 Mental Health & Developmental Disability Services Division
- ■ 34 Geropsychiatric Treatment Services
- ◯ 35 Oregon State Hospital Communications Center
- ✱ 35 Adult Treatment Services
- ■ 36 Department of Corrections Administration Offices
- ■ 40 Child & Adolescent Tr
- ✱ 48 Forensic Hospital Trea Administration

about what mental illness is and how you treat it, whether it is hereditary, organic, psychosocial, or what-not. The answer is all of the above."[3]

Today, as new buildings replace the old, a bright spotlight has finally illuminated the hospital's many needs. In almost all instances of significant change at OSH, newspaper and federal investigations preceded the change. How those changes came about is the central theme of *Inside Oregon State Hospital: A History of Tragedy and Triumph.* How the future will play out remains to be seen. Will we, as Oregon's citizens, remain apathetic toward our mental health system, or will we be involved in its reform? After all, we, or someone in our family, may be the next person sent to OSH. What kind of treatment will be waiting for us?

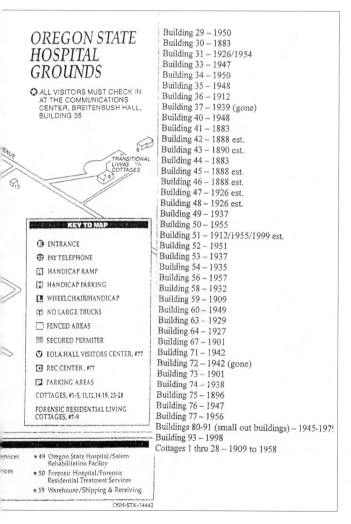

OREGON STATE HOSPITAL GROUNDS

✪ ALL VISITORS MUST CHECK IN AT THE COMMUNICATIONS CENTER, BREITENBUSH HALL, BUILDING 35

TRANSITIONAL LIVING COTTAGES 7-9

KEY TO MAP

- 🄳 ENTRANCE
- ☎ PAY TELEPHONE
- 🄷 HANDICAP RAMP
- 🄷 HANDICAP PARKING
- 🄴 WHEELCHAIR/HANDICAP
- 🄣 NO LARGE TRUCKS
- ⬚ FENCED AREAS
- ▨ SECURED PERIMITER
- ✪ EOLA HALL VISITORS CENTER, #77
- 🄶 REC CENTER, #77
- 🄿 PARKING AREAS

COTTAGES, #1-5, 11,12,14-19, 23-28

FORENSIC RESIDENTIAL LIVING COTTAGES, #7-9

Building 29 – 1950
Building 30 – 1883
Building 31 – 1926/1954
Building 33 – 1947
Building 34 – 1950
Building 35 – 1948
Building 36 – 1912
Building 37 – 1939 (gone)
Building 40 – 1948
Building 41 – 1883
Building 42 – 1888 est.
Building 43 – 1890 est.
Building 44 – 1883
Building 45 – 1888 est.
Building 46 – 1888 est.
Building 47 – 1926 est.
Building 48 – 1926 est.
Building 49 – 1937
Building 50 – 1955
Building 51 – 1912/1955/1999 est.
Building 52 – 1951
Building 53 – 1937
Building 54 – 1935
Building 56 – 1957
Building 58 – 1932
Building 59 – 1909
Building 60 – 1949
Building 63 – 1929
Building 64 – 1927
Building 67 – 1901
Building 71 – 1942
Building 72 – 1942 (gone)
Building 73 – 1901
Building 74 – 1938
Building 75 – 1896
Building 76 – 1947
Building 77 – 1956
Buildings 80-91 (small out buildings) – 1945-197?
Building 93 – 1998
Cottages 1 thru 28 – 1909 to 1958

rvices ⁿ 49 Oregon State Hospital/Salem Rehabilitation Facility
ices ⁿ 50 Forensic Hospital/Forensic Residential Treatment Services
 ⁿ 59 Warehouse/Shipping & Receiving

OSH-STK-14442

This 1998 map shows the names and numbers of all the buildings before reconstruction began. On the right side are the dates each building was erected. *Oregon State Hospital.*

NOTES

1. Michelle Roberts, "Years in the Shadows," *Oregonian*, October 31, 2004.
2. James Long, "35-C: Another World," *Oregon Journal*, December 7, 1976.
3. C.L. Brown, "Oregon State Hospital During the 1960s," *Oregon Historical Quarterly* 109, no. 2 (2008).

SUPERINTENDENTS

HAWTHORNE ASYLUM

1. Dr. A.M. Loryea	1861–1872
2. Dr. James C. Hawthorne	1872–2/1881
3. Dr. Simeon Josephi	2/1881–10/1883

OREGON STATE INSANE ASYLUM AND OREGON STATE HOSPITAL

1. Dr. Horace Carpenter	10/23/1883–4/30/1886
2. Dr. Simeon Josephi	5/1/1886–6/30/1887
3. Dr. Harry Lane	7/1/1887–7/7/1891
4. Dr. Levi L. Rowland	7/8/1891–7/31/1895
5. Dr. D.A. Paine	8/1/1895–12/31/1899
6. Dr. John Calbreath	1/1/1900–12/31/1907
7. Dr. R.E. Lee Steiner	1/1/1908–6/30/1937
8. Dr. John C. Evans	7/1/1937–8/6/1948
9. Dr. Charles Bates	8/7/1948–12/31/1954
10. Dr. Dean Brooks	1/1/1955–12/31/1981
11. Dr. James Bradshaw	8/1/1982–12/31/1983
12. Dr. Robert J. Benning	1/1/1984–5/23/1987
13. Dr. George W. Bachik	12/7/1987–4/7/1991
14. Dr. Stanley Mazur-Hart	4/8/1991–9/30/2003
15. Dr. Marvin D. Fickle	4/26/2004–10/1/2007
16. Dr. Roy Orr	2/25/2008–4/1/2010
17. Gregory Roberts	9/20/2010–

OREGON STATE HOSPITAL TIMELINE

1843 Oregon's new provisional government required courts to conduct inquests into credible reports of insanity, and $500 was allocated to pay for the expenses.

1862 The Oregon State Insane and Idiotic Asylum (also known as the Hawthorne Asylum) opened in East Portland.

1865 The state purchased two donation land claims (147 acres) east of Salem next to the state penitentiary for $8,615 and set it aside for a state mental hospital.

1880 The Oregon State Insane Asylum Fund was established and construction began. A Board of Trustees was appointed to administer asylum business.

1883 Patients were transferred from Portland to the new Oregon State Insane Asylum (OSIA) in Salem.

1890 Cottage Farm (640 acres) was purchased for $30,000 and electric lights were put in the asylum.
A hot air heating system was replaced by a hot water system.

1892 The asylum infirmary was built.

1895 Streetcars reached the asylum.

1908 The State Institution for the Feeble-Minded was opened, and patients housed in OSIA were transferred.

1909 A new home was constructed for the superintendent and his family.

1912 The Treatment and Psychopathic Hospital (also known as the Receiving Hospital and the Dome building) was opened as the new receiving hospital.
The legislature ordered a crematorium installed.
OSIA began returning non-resident patients to their resident states and countries.
Overcrowding forced patients to sleep in corridors and smoking rooms.

1913 The name of the hospital was changed to Oregon State Hospital. Eastern Oregon State Hospital was opened.
The Board of Control was created to oversee the various public institutions in Oregon. It consisted of the governor, the secretary of state, and the state treasurer. The bodies from the Asylum Cemetery were cremated and the cemetery disappeared.

1914 Superintendent Steiner enacted a parole system for patients at OSH.

1917 The State Board of Eugenics was created. Oregon passed the Eugenics law allowing for the sterilization of patients in various Oregon institutions.

1918 The Dome building was finished.

1928 The Griffith Nursing Home opened on January 29.

1931 OSH began charging patients or their families twenty dollars a month for care in hospital.

1937 Metrazol and insulin shock therapy were introduced.

1942 Forty-seven patients died and more than four hundred others became ill from a dinner of poisoned eggs.

1944 The Senior Cadet Nurses School was established to train nurses. By 1948 nearly 480 nurses had graduated from the school.

1947 The Board of Control authorized the first lobotomy.

1953 The eight-hour workday was instituted at OSH.

1955 OSH opened a 676-bed geriatric building.

1958 On July 1 OSH reached a historic high of 3,545 patients.

1962 The Mental Health Division under the Board of Control was created. The hospital was reorganized into six geographically oriented psychiatric units and one medical/surgical unit.

1963 The Sexually Dangerous unit was opened in September for patients transferred from the Oregon State Penitentiary who were judged criminally insane and sexually dangerous.

1960s Community care and deinstitutionalization policies were instituted at OSH.

1966 The Psychiatric Security Program was opened with three thirty-bed wards and organized into three levels of security: maximum, medium, and minimum.

1969 The Board of Control was dissolved and the Department of Human Addiction and Mental Health was assigned administrative duties over OSH.

1975 *One Flew Over the Cuckoo's Nest* was filmed inside the hospital.

1976 OSH opened its Child and Adolescent Secure Treatment Program.

1977 The Psychiatric Security Review Board (PSRB) was created to oversee people ruled guilty of a crime "except for insanity."

1981 The use of lobotomy and the Psychosurgery Review Board was abolished.

1983 The OP/RCS computer project was implemented throughout the campus.
 The Board of Eugenics was abolished.

1990 Buildings previously known by numbers were given names based on geographic features.

1991 Measure Five passed and ninety-one hospital employees were laid off. At the same time the Federal Health Care Financing Administration demanded an increase in staff or OSH would lose federal funding.

1995 Dammasch State Hospital was closed.

2002 U.S. District Judge Owen Panner ruled that Oregon had violated the rights of mentally ill criminal defendants by making them wait for weeks or months in county jails.
 Governor John Kitzhaber publicly apologized to the 2,500 individuals sterilized in Oregon during the Eugenics Movement.

2004 The state Legislative Emergency Board authorized money to study the future of OSH. The stored cremains of deceased patients were publicly recognized.

2005 The Oregon Advocacy Center filed a federal suit alleging that hospital overcrowding and inadequate staffing posed a threat to patients and workers. It was settled after legislators agreed to spend $9.2 million to hire thirty-five workers and make other improvements.

2006 The OSH Site Selection Criteria Committee picked Salem for a 620-bed facility to open in 2011 and Junction City for a 360-bed facility to open in 2013.

2008 CRIPA report from the U.S. Department of Justice revealed that conditions at OSH threatened the patients' safety and violated their constitutional rights. The campus was placed on the National Register of Historic Places.

2009 Construction began on the new hospital in Salem.

2010 The U.S. Department of Justice delivered a distressing report regarding the death of Moises Perez at OSH.

2012 Construction was finished on the new buildings in Salem.

Chapter 1
THE CASE OF CHARITY LAMB

Charity Lamb was thirty-three years old in 1854, married, and the mother of six children: a daughter and five sons. She had given birth to her fourth son in a wagon while on the Oregon Trail in 1852 and now, with her fifth son in her arms, lived in a rustic, dirt-floored cabin. The family's donation land claim was twenty miles east of Portland, just a few miles south of the Multnomah County line, between the Clackamas County towns of Damascus and Barton.[1] She was described as a small woman, work-worn, emaciated, and poor, even by frontier standards. Her clothing was thin, scanty, torn, and dirty. No one who knew her would ever guess she was about to become historically significant or that readers would care about her 158 years later. She had one important character trait—a stubborn determination to protect her children. She had given birth to six children and in a heroic effort had managed to keep all six children alive and healthy. Faced with the threat of losing them and possibly her life, she fought back.

On Saturday, May 13, 1854, she walked up behind her husband, her abuser and the man threatening to take her children away from her, while he ate dinner. With her arms held high she brought the ax down on his head. Nathaniel Lamb had a hard head, and although the ax bounced once, it did the job well enough. He died seven days later. Charity was convicted of second-degree murder in September 1854.[2] Her lawyers argued that she was temporarily insane when she killed Nathaniel Lamb; however, the all-male jury rejected the idea mostly because that would have meant an acquittal and she would have gone free. Visions of abused wives wielding axes on

unsuspecting husbands made them shudder. She was the eighth person incarcerated in Oregon's prison system.[3]

Her children were fostered with various families. Her property and belongings were auctioned off to the highest bidders, and she remained at the mercy of the men around her. Witnesses described seeing her wash Warden Joseph Sloan's family laundry at the prison in Portland. While convicted prisoners seemed to "elope" or escape at will from the facility, Charity remained. Where could she have gone if she had escaped?

On December 2, 1862, by order of Oregon Governor A.C. Gibbs, she was transferred to the Oregon State Insane and Idiotic Asylum, recently established in East Portland by Dr. James Hawthorne and Dr. A.M. Loryea. Was she insane? Even if the jury wouldn't acknowledge it, by the standards of Oregon society she probably was. After all, a woman who tried to kill the father of her children, no matter what the provocation, must be crazy.

The Oregon legislature had signed a bill in September 1862 authorizing the governor to pay $20,000 to Dr. Hawthorne to care for Oregon's insane patients. Governor Gibbs was a smart man and immediately recognized this as a way to remove Charity, Oregon's only female prisoner, from public scrutiny. Now he could say with all honesty that Oregon no longer had any female prisoners.[4] What Charity Lamb found in Oregon's first and only insane asylum was different from anything she'd experienced before in her life.

As early as August 1860, Oregonians were discussing who was responsible for the state's mentally ill. These were the community's weakest members—those least able to care for themselves. Oregon's prominent citizens recognized that the state needed to take responsibility for their care. "We are in a fever of movement. It is demanded of us by humanity, civilization, and Christianity…Who is safe from this terrible visitation?"[5]

Operated by Drs. Hawthorne and Loryea, the Oregon State Insane and Idiotic Asylum (also known as the Hawthorne Asylum) celebrated its inauguration on September 21, 1861, in a temporary facility on Taylor Street between First and Second Avenues in Portland.[6] Within a year the patients were moved to a permanent location across the Willamette River in East Portland. (It wasn't until July 1891 that the cities of East Portland and Albina were consolidated with Portland proper.)[7] The asylum occupied seventy-five acres between what are now Ninth and Twelfth Avenues and Hawthorne Avenue and Belmont Street. The asylum property included a dairy, a produce garden, and a wood lot. The street was originally called Asylum Street but quickly acquired its permanent name, Hawthorne Avenue, which eventually spread to the Hawthorne Bridge and the

Hawthorne District. The new frame two-story structure located just east of Southeast Twelfth Avenue and Hawthorne Avenue was located on twelve cleared acres, had an excellent water supply, and was surrounded by a high board fence. "Large halls run through the whole length of the building in both stories, and there are three large wards for the accommodation of the first class patients who are harmless; also a set of single rooms for the more unruly and vicious inclined."[8] There was a chapel, a reading room, and a billiard room. Prominent Portland citizens Ladd, Corbett, Stephens, and Stark (now immortalized in Portland's streets and districts) donated money and necessary items to be used at the asylum.

A bell tower topped the Greek revival building, and the bell tolled the daylight hours. As of 2008, "the bell, all that remains of the asylum, is housed at Oregon Health & Science University."[9]

On January 7, 1863, the *Oregon Sentinel* of Jacksonville, Oregon, was the first newspaper in Oregon to publish the name of a person committed to the asylum. Besides noting that "he is raving constantly and is a dangerous person," the writer complained strongly about the cost ($300) of transporting the man all the way to Portland.

By 1863 an additional wing had to be added to the new asylum. Charity was one of the five women and twenty-nine men living at the asylum with diagnoses of melancholia, mania, monomania, dementia, and idiocy. From month to month the number of patients varied. A report from the asylum dated April 6, 1863, noted that there were twenty-eight state patients (one was Charity) and one private patient and that "perfect silence and well arranged discipline seems to reign throughout."[10]

On July 25, 1863, C.H. Hall wrote about his visit to the asylum and noted Dr. Loryea lived in the asylum with his family and "studies the happiness of its inmates, and extends to them every kindness within his power. He walks and plays with them, amuses them with various games, and endeavors to keep them from brooding over their cares."[11]

This was a new life for Charity. No longer the only woman locked in a facility designed for men, she now had the freedom to talk to other women, participate in outdoor activities, and evade the heavy labor imposed at the penitentiary. This also made it possible for her children to visit her. Visitor records no longer exist, if such records were ever made; however, the children supported her and testified at the trial about how badly their father had abused Charity, so hopefully they remained sympathetic to her condition.

By 1864 the inspecting physicians counted forty-five patients on site. One patient had been discharged as cured, one had escaped, and three more had

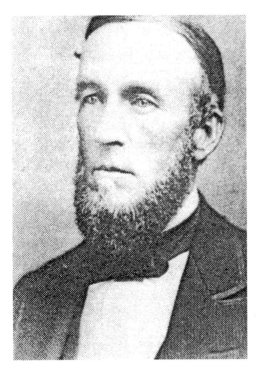

Dr. James C. Hawthorne (1819–1881) established the Oregon State Insane and Idiotic Asylum in Portland. *Oregon State Hospital.*

been admitted.[12] In 1865 a county hospital was built behind the asylum and a forty- by one-hundred-foot north wing was added to the main building.[13] There were two additional wings and a third floor with eleven wards, including one hundred for thirty-three men and thirty-six women built in 1866. The staff included forty-nine attendants. The patients used two fenced garden promenades, one of three acres and the other of six acres. Dr. Hawthorne was listed as the resident physician, and John Kenworthy was superintendent and manager.[14]

Dr. Hawthorne spent a year visiting asylums in Connecticut, Massachusetts, Pennsylvania, and other states. He studied the best psychiatry had to offer at that time, and when he returned to Oregon he based his treatments on the concept of "moral management," often referred to as "moral therapy." It was founded on the philosophy that it was necessary to treat the patients with kindness, consistent expectations, and exposure to a natural rural setting. Moral management believed it was important to entertain the mind with books, music, and conversation as well as exercise the body with productive work and healthful pursuits.[15] Patients were encouraged to enjoy swings, ball playing, and other games. The asylum's wards were clean, well ventilated, and kept in excellent repair. Healthy food, air, and water helped patients physically while pleasant activities and kind treatment helped them mentally. Physical activities included walking, gardening, sewing, and outdoor games. Reading, writing, and conversation were prescribed mental activities. All was done in a regular and consistent manner so patients knew exactly what was expected of them. Laxatives in the form of Epsom salts, calomel, and cochineal seemed to relax manic patients.[16] Physical restraints were used only as a last resort.

At some time in Charity's past she had attended school and could read and write. This was unusual for a woman of her economic and social standing. Moral therapy provided her with the opportunity to use her education, read books, and enjoy a part of life denied to her as a poor homesteader.

The men wore thick woolen jackets and pants, flannel shirts and drawers, black wool hats, heavy shoes, and woolen stockings. Cotton was substituted in the summer. Women wore calico dresses, flannel and cotton underclothing, comfortable shoes, and stockings. The patients produced all their own clothing and bed linens.[17] The patients were fed a nutritious but simple diet.

This was in direct opposition to earlier concepts of cruelty, punishment, and imprisonment practiced by European facilities. By October 1866, a legislative team (J.C. Cartwright, R.H. Crawford, James Sterns, John Whiteaker, James G. Ngles, and F.G. Lockhart) assigned to inspect the asylum reported 160 patients and attendants living there.[18]

In September 1867, the visiting physician, Dr. J.S. Giltner, reported there were seventy-nine male and thirty-three female patients at the asylum—nine fewer than a year earlier. Eleven had been discharged as cured, five had died, and three had escaped. One patient died from exhaustion of acute mania, three from softening of the brain, and one from epilepsy. Charity remained as part of the incurable class. Noting that the majority of the patients were from the working class, Dr. Giltner drew the conclusion that "continuous physical labor, without an adequate amount of mental labor or recreation, is one of the most frequent causes having a tendency to bring on insanity."[19] He suggested that people do less work and more recreation to prevent insanity. He described the asylum's moral treatment as hygienic and accompanied by kindness and moderate restraint similar to other institutions. He did not offer suggestions on how poor homesteaders living in isolated parts of Oregon were supposed to manage his prescription.

A year later, Dr. Giltner noted in his next report that as of August 31, 1868, there were ninety-one patients: forty-nine incurable, thirty-one curable, and eleven doubtful. Causes of insanity were listed as self-abuse, intemperance, domestic trouble, financial problems, and religious excitement. Heredity was also listed as an underlying cause. No mention is made of how Charity was classified. As a convicted felon, Dr. Hawthorne and Dr. Loryea made no mention that she was treated any differently than other patients.

Dr. Giltner described the hospital as follows:

In the summer of 1866, several acres of ground shaded by a beautiful fir grove, were enclosed with a high board fence, and well provided with

31

swings and various other fixtures for gymnastic exercise, for the benefit and amusement of the inmates; also, games of ball, draughts, and quoits were introduced, all of which is calculated to divert their attention and produce a soothing effect on the mind.

The following named articles constitute the diet: Meats: Beef, pork, mutton, and salmon, both fresh and salted. Vegetables—Potatoes, cabbage, turnips, onions, tomatoes, parsnips, lettuce, beets, beans, peas, etc. Drink—Coffee and tea. Fruit—of various kinds in season; and dried when out of season. Bread of the best quality is supplied in abundance. Sugar and molasses are furnished at all the meals.

The dining rooms, kitchen and bake house are well supplied with all the necessary fixtures, and the most improved utensils are provided, all of which are kept neatly and in proper order.

The dispensary connected with the place is always supplied with a good stock of standard drugs and is always kept in excellent condition.

Sewing and knitting and ironing are the employment of the females. They manufacture the greater part of the clothing worn by the males, and all that is worn by themselves; affording them light employment, and relieving the monotony of their confinement. A limited number of the convalescent males are employed at different kinds of out-door work on the farm and in the gardens. It would be a great advantage if more were so employed, as it would hasten their restoration; but the limited number of attendants will not admit of it. The clothing worn by the males is of Oregon manufacture, of good quality; and that of the females is calicoes and all are constantly kept neat and clean.

The supply of water comes from an excellent spring, which is thrown into a large reservoir. The reservoir is on a high tower, built expressly for this purpose, with hose attached of sufficient length to discharge water on any part of the building.[20]

On October 16, 1868, the *Oregonian* reported the first rumbling of discontent with the asylum. An anonymous writer, "Justice," maintained that patients slept on "straw beds, under gray blankets and have not sheets, neither are they furnished butter or delicacies."[21] He accused Dr. Loryea of setting up a whiskey shop and cigar stand in Salem to persuade legislators to vote seven dollars a week per patient for a new contract until Hawthorne arrived in Salem and sent him away. Soothing ruffled feathers, Dr. Hawthorne negotiated successfully for a new two-year contract.

The only punishment allowed in the asylum was isolation in solitary confinement and the use of straitjackets to prevent patients from injuring

themselves.[22] Charity was never violent (other than using the ax on her husband in her own defense), and it's doubtful she ever experienced restraints. In 1868 a patient killed two other patients, triggering an investigation. However, the asylum was subsequently absolved of all responsibility.

Various visitors wrote positive reports about their observations at the asylum, and officials appointed by the legislature praised the treatment and care of the patients.[23] As of September 1870, there were 111 patients at the asylum.[24] In the previous two years, 14 men and 3 women had died—6 from pulmonary consumption, 3 from brain disease, 1 from epilepsy, 3 from puerile debility, 1 from acute mania, 2 from chronic mania, and 2 from strokes. The report also noted that Dorothea Dix (1802–1887), a famous advocate for humanely operated insane asylums, had visited the asylum twice and recommended Dr. Hawthorne continue to care for the insane, as she believed the state wasn't prepared to care for them as well as the Hawthorne Asylum could.[25] Dix supported the belief of moral therapy developed in France and England. Through her work and political influence, she steered mental healthcare in the United States toward a more compassionate and humane philosophy.

The 1870 Oregon Federal Census for East Portland, Multnomah County, Oregon, showed 11 attendants (9 men and 2 women) and 2 children living at the asylum. They cared for 128 identified inmates: 33 women ages fifteen to sixty-eight and 95 men ages six to sixty. The average age was thirty-eight. Charity was listed as being forty-eight years old. She had now been institutionalized for sixteen years.

Abigail Scott Duniway visited the asylum in 1871 and published her findings in *The New Northwest*. She described the patients as fond of their gentlemanly physician, Dr. Hawthorne. One elderly gentleman told her, "We have a very comfortable home here, madam; I had no idea that the accommodations were so good." Another elderly woman concentrated on working colorful rags into floor mats. Duniway marveled at an elderly African American woman, Polly Holmes, age sixty-eight, a mother of twenty-three children and "a hideous monster of mein [*sic*] sufficient to convert Darwin himself to a life long adherence to his own theories. Twenty-three children! To nurse through measles, whooping cough, mumps, scarlet fever, rash, teething, weaning, jaundice and dysentery! No wonder she's insane."[26] Duniway noted that at that time there was no female physician attending patients in the asylum. She did not mention meeting Charity; however, in such a small facility it would be highly unusual if she didn't.

By 1872 there were 165 patients (125 men and 40 women). The state allocated $135,000 to support the asylum for the 1873–74 biennium.[27] That same year, Dr. Loryea sold his portion of the asylum to Dr. Hawthorne and left Oregon with his family.

The patient count continued to grow. By September 30, 1874, there were 195 patients: 140 men and 55 women. The 215 patients admitted to the asylum during the previous two years included the following: chronic mania (100), acute mania (39), epilepsy (24), dementia (34), monomania (2), melancholy (2), and idiocy (14). During the same period, 33 patients (25 men and 7 women) had died in the asylum.[28] It was estimated it would cost $58,000 (about $6 per week per patient) to care for the patients for the next year.[29]

The Portland *Weekly Oregonian* of October 8, 1874, had this to say about the concept of insanity: "Insanity, like fever, consumption, etc. is a disease, but of the brain and like any other disease requires the best treatment and care to obtain a speedy and permanent cure, but by poor treatment and neglect will linger along and in many cases when a cure could have been wrought no cure be performed."

Various proposals were investigated to replace the Hawthorne Asylum, but Dr. Hawthorne's ability to successfully navigate Oregon politics ensured the state continued to maintain his current contract. Senate Bill 31 was proposed in 1876 in an effort to force the counties to help pay for patients admitted from their area. It also provided that two physicians and one lawyer would have to agree on a person's sanity instead of a single county judge. Senate Bill 102 also proposed a special tax to build an asylum. The ideas were ahead of their time, but the voters weren't ready and both bills were rejected.

By July 1877, there were 230 patients and it was costing the state about $70,000 a year, paid in gold, to support the asylum. This amount represented 42 percent of Oregon's yearly tax base.[30] It was costing $8,325 a year just in sheriff's bills for transporting patients to the asylum. The costs raised questions about extravagance, and some people accused Dr. Hawthorne of extorting money from the state and manipulating the political process. "Dr. H. is an accomplished lobbyist, and he keeps at the capitol a considerable train, among whom have been Sweeney and Johns, witnesses last week before the senatorial investigating committee."[31]

Another protest about Dr. Hawthorne's contract for the insane surfaced in October 1878, stating that he had manipulated the law used to identify patients sent to the asylum and that this "accounts for our insanity being of a milder type. In other states judges could send only the really insane to the

asylum. Here everybody is sent whom it is convenient to have out the way of anybody else, and profitable for the contractor to keep."[32] For the first time an article in a newspaper stated that the primary objective of the asylum was to protect the community and keep it safe from the insane instead of cure the insane. The governor approved a six-year contract with Dr. Hawthorne beginning December 1, 1878, for the care and keeping of the insane and idiotic, providing that if the state should build an asylum within four years then the contractor would turn the patients over to the state.

Cornelius Austin conducted the federal census of 1880 in East Portland, Multnomah County, on June 16, 1880. At that time there were 285 inmates: 204 men and 81 women. Twenty were male Chinese, one was female Chinese (Toy May), and one was a black male. The youngest was a nine-year-old girl and the oldest was an eighty-seven-year-old woman. Some well-known families were named, e.g. Frank G. Herron (age forty), Amanda Fournoy (age thirty-two), and Malinda Applegate (age forty). Malinda and Charity had entered the asylum within a few months of each other. One was sent there by the state and the other by her family.

Charity Lamb died in September 1879 of apoplexy. She was fifty-eight years old. Her name appears for the last time in the Mortality Schedule at the end of the 1880 census. During the nearly twenty years Charity had lived at the asylum, 1,349 patients had been received and treated.[33] The asylum's dead were routinely interred at the nearby Lone Fir Cemetery. Although Charity's name is not listed in the cemetery records, she was most likely buried there.

Researchers believe that at least 140 indigent patients were probably buried under what is now a parking lot at Lone Fir Cemetery at Southeast Morrison and Twenty-first Streets.[34]

Finally, in 1880, recognizing that they had three years until Hawthorne's contract expired, the legislature authorized the building of a state asylum in Salem. Section six (laws of 1880, page 51) provided: "For the purpose of carrying into effect the provisions of this act, there shall be and is hereby appropriated of the surplus money, now in the treasury or which may hereafter arise under an act entitled 'An act to provide for a tax to defray the current expenses of the state and to pay the indebtedness thereof,' Approved October 26, 1876, the sum of $25,000 * * * to be used in the construction of said insane asylum, to be known as the 'Insane Asylum Building Fund.'" Additionally a county tax was initiated and paid into the fund.[35] The act indicated that the new asylum would be located in Salem on 107 acres already owned by the state about one half mile east of the penitentiary. The new asylum would sit on a small rise with a splendid view of the city.

An anonymous writer, "M," for the *Oregonian* warned:

> *Let the trustees be carefully chosen because of their high character and independence from political or pecuniary influence. Let them be few in number, so as not to be unwieldy, and so, slow of united action. Let them represent the state in all the concerns of the hospital, and be responsible for its proper equipment, organization, and conduct. Let them appoint its officers and approve of its employees, and let these officers be responsible to the trustees, who should see to it that none but those of the largest experience, attainments, and character be put in place, and when in place that no agitation as to tenure of office or necessity for political influence, or legislative lobbying, shall be allowed to divert them from their proper hospital work, who, to be well done, must not only have a full staff of medical officers; but these officers should have charge of all the concerns of the hospital as whatever bears upon it as a hospital must also bear upon it as means of cure, and who can administer the means of cure so well as the physician.[36]*

Unfortunately the upcoming legislatures ignored the advice, and for many years political patronage ruled asylum employment. Instead of hiring the best to supervise and treat the patients, each new governor reserved the right to appoint men from his own party, creating a system in turmoil open to graft and corruption.

Dr. James C. Hawthorne died on February 16, 1881.[37] He was born in 1819 in Pennsylvania and arrived in Portland in 1857. For twenty-one years he had been the heart of the Oregon State Insane and Idiotic Asylum. Even though he was a Democrat, he had remained friendly and cooperative with Republican politicians—an astonishing ability in an era when political affiliations defined a man. He was married and had two daughters, Louise and Catherine.

After his death, Dr. Simeon E. Josephi, connected with the asylum for the previous fifteen years, became superintendent until it closed in 1883. Dr. Josephi later became superintendent of the Oregon State Insane Asylum in Salem from 1885 to 1886. He continued Dr. Hawthorne's modern methods of treating patients as individuals. Instead of classifying and treating patients as a group, physicians began to regard the mentally ill as having separate personalities and problems different from each other and therefore needing dissimilar treatments to be cured.

The earliest contract with the Hawthorne Asylum established the form and method Oregon would use to finance care for the insane for the next

one hundred years. Cost became based on the amount of money allocated per patient per week or month. The more patients were admitted, the more money it cost the state. This escalation seemed endless until the concept of community healthcare was developed in the 1960s.

NOTES

1. Frank Branch Riley, letter dated April 22, 1969, addressed to the editor of Transcontinental Lecture Tours. Vertical file for Charity Lamb, Oregon Historical Society Research Library, Portland, Oregon.

2. Diane L. Goeres-Gardner, *Murder, Morality and Madness: Women Criminals in Early Oregon* (Caldwell, ID: Caxton Press, 2009), 15.

3. Oregon State Prison Inmate Case Files, 1853–1983, Oregon State Archives, Salem, Oregon.

4. Steve Wade and Laurel Paulson, "Charity and Justice," *Extracting Roots II, Frying Pan* (June 1979), Oregon Historical Society Research Library, Portland, Oregon: 23.

5. *Weekly Oregonian* (Portland, Oregon), August 4, 1860.

6. "Oregon Hospital for the Insane, Portland 1861–1881," Oregon State Hospital Museum Project, http://oshmuseum.wordpress.com.

7. Eugene Snyder, *Portland Names and Neighborhoods: Their Historic Origins* (Portland, OR: Binford and Mort, 1979).

8. *Weekly Oregonian*, January 14, 1862.

9. Fran Genovese, "Buckman: Planning a Garden for Forgotten Residents," *Oregonian*, October 23, 2008.

10. *Weekly Oregonian*, April 6, 1863.

11. *Weekly Oregonian*, July 25, 1863.

12. *Weekly Oregonian*, May 13, 1864.

13. *Oregonian*, May 11, 1865.

14. *Oregonian*, April 17, 1866.

15. Alex Beam, *Gracefully Insane: Life and Death Inside America's Premier Mental Hospital* (New York: Public Affairs, 2001), 11–12.

16. Ibid., 24.

17. J.S. Giltner, "Report of the Inspecting Physician to the Insane Asylum: Oregon. To the Legislative Assembly Thereof, for the Sixth Regular Session, September 1870" (Salem, OR: W.A. McPherson, State Printer, 1870), 4.

18. *Oregonian*, October 30, 1866.

19. *Oregonian*, September 25, 1867.

20. Giltner, 4.

21. *Oregonian*, October 16, 1868.

22. Giltner, 6.

23. Giltner, 5. Also J.S. Giltner, "Report of the Visiting Physician of the Oregon Hospital for the Insane for 1867–8" (Salem, OR: W.A. McPherson, State Printer, 1868), 3.

24. O. Larsell, "History of Care of Insane in the State of Oregon," *Oregon Historical Quarterly* 46, no. 4 (1945): 304. In contrast he later states on page 307 there were 122 patients in 1870.

25. *Oregonian*, September 26, 1870.

26. *The New Northwest* (Portland, Oregon), September 8, 1871. Polly Holmes was the only black female patient at the asylum and is listed in the 1880 census.

27. *Willamette Farmer* (Portland, Oregon), November 2, 1872.

28. *Democratic Times* (Jacksonville, Oregon), October 2, 1874.

29. Ibid.

30. *Oregonian*, July 24, 1877.

31. Ibid.

32. *Oregonian*, October 1, 1878.

33. Ronald B. Lansing, "The Tragedy of Charity Lamb, Oregon's First Convicted Murderess," *Oregon Historical Quarterly* 101, no. 1 (2000): 73.

34. Genovese.

35. *Oregonian*, May 28, 1881.

36. *Oregonian*, July 17, 1882.

37. Larsell, 310.

Chapter 2

THE CASE OF MALINDA APPLEGATE

In 1861, the head of the large Oregon Applegate clan, Jesse Applegate, was asked to be a trustee for the new Hawthorne Asylum. Jesse declined the opportunity and replied in a letter, "Our family supports an insane pauper, who I hope provided with proper care and treatment might return to reason and usefulness and when you are prepared to receive patients I maintain my interest in having her placed under your charge."[1] It's unknown exactly who Jesse was referring to, but certainly other members of the Applegate clan were committed to the Oregon asylum.

The three Applegate brothers, Jesse, Charles, and Lindsay, moved to Oregon from Missouri in 1843. Before the move, Lindsay and Charles married two sisters, Elizabeth and Malinda Miller, while Jesse married Cynthia Ann Parker. The Miller family accompanied the Applegate family on their move. In Yoncalla, where they all settled, Jesse and Cynthia had twelve children, Lindsay and Elizabeth had eight children, and Charles and Malinda had eight children.

Jesse and Cynthia's fifth child, Robert, married his Aunt Malinda's niece, also named Malinda, on December 5, 1858.[2] Robert and Malinda had eight children over the next twenty years. On May 18, 1878, at the age of thirty-eight, Malinda Applegate, Robert's wife, was committed to the Hawthorne Insane Asylum by Judge Thomas Smith of Douglas County and left her husband and children in Yoncalla.[3] Her second child, William, was seventeen years old; her third child, Oscar, was fifteen years old; Edna, her sixth child, was eight years old; and her youngest child, Ira, was two years old.

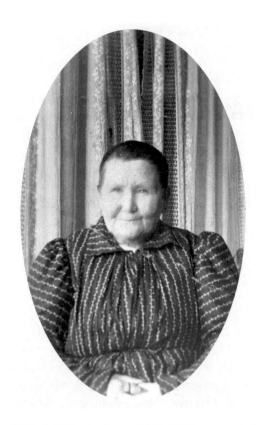

Malinda Miller Applegate (1840–1893) was married to Robert Applegate in Douglas County. *Douglas County Museum.*

Records state that her traveling trunk held one gray sunbonnet, one brown waterproof sacque (loose jacket), one brown skirt, one gray felt skirt, two chemises, one dark print suit, one gray cotton polonaise (a fitted overdress that extended into long panels over an underskirt) and skirt, two cotton handkerchiefs, and three pairs of hose.[4] Notably not listed were underclothing or shoes.

While she was a patient at the Hawthorne Asylum, the Oregon legislature passed the following law in 1880: "An Act to provide for the construction of a brick insane asylum building, to levy a tax and appropriate money." Constructing an asylum was expensive business and was usually the third (after the penitentiary and the capitol) public building erected when a territory became a state. Oregon was no exception.

Governor W.W. Thayer, Secretary of State R.P. Earhart, and State Treasurer Ed Hirsch were named to the Board of Commissioners supervising the implementation of the act. Several architectural plans were submitted. However, none of them met the exact requirements specified for the Oregon asylum. The five architects who submitted plans were each paid $200, allowing the best parts of each proposal to be incorporated into the final drawings. A total of $140,000 was spent building the asylum and $40,000 was used to furnish it.

The J Building

Thomas Story Kirkbride, a well-known Quaker physician, was superintendent of the Pennsylvania Hospital for the Insane from 1841 to 1883. He was an ardent believer in moral therapy for the insane and encouraged patients to participate in a wide variety of mental and physical activities. As described in 1811, moral treatment consisted of moving patients to a calm retreat in the country, with soothing and tolerant acceptance of aberrant behavior. The asylum adopted a consistent schedule encouraging patients to get out of bed, eat, exercise, and go to sleep at the same time every day. "When convalescing, allow limited liberty; introduce entertaining books and conversation, exhilarating music, [and] employment of body in agricultural pursuits."[5] His gentle application of such behavioral controls resulted in some nearly miraculous recoveries. Kirkbride also believed that the shape of the structure the patients lived in was critical to their successful recovery. "Architecture became an obsession for asylum administrators."[6] While Kirkbride did not directly design the Oregon State Insane Asylum (OSIA), his philosophy did. The Kirkbride plan dominated asylum architecture between 1840 and 1880.[7]

A typical Kirkbride plan was linear and V-shaped, developed around a central core structure with connected pavilions. The outside façade would be made of stone or brick with a formal entrance. The inside was broken up into wards with day rooms, wide hallways, and small bedrooms reminiscent of homes. Good ventilation and lighting were vital. The plan made it easy to add wings or do remodeling.

In addition to the architecture of an asylum, the natural scenery surrounding the asylum was considered essential. Frederick Law Olmsted, famous for designing New York's Central Park with his partner Calvert Vaux, designed five American asylum landscapes. He believed that the natural elements of scenery helped the unconscious mind heal and reorganize itself. His plans and ideas became the basis for asylum landscape design across the United States, including in Oregon.

W.F. Boothby, supervising architect and superintendent of construction, designed the Oregon State Insane Asylum. It incorporated all the many innovations that had been developed in the previous fifty years by Kirkbride. It was brick with a gracious entrance, long hallways, and corridors extending from a central entrance. Patients were separated by sex, males in the north wing and females in the south. There were twelve wards with patients assigned to various wards according to their diagnosis and violence levels.

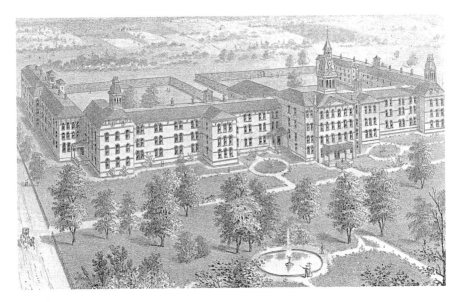

W.F. Boothby was the designing architect of the Oregon State Insane Asylum. *Oregon State Library.*

Young children diagnosed as mentally deficient and elderly dementia patients were often housed together in the same ward.

Oregon's new asylum was a modified Italianate. The entrance faced west and was 485 feet long with a wing at either end, running east for a little over 220 feet. The center or administration building was four stories tall with a decorative cupola reaching 120 feet high. Iron cresting and small cupolas topped the wings. The wards were 42 feet wide with 12-foot corridors running down the center with enough rooms to house 412 patients. The outer walls were faced with brick and anchored with iron bars to the inner walls, allowing air to flow freely and keeping out mold and condensation. (This was later recognized as a serious fire danger as the opening allowed fire to burn between the walls.) Oregon State Penitentiary superintendent George Collins provided the brick, and 20 convicts provided the labor.[8]

Groundbreaking took place on May 1, 1881. The foundation extended four feet deep to hardpan and was laid with rubble stonework. A basement seven feet four inches deep allowed for the railway tunnel used to convey food, wood, and other supplies to various parts of the building. A turntable in the basement was engineered to aim the rail car in either direction inside the tunnel.

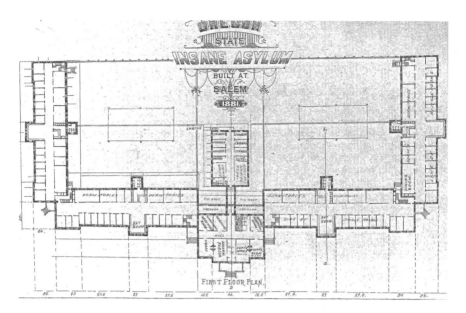

The first-floor blueprints show the various living quarters and the main entrance to the asylum. *Oregon State Library.*

The first or primary floor housed the 10-foot-wide entrance hall with the superintendent's public and private offices to the right and the general reception room and library to the left. The hall intersected with the 8-foot-wide north–south hall running into the wards and continued east into the kitchen. There were stairs at the end of each wing, and where the wings joined the front of the building the stairs also accessed outside entrances. The twelve wards were essentially identical with 12-foot-wide corridors running 168 feet in length. The wing wards were 11 by 155 feet. Each ward had a dayroom with windows on three sides and furnished with upholstered seats. Across the hall were the washrooms, water closets, and linen rooms. Dumbwaiters connected the kitchen with each floor. Violent patients were housed in the east half of the north and south. Due to her periodic outbursts, Malinda would most likely have been housed in the women's violent ward.

The superintendent's family living quarters were on the second floor of the J building. Accommodations for assistants, supervisors, matrons, and druggist supplies were also on this floor. The third floor contained living areas for other attendants. The fourth floor was divided into seven large storage rooms. Verandahs on the back of the office connected to the wards and were enclosed with wire mesh for the safety of the patients. The tin roof provided protection from Oregon's rainy climate.

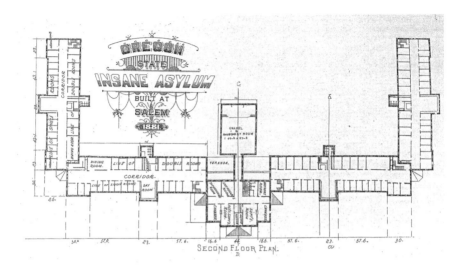

The second-floor blueprints show the living quarters for the staff and the kitchen/chapel extension in the center. *Oregon State Library.*

Seven wood-burning furnaces attached to large metallic tubes provided heat throughout the building. Flues and metal registers were constructed throughout to provide ventilation. Gas pipes delivered lighting. Four water tanks holding six thousand gallons each delivered water to the asylum. The newest innovation, telephones, connected attendants' living quarters with the kitchen, dining rooms, and superintendent's office. All woodwork, inside and out, was painted white.

Dr. Horace Carpenter, at a salary of $800 a year, was appointed the first superintendent of OSIA, a year before the asylum was built. He had been the first dean of Willamette University Medical Department from 1865 to 1876 before it was moved to Portland. He was by training a surgeon and obstetrician, not a psychiatrist. However, he campaigned diligently and persuaded Governor Oswald West that he was the man for the job.

On October 22, 1883, one man was transferred to the new asylum. On October 23, 1883, at 10:30 a.m., 263 men were transferred by train to the new asylum.[9] Secretary of State R.P. Earhart, Dr. Simeon Josephi of the Hawthorne Asylum, and Multnomah County Sheriff George Sears assisted in the transfer. Five omnibuses owned by the United Carriage and Baggage Transfer Company carried patients unable to walk on their own or too violent to allow freedom of movement from the Hawthorne Asylum in East Portland to the train waiting two miles from the east side depot near the neighborhood of Brooklyn. The train consisted of an engine, five passenger

coaches, and a baggage car—all with their blinds and windows closed to the outside world. It arrived at 2:45 p.m. in Salem, where seventy-five hacks and carriages waited to carry the men unable to walk. Twenty attendants accompanied the patients on their journey. Superintendent Carpenter, Dr. J.W. Givens, Dr. A.J. Giesy, John Kenworthy, and others were on hand to assist where needed.[10] After a warm dinner the patients were escorted to their assigned quarters.[11]

Patient records included nativity, vocation, county of origin, marriage status, date, and age when admitted to the Hawthorne Asylum. Ten of the men were Chinese and the rest were Caucasian. Ages ranged from seven to eighty-three. The most common occupations were laborer, with seventy-five listed, and farmer, with forty. Five merchants, two physicians, a teacher, and a lawyer were also listed. Sixty-three patients were from Multnomah County. Only thirty-eight were from counties east of the mountains. Douglas County sent nineteen men, while Wasco and Jackson Counties each sent eighteen. The primary cause of insanity was listed as masturbation. Head injuries, heredity, infections, epilepsy, and alcohol accounted for the remainder. The most unusual diagnoses were "onannism," or masturbation (referring to the biblical story of Onan and the idea of having sex without purpose of procreation), and "spermatorrhea" (excessive ejaculation).

Itemized diagnoses for men were as follows:

Mania	72 = 31 percent
Chronic mania	70 = 31 percent
Dementia	33 = 14 percent
Epilepsy	20 = 9 percent
Melancholy	19 = 8 percent
Idiocy	9 = 4 percent
Imbecile	7 = 3 percent
Feeble-minded	1

The next day, on October 24, 1883, 102 women and 2 men were transferred from Portland to Salem.[12] The transfer followed the same procedure as the day before, and Malinda Applegate was part of that transfer. Her OSIA admission papers stated the following: "This patient is occasionally violent—her appetite is fare [sic] sleeps only as med[icine] is given—noisy at night occasionally. April 11th, 1884."[13] By this time she was forty-three years old.

The women were again primarily from Multnomah County (twenty-nine), with fewer numbers coming from eastern Oregon (seventeen), Marion (ten), Yamhill (eight) and Douglas (eight). The rest were from outside the state (five) and other western counties (twenty-five). Most of the women identified as having occupations were housewives, with forty-nine listed, or domestic servants, with seven. There were also one hotelkeeper, one teacher, one dressmaker, and one prostitute. Forty-one listed their occupation as unknown. The most common cause of insanity was listed as unknown (fifty-nine). The next most common causes listed were heredity (six), emotional issues (thirteen), disease and injury (twelve), and sexual problems including menopause (six). Also listed were overwork, alcohol, and old age. No cause was listed for Malinda.

Itemized diagnoses for women were as follows:

Chronic mania	36 = 35 percent
Melancholy	24 = 24 percent
Dementia	13 = 13 percent
Idiocy	9 = 9 percent
Acute mania	4 = 3.5 percent
Epilepsy	6 = 6 percent
Unknown	9 = 9 percent
Paresis (schizophrenia)	1 = 0.5 percent

Treatment was rudimentary and consisted of hard work and lots of sleep coupled with liberal amounts of alcohol and laxatives.[14] A physician's list of supplies included five gallons of Cutler whiskey, five gallons of grape brandy, three gallons of Norwegian cod liver oil, twenty-five pounds of ground flaxseed, and twenty-five pounds of Epsom salts.[15]

The *Oregonian* of October 25, 1883, attempted to analyze the current causes of insanity in Oregon. The writer stated, "We have according to the last census one insane person to every 500 of our population," and "the numbers will become much larger unless the causes of insanity are in some degree removed."

It was believed that alcohol or intemperance was the leading cause of the terrible malady of mental illness, and the Portland saloons provided the booze. Indulging in acts of violent temper, evil desires, and wild emotions were the downfall of others. Mental and social stagnation, particularly among the lonely women living in eastern Oregon, was thought to be a common

cause. "The influence of this depression, unrelieved by any healthy mental or moral object of interest, has made many women, especially weakened by overbearing, insane." Too many children and too much work seemed to be a prescription for insanity.

Besides erecting an asylum to house the patients, the asylum found it necessary to create a cemetery before the end of the year. Lizzie Hazelton (age twenty-four) was the first patient to die in the new asylum; however, her body was shipped back to her family.[16] Frank Holdridge (age sixty-five) was committed to the Hawthorne Asylum on August 5, 1879, and died on November 11, 1883. He was the first patient buried in the Asylum Cemetery.[17] The cemetery was established on the northeast corner of the property near where the Dome building was constructed in 1912. By the end of 1913, the cemetery held 1,539 bodies.[18]

An early *Oregon Daily Statesman* newspaper described the Asylum Cemetery: "On Decoration Day, the little inmates of the orphans' home, under the supervision of their matron, gathered a lot of wildflowers and

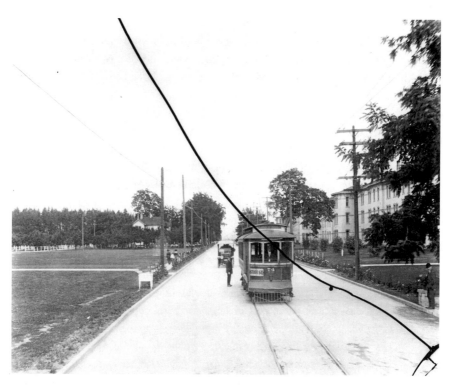

The Asylum Cemetery with a white picket fence is just visible in the upper left-hand corner. *Oregon State Archives.*

decorated the graves of the insane dead…the deed was a worthy one, and to the little ones is due a great deal of credit for doing this act of mercy to the unfriended dead."[19]

At the end of the OSIA's first year there were 541 patients present (396 men and 145 women), 127 discharged, 42 dead, and 17 escaped (only 12 returned).[20] Superintendent Horace Carpenter's report of December 1884 had slightly different figures. He stated that between October 22, 1883, and November 30, 1884, there had been 182 admissions, and of these 17 were readmissions. Of these, 135 were discharged and 55 were completely recovered; 46 patients had died.[21] He deplored the actions of family and friends tricking people to get them to the asylum. Bedtime was at 6:00 p.m., and gaslights were only lit for one hour per day.[22] Patients who arrived by stagecoach were often strapped down with the mail, and those who arrived by rail had to ride in the baggage car.[23]

It had cost almost $200,000 to build the new asylum with an annual interest fee of $15,000 on the money borrowed. By the end of 1884, it was costing the state $3 a week per patient, and the asylum's garden was providing the major portion of food needed to feed the 360 inmates. Of those, 20 were either from Idaho Territory or private patients.[24] (The Idaho patients were sent to Blackfoot State Hospital in 1885.)[25] This was a considerable savings over what the Hawthorne Asylum had been charging in Portland. In August 1885, homeowners living along Asylum Avenue in Salem contributed money to build a board sidewalk from downtown Salem to the asylum. Ed Frazier was in charge of the endeavor.[26] The road east of Seventeenth Street was called Asylum Avenue. About 1912 the name was changed to Central Street.[27]

Malinda seemed to do well at the new asylum. She received additional positive reports in her medical record. While the physician attending her did not sign his name, he did write the following:

The patient is soft & flabby. Tongue is clean—many teeth decayed— appetite good—bowels move once daily—menstruates regularly—pulse 76—hands cold—complains of cold feet—abdominal viscera apparently normal and rather sleepless—is liable at any time to strike some of the patients—is rather incoherent. One day when the workman was fixing a defective water closet she got a pan of hot water and unobserved threw the hot water on his face and head—slightly scalding the skin of his face. She said she did so because she believed he was trying to kill some children who were down in the basement, she could not be persuaded that there were no children down there. The lesions that give use to her condition are unknown

to me. I suppose it to be some brain lesion, but what I do not know. May 15, 1884.[28]

A few months later another physician wrote: "The patient is in fair physical health—she is usually good-natured but subject to outbursts of sudden passion when she will do violence to other patients—she is incoherent at all times. October 24, 1884."[29]

By the end of 1886, the Oregon newspapers began listing the names and other particulars about the patients being sent to the asylum. Usually they just gave the name, age, and county the person was from. Occasionally it was a much longer story with details about their diagnosis and the cause of their insanity, as in the case of Mrs. Emeline V. Fisher, who was transported from Grant County because she "tries to starve herself."[30]

On April 30, 1886, Dr. Horace Carpenter resigned as superintendent due to the fact that "his nervous system demands rest and that is not the place to get it."[31] Dr. Simeon Josephi, previously superintendent at the Hawthorne Asylum and a Republican, was appointed to succeed him. Dr. Josephi only served seven months and resigned when Democrat Sylvester Pennoyer was elected governor in 1886. Dr. Josephi had been a bookkeeper for Dr. Hawthorne at the Hawthorne Asylum from 1867 to 1875. Dr. Hawthorne encouraged Josephi to study medicine, and in 1875 Josephi entered the medical department of the University of California and graduated two years later. He returned to Oregon and began working for Dr. Hawthorne as an assistant physician. After Hawthorne Asylum was closed, he entered into private practice. He became the first dean of the University of Oregon Medical School in Portland from 1887 to 1912. He died in August 1935 at the age of eighty-six.[32]

On July 7, 1886, Jesse Applegate, known as "The Sage of Yoncalla" and Malinda's uncle, was admitted to OSIA with a diagnosis of acute mania. Records indicated it was his first attack and was caused by "old age and financial reversals."[33] He was seventy-five years old, a widower, and a farmer. He stayed at the asylum in ward 9 for exactly a year before he was released. Friends escorted him back to his son's home after his condition improved. He died a few months later in 1888.

Malinda's sixth child and daughter, Edna M. Applegate (age eighteen), suffered her first mental breakdown and joined her mother at OSIA in ward 11 on October 25, 1888. Diagnosed with acute mania, Edna was five feet two inches tall, weighed 170 pounds, and had blue eyes and red hair. Judge J.S. Fitzhugh signed her commitment papers. Her admission record states that the cause of her insanity was hereditary. The physician wrote in

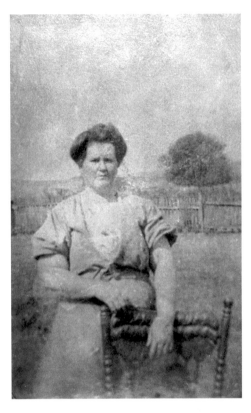

Edna Applegate (1870–1951) was Malinda's sixth child. She was admitted to the hospital three times. *Douglas County Museum.*

her admission record that the patient was "wildly excited—profoundly incoherent—noisy, boisterous and profane. Bowels constipated—tongue coated—breath foul." He administered a hypodermic of hyoscyamine sulfate (one and a half milligrams) with good results. He ordered half an ounce of the house laxative and prescribed two ounces tincture of cannabis and two ounces of sodium bromide to be given at once. Elixir of potassium bromide (half of an ounce) was to be given three times a day.[34]

Her attack had begun six weeks before being committed to the asylum. Her family took great care to send sufficient clothing for her. The following items were packed in her satchel:[35]

Three pairs of drawers
Four chemises [one old one]
Four pairs of red stockings [one old pair]
Two blue checked gingham skirts
One gingham dress
One blue gingham waist [blouse]
One red flannel underskirt
One red flannel sacque [loose jacket]
One black and white jersey dress
One white skirt
One pair leather shoes
One black cloak

Two weeks later, on November 8, 1888, the physician wrote in her medical record that she required the hypodermic administration of hyoscyamine sulfate each evening for about a week to control her noise and violence. She had improved somewhat, though still incoherent, and was noisy during the day. She was eating regularly but had lost weight. Her bowels were now regular, menses too, but she still required constant attention.

The biennium budget for 1887–88 included $150,000 for salaries and other general asylum expenses, $4,000 to pay for patients returning home, and $10,000 to pay the various county sheriffs for conveying patients to the asylum.[36] The last item became very contentious as time went on and the cost increased.

On July 1, 1887, Dr. Harry Lane replaced Dr. Simeon Josephi. Dr. Lane accepted the position based on the assumption it would be non-partisan. At that time there were 318 men and 148 women committed to the asylum.[37] The asylum had purchased additional land, which now totaled 285 acres, of which only 90 acres were capable of being farmed.[38]

Malinda remained in the new Oregon State Insane Asylum, and her condition was upgraded. She continued to hallucinate, but her violent episodes decreased. Records state: "Physical condition satisfactory, the nutritive junctions being well performed. Is profoundly incoherent, but her general disposition has improved. She almost never now becomes passionate, and displays no violence. Will mutter to herself and at night gets up and moves her bed, sings, etc. September 20, 1887."[39]

Edna was also doing better. On March 12, 1889, the physician wrote, "After a period of considerable disturbance lasting until near the end of December, she became more quiet, and rapidly improved both mentally and physically, and was today discharged [to Douglas County] as recovered." Edna was able to sign her name to a receipt for her clothing when presented to her by Superintendent Harry Lane. ..

A year later a new physician wrote in Malinda's record: "Continues well nourished, eating and sleeping well—bowels regular—good pulse—mentally weak, muttering incoherently to herself nearly constantly—at times governed by illusions and hallucinations, she continues disturbed during the night—seldom indeed, violent, this tendency decreasing with years. June 6, 1889."[40]

It's interesting to note the value placed on certain aspects of Malinda's physical health. Considering the level of psychiatric knowledge, her physical condition was the only measurable value the physicians had to evaluate her

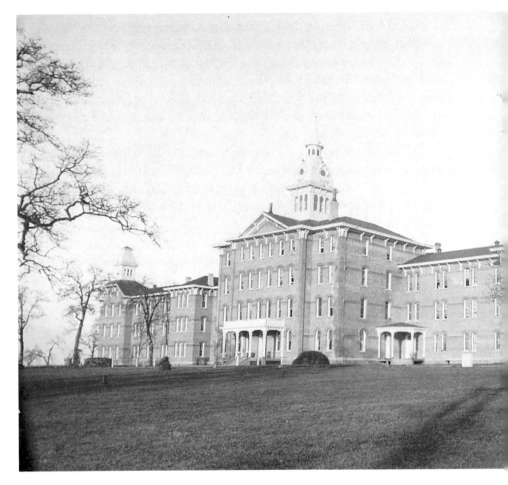

This shows the hospital as it appeared in 1887 before any additions were built. *Oregon State Archives.*

mental problems. It's difficult to decide whether the decrease in "passion" was an improvement or not. Certainly it made her easier to manage in an institutional setting.

By March 1889, Dr. Harry Lane was desperately vaccinating the entire asylum as smallpox raged along the Pacific Coast. A patient, George M. Alberts, was diagnosed with smallpox and confined to the asylum pest house (a building set aside to quarantine patients with contagious diseases).[41] In addition to smallpox, measles and scarlet fever were diagnosed in patients at the asylum. Sulfur, stick brimstone, and other disinfectants were used throughout the building.[42]

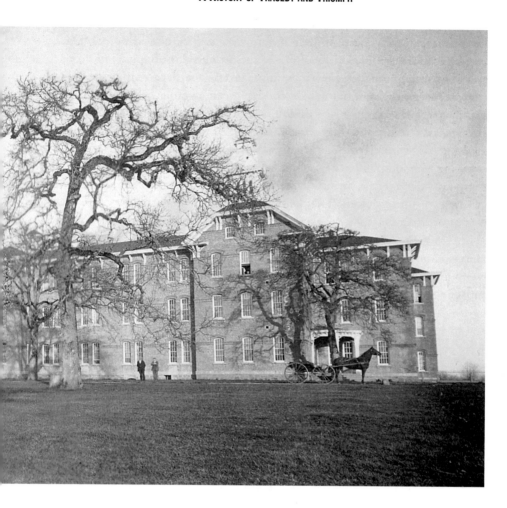

In the summer of 1890 Dr. Lane had the high board fence around the asylum removed and replaced with a picket fence in an attempt to reduce the prison-like atmosphere. He started the tradition of canning surplus products grown on the property.[43]

In December an excellent Christmas dinner was served to the patients, and the employees enjoyed a social dance.[44]

Comparative costs for various Oregon institutions were published on January 14, 1891. In the 1885–86 state biennium, the asylum budget was $133,920. In the 1887–88 biennium, it was $148,137. In 1889–90 it had increased to $176,168.[45] During that time $224,100 was spent on improvements.

The legislature of 1889 appropriated $30,000 for the purchase of a farm, and in 1890 it purchased 640 acres of land about three and a half miles

from the asylum.[46] This eventually became known as the Asylum Cottage Farm. Dr. Lane was an avid supporter of the cottage plan adopted in Europe and used at the most progressive asylums. Progressive asylum management advocated vigorous outdoor work by both men and women to promote sleep and decrease the use of drugs. The first three-story building cost $28,231. He moved as many able-bodied patients as possible out to the farm. Using produce from the farm, Dr. Lane instituted a mainly vegetarian diet, believing it would reduce the asylum death rate. "Clothing is kept clean and neatly mended; shoes are patched when needing it; each patient has two good sets of underclothes. The bedding is good. The culinary products are of a high order. Discipline is excellent."[47]

In 1891 there were 478 male and 212 female patients. While Dr. Harry Lane was superintendent, several outbuildings were erected and two additional wings were added to the main asylum building, increasing capacity on each side to 628 patients. Inside the main building he replaced

This was the first building erected at the Asylum Cottage Farm in 1893. By 1903, the farm housed 270 patients. *Oregon State Archives.*

the gaslights with electric lights, reducing the fire hazard.[48] Hot air furnaces were replaced with a hot water heating system. He worked assiduously to make the asylum as independent as possible.

Dr. Lane refused to succumb to nepotism. He even refused to add his wife to the asylum payroll as a matron, as previous superintendents had done.

His one failing was as a politician. Even though Dr. Lane was a Democrat working under a Democratic governor, he had offended Martin Raleigh, chairman of the Democratic committee of Marion County, by neither providing him with asylum business outside the bidding process nor favoring Democratic candidates for job openings. Raleigh demanded Governor Sylvester Pennoyer fire Dr. Lane and appoint someone more sensitive to the political climate. At the end of July the board, composed of Governor Pennoyer and two Republicans, voted not to renew Lane's contract.

The employees gave a gala farewell reception for Dr. Lane on July 7, 1891.[49] A band played and refreshments were served. The incoming superintendent, Dr. Levi L. Rowland, gave a speech complimenting Dr. Lane's work during the previous four years. At 8:00 a.m. on July 8, Dr. Rowland presented his certificate of appointment and took charge of the asylum. Three copies of the asylum inventory were prepared, and one each was given to Dr. Lane, Dr. Rowland, and the secretary of state.

Dr. Levi L. Rowland officially became superintendent on July 8, 1891, and assumed responsibility for 713 patients. Besides being a physician he was also an ordained Christian minister.[50] On October 3 he issued his first report of asylum conditions, causing a great furor that played out in the newspapers until the end of the year. He described the asylum as unsanitary, full of bedbugs, lacking adequate fire defense equipment, lacking adequate attendants, lacking bath towels, and needing seventy-five bedsteads for patients who were sleeping on the floor. Lane's furious reply refuted Rowland's condemnation in everything except the bedbugs. Yes, Dr. Lane admitted, the bedbugs, which no one had been able to eliminate, had come with the patients in 1883 from the old asylum.[51]

It's unknown whether Malinda was aware of it, but on January 24, 1892, her son, William Hayhurst Applegate, age thirty, joined her at OSIA. He was committed by Judge George W. Riddle with the notation that he had "attempted to kill members of the family." He was considered to be very violent. The admission record stated that he was six feet four inches tall, weighed 240 pounds, had blue eyes, light hair, a limited education, and was single. This was his first attack, and it was attributed to mental strain. Records state he brought a hat, a coat, two pairs of pants, two pairs of overalls, six

William Applegate (1862–1916) was Malinda's second child. After eighteen years, he was transferred in 1910 to the newly opened State Institution for the Feeble-Minded. *Douglas County Museum.*

shirts, one undershirt, two pairs of drawers, one pair of boots, and two pairs of socks.[52] The asylum records were remarkably silent about William's condition until January 22, 1910, when it was noted that he was sent with other patients to the newly opened Oregon State Institution for the Feeble-Minded (later renamed Fairview). Superintendent R.E. Lee Steiner notes in the 1911 Biennial Report that ninety men and forty-two women were transferred at that time.[53] William died six years later on April 22, 1916, at the age of forty-six.

By July 1892, Dr. Rowland reported that there were a total of 775 inmates (545 men and 230 women) and 93 attendants and employees living in the asylum.[54] New buildings were desperately needed, as male wards built for 35 now held 42 and female wards built for 38 held 56.[55] By the end of 1892 OSIA had opened its first infirmary. It was "the best in every way, being patterned after the medical college at Edinburgh, Scotland."[56] The infirmary was constructed of brick, 146 feet wide and 68 feet long, two stories high with attic and basement. There were four wards with separate entrances so that patients and nurses could enter and not carry infectious diseases from one to another. It had room for 120 patients.[57]

At the end of the year another scandal rocked the asylum when the Board of Charities and Corrections filed eight legal charges against the asylum. Only three of the charges were found to be true: that keys were given out too promiscuously; that a painter working in the asylum was discovered hiding under a female patient's bed; and that a young female attendant,

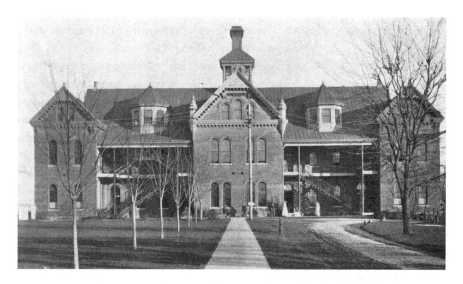

The asylum infirmary was built in 1892 in two sections, making it possible to separate men from women or isolate patients with contagious diseases. *Oregon State Archives.*

Miss Roblim, escorted a patient, Mrs. White, out of the asylum at night to see her husband. He was a guard on duty at the penitentiary.

The Report of the Legislative Committee at the end of 1892 stated that the asylum owned 1,020 acres and had 828 inmates at a per capita cost of $12.16 a month. The consumables budget was $118,707 for the two years. Payroll totaled $91,092 for the biennium.[58]

Superintendent Levi L. Rowland began conducting fire alarms periodically, which required the patients to exit the asylum in an orderly manner. There were now over five thousand feet of fire hose in the building and twelve fire pails filled with water stored in the wards. Practice alarms were also given twice a week at night. "So well are the patients trained that they fall in line in a perfectly mechanical or one might say automatic manner."[59]

In February 1893, the asylum attendants and employees presided over another large social gathering. No patients were admitted. A large group of legislators from the Seventeenth General Assembly also attended the festivities.[60] Balls, dances, and parties became monthly activities for the next twenty years and were reported on a regular basis in the Salem newspapers. Those attending represented the elite of Salem society. The asylum orchestra played and entertained at the parties.[61]

As of November 30, 1893, there were 909 patients compared to 794 in 1891. The asylum budget for 1893–94 was $275,000.[62]

Malinda's youngest son, Ira, had his first commitment to the asylum on January 1, 1894, at the age of seventeen by Judge George W. Riddle. He was six feet three inches tall, weighed 168 pounds, had light brown eyes, auburn hair, and had been ill with the condition for six weeks. He was diagnosed with melancholia and suffered "hallucination of hearing."[63] The cause of his insanity was "masturbation and heredity."[64] He recovered quickly and was released to his family in Drain, Oregon, eight months later on August 13, 1894.[65]

OSIA still wasn't paying its physicians commensurate with their educations. Dr. Clara Montague Davidson, the first female physician hired at the asylum, sent a letter to the asylum board on September 1, 1895, asking for either a raise or acceptance of her resignation. She was receiving fifty dollars a month plus room and board.[66] The board accepted her resignation. Clara Anne Montague was born in Vancouver, Washington, on October 21, 1863. She married James Davidson, and after their daughter Genevieve died in 1889, the couple moved to Philadelphia. She graduated from the Woman's Medical College of Pennsylvania in 1893.[67] After leaving OSIA she set up a private practice in Newberg, where she died April 20, 1905, at the age of forty-two.

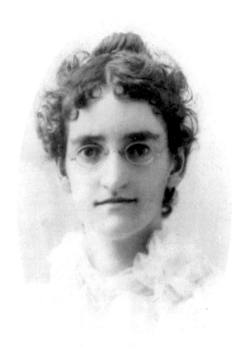

Dr. Clara M. Davidson (1863–1905) was the first female physician hired to work at the asylum. She quit in 1895 after the trustees declined to increase her salary. *Oregon State Archives.*

There were 1,024 patients (711 men and 313 women) in the asylum by the end of July 1895.[68] The streetcar system had finally put in a line down Asylum Avenue (later renamed Center Street) so relatives and employees could reach the asylum more easily.

Dr. Rowland resigned on August 1, 1895. He died in Salem on January 19, 1908.[69] Dr. D.A. Paine was hired as the new superintendent. He began a needed reform of discharging

inmates kept in the asylum based on charity rather than a possibility of cure. "Notice should be given that paupers, seniles, inebriates and effeminates that are clearly not insane, but the victims of appetites and mere old age, shall not be unloaded on the state asylum for insane, as though it were a state poor house."[70] He was described as an efficient administrator and reduced the cost of keeping an individual inmate to $9.32 per month, the lowest cost ever attained during the history of the asylum.[71] By September the patient population had been reduced to 1,020 patients.[72]

Cronise Studios in Salem published a photo collage of the asylum employees early in 1895. Individual photos showed Dr. D.A. Paine as superintendent, Dr. W.T. Williamson as first assistant physician, Dr. Lewis F. Griffith as second assistant physician, Dr. W.D. McNary as farm physician, and Dr. Clara Davidson as lady assistant physician. In the center of the collage was a photo of the asylum entrance. Photos of all other employees spiraled around the center of the collage labeled with names and asylum positions.

By the end of 1896 the asylum had added seven new buildings: an engine house, a morgue, a bakery, a carpenter shop, a laundry, a machine shop, and a new three-story ward addition to the J building.[73] Morphine addicts were no longer admitted, and Dr. Paine suggested patients from dissimilar classes of patients such as idiots, lunatics, and epileptics be placed in separate facilities. He also wanted to change the name of the hospital from the Oregon State Insane Asylum to the Oregon State Hospital (OSH)—something that wasn't accomplished until 1913.

The Ninth Biennial Report of 1901 listed the causes of insanity for the 579 patients admitted between December 1898 and November 1900 as follows:[74]

	Men	Women	Total	Percent
Unknown	195	80	275	47%
Alcohol/opium	36	7	43	8%
Paralysis/head injury	29	5	34	6%
Old age	18	16	34	6%
Heredity	23	9	32	5%
Syphilis/infections	18	10	28	5%
Masturbation	26	-	26	4%
Epilepsy	13	9	22	4%
Worry/grief	7	13	20	3%

	Men	Women	Total	Percent
Religion	10	6	16	3%
Domestic/hardships	8	7	15	3%
Hallucinations	7	2	9	2%
Idiocy	4	5	9	2%
Hysteria	2	6	8	1%
Female trouble/pregnancy	7	7	14	1%

Expenses for the same period included the following:

Food	$81,270
Household supplies	$33,207
Clothing and bedding	$8,023
Miscellaneous	$5,224
Farm supplies	$4,805
Medical supplies/drugs	$3,857
Building supplies	$3,544
Kitchen supplies	$3,258
Tobacco	$3,057
Office supplies	$579
Insurance	$402
Amusements	$219
Total	$148,445

While the federal 1890 census information has been lost, the 1895 Oregon state census provides some valuable statistics concerning OSIA. Oregon's total population was 30,041, and 1,000 of those (one out of thirty) were incarcerated in the asylum. Of the 1,000 inmates, 710 were men and 290 were women. There were only 305 Chinese listed as living in the state, but of those interned at OSIA, 23 were Chinese. There were 579 inmates who had been born in America and 421 born in other countries, including 123 who had emigrated from Germany. No information as to age, diagnosis, or marital status was listed in the census.[75]

On March 14, 1896, Malinda's daughter, Edna (age twenty-five), was committed to OSIA for the second time by Judge A.F. Stearns. Her admission record states that the cause of her insanity was "hereditary." The physician wrote that she expressed herself as having great ruling power and intended to establish a monarchy. She was listed as five feet six inches tall (four inches taller than recorded eight years earlier), weighed 150 pounds, and had blue

eyes, red hair, and a limited education. Her first attack had occurred at the age of eighteen, and she was discharged from ward 14 almost two years later on December 8, 1897, much improved.[76] Her clothing included one black dress, one black and white duck dress, two calico dress skirts, three knit under vests, five pairs of drawers, one calico waist, one black collaret, one calico apron, one corset, one black sailor straw hat, one black cape, one pair of shoes, and one brown valise.[77] She was married in 1905 at the age of thirty-five in Douglas County to Michael Dammrose.[78]

For just a few months at the end of 1897, there were four Applegates in the asylum: Malinda, William, Ira, and Edna. Ira, Malinda's youngest son, had been committed for the first time on September 19, 1897, by Judge A.F. Stearns after destroying his brother's horses and setting fire to his fences. Ira was twenty-one years old, six feet, three inches tall, and weighed two hundred pounds with brown eyes and auburn hair. All he had with him on September 19 was what he had on: a hat, a coat, a vest, pants, a shirt, an undershirt, a pair of drawers, shoes, and socks. Two days later his family sent two undershirts, three over shirts, two overalls, two pairs of socks, one pair of drawers, and a jumper.[79] He had experienced his first attack at age thirteen and was diagnosed with acute mania.[80] He stayed in OSIA for almost a year until July 20, 1898, when he was discharged from ward 9 much improved.

Unfortunately, Ira was readmitted seven years later on April 23, 1904, at the age of twenty-eight. This time the cause of his insanity was labeled hereditary delusional mania. Ben Huntington of Yoncalla was listed as his guardian, and Judge M.D. Thompson signed the commitment papers. (His father, Robert, had died on October 1, 1893.) The physician noted that he had "delusions of a religious character." (His description had changed as he was listed as having blue eyes and sandy hair this time.) He wasn't discharged until September 8, 1906.[81]

His third commitment occurred on January 31, 1915, at age thirty-nine, and his record states the cause of his incarceration was religious fanaticism. He was discharged as cured on July 19, 1917. Unfortunately, the recovery didn't last long, and he returned to OSH on December 4, 1918. This time he wasn't released and remained in the hospital until his death on December 9, 1930, at the age of fifty-four from maniacal exhaustion.

Asylum costs continued to rise, and in 1897, Senate Bill 37 was proposed but not passed; it proposed that asylum attendants transport patients from their home counties to the asylum instead of the county sheriff.[82] It wasn't until 1904 that a similar bill was finally passed by the legislature. Up to that time the state

paid mileage and expenses to deputy sheriffs to accompany insane persons to the hospital from their homes. In a report issued by the Oregon Board of Charities and Corrections, OSIA Superintendent Rowland complained,

> *As they are now managed, patients are very apt to arrive at the hospital in a high state of excitement, possibly having had nothing to eat for many hours, and may suffer from high fever and other disorders, due in a large measure to the ignorance, carelessness, timidity or brutality of the persons deputized to convey them to the hospital. This is especially true of female patients sent under the care of men. In such cases the trouble and bad effects of inexperience are necessarily still greater.*[83]

The Oregon State Board of Charities and Corrections, which supervised the hospital, listed the asylum costs. Between 1857 and 1891, it cost $535,479 for asylum construction and equipment, $1,964,351 for maintenance, and $181,126 to pay county sheriffs to take patients to the hospital. In 1892 it cost $22,518 to transport patients to OSIA.[84]

G.W. Handsaker, the OSIA steward, reported in 1897 that twenty-six veal totaling 2,887 pounds and forty-nine hogs totaling 10,477 pounds had been slaughtered and consumed by the patients at the asylum over the past two years.[85]

By the end of April 1899, there were between 1,175 and 1,190 patients. Abuses under Dr. D.A. Paine's regime came to light in August. Mostly the abuses centered on patient care and mismanagement of patients' funds and belongings. In addition, a long list of employees was published October 14, 1899, in the *Daily Journal* identifying each person's political affiliations and relationships. It was obvious many of the employees had received their jobs based not so much on ability as political and family connections.

Even though Dr. Paine's term expired on August 1, 1899, the asylum board retained him for an additional six months to supervise the completion of the new addition to the north wing then under construction and costing a total of $30,000. At the end of his term he returned to Eugene and his regular medical practice. Physicians serving under him included Dr. W.T. Williamson, first assistant; Dr. L.F. Griffith, second assistant; and Dr. W.D. McNary, consulting physician.

On January 1, 1900, Dr. Paine was released as superintendent and Dr. John F. Calbreath from McMinnville assumed control. Dr. Calbreath took the job at $2,496 per year and was furnished living quarters, household furniture, provisions, fuel, and light from the asylum supplies.[86] A regular physician living at the asylum earned about $1,020 per year.

As of February 28, 1900, the new three-story wing at the asylum was nearly complete. Additional money beyond the $30,000 appropriated was required to finish the structure and the new kitchen.

The admission register of the asylum gave the name, age, vocation, marital status, and diagnosis of each patient. It didn't tell the patient's story. In 1888 the local newspapers had begun listing some of the admissions and the circumstances behind each commitment. Below is a partial list of those named in the newspapers and admitted to the asylum between 1888 and 1900:

Mary Matthews, age 18, over studious, 4/23/88.
Fred Crump, convict, suicidal, 6/26/88.
Mrs. Reardon, alcoholic, 10/1/88.
Mrs. George Elliott, a weak decrepit old lady, 10/2/88.
Maurice Keating, age 43, discharged and returned, alcohol, 10/2/88.
Edna M. Applegate, age 18, hereditary, 10/25/88.
F.W. Dearborn, hallucinations, 2/5/89.
Emanuel Ritchie, age 50, insanity mild type, 2/6/89.
Deaf and dumb boy, no name or age, 2/6/89.
Jones, captured with a lasso, 3/13/89.
Peter Burgerson, age 35, depraved and waving a knife, 3/30/89.
Fred Smith, hallucinations, 2/13/90.
George Enos, business reversal, 10/5/90.
Lottie Miller, age 13, idiotic, 7/8/91.
Carl Gruenwald, friends dispute commitment, 7/14/91.
Mrs. Lluchy, age 43, suffered sunstroke 10 years ago, 8/5/93.
Mary F. McCoy, insane for 15 years, 10/10/93.
Mrs. Robinson, 12/9/93.
Mary A Chrisman, age 49, third commitment, 12/9/93.
Marion Oman, age 54, 12/9/93.
Mrs. D.S. Neely, crazed and starving, 11/94.
Thomas Murphy, age 28, morphine fiend, 1/1/95.
William Fay, hallucinations, 1/23/95.
Rev. J.C. Reed, age 40, violent impulse, 8/30/95.
Charles Hawk, age 31, alcoholic, 11/27/95.
Henry Schneider, age 72, pauper, 11/27/95.
Orin Morgin, assaulted a woman, fits of anger, 2/17/96.
Mrs. E.F. Lohmere, cocaine addict, 4/15/96.
Barbara Melcher, nude exhibition, 8/28/96.
Lydia Wright, age 51, threatens violence, 1/1/97.

Jennie S. Webb, age 33, hallucinations, 10/9/97.

Givoano Pitano, age 36, convict, 1/6/98.

Ambrose Cox, age 78, spiritualist, 3/14/98.

Michael Gwynn, age 54, hallucinations, 7/13/98.

Christine Trivillion, religion and spinal meningitis, 7/26/98.

William B. Bunschel, paroled and readmitted, 9/23/98.

Willie Hathaway, age 10, epileptic, 10/29/98.

Mary E. Townsend, age 34, hereditary, 3/25/99.

Man and wife Gray, age 25, dope fiends, 6/25/99.

Sylvester Wilson, age 12, epileptic, 11/8/99.

Julius Adler, dissipation, 1/18/00.

Peter Foote, age 31, religious mania, 6/19/00.

J.F. Ebersole, age 54, paralysis, 7/10/00.

Christian Shroeder, violent, second commitment, 7/13/00.

Fletcher Henderson, age 72, pauper, 12/19/00.

Suicides committed at the asylum tended to be dramatic and were always reported in the newspapers. Occasionally the newspapers also reported natural deaths at the asylum. Below are listed some of the suicides and deaths listed in the newspapers between 1888 and 1900:

R.L. Milster, age 60, shot self one year after being released from asylum on 10/1/88.

Charles F. McCormac, age 30, slit his throat with razor on 10/2/88.

George Brown, age 63, hanged self on 2/27/89.

Mary E. Seal, jumped from fourth-floor window on 10/9/90.

John Morrell, parolee died from self-exposure on 10/9/90.

Alex McNeal, escaped and died of exposure on 1/23/95.

John Bucher, escaped and committed suicide on 3/19/96.

Edward Lyons, age 27, hanged self on 9/6/97.

Frank Chamberlain, age 37, jumped from third floor on 10/11/97.

T.A. Chatfield, jumped from third-floor window, pushing A.H. Moore out also on 3/14/98.

John W. Patterson, rapist and escapist, died on 7/19/98.

John D. Shearer, age 96, in OSIA since age 60, died on 3/24/99.

Mary Staiger, age 28, committed to asylum at age six, died on 10/16/99.

George Taylor, age 75, cerebral hemorrhage, died on 2/12/00.

John F. Adams, age 51, hanged self on 10/16/00.

Hans Fischer, epileptic, died on 11/14/00.

On February 20, 1908, a niece joined Malinda at OSIA. Adelaide Applegate was also the granddaughter of Charles and Malinda and the daughter of Milton and Sarah Applegate. She was twenty-nine years old, single, five feet tall, weighed 120 pounds, and had blue eyes and dark brown hair.[87] It was her second attack. Her admission record states that heredity was the indirect cause of the attack. The physician wrote the following: "Imagines she had done wrong, and had great fear of punishment. Has fear of impending danger to family. Has not been violent, but difficult to restrain at times, and wants to get away." The cause of her insanity was thought to be menstrual irregularity causing dementia praecox (schizophrenia). All her belongings were sent with her to ward 14. They included one white knit fascinator (an elaborate headpiece usually attached to a hat but occasionally worn alone), one gray wool jacket, one black wool dress shirt, one black sateen waist, one black sateen petticoat, one small black hair ribbon, one white outing flannel petticoat, one knit union suit, one knit corset cover, one pair of shoes, one pair of stockings, and one handkerchief.[88] She was stabilized and returned to Yoncalla on June 19, 1908.[89]

Seven years later Adelaide was readmitted to OSIA on January 15, 1913, at the age of thirty-four. She was diagnosed as manic-depressive, and her attack was attributed to menstrual pain. This time she stayed at the asylum until April 14, 1913, when she returned home.[90]

Adelaide returned to OSH on February 16, 1933, at the age of fifty-four with a diagnosis of manic-depressive psychosis in the depression phase.[91] She died in the hospital on October 28, 1952, after spending nineteen years, eight months, and twelve days in OSH.[92] An autopsy revealed the cause of death as uterine cancer. Her body was shipped back to Douglas County, and she was buried in Oakland, Oregon.

Malinda's third son, Oscar Applegate, was committed to the Oregon State Hospital on November 8, 1918, at the age of fifty-five with a diagnosis of acute mania and manic-depressive psychosis. He was treated at the hospital until July 2, 1919, when, much improved, he was

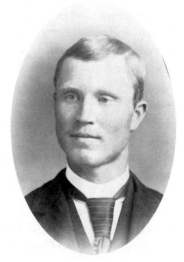

Oscar Applegate (1863–1929), Malinda's third child, was admitted to the asylum four times and died there in 1929. *Douglas County Museum.*

discharged and returned to Yoncalla.[93] He returned to OSH three more times: on August 6, 1921, April 12, 1924, and August 29, 1928.[94] He died in the hospital on February 22, 1929, at the age of sixty-four of chronic myocarditis (heart failure) and was buried in Drain, Oregon.[95] He had married Matilda Peterson on February 18, 1894, at the age of thirty-one before his hospital admissions began.[96]

Malinda Applegate lived in the Oregon State Hospital until January 31, 1930, when she died of chronic myocarditis just eleven months before her youngest son, Ira, also died. She was eighty-nine years old and had been a patient in Oregon's mental health system for fifty-one years, eight months, and thirteen days. Her body was shipped to Drain, Oregon, where she was buried.[97] Ira was buried nearby.

NOTES

1. *Weekly Oregonian*, September 7, 1861.
2. Leta Lovelace Neiderheiser, "Jesse Applegate: A Dialogue with Destiny" (Mustang, OK: Tate Publishing, 2010), 13–17.
3. Admission Record for Malinda Applegate, Vol. E, p. 6, OSIA Records, Oregon State Archives. Salem, Oregon.
4. OSIA Patient's Personal Property Records, 1883–1926, for Malinda Applegate, Oregon State Archives, Salem, Oregon.
5. Alex Beam, *Gracefully Insane: Life and Death Inside America's Premier Mental Hospital* (New York: Public Affairs, 2001), 11–12.
6. Carla Yanni, *Architecture of Madness: Insane Asylums in the United States* (Minneapolis: University of Minnesota Press, 2007), 7.
7. Ibid., 14.
8. W.F. Boothby, "Report of the Supervising Architect and of the Board of Insane Asylum Building Commissioners, to the Legislative Assembly, Salem, Oregon" (W.H. Odell, State Printer, 1882), Oregon State Library, Salem, Oregon.
9. "Report of the Board of Insane Asylum Building Commissioners of the Trustees of the Oregon State Insane Asylum with a Report of the Medical Superintendent" (W.H. Byars, State Printer, Salem, 1884), 12, Oregon State Archives, Salem, Oregon. It states, "The removal of the patients from the private asylum at East Portland to the State Asylum at Salem was successfully accomplished on the 22nd, 23rd and 24th days of October, 1883. The number of patients thus received from the private contractors was 268 males and

102 females." This included 15 Idaho patients. It's a myth that patients were transported secretly in the middle of the night. "The Admission Records for the Oregon State Insane Asylum. Female, Volume E, 1883–1920 and Male, Vol. 1, 1883–1910," Oregon State Archives, Salem, Oregon, show that 106 women and 259 men (365 total) were transferred. This part of the record also included patients admitted directly into the asylum in Salem. However, several pages further is a special section with the heading "To OSIA on 10/23/1883" for the men and "To OSIA on 10/24/1883" for the women. The women's list is alphabetical, and the men's list is ordered by the earliest date a person was admitted to Hawthorne Asylum. It states that 229 men and 102 women for a total of 331 were admitted. Some later reports say 412 total (261 men and 151 women) were transferred, and other records say 372 (138 women and 234 men). In 1958 Ben Maxwell (*Capital Journal*, Salem, Oregon, October 26, 1958) stated that 367 patients were transferred.

10. "Off Center," Vol. 2, No. 3 (March 1, 1983).

11. *Oregonian*, October 24, 1883. This article has become the primary reference for the move. No similar newspaper account has been found for the women's transfer. (268 males and 102 females for a total of 370 patients were reported transferred in the *Willamette Farmer*, January 23, 1885.)

12. "The Admission Record for the Oregon State Insane Asylum, Female, Vol. E, 1883–1920," and "The Admission Record for the Oregon State Insane Asylum, Male, Vol. 1, 1883–1910," Oregon State Archives, Salem, Oregon.

13. Personal Record for Malinda Applegate, Vol. B, p. 2, OSIA records, Oregon State Archives, Salem, Oregon.

14. "History of Mental Illness in Oregon and Oregon State Hospital," published by Oregon State Hospital, Salem, Oregon.

15. Perri Strawn, "100 Years of Steady Progress," *Statesman Journal* (Salem, Oregon), October 16, 1983.

16. Admission Record for Lizzie Hazleton, Vol. D, p. 27, OSIA Records, Oregon State Archives, Salem, Oregon.

17. Admission Record for Frank Holdridge, Vol. D, p. 11, OSIA Records, Oregon State Archives, Salem, Oregon.

18. "Cremains Chronology," January 2012, Oregon State Hospital, Salem, Oregon.

19. Editorial, "Oregon's Forgotten Hospital—Elda's Ashes," *Oregonian*, May 31, 2005.

20. "OSIA Daily Statistics Report for 1883–1899," Oregon State Archives, Salem, Oregon.

21. *The Coast Mail* (Marshfield, Oregon), January 29, 1885.

22. Ann Sullivan, "Decline in Mental Patient Population Reflects Changes in Treatment," *Oregonian*, October 17, 1983.

23. Ibid.

24. *Willamette Farmer* (Portland, Oregon), January 16, 1885.

25. "History of Mental Illness in Oregon and Oregon State Hospital."

26. *Daily Statesman* (Salem, Oregon), August 19, 1885.

27. Polk's Salem (Marion County, OR) City Directory (Los Angeles: R.L. Polk and Company, 1913).

28. Personal Record for Malinda Applegate, Vol. B, p. 2, OSIA Records, Oregon State Archives, Salem, Oregon.

29. Ibid.

30. *Daily Statesman*, October 14, 1886.

31. *Willamette Farmer*, April 9, 1886; *Oregonian*, April 2, 1886.

32. OHSU Library Biography Files, Portland, Oregon.

33. Personal Record for Jesse Applegate, Vol. B, OSIA Records, Oregon State Archives, Salem, Oregon.

34. Personal Record for Edna M. Applegate, Vol. BB, p. 57; Admission Record for Edna M. Applegate, Vol. E, p. 17; Discharge Record for Edna M. Applegate, Vol. F, p. 18, OSIA Records, Oregon State Archives, Salem, Oregon.

35. OSIA Patient's Personal Property Records, 1883–1926, for Edna Applegate, Oregon State Archives, Salem, Oregon.

36. *Willamette Farmer*, February 25, 1887.

37. *Capital Journal*, August 1, 1891.

38. Ibid.

39. Personal Record for Malinda Applegate.

40. Ibid.

41. *Capital Journal*, March 12, 1889.

42. *Capital Journal*, March 5, 1889.

43. *Capital Journal*, June 7, 1890.

44. *Capital Journal*, December 27, 1890.

45. *Capital Journal*, January 14, 1891.

46. "Report of the Joint Committee to Examine into the Condition of the Oregon State Insane Asylum," Legislative Assembly, 17th Regular Session (Frank C. Baker, printer, 1893), Oregon State Archives, Salem, Oregon.

47. *Capital Journal*, August 8, 1891.

48. Alfred C. Jones, *Capital Journal*, October 23, 1973.

49. *Capital Journal*, August 8, 1891.

50. J.F. Santee, "Christian College, 1866–1882 and Its Presidents," *Oregon Historical Quarterly* 42 (March–December 1941): 307.

51. *Oregonian*, October 15, 1891.

52. Admission Record for W.H. Applegate, Vol. D, p. 48, OSIA Records, Oregon State Archives, Salem, Oregon.

53. "Fourteenth Biennial Report of the Board of Trustees and Superintendent of the Oregon State Insane Asylum to the 26th Legislative Assembly" (Willis S. Duniway, State Printer, 1912), Oregon State Archives, Salem, Oregon.

54. *Capital Journal*, July 6, 1892.

55. *Capital Journal*, February 19, 1892.

56. Ben Maxwell, "State Hospital Formulates Plans for Observing 'Diamond Jubilee,'" *Capital Journal*, October 18, 1958.

57. "Off Center," Vol. 2, No. 4 (April 1, 1983).

58. "Report of the Joint Committee to Examine into the Condition of the Oregon State Insane Asylum, Legislative Assembly, 17th Regular Session" (Frank C. Baker, State Printer, 1893), Oregon State Library, Salem, Oregon.

59. *Capital Journal*, February 13, 1893.

60. *Capital Journal*, March 7, 1893.

61. *Capital Journal*, October 26, 1895.

62. *Capital Journal*, January 1, 1894.

63. Personal Record for Ira Applegate, Vol. 4A, p. 104, OSIA Records, Oregon State Archives, Salem, Oregon.

64. Admission Record for Ira Applegate, Vol. D, p. 61, OSIA Records, Oregon State Archives, Salem, Oregon.

65. Discharge Record for Ira Applegate, Vol. F, p. 45, OSIA Records, Oregon State Archives, Salem, Oregon.

66. *Capital Journal*, September 2, 1895.

67. OHSU Library Archives, Biography File for Clara Montague Davidson, Portland, Oregon.

68. *Capital Journal*, August 8, 1895.

69. Harvey Scott, "History of the Oregon Country," *Oregon Historical Society Quarterly* 11, 323.

70. *Capital Journal*, August 28, 1895.

71. Ibid.

72. *Capital Journal*, October 9. 1895.

73. "Seventh Biennial Report of the Board of Trustees and the Superintendent of the Oregon State Insane Asylum to the Legislative Assembly, 19th Regular Session" (W.H. Leeds, State Printer, 1897), Oregon State Archives, Salem, Oregon.

74. "Ninth Biennial Report of the Board of Trustees and the Superintendent of the Oregon State Insane Asylum to the Legislative Assembly, 21st Regular Session" (W.H. Leeds, State Printer, 1901), Oregon State Archives, Salem, Oregon.

75. Oregon State Census for 1895, Marion County, Oregon State Archives, Salem, Oregon.

76. Personal Record for Edna Applegate, Vol. 3B, p. 375, OSIA Records, Oregon State Archives, Salem, Oregon.

77. OSIA Patient's Personal Property Records for 1883–1926, for Edna Applegate, Oregon State Archives, Salem, Oregon.

78. Neiderheiser, 16.

79. OSIA Patient's Personal Property Records, 1883–1926, for Ira Applegate, Oregon State Archives, Salem, Oregon.

80. Personal Record for Ira Applegate, Vol. 5A, p. 162, OSIA Records, Oregon State Archives, Salem, Oregon

81. Personal Record for Ira Applegate, Vol. 6A, p. 443, OSIA Records, Oregon State Archives, Salem, Oregon.

82. *Capital Journal*, January 28, 1897.

83. "First Biennial Oregon State Board of Corrections and Charities Report of 1892," Oregon State Archives, Salem, Oregon, 27.

84. "First Biennial Report," 19–21.

85. *Capital Journal*, April 6, 1897.

86. *Oregonian*, September 6, 1899.

87. Admission Record for Adelaide Applegate, Vol. E, p. 108, OSIA Records, Oregon State Archives, Salem, Oregon.

88. OSIA Patient's Personal Property Records, 1883–1926, for Adelaide A. Applegate, Oregon State Archives, Salem, Oregon.

89. Personal Record for Adelaide Applegate, Vol. 4B, p. 507, OSIA Records, Oregon State Archives, Salem, Oregon.

90. Personal Record for Adelaide Applegate, Vol. 2D, p. 139, OSIA Records, Oregon State Archives, Salem, Oregon.

91. Admission Record for Adelaide Applegate, Vol. 2E, p. 22, OSH Records, Oregon State Archives, Salem, Oregon.

92. Death Record for Adelaide Applegate, Vol. 3G, p. 23, OSH Records, Oregon State Archives, Salem, Oregon.

93. Admission Record for Oscar Applegate, Vol. 2D, p. 96, OSH Records, Oregon State Archives, Salem, Oregon.

94. Admission Record for Oscar Applegate, Vol. 2D, p. 131; Vol. 2D, p. 168; and Vol. 3D, p. 2, OSH Records, Oregon State Archives, Salem, Oregon.

95. Death Record of Oscar Applegate, Vol. 2G, p. 143, OSH Records, Oregon State Archives, Salem, Oregon.

96. Neiderheiser, 16.

97. Death Record for Malinda Applegate, Vol. 2G, p. 154, OSH Records, Oregon State Archives, Salem, Oregon.

Chapter 3
THE CALBREATH YEARS

Dr. John F. Calbreath, age forty-five, and his wife, Irene, age fifty, moved into the OSIA living quarters on January 1, 1900, with their two daughters: Helen, age twenty-one, and Evelene, age eleven. The couple had also had a son who died at a young age.[1] Helen left a handwritten biography of her father's life, including the years they lived in the asylum. It provides a fascinating look into the day-to-day operations of the asylum from her perspective and describes Dr. Calbreath's thoughts on dealing with asylum business. The family had seven rooms on the second floor of the J building, a dining room on the first floor, and a kitchen in the basement. Dr. Calbreath had a good reputation, not only in McMinnville where he practiced medicine but also throughout Oregon. The *Southern Oregon Eye* of Medford had this to say:

> *Dr. John F. Calbraith [sic] of McMinnville, who has just taken charge of the Oregon Asylum for the Insane is a physician of high standing on the West side where he has practiced for many years. The writer is personally acquainted with Dr. Calbraith and speaks from actual knowledge when he asserts that the Dr. will go into office an honest man and a perfect gentleman. If he exerts himself in the interests of the poor unfortunates under his charge, as we believe he will make a popular superintendent with the people. One thing he must do, and that is this: He alone must run the institution and not allow politicians to run it for him. From what we know personally of Dr. he will run things himself, and that he will be a success.*[2]

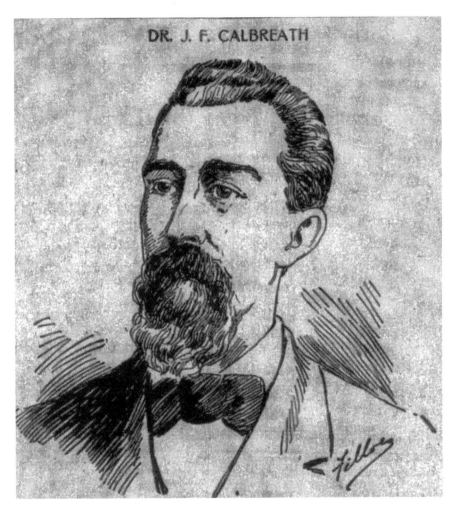

DR. J. F. CALBREATH

Dr. John Calbreath (1855–1931) was superintendent of OSIA from 1900 to 1907. *Oregon State Hospital.*

Dr. Calbreath appeared to act true to the confidence placed in him by the *Southern Oregon Eye* at the time of his appointment. Helen Calbreath described in detail the political maneuverings made to secure and keep staff positions at the asylum not only by the superintendent but also by the other employees. In his first month at OSIA, Dr. Calbreath had a confrontation with the agent supplying meat to the asylum. The agent wanted a payoff similar to what the previous superintendent had paid, and he wanted to continue providing diseased meat. Dr. Calbreath was furious and kicked him out. He told his wife, "Irene, as long as the head of an institution is honest

and has nothing to hide you can punish the petty thieves. Whenever there is petty stealing escaping notice, the higher-ups are corrupt. As long as I am superintendent I shall try to protect the people under lock and key to me and see that they have their rights and all possible help to recovery."[3]

Just ten days prior to Dr. Calbreath's appointment, another girl, only seventeen years old, had moved into the Oregon State Insane Asylum. Her story is further evidence of Dr. Calbreath's gentle interest in the "poor unfortunates under his charge." Female convicts, although sane, were often sent from the Oregon State Penitentiary (OSP) and kept in the asylum to allow them freedom from solitary confinement with access to fresh air and exercise, as in the case of Charity Lamb. Nora Etta Cole was five feet and one inch tall and weighed 125 pounds when she entered the penitentiary. Her admission records note that she was uneducated, had irregular habits, and was not suicidal or homicidal. The cause of her mental illness (acute mania) was imbecility.[4]

She had been sentenced to one year in the penitentiary from Douglas County on December 6, 1899.[5] The authorities at the penitentiary were able to see something the authorities in Roseburg either didn't notice or didn't want to notice: the little seventeen-year-old was pregnant.

Nora Etta Cole, convict #4183, was sentenced to the Oregon State Penitentiary in 1899 before being transferred to OSIA. She lived in the asylum until 1902. *Oregon State Archives.*

Nora Etta Cole was probably the poorest and most defenseless resident in Oregon. She and William Perkins were arrested by Deputy Sheriff B.F. Wells on October 7, 1899, and charged with lewd cohabitation and larceny of a horse. The Douglas County district attorney originally spelled her name Dora instead of Nora. The indictment read as follows:

> *Wm. Perkins and Dora Etta Cole are accused by the District Attorney of the Second Judicial District of Oregon, and for the County of Douglas State of Oregon by this information of the crime of lewd cohabitation committed as follows: "The said Wm. Perkins and Dora Etta Cole on the 7th day of October A.D. 1899 in the said County of Douglas and the State of Oregon, then and there being and then and there not being married to each other did then and there unlawfully and wrongfully, lewdly and lasciviously cohabit and associate together." Dated October 17, 1899.*[6]

It was against the law in 1899 to cohabit with someone of the opposite sex without being married. No consideration was given to the fact that both were illiterate.

The following day they were charged with larceny of a horse from W.L. Laird, who owned a stage station near the Coos County and Douglas County border.

Perkins pled not guilty, saying that Nora, not he, had stolen the horse. The jury didn't take long to return a verdict of guilty, and he was sentenced to two years in prison. Nora pled guilty to both charges and was sentenced to one year in prison. Together they arrived at the Salem penitentiary on December 6, 1899. Both were sentenced to serve three months in the county jail after their prison term was over on the lewd cohabitation charge.

No pregnant woman had ever been sent to prison before, so it may be assumed Nora didn't tell anyone she was expecting a baby or she didn't know herself. Rosanna Carlyle, the only other female prisoner and being older (age forty) and married, was able to tell poor Nora what was happening to her. Governor T.T. Geer quickly authorized her transfer to OSIA on December 21, 1899, for medical care.[7]

She became friends with Helen Calbreath, and soon the true story came out.[8] Helen learned that Nora's mother was dead, and she had grown up living in a wagon with her alcoholic and abusive father. William Perkins joined their outfit in the spring. One day Perkins instructed her to bring him the horses in a pasture across the fence from their camp. She did as he said, and they moved camp. Later he sold these horses and was arrested for

stealing them. Both he and her father swore to the sheriff that Nora was twenty years old and had been the real thief. Perkins threatened to cut out her tongue if she ever told on them, and being terribly frightened, she pled guilty to the charges.

When the baby was born it was alive but deformed, probably because of the severe malnutrition Nora had experienced while pregnant. One leg was longer than the other, one foot larger, both hands lacked fingers, and the child had a distinctly pointed head.[9] As there was no place to keep a patient's baby at the asylum, Dr. Calbreath persuaded a Catholic orphanage to accept it. What became of the baby after that is unclear, but it's doubtful it lived very long.

Nora loved the asylum and swore it was the best home she'd ever had. She enjoyed the opportunity to socialize with other women, the various entertainments, and the food. For the first time in her life people were kind to her. In her thankfulness she became a hard worker and was always happy and smiling. It became her first school and her haven. Even after her prison term expired and it was recognized that she did not have a mental illness, Dr. Calbreath let Nora remain because she was incapable of earning her own living.[10]

She wasn't the only one who experienced the asylum as a haven. On April 7, 1900, Rosanna Carlyle, the other female prisoner at the penitentiary, joined her in the asylum.[11] Rosanna's admittance record stated that the cause of her insanity was unknown (probably from being in solitary confinement in the prison for almost seven months), and she was diagnosed with acute mania. At her trial in Medford she had admitted starting a fire in her brother's barn because "her brother who owned the property had occasioned her trouble and she took this means of evening up the score."[12] Burning his barn down with his horses and a season's worth of grain and hay in it was a mighty big price to pay for whatever trouble he had caused her. The jury must have felt the same way because she was sentenced to nine years in prison, a longer sentence than some murderers received. Her belongings included one green straw hat, one old black fur cape, one gray outing flannel petticoat, four outing flannel wrappers, five handkerchiefs, two under vests, two pairs of drawers, one pair of shoes, three pairs of stockings, one pair of garters, one chemise, one blue calico dress, one union suit, one black dress, one gold ring (kept in the office), one point lace handkerchief, four linen hemstitched kerchiefs, three crochet laced hankies (left in office for sale), and scissors entrusted to an attendant in the ward to be used by Mrs. Carlyle. Another kerchief was added a year later, and a pair of scissors decorated

Kate Saunders, convict #3812, was transferred from the penitentiary to OSIA in 1899. A jury had convicted her of rape for coercing a young girl into becoming a prostitute. *Oregon State Archives.*

Charles Wilson, convict #8488, was a convict admitted to OSIA on September 3, 1901. *Oregon State Archives.*

with ribbons was given to her in 1901. Rosanna Carlyle was returned to the penitentiary one year and nine months later on December 30, 1901, from ward 21 recovered from her mental illness.[13]

On April 12, 1899, a third female prison inmate arrived at OSIA. Kate Saunders, age thirty-seven, had been convicted of rape in Multnomah County and sentenced to fifteen years in prison on March 27, 1897. Two years later she was diagnosed with chronic mania and transferred to the asylum. She was five feet tall, weighed 104 pounds, and had gray eyes and light brown hair. She was described as homicidal and kept in the asylum until July 27, 1909, when she was returned to the penitentiary.[14]

Other prisoners were sent from the penitentiary to the asylum. On September 3, 1901, four men were transferred: Charles Wilson, age twenty-three, Henry Kubli, age twenty-five, Joseph Strohlberg, age seventy, and Axel Isaacson.[15] Wilson's record stated that he "has made two attempts upon his life—one by drowning and one by eating pounded glass."[16] The cause of his insanity was "congenital idiocy." He had been sentenced to prison for two years for a burglary. He escaped on October 10, 1906, but was recaptured and eventually released on February 28, 1907, much improved.[17] Henry Kubli's hospital record stated that he was "mentally deranged and considered by the officers to be a dangerous man."[18] Joseph Strohlberg's hospital record simply noted that the cause of his problem was "La Grippe," another term for influenza.[19] He recovered and was discharged on May 7, 1903.[20] Axel Isaacson's record noted that he had made "two homicidal attacks upon officers."[21]

A long article in the *Oregonian* of September 28, 1901, discussed a paper on "Insanity and Crime" prepared by Dr. W.T. Williamson of the asylum. The newspaper editor argued that instead of being insane, some of the cold-blooded murderers were:

> *only depraved, brutal-minded folk, full to overflowing all their days with "pure cussedness"...These murderous, vindictive rebels against the peace, order and safety of society, who resort to their own inner consciousness for a code under which they try, convict, sentence and execute their real or fancied enemies, are a terror to civilization. They are not insane enough to be placed under restraint, and yet the plea of insanity is always pleaded for them as a defense against legal punishment.*[22]

Instead the *Oregonian* writer advocated that every "criminal homicide" that has never previously been suspected of insanity should suffer the full extent of the law, including hanging.

Frank L. Smith, convict #4111, was convicted of murder and sentenced to hang when the governor commuted his death sentence. He was sent to OSIA in 1907 and died there in 1915. *Oregon State Archives.*

However, compassion prevailed for some Oregonians. On February 27, 1907, Frank Lawrence Smith, age twenty-eight, was transferred from the penitentiary to OSIA. He had been sentenced to prison on May 25, 1899, after Governor T.T. Geer commuted his death sentence to life in prison. Smith was convicted of first-degree murder in the death of Peter Nelson. Smith was a tramp who told everyone he was really an opera singer. He was diagnosed with dementia praecox or schizophrenia. Unfortunately he developed lung cancer in the asylum and died eight years later on June 22, 1915. By then the Asylum Cemetery had been removed, and his body was cremated.[23]

Dr. Calbreath found that "the most difficult problem at the hospital was curbing <u>abuse of patients</u> [*sic*]."[24] Because the patients were delusional, no one believed them, and any nurse or attendant who actually reported abuse was harassed by other staff until they quit. One attendant was able to smother patients with a wet towel without leaving any marks or bruising yet still provide a very painful and dangerous punishment. Dr. Calbreath no longer followed the previous "see nothing, hear nothing, say nothing" rule. Instead he reported all accidents to the press and instructed the coroner to actually investigate all cases of death. He instituted a new rule that anyone

abusing a patient would be immediately fired. The asylum physicians used this to get rid of any attendants they disliked or they felt were disloyal. "For eight years, [Calbreath] fought continuously to make the employees realize they were dealing with ill people. [*sic*] People not responsible and not criminal."[25] This principle of kindness and human decency made the asylum a happier and safer place for people like Nora.

On November 30, 1900, there were 1,173 patients in the asylum.[26] Of those, 102 were classed as curable, 980 as incurable, and 91 as doubtful. Dr. Calbreath noted in the biennial report that "it is unfair and unwise to place the criminal insane with the other classes, because of personal dangers, difficulty of management, danger of escape and their contaminating association." This was the first attempt to segregate those patients who were known to be dangerous from those who might not be dangerous. In 1905 he requested another new wing be added on to the J building and an additional $7,500 be used to equip the top floor for housing the criminally insane. Two or three attendants were assigned to each ward of 40 patients depending on the level of violence in the ward. By the end of 1901 the asylum had built another three-story addition about 130 feet by 40 feet, with basement, to the J building on the north side. He also noted in his 1901 biennial report that he believed the first man admitted to the Hawthorne Asylum in 1864, John Marshall, had recently passed away.

He also recommended separating those patients who were curable from those who were incurable. Between 1900 and 1902, 679 patients were admitted and 217 were discharged as recovered. Diagnoses of the patients included: alcoholism (39), heredity (28), epilepsy (22), injury to head (23), old age (31), worry (17), religion (16), and unknown (275). In addition, 7 boys and 3 girls under the age of fifteen were also admitted. Eight children had come down with diphtheria, and one had died. The total asylum cost for those past two years was $148,461. An additional $281,506 was needed for the next biennium including capital improvements. He wanted to purchase new washing machines, a mangle (a dryer), and a shirt ironer for $2,225.

The number of patients continued to rise. In March 1901, Alaska contracted with Oregon to house its patients (approximately 50) at a cost of twenty dollars per month per patient, but this was discontinued in 1904 because of the overcrowding. New bathrooms and lavatories improved the sanitation at the asylum in 1903. The asylum had one of the best operating rooms in the state and was used for patients from all the state institutions, including the prison. Asylum physicians were Dr. W.T. Williamson, Dr. L.F.

Griffith, Dr. W.D. McNary, and Dr. A.E. Tamiesie. Even the tunnels under the buildings were expanded during this time.[27]

Contagious diseases were always a problem at such a large institution. In 1902 Evelene Calbreath contracted varioloid (a mild form of smallpox usually acquired after being vaccinated), requiring a quarantine of the asylum.[28] Visitors were prohibited from entering the asylum for nearly a month. The vaccination program that had been initiated in 1888 was effective, and no one else got ill. A patient entering the asylum a year earlier had died from diphtheria and infected three others. Typhus from contaminated water also spread through the asylum in 1902. At least seventeen patients (eleven men and six women) and five attendants were taken ill and isolated until the outbreak was traced to water from Salem's Mill Creek.[29] This necessitated a change in the water supply for the entire asylum. A new sewage system had already been installed. In January 1904, two patients came down with typhoid fever in ward 29.[30]

At the time Dr. Calbreath became superintendent in 1900, Milieu Therapy was being touted as the newest psychiatric treatment. Patients were assigned to smaller groups where they could feel safe yet still have satisfying activities to occupy their minds. The Asylum Cottage Farm grew out of this philosophy, and as patients worked toward recovery, they were sent to the farm to practice their new skills. At that time asylums provided rest, occupational therapy, artistic expression, and entertainment for the patients.[31] Asylum physicians were more administrators than actual physicians. While "talk therapy," or Freudian psychoanalysis, was advisable, there weren't enough physicians at OSIA to provide even a minimum of this to patients.

An interesting event on January 11, 1905, illustrated how patients were treated when first admitted to the asylum. Etta Walmsley, age six, was sent to OSIA from Deer Island in Columbia County and was accompanied by a female attendant and the county sheriff. Once they arrived at the asylum, the woman and child were asked to follow the attendant supervising the female receiving ward into a reception area. After half an hour had passed the sheriff asked the porter to find out why his assistant hadn't returned. The porter telephoned the receiving ward and asked if the sheriff's assistant would be coming down soon.

"Why no," came the reply, "she's in the bathtub." Apparently the attendant had not believed the woman's assertions that she was not insane and had forced her into the tub anyway. The attendant had followed the unbreakable rule that every new patient be given a bath before being taken into the ward.[32] No explanation was given as to why a bath was such a necessity.

Her record stated that Etta was "willful and rather hard to manage, only restraint has been that of her parents." Etta was transferred to the Oregon State Institution for the Feeble-Minded (Fairview) on December 3, 1908.[33]

About 1903 the asylum was entertaining patients' relatives when a patient started hallucinating and caused a disturbance in Helen's presence. An attendant put the upset patient in straps and cuffs and locked her to a chair in the "strong room." The attendant shook her and bashed her head repeatedly against the wall as punishment. Later the attendant boasted that because of her political and asylum connections she couldn't be fired and could have anyone else fired if she wanted. Instead, Dr. Calbreath confronted and fired her. He even gave the two attendants who didn't report the incident a three-week unpaid vacation. Dr. W.T. Williamson, a physician at the asylum for seventeen years, was also implicated and resigned on November 4, 1903.[34] About every six months incidents such as this occurred, resulting in more attendants being fired.

Good behavior by patients like Nora resulted in special privileges and prized work assignments. Patients were escorted on walks, rides, and excursions to the state fair and baseball games. Summer picnics, chapel on

This photo shows the auditorium decorated for a Valentine's Day dance about 1904. *Oregon State Archives.*

Sunday, and asylum dances provided entertainment. These were activities Nora had never seen before. The dances began promptly at 6:30 p.m. and ended at 8:00 p.m. There were four square and four round dances consisting of two dancers doing two quadrilles, two waltzes, and two "two-steps." Employees were required to participate in the square dances but were forbidden to dance the round dances with patients. Just threatening to keep a patient from the dances stopped any raving, shrieking, and swearing.

The Calbreath family and other employees invited friends and families to the many parties and dances held at the asylum. Helen invited Chauncey Bishop (future founding partner of the Pendleton Woolen Mills and son of C.P. Bishop, a prominent Salem merchant) as her partner to a special dance in April 1900.[35] A "gay trolley party" on August 1, 1901, featured the asylum orchestra led by Lieutenant Opplinger playing songs as the electric trolley cars traveled around town.[36] In 1904 the asylum sponsored a St. Patrick Ball for the female employees that was attended by sixty couples.[37] A Valentine's Day dance sponsored by Dr. and Mrs. Calbreath entertained over one hundred guests. The ballroom was decorated with evergreens, flowers, potted plants, hearts, and miniature cupids. A delightful dinner was served at midnight.[38]

Nora participated in other kinds of entertainment besides the dances. "A baseball club of patients and staff has been organized at the Cottage Farm and at the asylum and the first match game will be played Saturday afternoon in

Baseball was popular with the employees and patients. The first asylum teams were organized in 1901. *Oregon State Archives.*

front of the main building. This is the first introduction of the national game among the patients and it is due to Superintendent Calbreath's enterprise in furnishing them harmless sports."[39] Patients became avid supporters of their favorite teams. As many as five croquet sets were set up on the asylum lawns and used by teams organized inside the asylum.

The asylum sponsored a large concert at Savage's Grove, and invitations were extended to numerous Salem citizens. A 2,000-candle power stereopticon was used to illustrate songs by the military band. A trick bicycle rider, Shaw, astonished the crowd with his skill. The asylum band orchestra played "Jolly Knight" and "Shuffling Pete." Lieutenant Opplinger played a coronet solo.[40]

Holidays provided themes with corresponding decorations that all the patients, including Nora, enjoyed to their fullest. On Thanksgiving, the asylum served turkey, chicken, and goose to everyone. At Christmas the wards were decorated, and every patient received candy, nuts, raisins, an orange, and a little present. One year a chronic patient stole the red paper streamers decorating the ward and used them to wrap her hair.[41] She was trying to imitate Helen's bright red hair. The patients affectionately called Helen "Little Sunshine" and Evelene "The Baby."

Dr. Calbreath found that when a patient was first admitted, 80 percent of the time the patient's relatives were very concerned and visited as often as possible. However, after a few months those feelings deteriorated into shame, indifference, and embarrassment. Mothers usually continued to visit and sacrifice for their children. Fathers were not as faithful. Children grew indifferent to their sick parents, felt depressed after visits, and refused to assume responsibility. Husbands neglected wives and requested divorces. Wives neglected husbands and feared them. Siblings became bored, and friends visited only out of curiosity. Fortunately, Dr. Calbreath was finally able to find a supportive relative of Nora's and arranged for her to leave the asylum. She was discharged from OSIA in 1902 much healthier and happier than she had ever been in her life.

Anger and violence from patients was always possible. Helen and Evelene were warned never to show fear as that could escalate any potential violence. One day the girls went to the kitchen to get some cookies where two patients, May and Miss J., assisted the cook. Suddenly, May grabbed a huge bread knife and threatened eleven-year-old Evelene with it. "What would you do if I was to put this knife right through you?"

Before anyone could think what to do, the little girl smiled up at her and gently pushed the knife away and said, "No, May. You can't scare me. I know you aren't that crazy."

Evelene Calbreath was eleven years old when her father became superintendent. The Baby Hercules fountain she is admiring was donated to the asylum about 1899. *Oregon State Library.*

May laughed. "You see, Evelene has more sense than anybody here. More sense than the superintendent, the doctors, and all the attendants put together."

Patients with private funds could purchase extras—candy, gum, ice cream, tobacco—or pay attendants to escort them on streetcar rides, walks, or meals downtown. Once, Dr. Calbreath discovered a patient's private account was being defrauded. He took a personal interest in the situation and had the man transferred to a better ward.[42] Eventually he was able to leave the asylum and worked as a professional photographer.[43]

Another patient, Nick, worked for twenty years as a patient janitor at the asylum. The young son of the previous superintendent and another physician's son had terrorized Nick by pulling his dust cloth, stealing his mop, spitting on the floor, and grabbing him.[44] Nick would retreat into a corner trembling, raving, and jabbering. Dr. Calbreath observed the teasing and stopped it. Nick became a special favorite of the family, and they always gave him little treats when they could.

Catharine Francisco, a French woman, had delusions of grandeur. She was thirty-six years old and thought she was a queen. "The nurses and

doctors had to bow to her and address her as your highness or your majesty depending on whether one was male or female. When she was having one of her regal spells she demanded to wear an old velvet dress with a real lace collar." If the dress was not brought when she demanded it, she would go into rages, upsetting the whole ward.[45]

Seeing how much attention Catharine was getting, another patient from Ireland, Bridget Shields, age forty-eight, began to imitate her. It was only after she was transferred to another ward that she started improving and was discharged.[46]

At that time, the husband of a patient, Hilda, tried to get the Oregon laws changed so a spouse could get a divorce whenever someone was committed to the asylum. It would have made it possible to railroad people into the asylum just to rob and abuse them. Hilda was a beautiful, well-educated, and wealthy woman who went into a deep depression after her only brother was killed and her baby was stillborn.[47] Her husband was supportive the first four or five years she was at OSIA, but after that he stopped sending money or visiting her. Finally he asked for a divorce and maintained the estate was bankrupt. Instead, she accused him of having another woman and wanting to get rid of her to get the money. The law was never passed.

A beautiful, wealthy, but violent woman, Ida Arlington, age thirty-four, trusted a court-appointed guardian with her expensive fur coats and several thousand dollars in diamonds before she was admitted on September 27, 1899.[48] When she recovered and was released on March 31, 1900, he told her he had sold everything to pay her bills and refused to give her any money.[49] Unable to prove that he had robbed her, she accepted a payoff of $20. She invested the money in a red taffeta petticoat and a bottle of champagne. Walking to the Portland Morrison Bridge, she crawled over the railing and attempted suicide by jumping feet first into the Willamette River. Fortunately the petticoat acted as a parachute, and a nearby boat rescued her. She was returned to the asylum on April 4, 1900.[50] After spending more time at the asylum, she asked to be released. She explained to Helen that she had been seduced at age thirteen by her father's friend and introduced into the life of a prostitute. Eventually she became the madam of the second-best disorderly house in Portland. She described the dangerous manner of kidnapping girls for brothels; of girls being sold who had been stolen or drugged; of the expense involved in supplying drugs and the rapid loss of value of the addicts in charm and ability to entertain; of the need to train new girls to always agree and flatter their customers; of the exorbitant costs of the good abortionists and paying police protection; of the danger of a girl falling in

Oliver Marshall, convict #3997, was transferred to the asylum in 1899. He died in the asylum in 1905. *Oregon State Archives.*

love and threatening to break up a man's home. She felt no embarrassment if the girls were discovered stealing money. It was a life gone wrong because of a seduction at age thirteen. On June 18, 1901, she was released from ward 18.[51]

Escapes, or "elopements" as they were called, were common, especially from the criminal wards. The most dangerous escape during Dr. Calbreath's term occurred on October 9, 1903, about 3:00 a.m., when four criminals escaped from the criminally violent ward.[52] They sawed a hole in the door, picked the lock, and, improvising a rope from blankets, escaped from a third-story window.

One of the escapees was Oliver Marshall, age eighteen. He and his brother William had murdered James Reid in April 1898 in Baker County. Convicted of manslaughter, they were sent to the penitentiary in July 1898. Oliver convinced Dr. W.A. Cusick, the penitentiary doctor, that he was insane and was transferred to the asylum in December 1899. His first escape attempt was on January 12, 1902, when he somehow got possession of a spare key.[53] Fortunately it was discovered before he could exit the building.

After the 1903 escape, Captain A.C. Dilley and Charles Latourette of the asylum security force finally recaptured Marshall near Oregon City.

The three other escapees were recovered later. Oliver Marshall died in 1905 while still in the asylum. Governor T.T. Geer pardoned his brother William on April 13, 1900.[54]

Another patient, Sam Patton, in his twenties, was very adept at escaping. Confined to the asylum as a child, he had escaped many times, even from a room especially built for him in the secure wing.[55]

Women seldom escaped, although Attie Bray, confined because of a religious mania, escaped in 1904 and walked barefoot from Salem to Corvallis before being recaptured.[56] She was a member of the Holy Rollers Cult started by F.E. Creffield. In 1904 the evangelist Franz Edmund Creffield arrived in Corvallis, Oregon, with his family and several followers. The group believed in wearing as little clothing as possible, which included going barefoot and bareheaded. Their behavior and beliefs were unacceptable by common social standards and therefore judged to be insane. Creffield was later murdered in Seattle. Mr. and Mrs. Frank Hurt, also members of the cult, were committed to the asylum in May 1904.[57]

There was a family group of three generations confined to the asylum with insanity on both sides of their family history. Mrs. R.J. Carlisle, age forty-nine, was admitted from Paisley, in Lake County, on February 2, 1901. She believed she was soon to be crowned queen on June 24. She also believed she was clairvoyant and threatened to kill one of her daughters.[58] Her father had died in an asylum back east. The cause of her insanity was thought to be heredity and change of life, or menopause. In addition her husband, a brother, and two sons were patients in the asylum. Five children, ages eighteen, sixteen, thirteen, and two younger children, remained in Lakeview. The two oldest found placement with local families, and the three youngest were sent to the Orphan's Home. She died on November 7, 1903, at age fifty-one from cancer. She was buried in grave #902 in the Asylum Cemetery.[59]

The most common causes of insanity were excessive living, liquor, narcotics, and venereal disease. There were more than twice as many men as women patients. A small percentage of the patients were insane as the result of accidents or tumors in the brain.

On July 27, 1906, a fire broke out in the men's receiving ward in the north wing about 10:20 a.m.[60] Special thermostats installed for just this purpose went off, sounding the alarm, as did a passerby, farmer Thomas Brown, who notified the Salem fire department. Most of the male patients were outside enjoying a recreation period, and the female patients were quickly marched into a small garden area and guarded by attendants. The weekly fire drills had not totally prepared the patients, and many became frightened and very

excited. Some of the patients "were waving their hands; others were merrily laughing; some were singing and all were talking at once. It was a trying hour for the attendants. At any moment it was expected the outbreak would come."[61] Even though the fire was contained, all the patients in that wing were escorted outside. Dr. Calbreath toured the empty building to make sure everyone was safe and found one man hiding in a washroom and holding a knife. The man believed God had shown him the way out and threatened to kill the doctor and steal his keys.

Dr. John Calbreath calmly led the patient to a door, saying that it opened to the outside. Instead, after unlocking it, the patient found himself in a "violent" ward filled with attendants ready to march the men in the ward outside. They safely relieved the patient of his weapon, and he joined the rest of the patients trooping outside. By noon the Salem fire department and the many other Salem residents rushing to the asylum had the situation under control. Cause of the fire was thought to be an electric wire in the attic. The asylum did not carry insurance, and the fire caused nearly $5,000 in damages in addition to furnishings ruined by water and smoke. This was the second fire during Dr. Calbreath's term. A fire in the middle of the night on November 3, 1902, destroyed the hog barns with eighty animals inside them and caused $2,000 in damage.[62] No one was injured in either fire.

Another time a patient on the violent ward for women, situated on the third floor of the J building, cornered a ward attendant inside a sleeping room and threatened to throw her out the window. Keeping calm, the attendant persuaded the woman to wait while she got another employee to finish the laundry. Then she ran for help.

Quite often patients jumped from the third-story windows in suicide attempts or escape attempts. On December 12, 1902, Alfred Blakeman, age thirty-five, jumped from a window twenty-five feet off the ground. He had attempted to escape from the county jail; however, he fell from a tree during the attempt and broke both arms. At the asylum Dr. P.W. Byrd was applying plaster casts to the broken arms when Blakeman leaped over the operating table and out the window. Miraculously he escaped without injury, was recaptured, and returned to the asylum.[63]

From 1900 to 1908 there were nine suicides or attempted suicides at the asylum. On July 11, 1903, Mrs. J.G. Toile, age thirty-one from Marion County, managed to steal some matches and set fire to herself while she hid in the ward linen room. She had attempted suicide several times before but had been unsuccessful. She died shortly after the fire.[64]

In 1904, John F. Jackson, age twenty-five, committed suicide by making a rope out of a sheet and tying it around his neck. He fastened the end to the iron grating, climbed out the window, and jumped. He had been confined to the asylum for four years and had never displayed any suicidal tendencies before.[65]

Charles Werden, age thirty, from Austria committed suicide by hanging on October 30, 1904.[66] He tied a silk handkerchief around his neck and a window bar, strangling himself in his sleeping room while the other patients were at breakfast.[67]

Two additional cottages were built at the Cottage Farm in 1902 and 1903 to house 80 patients each.[68] Approximately 270 patients lived and worked at the farm. The Cottage Farm sat on 1,200 acres and provided vegetables and other consumables, saving the asylum nearly three dollars per person per week.[69] Patients and hired help did the work. Dr. Calbreath believed that "as many of the patients as are able to work and can be induced to do so are kept busy, though none are compelled to work against their protest. Physical employment is good for the patients who are strong physically, provided that it is not so disagreeable to them as to cause mental excitement."[70] The women were also encouraged to work. They sewed linens and clothing for other patients and made baskets to use throughout the asylum.

In 1903 a new dairy barn was built to replace one that had been infected with tuberculosis, in addition to a new horse barn. A building for the pigs also replaced one that had burned down in 1902.[71] A septic tank sewage system was built in 1903 to replace the open sewage ditch previously used at the Cottage Farm.

In 1904 Dr. Calbreath recommended that the state build accommodations for insane patients infected with tuberculosis. The number of infected patients confined to the asylum had reached an all-time high and made caring for them inside the asylum dangerous to other patients. Open-air sleeping porches were constructed to help alleviate the possibility of infection.

The highest paid employees in 1903, besides Dr. Calbreath and the physicians, were the bookkeeper and the engineer at $100 per month. Physicians earned between $90 and $150 a month including their room and board at the asylum.[72] The average American household earned $62.50 a month, and $1 in 1903 would be worth $25.20 today. Attendants were required to live in rooms at the asylum and work six-day weeks and twelve-hour days. They earned between $37.50 and $42.50 a month. Women earned $2.50 less than men for the same work. A stenographer, a gardener/farmer, a druggist, and a mason plasterer each earned $50 a month. Farm

workers earned the least amount at $25 a month.[73] Salaries increased about 10 percent in 1907.[74]

Several laws were passed in 1905 that affected the asylum. The first, House Bill No. 172, passed on May 18, 1905, and required that trained asylum attendants escort patients from the various counties to the asylum.[75] This was expected to save the state many thousands of dollars that were once paid to the county sheriffs for the same escort duties. The first patient escorted under the new law was Musey Rhodes from Cottage Grove by a female attendant, Mrs. W.J. Irwin.[76] The second law required that relatives pay ten dollars a month toward the support of patients in the asylum. Not many judges enforced the second law, and not many relatives paid the fee.

At the end of 1904, Dr. Calbreath requested additional money for the asylum:[77]

Constructing and furnishing a new wing	$45,000
Finishing quarantine building	$1,500
Five new lavatories at $3,250 each	$16,250
Blacksmith shop	$450
Hose cart house	$350
Two cottages for consumptives	$5,000
New cottage for physician	$2,500
New heating system for cottages	$3,000
Painting buildings and cottages	$10,000
Compartments for criminally insane	$7,500
Cementing walls of asylum	$5,900
Modern steam cookers for cottage farm	$900
Finishing ward 28	$1,650
Total	$100,000

Dr. John F. Calbreath was superintendent for eight years. During that time he had the inside and outside of the J building repainted, installed about six hundred new radiators, cleaned out the yards, cut out the trees, perfected the drainage, reduced communicable diseases in the asylum, installed new showers and tubs, built fire escapes, and added a sprinkler fire system. The biggest expense was a new wing for female patients in 1907 costing $225,000.[78] Total improvements at the asylum for 1907 cost $258,604.[79]

On December 24, 1907, the entire asylum celebrated the Christmas holiday just as any large family would. R.A. Watson, a writer for the Portland *Oregonian*, visited the asylum and wrote a long article for the newspaper. A

few weeks before Christmas, attendants asked the patients what they wanted, and every effort was made to find the item. A few days before Christmas the gifts were handed out, each patient receiving an additional sack of candy and a sack of nuts. Nearly 400 pounds of candy, 460 pounds of nuts, and two barrels of popcorn were distributed to 1,253 patients.

At 3:00 p.m. on December 24, 1907, Christmas dinner was served. The menu consisted of the following: coleslaw, apples, celery, baked turkey, goose, duck, chicken, dressing, cream gravy, mashed potatoes, stewed tomatoes, bread and butter, rice pudding, jelly, canned fruit, ginger cake, tea, and milk. It required 1,300 pounds of meat to produce the main course for the seventy-five dinner tables in the asylum. The entertainment for the day was "some of the best amateur talent in Salem"[80] and was performed at 7:00 p.m. in the asylum chapel where several hundred patients watched. The asylum orchestra played; a female quartet and a male quartet sang songs; Evelene Calbreath gave a piano recital; Frank Snyder, Carl Poppa, and Albert Diaque sang solos; and Miss Hewitt performed two poetry readings. It was the last celebration the Calbreath family enjoyed at the asylum. The family moved to Portland after he retired on December 31, 1907, and Dr. R.E. Lee Steiner became superintendent. Dr. John Calbreath died in 1931.[81]

Notes

1. "John F. Calbreath Papers, Mss. 1027," Section 1–5, Oregon Historical Society Research Library, Portland, Oregon.
2. *Southern Oregon Eye* (Medford, Oregon), January 4, 1900.
3. John F. Calbreath Papers.
4. Admission Record for Nora Etta Cole, Vol. E, p. 65, OSIA Records, Oregon State Archives, Salem, Oregon.
5. Oregon State Penitentiary Case File #4184 for Nora Etta Cole, December 6, 1899, Oregon State Archives, Salem, Oregon.
6. Ibid.
7. Ibid.
8. John F. Calbreath Papers.
9. Ibid.
10. Personal Record for Nora Etta Cole, Vol. 4B, p. 56 and Discharge Record Vol. F, p. 98, OSIA Records, Oregon State Archives, Salem, Oregon.

11. Admission Records for Rosanna Carlyle, Vol. E, p. 67, OSIA Records, Oregon State Archives, Salem, Oregon.

12. *Medford Mail* (Medford, Oregon), September 22, 1899.

13. Personal Record for Rosanna Carlyle, Vol. 4B, p. 68, OSIA Records, Oregon State Archives, Salem, Oregon.

14. Personal Record for Kate Saunders, Vol. 4B, p. 25, OSIA Records, Oregon State Archives, Salem, Oregon.

15. *Oregonian*, August 30, 1901.

16. Personal Record for Charles Wilson, Vol. 6A, p. 114, OSIA Records, Oregon State Archives, Salem, Oregon.

17. Discharge Records for Charles Wilson, Vol. F, p. 134, OSIA Records, Oregon State Archives, Salem, Oregon.

18. Personal Record for Henry Kubli, Vol. 6A, p. 113, OSIA Records, Oregon State Archives, Salem, Oregon.

19. Personal Record for Joseph Strohlberg, Vol. 6A, p. 113, OSIA Records, Oregon State Archives, Salem, Oregon.

20. Discharge Record for Joseph Strohlberg, Vol. F, p. 103, OSIA Records, Oregon State Archives, Salem, Oregon. This is additional evidence that convicts were regularly sent to OSIA for medical care.

21. Personal Record for Axel Isaacson, Vol. 6A, p. 112, OSIA Records, Oregon State Archives, Salem, Oregon.

22. *Oregonian*, September 28, 1901.

23. Death Record for Frank Lawrence Smith, Vol. 2G, p. 14, OSIA Records, Oregon State Archives, Salem, Oregon.

24. Ibid.

25. Ibid.

26. "Biennial Report of Superintendent Calbreath," *Oregonian*, December 19, 1900.

27. *Capital Journal*, January 2, 1904.

28. *Oregonian*, February 15, 1902.

29. *Oregonian*, December 26, 1902.

30. *Capital Journal*, January 5, 1904.

31. Alex Beam, *Gracefully Insane: Life and Death Inside America's Premier Mental Hospital* (Cambridge, MA: Perseus Books, 2001), 13.

32. *Oregonian*, September 10, 1905.

33. Personal Record for Etta Walmsley, Vol. 2G, p. 318, OSIA Records, Oregon State Archives, Salem, Oregon.

34. *Oregonian*, November 5, 1903.

35. "That's Entertainment," Oregon State Hospital Museum Project, http://oshmuseum.wordpress.com.

36. *Oregon Journal*, August 2, 1901.

37. *Capital Journal*, March 18, 1904.

38. *Capital Journal*, February 5, 1904.

39. *Oregon Journal*, August 2, 1901.

40. Ibid.

41. Federal Census 1900 for Marion County, Oregon State Archives, Salem, Oregon.

42. Federal Census 1900.

43. John F. Calbreath Papers.

44. Ibid.

45. Ibid.

46. Ibid.

47. Federal Census 1900.

48. Admission Record for Ida Arlington, Vol. E, p. 64, OSIA Records, Oregon State Archives, Salem, Oregon.

49. Discharge Record for Ida Arlington, Vol. F, p. 83, OSIA Records, Oregon State Archives, Salem, Oregon.

50. Admission Record for Ida Arlington, Vol. E, p. 67, OSIA Records, Oregon State Archives, Salem. Oregon.

51. Discharge Record for Ida Arlington, Vol. F, p. 91, OSIA Records, Oregon State Archives, Salem, Oregon.

52. *Oregonian*, October 10, 1903.

53. *Oregon Journal*, January 13, 1902.

54. Oregon State Penitentiary File for #3998, William Marshall, Oregon State Archives, Salem, Oregon.

55. *East Oregonian* (Pendleton, Oregon), April 3, 1903.

56. *Oregonian*, June 9, 1904.

57. *Capital Journal*, May 2, 1904.

58. *Lake County Examiner* (Lakeview, Oregon), January 31, 1901.

59. Death Record for Mrs. R.J. Carlisle, Vol. G, p. 55, OSIA Records, Oregon State Archives, Salem, Oregon.

60. *Capital Journal*, July 27, 1906.

61. Ibid.

62. *Oregon Journal*, November 4, 1902.

63. *Oregon Journal*, December 19, 1902.

64. *Oregon Journal*, July 11, 1903.

65. *Oregonian*, April 16, 1904.

66. *Capital Journal*, October 31, 1904.

67. Ibid.

68. *Oregonian*, November 14, 1902.

69. *Oregon Journal*, December 24, 1902.

70. Ibid.

71. *East Oregonian*, March 5, 1903.

72. *Oregonian*, November 5, 1903.

73. "Payroll Register 1902–1906, Board of Trustees of OSIA, April 1, 1903," Oregon State Archives, Salem, Oregon.

74. *Capital Journal*, March 7, 1907.

75. "Eleventh Biennial Report of the Board of Trustees and Superintendent of the Oregon State Insane Asylum of the State of Oregon to the 24th Legislative Assembly" (J.R. Whitney, State Printer, 1906), Oregon State Archives, Salem, Oregon.

76. *Capital Journal*, May 26, 1905.

77. *Oregonian*, December 6, 1904.

78. *Capital Journal*, December 25, 1907.

79. Ibid.

80. *Oregonian*, January 1, 1905.

81. John F. Calbreath Papers.

Chapter 4

THREE DECADES OF
SUPERINTENDENT STEINER

On January 1, 1908, Dr. R.E. Lee Steiner became superintendent of the asylum and served for the next twenty-nine years. He was thirty-eight years old and married to Belle, age thirty-six. They had three children: Rita, age fourteen, Barbara, age twelve, and Milton, age six.[1] After the Steiner family arrived, Salem experienced an exceptionally cold spell, freezing the iconic water fountain in front of the entrance.

Belle Steiner was an avid gardener and, in collaboration with Dr. Steiner, designed the many gardens around the hospital grounds. Using patient labor they were very particular about every tree and bush, installing protective latticework around them. "They did not permit anyone to pick a flower."[2] She encouraged the display of artwork done by patients in the hospital, including many murals painted on walls in the halls and wards.

The Oregon State Institution for the Feeble-Minded (later renamed the Oregon Fairview Home in 1933 and Fairview Hospital and Training Center in 1965) was opened in Salem that same year. Between 1882 and 1913 there were fifty-two children between the ages of four and twelve admitted to Oregon State Insane Asylum who were eligible for the new institution. Most had a diagnosis of idiocy caused by epilepsy. Some had experienced brain infections, injuries, or been born mentally deficient. Two of the girls, ages eight and nine, exhibited symptoms of unrecognized sexual abuse with diagnoses of masturbation and nymphomania. One ten-year-old's admission record indicated that his "imbecility" was caused by bad parentage.[3] County physicians and judges admitted that they

Emma Hannah, convict #3548, was convicted of murder and sent to prison for life. Governor Lord transferred her to OSIA in 1897. *Oregon State Archives.*

had difficulty discerning the difference between mental retardation and mental illness in children.

Of particular concern was the case of Ellen Schultz Wood, the child bride of E.E. Wood of St. Johns, Oregon. Ellen Schultz was admitted to the hospital on November 29, 1905. Her father stated that her first attack had occurred at age five. At age eleven her speech was barely coherent, she wandered away all the time and was incompetent to take care of herself, and everyone who had known her for the last nine years agreed that she was insane, yet her father and husband persuaded a judge to perform a marriage ceremony anyway.[4] When she was admitted to the hospital the newspaper expressed disgust at the whole situation. "Think of a child in dresses hardly reaching to her knees, dirty and bedraggled, posing as a wife in a civilized community! And think of a 'man' of thirty-eight who would make such a child his wife!"[5] Five years later, in the 1910 hospital census, she was listed as sixteen years old and the mother of one living child.

Oregon Governor William Lord also transferred Emma Hannah, prisoner #3548, to OSIA on March 2, 1897. Her admission record reads as follows:

OSIA Report on Emma Hannah
Imagines people are all trying to kill her. Medium nutrition—eats well and probably sleeps well—bowels regular—talks of delusions of persecution and of suspicions regarding others in a very uncertain way—creating a doubt as to her entertaining them. March 24, 1897. Continues to be: slightly improved in her physical health and efforts to feign insanity—while at the same time there appears to be an underlying morbid condition which probably asserts its strength with varying force at different times—converses coherently and always with in the lines of, at least, possibility, without

the display of any excess of emotion—hence with that insane condition present—she is a dangerous person. April 27, 1897.[6]

She joined her husband's sister, Queen America Hannah. Queen had been committed to the Hawthorne Asylum on July 10, 1873, at the age of thirty-five with a diagnosis of chronic melancholia. She was a single woman and part of the group transferred from the Hawthorne Asylum to the new hospital in Salem. The physician reported the following after the transfer: "This patient is poor in flesh—demented partially. January 23, 1884."[7]

A later report concerning Queen Hannah, undated, stated: "The patient is thin and debilitated. She has no palpable lesion or structure on any organ aside from the thinness of flesh. She is able to be around all the time and attend to her person. She only speaks to answer or ask questions. Her mental powers are wholly insufficient to enable her to obtain her own support."[8] Queen remained in the asylum, and on May 7, 1889, a physician reported: "Nutrition fair, eats and sleeps well and menstruates regularly—bowels regular—very quiet and dull—demented." She lived until October 20, 1905, when she died at the age sixty-seven of apoplexy (incapacity from a cerebral hemorrhage or stroke).[9] She was buried in the Asylum Cemetery, grave #1042, until the cemetery was removed and all the bodies were cremated.

After spending almost three years in the asylum, Emma Hannah was transferred back to the penitentiary on January 11, 1899, from ward 11 and labeled recovered.[10] At the penitentiary she didn't do well, and she was recommitted a little over a year later from the prison to the asylum on June 23, 1900.

OSIA itemized every patient's personal articles and clothing accompanying them. Emma's list of items for June 23, 1900, was exceptionally long and complicated:[11]

One black straw sailor hat
One black cape
One black wool skirt
One red waist
One red canton flannel skirt
One grey flannel petticoat
Two under vests
One green flannel petticoat
Two pairs of knit drawers
One crochet petticoat

Two pairs of wool stockings
One pair shoes
One out flannel gown
One corset
One brush
Articles kept in flour sack in office included one mirror, thread, one pair of scissors, one pair of buttonhole scissors, and towels.

A little over a month later, on August 6, 1900, her family sent a trunk filled with "a little of everything."[12] On January 18, 1905, she received $0.50, and on December 26, 1905, her family sent an additional $1.05 for her spending money account.[13]

It was against Oregon law in 1903 for a spouse to receive a divorce just because the husband or wife was in the asylum. John Hannah, Emma's husband, found a way around the law by declaring that Emma was a "prisoner" on January 24, 1903, when he filed a petition for divorce.[14] Emma had been sentenced to life in prison for the murder of Lottie Hyatt, who died on October 4, 1895. Emma believed Lottie was having an affair with John because she'd been receiving anonymous notes in her mailbox. Apparently the women of Jordan, Oregon, had been playing a mean trick, which backfired in Lottie's death. The notes fed Emma's paranoid delusions.

Only twenty-three women were sentenced to prison between 1854 and 1900. Most of those women spent only a few months in the penitentiary. They were incarcerated in a cell behind the warden's office alone, with almost no access to exercise, sunshine, or company. It was believed that the asylum was a better place for Emma to spend the rest of her life.

The governor had to authorize the transfer of all insane convicts to OSIA.[15] Of those, 41 percent were sent to the asylum for medical care and 25 percent died while they were there. Only 13 percent were discharged as cured or transferred to other institutions outside Oregon. After Emma's second transfer from the prison to the asylum, she remained there for the rest of her life.

Other female prisoners were transferred from the penitentiary. On November 29, 1898, Jennie Melcher was admitted with the diagnosis of acute mania. Her admission record indicated she displayed incoherent talk with violent acts.[16] She was five feet six inches tall, 130 pounds with brown eyes and black hair. She was assigned to ward 21 (the ward for dangerous females) and was sent back to the penitentiary six months later on January 11, 1899. Records stated she had recovered. She had been convicted of

Jennie Melcher, convict #3791, was transferred to OSIA in 1898 and stayed there until 1899. *Oregon State Archives.*

Rosa De Cicco, convict #5814, was convicted of assault and sentenced to prison for two and a half years. She spent about three years in the asylum. *Oregon State Archives.*

perjury in Multnomah County.[17] On May 12, 1899, she was released from the penitentiary.

Rosa De Cicco entered the asylum on December 4, 1908, and was diagnosed with paranoia after being in prison for five days.[18] She had been convicted of assault and sentenced to two and a half years in prison. She was married, five feet seven inches tall, 130 pounds, and forty years old. She had knocked down G.B. Murray, a Portland policeman, with a sledgehammer when he went to arrest her. The only reason she didn't kill him was because he had on a metal helmet.[19] At the asylum she was held until October 8, 1911, and released as recovered.

In 1911 Dr. Steiner wrote the following rules of conduct applying to every employee at the asylum: "All attendants shall be persons of good character, of even temper and of sound judgment, shall avoid all rudeness, undue familiarity or use of disrespectful terms."[20] Additional rules included the following:

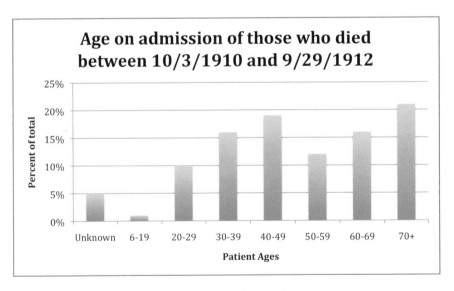

This graph supports Dr. Steiner's assertions that the counties were sending a disproportionate number of elderly patients to the asylum. *Analysis by author.*

Opposite, top: This graph illustrates the various causes of death listed for the patients who died between 1910 and 1912. *Analysis by author.*

Opposite, bottom: This graph shows the number of men and women in the asylum on October 1, 1910, and how that population changed over the next two years. *Analysis by author.*

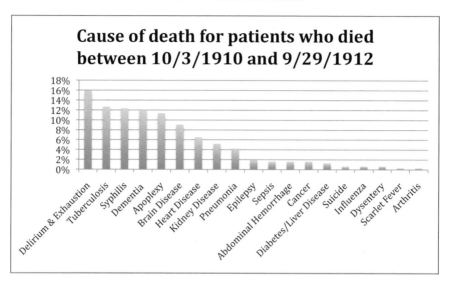

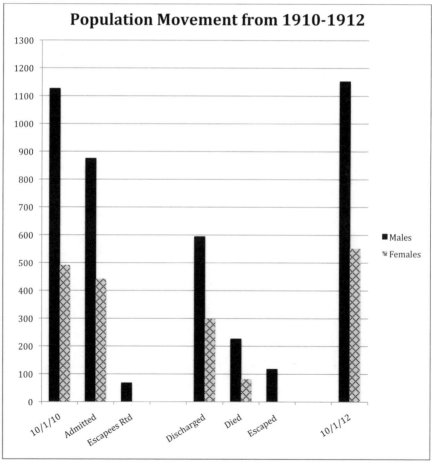

• Attendants were required to be neat and clean in dress, courteous and respectful to the officers, to one another and to all persons. Specifically, this included never wearing their hat indoors or going in their shirt sleeves, never to use profane or vulgar language, never to lounge upon the tables or other furniture.

• Attendants must rise punctually at the ringing of the morning bell and take charge of the hall, unlock all patient doors and give them a cheerful greeting.

• The use of restraining apparatus was prohibited except by express permission of the superintendent or attending physician. Seclusion to a private room or the personal care of the attendants was to be used until further directions could be obtained.

• No patient's door was to be left unlocked at night except by permission of the attending physician. On retiring, the patients' clothing was placed in the hall, the lights extinguished and the attendants were to retire to their respective rooms and extinguish their lights promptly at 10:00 p.m. unless specially excused by the superintendent.

• Attendants were allowed off the asylum ground two evenings a week until 10:00 p.m. with permission of the superintendent.

Dr. R.E. Lee Steiner was superintendent of OSIA from 1908 to 1937. *Oregon State Hospital.*

Such sentiments provided a positive and safe environment for patients like Emma. Even though Emma was confined in the violent female ward, the attitude of attendants brought a very real change to all the patients. Dr. Steiner stood behind his philosophy, and in 1914 an attendant, C.K. Sullivan, was arrested for assaulting three patients and fined fifty dollars.[21] While Dr. Calbreath had initiated the changes, Dr. Steiner continued the process by having attendants arrested and publicly charged with assault.

Between 1895 and 1913 the asylum maintained a book of employee records. It detailed

personnel information including when they were hired, rates of pay, when they were discharged, and why. Approximately 90 percent resigned in the first year of employment. The primary explanations listed as "reason for leaving" were "absconding," "drinking on job," and "stealing from patients." In several cases employees were fired for abusing patients. On October 25, 1900, Fred Lumen was discharged for abusing a patient after working two years at the hospital. Another attendant, Grace Brossus, was fired a little after a year of employment on October 3, 1911, for "brutal hitting patient over head with brush."[22] Those who stayed and didn't abuse patients were rewarded with incremental pay raises. Winifred Lampson, age thirty-three, began working at OSIA on February 28, 1912, for $25 a month. On April 1 her pay increased to $30 a month. On July 1 it was $32.50 a month. On October 1 it increased to $35 a month and to $37.50 on January 1, 1913. This was in addition to the fact that attendants were provided room and board at the asylum.[23]

Attendants were often in danger themselves. Hans Hansen, about twenty-four years old, a patient in the semi-violent ward, attacked George C. Harrington, who was an attendant and also the traveling agent who escorted Hansen to OSIA on Saturday, February 5, 1911. In the excitement Hansen nearly bit off Harrington's finger. Two other attendants, W.R. Kane and J.C. Ackerman, assisted their colleague by partially strangling the patient until he let go of the finger. A patient kicked Hansen in the stomach during the scuffle, causing an internal rupture. Hansen was later found dead in a holding room.[24]

In the superintendent's 1911 biennial report, Dr. Steiner listed 421 people, their names, marital status, salary, and title, as having been employed at the hospital between the years 1908 and 1910.[25] The numbers named in this report, compared with 120 employees listed in the 1910 census as living at the hospital, indicated an enormous turnover during the previous two years. Many of the attendants and employees were married to one another, making it easier to live inside the hospital. Their listed wages were between twenty-five and forty-seven dollars a month. Men earned more than women. Assistant physicians were Dr. G.C. Bellinger, Dr. Harvey J. Clements, Dr. Lewis F. Griffith, Dr. John C. Evans, Dr. J.H. Robnett, and Dr. A.E. Tamiesie. There were no female physicians. Dr. Bellinger and Dr. Clements were not listed in the 1910 census. The report also stated that there had been twenty-seven cases of diphtheria within the last two years. The open-air porches had reduced the death rate from tuberculosis by 20 percent.[26] At this time there was no provision at the Oregon State Tuberculosis Sanatorium for the tubercular insane.

The report compared the population on October 1, 1908, of 1,558 to 1,617 on October 1, 1910. Out of 263 deaths Dr. G.C. Bellinger had performed 57 autopsies. During the two years, 1,068 new patients had been processed into the hospital and 84 had escaped.

The asylum made every effort to keep the employees and patients entertained. Monthly dances continued to be held at the asylum for the employees and their friends. Nearly two hundred guests attended the St. Patrick's Day dance on March 20, 1908. "Superintendent Steiner and the attendants who gave the dance had fitted up the hall in green decorations in observation of the occasion. Nearly all present wore something green, a ribbon, a necktie, a belt, a flower or something of that color, and the punch served was also green."[27] The asylum orchestra provided the music. In 1909 the Steiner family hosted card parties where daughters Barbara and Rita were hostesses.[28] In addition various live performers came to the asylum. Superintendent Steiner reported the following at the end of 1910:

> During the past two years on a number of occasions Mrs. Sarah Brown Savage with her troupe of players have given us performances, as well as the Y.M.C.A. minstrels, Mrs. Hallie Parish Hinges, Mrs. W. Carlton Smith, Jacob Wenger and wife, Prof. Mendenhal, Prof. W.E. McElroy and his orchestra, Mrs. Kaiser and many other kind citizens have contributed their talent for the benefit of our patients.[29]

The asylum purchased its own moving picture machine and joined the Pantages theater circuit, which sent it a new movie once a week. Employees enjoyed the movies as much as the patients. Sixteen newspapers from all over Oregon donated subscriptions to the asylum: *Ontario News, Blue Mountain Eagle, Hood River Glacier, Heppner Gazette, Baker City Herald, Grant County Advertiser, Prineville News, Grants Pass News, Polk County Observer, Telephone-Register, Corvallis Gazette, News Reporter, Hillsboro Argus, The Spectator, Coos Bay News,* and the *Weekly Republican.*

At the end of Dr. Steiner's first year there were 1,549 patients at the asylum. A new wing was completed that had the third floor devoted to the criminally insane. A sanitation ditch eight feet wide at the top and four feet wide at the bottom was constructed to drain sewage through the low ground between the asylum and the penitentiary, through the Englewood districts to the Southern Pacific railroad bridge on Twelfth Street to where it emptied into North Mill Creek.[30]

On July 25, 1910, five inmates escaped from the criminally insane ward by breaking through the grating of the outer court where they were having

a recreation period. Three of the escapees, George Bowerman, J.H. Kirby, and Reynolds Johnson, were recaptured the next day. Frank Wade was serving a life sentence for a murder committed in 1895.[31] Wade was recaptured three months later in Willows, California.[32] It was unknown where Christopher Smith had gone. Wade was admitted to the asylum on June 24, 1899, after being sent to the penitentiary with his brother Lawrence for killing Francis Marlow. Frank pled guilty to second-degree murder, and Lawrence pled guilty to manslaughter. Frank's admission record at OSIA stated that he was "very violent and destructive."[33] He had previously been admitted to OSIA on December 2, 1898, and returned to the prison on March 21, 1899, as recovered.

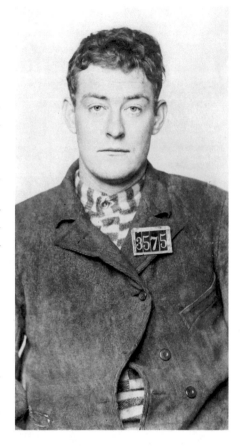

Frank Wade, convict #3575, was transferred to the asylum and escaped in 1910. *Oregon State Archives.*

Two other convicts escaped on June 10, 1914. Milton McDowell, age thirty-six, and Allen Jay, age twenty-six, sawed through the framework of a window while they were exercising in an enclosure with one hundred other men. McDowell had been convicted of blowing open a safe, and at the trial the jury determined that he was insane. Jay had escaped from the asylum three previous times.[34]

On February 25, 1917, William O. Bowen, age twenty-five, was part of a group in the criminally insane ward that caused a riot during which attendant P.B. Fitch was beaten to death.[35] A month later Bowen was transferred to Stockton, California, where he was wanted on a bogus check charge. He subsequently returned to Oregon and was sent to OSH on August 3, 1933. There were about sixty violent and dangerous men committed to the ward in 1917.

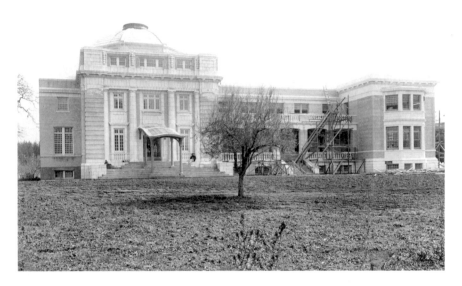

In 1911, the Dome building was nearly completed at OSIA. This photo shows the work being done on the center and southern sections. *Willamette Heritage Center, #2011.006.0781.*

Most escapees were harmless parolees working around the asylum grounds. In 1912 over fifty patients walked away from the asylum without permission.[36] It was only when they were from the criminal ward or had a violent background that the newspapers publicized the event.

In 1910 the Oregon Senate requested an investigation into the various state institutions. The committee was composed of James D. Abbott, C.W. Nottingham, W.D. Wood, and G.W.H. Merryman. Average daily attendance at OSIA for the previous two years was 1,736. Dr. Steiner had requested $812,375 for improvements and maintenance while the committee recommended $592,157. He asked for $88,177 for the Cottage Farm, and it allocated $24,234.

The committee's report was particularly critical of Dr. Steiner. He had requested an appropriation for a car, which was denied. The car was purchased anyway. Vouchers showed that the car cost $2,198.

In 1909 two houses were designed and built by Louis Hazeltine and designated as physicians' housing.[37] Household furnishings for the two houses totaled $3,205—an amount the committee considered excessive. This included furniture, floor coverings, mattresses, curtains, and decorations.[38] A total of four cottages now occupied the campus. A new infirmary and surgery was built updating the hospital's quality of care. A larger auditorium and amusement hall costing $35,000 was erected in 1914.

These physicians' houses were designed by Louis Hazeltine and built in 1909. *Oregon State Hospital.*

The Oregon Laws of 1910 summarized the laws governing the commitment and care of the insane in Oregon.[39] The Board of Trustees, consisting of Governor Oswald West, Secretary of State Ben W. Woolcott, Treasurer T.B. Kay, and Clerk R.W. Watson, administered the affairs of the asylum, including the appointment of all officers and employees. The superintendent was appointed for a term of four years and was required to be a licensed physician who had practiced medicine for at least five years. "All insane persons and idiots, residents of the state, are entitled to admission to the state hospital."[40] No provision was made for patients leaving the hospital except when judged permanently sane or dead.

By 1911 the asylum was so overcrowded it began to refuse admittance to the elderly suffering from dementia, morphine addicts, alcoholics, and persons who had relatives capable of taking care of them.[41] Patients with the financial ability were required to pay ten dollars per month. Dr. Steiner began deporting any patient who was a resident of another state. Between 1928 and 1930 he transferred nearly one thousand patients back to their home states.[42] The 1913 report to the Board of Trustees stated, "The institution is now so badly over-crowded that it has been necessary to place beds in corridors and smoking rooms."[43]

A dispute in 1911 erupted at the Cottage Farm regarding the hiring of black personnel. A black couple was hired to work in the Cottage Farm

Left: This photo was taken in the center room of the Dome building and shows the circular floating staircase. *Photo by author.*

Below: The Cottage Farm had two dining halls—one for each sex—that seated 150 persons on each side. *Oregon State Archives.*

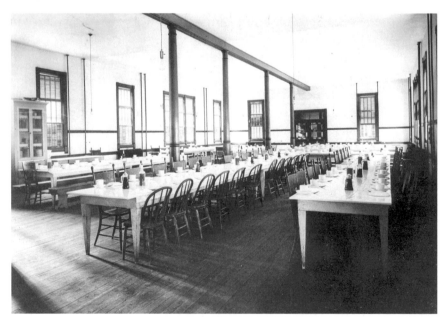

dining hall, and ten of the attendants signed a protest statement saying, "We the employees of the hospital farm consider it an imposition and disgrace to have colored people working the positions that they do and we object most strenuously."[44] Consequently Dr. Steiner fired A.C. Dilley, supervisor of the Cottage Farm, for participating in the protest.

At the same time, Dr. Steiner was fielding an investigation of excessive and lavish spending from Senator Jay Bowerman, who had picked the asylum as his personal political cause. In a confrontation, Dr. Steiner and an associate of Bowerman's, Senator Wood, came to blows. Dr. Steiner accused the senator of impugning his honor and lying. The accusations continued back and forth for at least two years.[45]

On May 12, 1911, the asylum experienced a fire in the south wing of the hospital, home for 150 mentally ill women. Caused by defective wiring, damages were in excess of $15,000. The automatic locks on the door were thrown open, and even though there were flames and dense smoke, no one died. "Panic seized the patients when smoke and flames burst out in the halls and they shook the bars of their windows frantically, shouting, 'fire.'"[46] Forty prison trustees rushed over to help remove the patients and assist the firefighters. Not a single convict took advantage of the situation to try to escape.[47] A few days later the hero convicts were fêted at a special banquet sponsored by Dr. Steiner and the hospital Board of Trustees.

Dr. Steiner instituted various cost-cutting maneuvers. Heating was changed from wood to fuel oil after special arrangements were made with the railroad to ship the fuel.[48] Instead of buying eggs costing $7,000 per year he set up a chicken house supervised by one staff person and inmate assistance.

In 1910 he had an incinerator installed. "Steiner's Chimney," as Salem residents referred to it, was originally built to burn infectious waste products.[49] In February 1913, the state legislature passed Senate Bill 109 directing the asylum to build a crematorium at a cost of $1,200 to exhume and cremate any unclaimed bodies from the Asylum Cemetery. The cremains were placed in copper cans soldered shut and stored in the basement of building 40. The final exhumations took place in March 1914.[50] In June 1914, the legislature passed a law requiring the asylum to cremate the body of anyone who died at the asylum and was unclaimed by their family.

In 1912 the central and southern wing of the new Treatment and Psychopathic Hospital (also known as the Receiving Hospital and/or the Dome building) was opened at a cost of $60,000 as a receiving hospital for the asylum and used as a medical hospital for women. In 1918 the northern wing for male patients was completed. It had the most up-to-date surgery center

This photo shows "Steiner's Chimney" (the red-and-white striped funnel), built in 1910. *Photo by Tom Green, National Register of Historic Places.*

and treatment facilities available at the time. For the first time the asylum had its own X-ray coil to diagnose fractures and other conditions. All of the hospital's future lobotomies and sterilizations were performed in this surgical center. It was later used for administration and eventually by the Department of Corrections, which still occupies it today. Edgar M. Lazarus (1868–1939), a prominent Portland architect, designed the building. Its unique shape has helped define the campus since that time. For the next thirty years the building received, tested, and diagnosed over five hundred new patients every year. The new Treatment and Psychopathic Hospital was equipped with all the modern hydrotherapeutic apparatus and appliances for special lines of treatment; it was a hospital in the proper sense, where the insane could have their physical illnesses treated as well as their mental illnesses. Dr. Steiner reminded the board, "We cannot lose sight of the central fact that the institution exists for the insane; that whatever adds to their comfort, promotes their welfare, or in any way alleviates their very distressing malady, *is right*; [*sic*] and that everything that deprives them of safe and sympathetic care, modern and scientific treatment, *is wrong* [*sic*]."[51]

Besides the cremation of the cemetery bodies, a number of other important events took place in 1913. The Eastern Oregon State Hospital (EOSH) opened in January 1913, with the transfer of 325 patients from OSIA. They were transported from Salem to Pendleton on a special train. Officials of the OWR&N Railroad stated that it was "marked by the absence of any property damage whatsoever."[52] Patients were quiet and orderly even

This photo, taken in 1914, shows the completed entrance where thousands of Oregon citizens entered Oregon State Hospital looking for treatment. *Photo by Tom Green, National Register of Historic Places.*

At the top of the dome is this octagonal-shaped leaded-glass window. *Photo by author.*

though the train was delayed between the Hood River and the Dalles by engine trouble. By November 1914, both asylums were crowded to their limits.[53]

In 1913 the state issued a small publication outlining the laws covering the admission and commitment of patients to the state penal and eleemosynary (supported by charity) institutions of Oregon. It covered OSIA, EOSH, the penitentiary, the State Institution for the Feeble-Minded, the Oregon State Training School, the Oregon State School for the Blind, the Oregon State School for the Deaf, the Oregon State Tuberculosis Hospital, and the Oregon State Soldiers' Home. The law defined whether county judges assigned patients to OSIA or EOSH. A county judge, in conjunction with a physician, could examine any person if notified in writing that such a person was insane, was unsafe to be at large, or was suffering from exposure or neglect. If they agreed the person was insane they issued a warrant committing the patient to the hospital. The county sheriff took the patient into custody until an attendant from the assigned hospital could escort the patient to the hospital.[54]

Dr. Steiner encouraged the trend toward active treatment of the insane using psychoanalysis and recommended the hospital change its name from the Oregon State Insane Asylum (OSIA) to the Oregon State Hospital (OSH). The legislature passed House Bill 433, which changed the asylum's name and its mission, in the middle of 1913.[55] No longer would the emphasis be on warehousing people with mental problems. From that day forward the emphasis would be on the treatment and cure of mental problems. At the same time the Board of Trustees was replaced with the Oregon State Board of Control, composed of the governor, the secretary of state, and the state treasurer.

OSH expenses for January 1913 revealed that the asylum paid $49.60 for shipping and $99.20 a month to the General Film Company to show four Hollywood films to the patients. An interesting expense included $649.90 for ninety-seven men's suits. Nothing was noted on the voucher as to why the suits were purchased; however, it's been suggested that they were for patients being discharged. Salaries for the staff totaled $9,592 a month. In February 1913, forty-nine prison trustees were paid $184 to work at the hospital.[56]

December 1913 expenses included the vouchers for Dr. Steiner's trip to China. Harry Minto, J.H. Barbour, and Dr. Lai H. Yick accompanied Dr. Steiner and twenty-five discharged male Chinese patients. The men had been residents of Oregon for many years, but the state now wanted to repatriate all patients to their countries or states of origin. Each patient

received $59.36 when he reached his destination. The state paid $262.50 for each of the physicians' round-trip boat tickets from Portland to Manila. The patients rode steerage at a cost of $46.00 each.[57] Total cost for the trip was $3,348.53 or an average of $133.94 per patient. Considering that it cost approximately $13.63 a month[58] or $163.56 per year to care for a single patient ($4,089 a year for twenty-five patients), returning the patients to China saved the state many thousands of dollars. The push to return immigrants to their original countries continued for the next fifteen years. As late as 1923 the U.S. immigration commissioner, R.P. Bonham, found eight aliens incarcerated in the prison and six aliens incarcerated in the hospital.[59]

In a move meant to publicize his agenda, State Labor Commissioner Hoff arrested Dr. Steiner on December 13, 1913, as he boarded the ship for China.[60] He had a writ charging the superintendent with violating the eight-hour law by requiring attendants to work longer than that at the hospital. Dr. Steiner was released a few hours later to continue on his journey. Eventually the Oregon Supreme Court decided the hospital was exempt.

Also included in the vouchers of December 1913 was $94.41 for Christmas decorations, $3 a week pay for each of the ministers who conducted Sunday church services, and prize money awarded the seven prisoners employed at the hospital and the Cottage Farm.

The year 1914 publicized for the first time the scheme of husbands having their wives committed to the hospital to secure their property. As women had procured the right to vote and serve on juries, along with changes in Oregon's property laws, such actions were less easily hidden from publicity. In Gold Beach, Oregon, Charles Smith attempted to have his wife committed to the hospital. Friends of Mrs. Smith were able to circulate a petition and secure a re-hearing. Mr. Smith, after meeting one of the men backing the petition, drew a gun and tried to shoot him. The action evidently confirmed Mrs. Smith's assertion that she was quite sane and her husband wasn't. He ended up in prison, and she retained her money and her independence.[61]

In October 1914, the legislature appropriated $307,181 per biennium to support the hospital. It cost an average of $14.64 per patient each month to provide clothing, food, medical treatment, heat, light, water, and repairs to the buildings.[62] By November there were 1,900 patients in OSH and EOSH, and the increase was about 200 patients per year.[63] Two years later $372,840 per year was requested by Dr. Steiner to care for an average population of 1,700.[64]

Dr. Steiner was finally able to institute a much-needed parole system so patients could visit their families and return to their communities on a trial

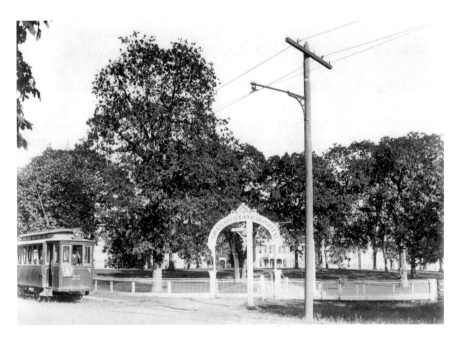

This streetcar delivered most of the patients and visitors to the primary entrance of the hospital. *Oregon State Archives.*

basis. Before this time there had been no provision in the law for patients to be out on temporary leave. In 1915 nearly 184 patients were paroled. Many were discharged at the end of the year. By 1936 that number had increased to 550.

Dr. Steiner accused the Multnomah County judges of sending patients to the hospital who should have properly been taken care of by the county. He told the Board of Control that "more improper commitments are made from Multnomah County than any other county in the state."[65] In reply Multnomah County Judge T.J. Cleeton wrote a letter to the *Oregonian* asking if Dr. Steiner felt the examining physicians were incompetent. He named some of the most eminent and experienced physicians in Oregon as serving on the examining board: Dr. W.T. Williamson, Dr. J.F. Calbreath, Dr. Simeon Josephi, Dr. William House, and Dr. Stanford Whiting. In contrast the judge asked Dr. Steiner to examine his own competency based on the number of patients he had discharged, paroled, and announced cured who had been returned to the hospital.[66]

The biennial report of 1916 reported that the number of admissions had declined and gave the credit to Prohibition. Alcohol-related insanity had decreased by over 50 percent during the previous two years. Patients

infected with syphilis were of particular concern, as treatment in 1916 was relatively ineffective and toxic and penicillin was still twenty-five years in the future. The cost to society was enormous. A 1916 *Oregonian* reporter wrote about the end stage of neuro-syphilis: "One hundred six men and nine women were received suffering from general paresis, which is simply one of the manifestations of syphilis. This malady always is fatal. The average duration of the disease is from two to five years."[67] He estimated that these 115 patients would cost the state over $50,000.

Oregon's violent wards were partially abolished in 1916, and patients were encouraged to participate in physical activities, work with other patients at farming, and play games and watch movies.

In March 1916, for the first time, a young man threatened innocent schoolchildren in a misguided attempt at revenge against some perceived wrongs. He barricaded himself and three family members inside his home. For several days previously he had threatened to enter the Ardenwald Elementary School and start shooting. After two deputy sheriffs entered the home in an attempt to arrest William Klinkman, age twenty-five, he pulled a gun and ordered them to get out. The next morning he shot the rope holding the school flag into two pieces using a shotgun at one hundred yards. The schoolchildren were immediately told to go home, and a scheme was set in motion to get him out of the house.[68] When finally arrested, it was apparent the man was insane, and he was admitted to OSH on March 2, 1916. His record stated that he suffered "delusions of persecution paranoia of about one year's duration."[69]

The 1916 Thanksgiving feast included 27 bushels of potatoes; 215 gallons of salad; one ton of turkeys, chickens, and ducks; 1,000 loaves of bread; 60 pounds of butter; 200 gallons of soup; 130 gallons of green beans; 210 gallons of applesauce; 95 gallons of giblet stew; 100 gallons of macaroni and cheese; 70 gallons of coffee; 30 gallons of tea; 110 gallons of rice pudding; 250 pumpkin pies; 500 pounds of fruit cake; and 40 gallons of cranberry sauce.[70] The Cottage Farm produced all the food served except the coffee, tea, macaroni, cheese, and butter.

The Statistical Manual for the Use of Institutions for the Insane, issued in 1918, listed twenty-two classifications of insanity:[71]

1. Traumatic psychoses
2. Senile psychoses
3. Psychoses with cerebral arteriosclerosis
4. General paralysis

5. Psychoses with cerebral syphilis
6. Psychoses with Huntington's chorea
7. Psychoses with brain tumor
8. Psychoses with other brain or nervous diseases
9. Alcoholic psychoses
10. Psychoses due to drugs and other exogenous toxins
11. Psychoses with pellagra
12. Psychoses with other somatic diseases
13. Manic-depressive psychoses
14. Involution melancholia
15. Dementia praecox (schizophrenia)
16. Paranoia or paranoiac conditions
17. Epileptic psychoses
18. Psychoneuroses and neuroses
19. Psychoses with constitutional psychopathic inferiority
20. Psychoses with mental deficiency
21. Undiagnosed psychoses
22. Not insane

The manual and the categories were designed to assist physicians in reporting the various diagnoses assigned to patients. The manual defined and described each category in detail so the subsequent statistics would be as reliable as possible.

From January 1918 to December 1919, the night attendant, E.B. Copeland, kept a written log of events that took place between 7:00 p.m. and 5:00 a.m., including births, deaths, suicides, escapes, fights, assaults, and thefts by other attendants.[72] One of the more interesting entries occurred on April 22, 1919, when the attending physician wrote "Room 18 Ward 4 alive with bedbugs [*sic*]."[73] By far the most consistent entry was the hourly water pressure readings. He also recorded assaults against attendants and other patients. On November 14, 1918, H. Hoger of ward 1 kicked attendant D. Graves in his privates, and Graves had the patient put in restraints.

Homosexual attachments occurred in the hospital but were usually unrecorded. However, on December 19, 1918, two male patients were discovered in the same bed. Copeland reported the indiscretion, and the men were separated. A few days later the couple was again found in bed together and separated. This time a fight ensued on the ward that injured the ward attendant.

In another incident on November 25, 1918, a patient tore up his bedding,

was disturbing other patients, and was given a "hypo" consisting of one-quarter grain of morphine. Later in the evening the patient struck the attendant in the face, and the attendant put him in restraints.

Copeland often wrote about Ira Applegate, one of the more unruly patients. He had been committed from Douglas County on September 19, 1897, after destroying his brother's horses. Over the next thirty years Ira was admitted and discharged three more times. His last admission began on December 4, 1918, and he remained in the hospital until he died on December 9, 1930.[74]

Ira's first entry as an unruly patient began on July 21, 1918, when the attendant wrote, "Ira Applegate very noisy between 3 and 4 a.m."

Copeland made a lengthy note concerning Ira on January 3, 1919: "Found Ira Applegate locked in room. had been tumbling ?eading around on floor of room. Reported by Hyland, down on Eight Earlier in night, with table up side down and long bench piled up on it. Seems to be very much disturbed. ought to be locked in strong room at night, with-out any bestead. Mattress on floor [sic]."[75] A month later he wrote that Ira was walking on the ward with a strip off of the door casing. Copeland had to put him to bed. The next night Ira began piling up benches, and Copeland locked him in a room. On February 11, 1919, Ira had to be put in restraints again after piling up beds in the middle of the night.

A month later he got out of his restraints but didn't do any damage other than disconnecting his bed from the floor and bending one of the side rails.

One of the last entries in the book concerned two men named Marsters and Churchill. They were fighting and howling before being put in restraints. It took four men to restrain each man.[76]

A young physician, Dr. Charles E. Bates (who later became superintendent in 1948), remembered removing the chains binding one poor patient when he arrived at OSH in 1913.[77] From that point he refused to allow his patients to be chained. However, as late as 1948, chains were still used to restrain the more violent patients.

It was common practice for the night duty physician (usually Dr. W.W. Looney, assistant physician) to administer morphine injections to unruly patients. Once started, the patient would experience disruptive withdrawal symptoms necessitating even more morphine. In some instances, as in the case of Emma Shrake in ward 18, she would be given an injection at 9:00 p.m., warm milk at 11:00 p.m., and another injection at 1:00 a.m., just to keep her quiet.[78] Dr. Looney seemed to accept and understand the addictive nature of the morphine, as he began referring to the nightly injections as her

"usual shot" in his notes.[79]

Mignon (Cawlfield) Applegate, age fifty-five (b. 1867), joined her husband's aunt and cousins at OSH on January 20, 1922, as a voluntary commitment to ward 10.[80] She was the wife of Winfield Applegate, who was a grandson of Jesse and nephew to Robert. She was forgetful and feeble-minded with a diagnosis of senile paranoid psychoses. She was only there about two months before she returned to Douglas County. Her belongings included one "kiki" [sic] colored woolen dress, one black woolen dress, one corset, one blue wool petticoat, six colored cotton dresses, one outing flannel gown, one outing flannel petticoat, three sleeveless union suits, five pairs of black hose, one pair of black shoes, and one pair of low shoes.[81] She was discharged on March 8, 1922.[82]

On September 20, 1923, she returned to OSH.[83] This time her belongings included one blue wool coat, one rose straw hat, one black wool dress, three blue outing jackets, one corset, one tan checked cotton dress, one striped apron, two checked cotton house dresses, three white outing chemises, two pairs of brown wool hose, one pair of black cotton hose, and one pair of black shoes. Stored in the asylum attic was a very old and worn suitcase with the additional clothing in it: one white petticoat, one gray cotton housedress, two short outing flannel gowns, one gown, two gray outing flannel dresses, one black satin petticoat, one striped cotton petticoat, one outing flannel chemise, and one brown wool dress.[84] She lived until December 5, 1923, when she died of a cerebral hemorrhage. She had been in the hospital for two months and fifteen days. Mignon Applegate was fifty-six years old.[85]

From May 1919 to February 1920, Dr. Steiner left OSH to become warden of the Oregon State Penitentiary at the request of Governor Ben W. Olcutt. He instituted some significant changes affecting discipline, sanitation, and personnel.[86] At the end of nine months he was reinstated as superintendent at OSH. While he was absent, Dr. L.F. Griffith was appointed temporary superintendent.

In 1922 the hospital had another fire causing nearly $15,000 in damage and destroying the upper floor of the structure and the roof. Lower floors were ruined by smoke and water. This part of the building was being used by female attendants who slept during the day and worked at night.[87] It was eventually dismantled, and on January 1, 1929, the Griffith Nurses Home was opened as a dormitory for nurses and female attendants living on the hospital grounds.[88]

In 1923 Dr. Steiner warned the Board of Control about the terrible overcrowding at the hospital.

We especially at this time wish to utter a caution against the evils of overcrowding. Wards designed to accommodate forty are crowded up to forty-five. Then gradually, there always being room for one more, the number creeps up to fifty, always upward, never going back to the proper number. Every one is inconvenienced, the sleeping quarters are too crowded for health or comfort, the dining rooms are jammed, the day rooms and water sections, everywhere a patient goes he has too little room, and this is not for a few days like a journey on an overcrowded train, but month after month, year after year.[89]

The year 1923 was a very difficult one for Dr. Steiner and OSH. The hospital had $25,000 cut from its budget, and he faced reducing salaries for his staff and himself. "While the superintendent of the Oregon hospital receives $1000 a year less than that paid to any other superintendent in the coast states, nevertheless I wish to volunteer the information that if any cut is made in salaries the superintendent will meet it with a proportionate cut in his own."[90] At that time Dr. Steiner received $3,000 per year.

As early as April rumors began circulating that Dr. Steiner was going to resign and that through his conduct he was defrauding the state. Suggestions that Dr. Steiner had exerted excessive power over the Board of Control seemed to be at the root of the controversy.[91] However, his national reputation for excellence helped support his denial of the accusations. Dr. Steiner went to the Marion County district attorney, John Carson, and instituted an investigation to determine who was slandering him. It was discovered two local Marion County men, a tailor, Larondo Pierce, and a local naturopathic physician, Dr. A. Slaughter, were the primary sources of the rumors.[92] Dr. Slaughter was a political radical and had been accused of being a communist during World War I. He was also an ardent supporter of Democratic Governor Walter M. Pierce. Also opposing Dr. Steiner was Lem Dever, editor of the official Ku Klux Klan publication and leader of Oregon's secret organization.[93] The Klan wanted Dr. Steiner removed so it could insert its man, Dr. Grant Smith, into the position. In the early 1920s Oregon had a Klan membership of approximately fifteen to forty thousand.[94] The Klan was involved in issues surrounding "immigration policy, prohibition and tax concerns, pushing their anti-Catholic, anti-Semitic and pro-white agendas."[95] The Democrats wanted Dr. Steiner removed so they could insert their candidate, Dr. Earl Morrow, the son of a prominent Democrat and friend of Governor Pierce.[96]

Meanwhile a visiting Canadian official visited the hospital and praised

Dr. Steiner's administration.[97] Also supporting Dr. Steiner, Dr. H.A. Haynes, superintendent of the Michigan Home and Training Institute, reported, "Oregon's state hospital…is one of the most modern and best conducted institutions of its kind in the United States."[98] He particularly praised the Cottage Farm operation, efficient medical staff, high rate of cures, cleanliness, and well-kept grounds as evidence of Dr. Steiner's unusual administrative ability.

> *The psychopathic department of the Oregon state hospital probably has no equal in the United States and undoubtedly has proved of material benefit in treating the insane. "My greatest surprise on visiting the Oregon state hospital is that the commonwealth has managed to retain a man of Dr. Steiner's ability at the paltry salary of $3,000 a year. Men at the head of similar institutions in other parts of the United States receive salaries ranging as high as $10,000 annually and they are allowed concessions barred under Oregon laws."* [99]

Being politically astute and recognizing when he was beaten, Governor Pierce bowed under pressure and no longer sought the superintendent's resignation. Dr. Steiner continued as superintendent for another fourteen years.

Psychological testing was gaining status in many parts of the country, and Oregon joined the popular movement. Of particular concern was interest in criminal psychology. Governor Pierce instructed Gus Anderson, a criminologist, to conduct a mental analysis of three convict escapees who shot their way out of prison on August 12, 1925. He used the army alpha test, which calibrated a normal person's mental age at 14 years. Tom Murray tested above normal with a mentality of 18.6 years, Ellsworth Kelley tested at 17 years, and James Willos tested at 12 years. Murray was the leader with an indomitable will, affable disposition, and rapid mental responses. Anderson also examined William R. Lloyd, OSP #8404, age 26, charged with the murder of Clinton I. Baun. Lloyd tested at 16.9 years, but "he has, however, a total lack of emotional response and apparently has no feeling of remorse for the crime he has committed. During the test, Lloyd was calm and did not show the slightest trace of increased heart action or nervous tension."[100] This would be considered consistent with today's understanding of psychopathic personality traits. He was hanged at the Oregon State Penitentiary on November 30, 1925.

Ellsworth Kelley, OSP #8663 and #7331, was a habitual criminal and had escaped from prison (OSP) before on May 10, 1915, at the age of nineteen.

Ellsworth Kelley, convict #7331, was a convict who escaped from the Oregon State Penitentiary with two others in 1925. *Oregon State Archives.*

James Willos, convict #30307, was hanged in the prison on April 20, 1928. *Oregon State Archives.*

He was sent back to OSP on January 20, 1923, and sentenced to twenty years. After his escape in 1925, he was hanged for the murder of the guard on April 20, 1928. He was twenty-nine years old.[101]

James Willos (alias Walter Burns), OSP #30307, age twenty-seven, was received at the prison on April 13, 1924, convicted of burglary, and sentenced to seven years. He was hanged on April 20, 1928, at the Oregon State Penitentiary for the murder of the guard during his escape, the same day as Ellsworth Kelley.

The number of patients confined to the hospital continued to climb to 1,829 in 1925 at a monthly cost of $17.87 per person.[102] Dr. Steiner prepared a report in 1927 showing the cost to the state per month for patients living the longest time at the hospital. Based on the average of $14 per month he estimated it had cost the state $8,230 to care for the patient who had lived forty-nine years at OSH, although logically it cost much less in the early years to care for a single patient.[103]

1 patient for 49 years = $8,230
2 patients for 47 years = $15,792
4 patients for 45 years = $30,240
1 patient for 44 years = $7,392
3 patients for 43 years = $21,672
2 patients for 42 years = $14,112
1 patient for 40 years = $6,720
19 patients for 35 years = $111,720
23 patients for 30 years = $115,920
27 patients for 25 years = $113,400
33 patients for 20 years = $110,880
55 patients for 15 years = $138,600
85 patients for 10 years = $142,800
TOTAL = $837,478

That same year, Dr. Steiner requested $247,652 for capital expenses, including $75,000 for a new industrial building, $125,000 for a nurses' dormitory, and other improvements.[104] The Board of Control finally approved the funds for the nurses' and attendants' dormitory in April 1928, releasing 168 beds that could now be used for patients.[105]

In 1930 Dr. Lewis F. Griffith died. He had been part of the OSH staff for thirty-nine years, and for twenty-five of those years he had been assistant superintendent. He had served as superintendent while Dr. Steiner was warden at the state penitentiary. He had been called to testify in almost all Pacific coast

cases involving psychiatric diagnosis for many years before his death.[106]

By 1932 the patient population at OSH had increased to 2,105 and at EOSH to 1,176, nearly a double increase since 1922.[107] Two hundred attendants, nurses, and doctors were required to care for them.[108] After a new ward was opened at EOSH, 150 patients were transferred from OSH.[109] The hospital continued to gain approximately 75 to 100 patients a year.

> *Population Increase at OSH for first five months of 1930:*
> *December 31, 1929 = 1955*
> *January 31, 1930 = 1993*
> *February 28, 1930 = 2019*
> *March 31, 1930 = 2019*
> *April 30, 1930 = 2029*
> *May 31, 1930 = 2040*[110]

On June 24, 1933, Emma Hannah died of a cerebral hemorrhage at the age of eighty-six.[111] She had been in the hospital for thirty-three years and one day since her admittance on June 23, 1900.[112] Her body was shipped to Lebanon by train, and she was buried in the Providence Cemetery in Linn County.

That same year Dr. Steiner sent a proposal to the State Board of Control requesting a new chapel seating one thousand people and costing $50,000. An additional $100,000 was also needed to modernize the wards for the criminally insane, the addition of firefighting equipment, and constructing new roads.[113]

Dr. Steiner remained superintendent until June 30, 1937, when Dr. John C. Evans assumed the position. Dr. Steiner had served for twenty-eight years and six months—almost as long as Emma Hannah had lived at the hospital. While there had been some scandal while he was superintendent, he had also modernized the hospital to the best of his abilities and the limit of the times. He was admired and honored by his colleagues, his friends, and his family.

Notes

1. Federal Census 1900 for Marion County, Oregon State Archives, Salem, Oregon.
2. *Lamplighter*, October 1958.
3. "OSH Female Admissions Book, 1883–1920," Oregon State Archives, Salem, Oregon.
4. Personal Record for Mrs. E.E. Wood, Vol. 4B, p. 378, OSIA Records,

Oregon State Archives, Salem, Oregon.

5. *St. Johns Review* (St. Johns, Oregon), December 1, 1905.

6. Oregon State Hospital Register of Personal History Females, 1887–1896, Oregon State Archives, Salem, Oregon, 212.

7. Personal Record for Queen Hannah, Vol. B, p, 41, OSIA Records, Oregon State Archives, Salem, Oregon.

8. Ibid.

9. Death Record for Queen Hannah, Vol. G, p. 65, OSIA Records, Oregon State Archives, Salem, Oregon.

10. Discharge Record for Emma Hannah, Vol. F, p. 73, OSIA Records, Oregon State Archives, Salem, Oregon.

11. OSIA Patient's Property Records, 1883–1926, Emma Hannah, Oregon State Archives, Salem, Oregon.

12. Ibid.

13. Ibid.

14. *Emma Hannah v. John Hannah*, Linn County Circuit Court #799, Vol. 24, January 24, 1903, divorce.

15. "Convict Admission Discharge Ledger, 1901–1945," Oregon State Archives, Salem, Oregon.

16. Personal Record for Jennie Melcher, Vol. 4B, p. 2, OSIA Records, Oregon State Archives, Salem, Oregon.

17. Diane L. Goeres-Gardner, *Murder, Morality, and Madness: Women Criminals in Early Oregon* (Caldwell, ID: Caxton Press, 2000), 44.

18. Personal Record for Rosa DeCicco, Vol. 4B, p. 563, OSIA Records, Oregon State Archives, Salem, Oregon.

19. *Oregonian*, July 30, 1908.

20. L. Crandall, "History of Mental Illness in Oregon and Oregon State Hospital," 8, published by the Oregon State Hospital, Salem, Oregon.

21. *Argus* (Ontario, Oregon), October 14, 1914.

22. Employee Records, 1895–1913, Oregon State Hospital Records, Oregon State Archives, Salem, Oregon.

23. Ibid.

24. *Lake County Examiner* (Lakeview, Oregon), February 16, 1911.

25. "Fourteenth Biennial Report of the Board of Trustees and Superintendent of the Oregon State Insane Asylum to the 26th Legislative Assembly, 1910" (Willis S. Duniway, State Printer, 1911), Oregon State Archives, Salem, Oregon.

26. Dr. R.E. Lee Steiner, "Superintendent's Report, October 1, 1910," Oregon State Insane Asylum. Oregon State Board of Control Files, Oregon State Archives, Salem, Oregon, 6.

27. *Capital Journal*, March 21, 1908.

28. *Capital Journal*, March 20, 1909.

29. "Fourteenth Biennial Report of the Board of Trustees."

30. *Capital Journal*, December 25, 1908.

31. *Mail Tribune* (Medford, Oregon), July 27, 1910.

32. *Mail Tribune*, October 23, 1910.

33. Personal History for Frank Wade, Vol. 5A, p. 476, OSIA Records, Oregon State Archives, Salem, Oregon.

34. *Oregonian*, June 12, 1914.

35. *Oregonian*, October 10, 1933.

36. *Oregonian*, November 21, 1912.

37. http://oshmuseum.wordpress.com/2011/06/26/osh-cottage-architect-makes-mark-on-salem/#more-890.

38. "Report of Special Committee to Investigate Institutions, 1910," Special Collections, Oregon State Library, Salem, Oregon.

39. John Koren, "Summaries of Laws Relating to the Commitment and Care of the Insane in the US" (New York: National Committee for Mental Hygiene, 1912), 223.

40. Ibid., 224.

41. *Oregonian*, March 24, 1911.

42. Crandall, "History of Mental Illness."

43. "Fifteenth Biennial Report of the Board of Trustees and Superintendent of the Oregon State Insane Asylum, to the Twenty-Seventh Legislative Assembly, 1913" (Willis S. Duniway, Printer, 1912), Oregon State Archives, Salem, Oregon.

44. *Oregonian*, March 23, 1911.

45. *Lake County Examiner*, February 2, 1911.

46. *Oregonian*, May 13, 1911.

47. *Evening Herald* (Klamath Falls, Oregon), May 18, 1911.

48. *Oregonian*, April 8, 1911.

49. "Cremains Chronology, " January 2012, Oregon State Hospital, Salem, Oregon.

50. Ibid.

51. Steiner, "Superintendent's Report," 1910.

52. *Oregonian*, January 26, 1913.

53. *Oregonian*, November 11, 1914.

54. "Laws of Admission and Commitments: Oregon State Penal and Eleemosynary Institutions, 1913," State Board of Control Files, Oregon State Archives, Salem, Oregon.

55. Most newspaper articles indicate the name was changed in 1907.

However, the "Administrative Overview for the Department of Human Services, Addictions and Mental Health Division" of November 2009 states that the name was changed in 1913. Further evidence supports this, as the "Fifteenth Biennial Report of 1913" still uses the title of Oregon State Insane Asylum to identify the hospital. The "First Biennial Report of the Oregon State Board of Control of 1914" uses the title of Oregon State Hospital. The hospital Daily Log Book of 1913 records daily hospital business. It refers to the hospital as OSIA up through June and OSH beginning in September 1913. This would seem to support the theory that the name change occurred between July and August of 1913.

56. OSH Vouchers for January 1913, Marion County Historical Society, Salem, Oregon.

57. OSH Vouchers for December 1913.

58. Report of Special Committee to Investigate Institutions.

59. *Oregonian*, October 11, 1923.

60. *Lake County Examiner*, December 11, 1913.

61. *Coos Bay Times* (Marshfield, Oregon), June 20, 1914.

62. *Oregonian*, October 31, 1914.

63. *Oregonian*, November 11, 1914.

64. *Oregonian*, November 17, 1917.

65. *Oregonian*, November 6, 1915.

66. Ibid.

67. *Oregonian*, October 21, 1916.

68. *Oregonian*, March 2, 1916.

69. Admission Record of William Klinkman, Vol. 2D, p. 63, OSIA Records, Oregon State Archives, Salem, Oregon.

70. *Oregonian*, November 30, 1916.

71. "Committee on Statistics of the American Medico-Psychological Association in Collaboration with the Bureau of Statistics of the National Committee for Mental Hygiene, Statistical Manual for the Use of Institutions for the Insane" (New York: 1918), Oregon State Hospital Folder, Oregon State Archives, Salem, Oregon. This was an early version of the Diagnostic and Statistical Treatment Manual (DSM).

72. Nightwatch Book for OSH between 1918 and 1919, Oregon State Archives, Salem, Oregon.

73. Ibid., 92.

74. Death Record for Ira Applegate, Vol. 2G, p. 165, OSH Records, Oregon State Archives, Salem, Oregon.

75. Nightwatch Book, 58.

76. Ibid., 248.

77. Alfred C. Jones, "A Hospital Marks Changing Times," *Capital Journal*, October 23, 1973.

78. Nightwatch Book, 72.

79. Ibid., 108.

80. Admission Record for Mignon Applegate, Vol. 2E, p. 13, OSH Records, Oregon State Archives, Salem, Oregon.

81. OSIA Patient's Property Records, 1883–1926, for Mignon Applegate, Oregon State Archives, Salem, Oregon.

82. Discharge Record for Mignon Applegate, Vol. 2F, p. 119, OSH Records, Oregon State Archives, Salem, Oregon.

83. Admission Record for Mignon Applegate.

84. Property Records for Mignon Applegate.

85. Death Record for Mignon Applegate, Vol. 2G, p. 80, OSH Records, Oregon State Archives, Salem, Oregon.

86. *Oregonian*, January 24, 1920.

87. *Oregonian*, April 27, 1922.

88. "Twenty-Third Biennial Report of the Oregon State Hospital for the Biennial Period Ending September 30, 1928, Eighth Biennial Report to the Oregon State Board of Control," Oregon State Archives, Salem, Oregon.

89. "Twentieth Biennial Report of the Oregon State Hospital for the Biennial Period Ending September 30, 1922, Fifth Biennial Report to the Oregon State Board of Control," Oregon State Archives, Salem, Oregon.

90. *Oregonian*, March 4, 1923.

91. *Oregonian*, April 9, 1923.

92. *Oregonian*, April 5, 1923.

93. *Oregonian*, June 25, 1923.

94. *News Review* (Roseburg, Oregon), June 29, 2005.

95. Ibid.

96. *Oregonian*, July 15, 1923.

97. *Oregonian*, July 31, 1923.

98. *Oregonian*, July 19, 1923.

99. Ibid.

100. *Oregonian*, September 7, 1925.

101. Oregon State Penitentiary Record for Ellsworth Kelly #7331 and #8663, Oregon State Archives, Salem, Oregon.

102. *Oregonian*, July 7, 1925.

103. *Oregonian*, August 7, 1927.

104. *Oregonian,* January 20, 1927.

105. *Oregonian,* April 18, 1928.

106. *Capital Journal,* June 16, 1930.

107. *Oregonian,* September 1, 1932.

108. *Oregonian,* June 1, 1930.

109. *Oregonian,* February 20, 1932.

110. *Oregonian,* June 8, 1930.

111. The hospital record states she was seventy-nine years old when she died; however, her tombstone at the cemetery and the 1880 census records indicate she was born in 1846, which would make her age at death eighty-seven, not seventy-nine. Patient records changed considerably from census to census. I have chosen to use dates used by the family at her death and in 1880 before she entered the various institutions.

112. Admission Record for Emma Hannah, Vol. 3B, p. 486, OSIA Records, Oregon State Archive, Salem, Oregon.

113. *Oregonian,* May 20,1933.

Chapter 5
THE CASE OF JAMES R. ROBBLET

James R. Robblet was not his real name but one chosen to hide his identity. He voluntarily entered the Oregon State Hospital in 1936 knowing that he was suffering a mental illness and seeking help. He wrote about his experience for the Portland *Oregon Journal*. Psychiatric counseling outside OSH was almost nonexistent in Oregon before 1936 and for nearly three decades after. A voluntary commitment to OSH was rare, and only occurred about twenty-five times a year. This amounted to a 12.6 percent voluntary admission rate.[1] Such a commitment had to be approved by the hospital superintendent or one of the physicians. According to Oregon law any person coming to the hospital seeking help was entitled to thirty days of care, observation, and treatment. At the end of thirty days he or she was generally released unless the physicians determined more treatment was needed or the patient was violent and dangerous to himself or others.[2]

The main hospital structure (the J building) was shaped like a capital E with the top cut off with "the center containing the offices and quarters; the short central area the service units, the assembly hall and a few wards; and the long arms three tiers of wards, the men's wing having been extended farther back than the women's wing."[3] The domed Receiving Hospital sat across Center Street but was connected by one of the many tunnels running from building to building. Drinking water came from five wells drilled 120 feet deep and able to produce one thousand gallons a minute. Sewage from the hospital was pumped through the Salem system and dumped untreated into the Willamette River as late as 1958.[4]

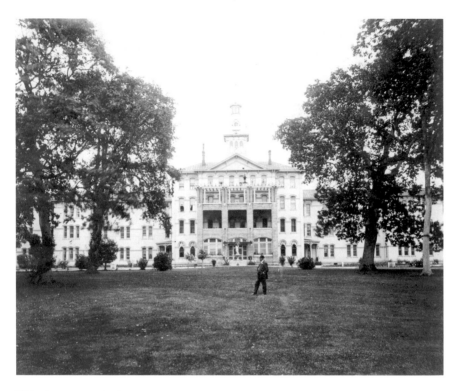

This photo shows the hospital entrance as it appeared about 1937. Dr. Steiner is featured in the foreground. *Oregon State Archives.*

As the Great Depression (from 1929 through the late 1930s) deepened, the state searched desperately for money to support its institutions. Sponsored by Carle Abrams, former secretary of the State Board of Control, and Governor Julius L. Meier, the Oregon legislature created a statewide furor by passing a new law. Chapter 187 and 189, also called the Ward Bills, went into effect on June 6, 1931.[5] Patterned after Washington's law, it mandated that relatives pay $4.50 a week (or $20 a month) to maintain patients in OSH and "in cases where these patients are found to be suffering only from infirmities attending old age, and their relatives are unable to pay for their keep, the counties from which they are committed will be compelled to reimburse the state at the rate of $4.50 per week."[6] After years of complaining that counties had been dumping their elderly, mentally deficient, and harmless indigents into the state institutions, it was finally time to reverse the trend. In actuality, Dr. R.E. Lee Steiner and the Board of Control interpreted the law to apply to any patient who wasn't violent.[7] Multnomah County was the hardest hit as it admitted nearly 40 patients a month to OSH.[8] It was

estimated the county would need to pay nearly $5,000 a month. "Of the 1,280 'not violent' patients in the two state hospitals, 480 [or 30 percent] were committed from Multnomah County."[9] Not counting payments from relatives, the county responsibility would be approximately $67,000 per year. Only 17.25 percent of the recently admitted patients were eventually discharged as cured or improved.[10]

Other counties also protested against the new tax and expressed relief when the tax was deferred for 1931. Because county and state budgets for 1931 had already been allocated, the Board of Control deferred county payments until January 1932.[11] In 1933 Marion County paid $10,000 to the state for its share of expenses for April, May, and June.[12] Because of the counties' protests, this part of the law was repealed in late 1933. The portion establishing the old age pensions for Oregon citizens remained in place. It was the beginning of PERS, Oregon's public employees retirement system.

How to categorize the various kinds of mental illness was and still is a hotly contested field. At the time of Robblet's commitment in 1936, the authorities at the 614 state hospitals in the United States believed there were twenty different types of mental illness. The first was dementia praecox, or schizophrenia, which constituted 26 percent of all first admissions, mostly in young adults, and resulted in a deterioration of mental abilities. Nearly 50 percent of those who lived at the hospital suffered from schizophrenia.[13] About 20 percent of these eventually recovered. Manic-depressive psychosis, also currently known as bipolar disorder, made up 16 percent to 18 percent of all first admissions. Patients with this condition alternated between euphoria and deep depression. Senile dementia in the elderly made up 12 percent of first admissions, and general paresis (syphilis infection) affected 10 percent. Alcoholics made up 15 to 20 percent of all first admissions. The final 14 percent were divided among the remaining sixteen types.[14]

Causes of mental illness ranged from heredity to old age. Physicians categorized causes as essential or incidental. Heredity was the primary cause in the essential category. Syphilis was the second most common cause. Alcoholism and head injuries made up the final two causes on the essential category. Incidental causes included stress, disappointments, infections, old age, brain tumors, and bad environment during early age.[15]

Patients with dementia praecox (schizophrenia) were divided into four different subdivisions: paranoid, catatonic, hebephrenic, and simple. Paranoid schizophrenics suffered from "unsystematized delusions of persecution."[16] Catatonic schizophrenics suffered periods of excitement and periods of stupor. While in the stupor they refused to bathe or make

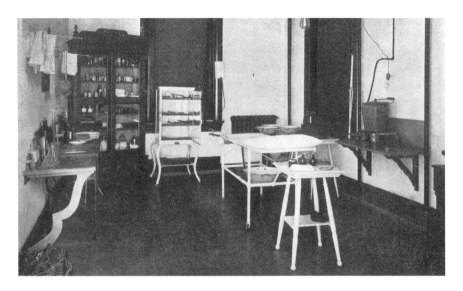

Patients were treated in this physician's office inside the old infirmary. *Oregon State Archives.*

any effort to care for themselves. The hebephrenic suffered a break from reality at puberty. They often had sexual obsessions. Simple schizophrenia was characterized by a gradually increasing apathy and listlessness in the young adult.

Manic-depressives alternated between euphoria and depression with specific physical symptoms. They often suffered from constipation, lack of appetite, altered sleep patterns, lack of self-esteem, and depression. Even when they recovered they often underwent repeated attacks.

Patients with senile psychosis were elderly and had physical deteriorations affecting the brain. It was believed at that time to be the result of arteriosclerosis, bringing on a state of childishness. Some were paranoid, while others were confused and delirious. Such patients usually had high blood pressure and died from apoplexy (stroke) or cerebral hemorrhage.

Syphilis infections resulted in three types of paresis: expansive, demented, and hypochondria. Blood and/or spinal tests confirmed the disease, while impaired speech, tremors, and a flat affect alerted physicians. Even when the bacteria were destroyed, the brain could not recover its normal function. The most common type was expansive (today labeled general paresis), with the result patients suffered from delusions of grandeur. The patient usually believed he had millions of dollars, lived in a palace, and occupied a position of great importance. The demented patient had little interest in

his surroundings and was apathetic. The hypochondriac patient was thought to be the opposite of expansive, although today it is included in the general paresis category as peripheral paresis. The patient was in constant pain and complained incessantly.

In 1936 melancholy was thought to be a form of severe depression lasting longer than the depressive cycle of the manic-depressive. Instead of many attacks, the patient with melancholy usually had just one episode, and nearly 67 percent of these cases recovered.[17]

Alcohol dependency was an increasing cause of insanity admissions at OSH. It caused symptoms of delirium tremens and/or acute hallucinations when alcohol was withdrawn from the patient. According to Superintendent John Evans, alcoholism was the direct cause of first-time male admissions at the rate of 3.6 percent in 1926, 9 percent in 1935, 12 percent in 1936, and 19.9 percent in 1938.[18] Patients saw hideous hallucinations both day and night. Some became paranoid and attempted suicide. Once they were alcohol free, the symptoms disappeared. Antabuse was not used in Oregon until 1951.

Mental illness caused by a head injury was the most difficult to treat. Any cure was doubtful, and depending on where the scar was located in the brain, the symptoms varied from patient to patient. When the patients were aggressive, uncontrollable, or disoriented, they were committed to the hospital.

Treatment varied depending on the patient's needs and particular symptoms. Drugs, when available, were used to keep the patient from harming himself or others. "Medicinal packs" were also used. Patients were wrapped in wet or dry sheets in an attempt to calm them. "This treatment has some therapeutic value, but if left unduly long or if the patient is wrapped too snugly is the most vicious form of restraint, far worse than the outmoded strait-jacket."[19]

"Nearly 30 percent of first admissions are released as recovered and 38 percent as greatly improved"[20]

James Robblet was feeling hopeless, discouraged, and depressed. The hospital grounds filled with flowers and green lawn cheered him a little when he arrived. Even knowing that nearly 2,400 people lived behind the many barred windows of the J building didn't depress him more than he already was. He was taken to the Treatment and Psychopathic Hospital, a beautiful facility erected in 1912 with a large dome on top. About 160 patients occupied the treatment and hospital wards. A large building for patients with tuberculosis and diabetes was located behind the Dome building.

Looking down from the third floor, the intricate tile work on the floor at the entrance to the Dome building is clearly visible. *Photo by author.*

Admittance procedures included surrendering all belongings and taking a bath. Patients were shown to ward C and assigned a bed to wait for a physician's examination. Routine blood tests checked for syphilis, and X-rays were used to examine heart and lungs. If syphilis spirochetes were discovered, the patient was injected with malaria in the hope the high fever would kill the bacteria. Wards C and D had bars on the windows but were "light and airy, almost like a well-regulated but not too fancy hotel."[21] Even the dining room resembled a hotel, seating patients four to a table, with other patients serving the food. It was easy to distinguish patients from attendants and physicians. Patients didn't dress as well and didn't wear the starched white coats like the physicians did or uniforms like the attendants did.

Each patient met with a doctor as soon as possible. By 1940 there were about one thousand admissions per year. The doctor's investigation and attendants' observations helped determine what treatment would be prescribed. This routine information tended to be scanty as the hospital lacked "enough clinical stenographers to take down the records as the physicians would like to give them."[22] Patients were permitted to write two letters a week, and the staff routinely screened these before they were mailed. There was a ratio of one physician to every 334 patients—nearly twice the number of patients recommended by the American Psychiatric Association at that time.[23]

A staff conference is held weekly for the consideration of new cases, the ones to be presented being picked by the assistant superintendent from those offered by the several physicians. This is a meager schedule, since only a small number of new cases can be presented and well discussed. It is felt at the hospital that more time spent in conference would involve fewer individual examinations.[24]

James enjoyed two hydrotherapy treatments a week. He stripped down to an improvised loincloth and was given a steaming hot footbath before being enclosed in a "Turkish bath contraption" referred to as a heat cabinet.[25] Light bulbs inside the enclosure heated the box to 136 degrees. After the sweatbox he had another bath and a massage. Finally, an attendant used a fire hose from about fifteen feet away to spray water up and down his back.[26] Between 1934 and 1936, OSH administered 2,760 hydrotherapy treatments. Between 1946 and 1948, hydrotherapy treatments had increased to 15,008. Over the next two years the therapy was reduced to 2,322 treatments.

According to the Survey of the State Mental Institutions of Oregon conducted in the fall of 1940, the hydrotherapeutic equipment was located in the Receiving Hospital (Dome building). Two tubs used for sedative therapy were in the same room as the jets used for stimulation.

These bathtubs were used for hydrotherapy to treat patients who needed relaxation therapy. *Photo by Tom Green, National Register of Historic Places.*

Most of the men in the hospital smoked. Every Thursday patients were given cigarettes or chewing tobacco. They were allowed a dollar a week to spend on candy, gum, or extra cigarettes. Men were shaved twice a week, and no one was allowed to keep a razor inside the hospital, as suicide was always a possibility.

Entertainment consisted of Monday night movies and religious services on Sunday in the winter. Movies were chosen by the physicians and censored by removing anything felt to be obnoxious or too exciting. The movies were shown in the assembly hall, which was on the second floor over the employees' dining hall. There were two exits and room for 350 people to sit. Although not very large, the high ceilings made it more comfortable than other rooms might be.

Patients were sent to bed and locked in their rooms at 7:30 p.m. every night except movie nights. Sleeping rooms rarely had knobs on the inside, making it impossible for patients to open on their own. Many were also locked in their rooms during the day. This practice was considered too dangerous in other states and was no longer allowed.

Work was considered a privilege, and working successfully at an assignment showed the physicians that a patient was ready to be discharged. This ensured

Hallways were long and narrow, stretching the entire length of a ward. Patients were locked in their rooms at night and let out in the morning. *Photo by Tom Green, National Register of Historic Places.*

All able-bodied patients were required to work somewhere in the asylum. These men were groundskeepers. *Oregon State Archives.*

that the hospital was always clean and tidy. "Big blocks are shoved over the floors by patients three times a day, a process that is really more for exercise than cleaning."[27] The blocks were wrapped in felt and shined the floors.

James started out as an assistant duster in the parlor of ward C and worked up to head duster after two weeks. Work duties were considered therapeutic both mentally and physically. His next work assignment was washing dishes in the dining room. Later he worked in the hydrotherapy unit and the surgery unit. About nine hundred of the men were employed in some way at the hospital.[28] Most did work farming or worked on the grounds. Some did jobs in the industrial department, which included a woodworking shop, a machine shop, a tin shop, a shoe shop, and a mattress shop. Women worked in the sewing department, cannery, and the art shop.

There were many patients in the hospital who needed medical care in addition to their mental health needs. A 1931 inventory of drugs listed many herbal remedies (calomel, peppermint, ephedrine sulfate, tannic acid, and arnica) in addition to more traditional compounds (choral hydrate, Novocain, milk of magnesia, codeine, and mercurochrome) and those not so traditional (opium, chloroform, and strychnine.[29])

After a month James moved to ward D and was assigned to a room with another male patient. The small sleeping rooms bordered a wide hall with polished floors. It had a pleasant parlor where the men played cards. Ward D had quieter patients than ward C. The men chatted, watched other patients play

137

In January 1916, snow covered the Willamette Valley, and hospital patients were treated to winter activities. *Oregon State Archives.*

softball, or played cards. Reading books and magazines from the hospital library was a common pastime. William Seabrook's *Asylum* was a popular choice.[30] The library had about three thousand books that were available to patients and employees. A selection was taken in baskets throughout the hospital weekly by patient helpers, creating a weekly circulation of about three hundred.[31]

The patients enjoyed anything that broke the monotony of everyday life in the hospital. Visits from family or friends were highlights—even if the visitors were hesitant or afraid. The hospital was open to visitors every day except Saturdays, holidays, and Sunday afternoons with exceptions made in cases where families had to travel a considerable distance to see a patient. In the summer there were picnics and excursions to the coast and to the state fair. Holidays were celebrated in the hospital just as they were outside.

Meals were served at 9:15 a.m., noon, and 5:15 p.m. All the food came in carts from the J building kitchen on an underground railway and was hauled up to the individual wards by a dumbwaiter. There were thirty-nine patient dining rooms and two for employees and officers. No knives were

allowed. Some wards only allowed each patient an aluminum pan and a pair of spoons to eat with. The doors to the dumbwaiters and the drawer with the bread knife were kept locked. An ice plant provided abundant ice for the patients, and twelve wards had their own refrigerators.[32]

Nearly 1,200 loaves of bread and 1,000 pounds of meat were prepared every day.[33] Much of the food was grown at the Cottage Farm and included 20,000 bushels of potatoes, 39 tons of dried prunes, 12,000 bushels of apples, 83 tons of carrots, and 320,000 pounds of tomatoes. What wasn't used daily was canned or preserved in other ways. The dairy herd produced 118,852 gallons of milk per month.[34] All this helped to keep the cost per patient down to $13.28 per month.

James was given permission (parole) to go where he wanted on the hospital grounds. His only restriction barred him from entering the women's wards and the wards housing the violent patients.

Unruly or violent patients were put in restraints or seclusion. Sometimes they were sent to hydrotherapy or given sedatives to help them relax. Patients occasionally attacked attendants or the physicians, but most trouble could be avoided. One young man thought he had been unjustly imprisoned in the hospital by his stepfather. This situation was not unusual. When patients got violent they were locked up or transferred to a more secure ward.

"Mechanical restraint is ordered by a physician or is applied in an emergency without an order…Its general acceptance may be noted in a sentence taken from a history, 'She is lying in bed without restraint,' as if this were a somewhat uncommon situation." The kinds of restraints used were camisoles, muffs, belts and cuffs, anklets, shoulder straps, and mittens. "Many of these patients are tied to their beds; others to chairs, and one occasionally to a pipe." A census of the men's wards was conducted on November 2, 1940, which found thirty-one men in restraint—some who had been restrained from five days up to eight and a half years.[35]

Only about 5 percent of the mentally ill were dangerous. Patients with paranoia were considered the most dangerous as they were liable to commit random violence at any minute. In 1933 there were fifty-nine people judged criminally insane and incarcerated in ward 38.[36] By 1940 ward 31 housed the most violent male patients. It was not a pleasant place to be as the patients ripped up clothing and scattered filth and excrement around their rooms and over anyone living or working there.[37]

Occasionally men would band together to escape. The escape of six criminally insane patients in 1933 created a major uproar in the state. Four men attacked attendant Charles C. William while he was making his nightly

These metal handcuffs were needed to keep some violent patients from attacking others. *Photo by author, Museum of Mental Health.*

rounds. The ringleader was William T. Bowen, age forty-two, alias Alfred Hadley. Bowen had been admitted to OSH on October 11, 1916. He was part of a group who caused a previous uprising on February 25, 1917, when attendant P.B. Fitch was beaten to death.[38] A month later he was judged "not insane" and transferred to Stockton, California, where he was wanted on a bogus check charge. California subsequently returned him to Oregon, and he was locked in OSH on August 3, 1933. The other five escapees were Alvin Carter, age twenty-six, George Farrin, age sixty-four, Adolph Bowser, age fifty-three, Elmer Becker, age twenty-six, and Frank Walsh, age forty-seven.[39] The men used smuggled saws to cut their way out of their cells and then took the attendant's keys and released two more patients. The state police were notified via radio, and a manhunt was immediately initiated.

William Bowen, convict #7193, and five other men escaped from the OSH forensic ward in 1933. *Oregon State Archives.*

Dr. R.E. Lee Steiner had requested in 1928 that a forensic ward with appropriate security be established at the prison, but the proposal was dismissed by the legislature.[40] Forensic patients are those accused or convicted of crimes. The events in 1933 served to emphasize the need for better security. "These men should be housed in a separate building in the penitentiary grounds where there is no contact with the outside. I have been urging this for 20 years, and Warden James Lewis of the penitentiary and I both urged the ways and means committee of the last legislature to appropriate funds for this purpose," Steiner said.[41] There were sixty-five men housed on the top floor of the J building behind double iron barred doors.[42]

The attendants worked hard to help the patients, but were severely overwhelmed. They worked twelve hours a day and six days a week for low pay.

Wards 1, 2, and 4 housed old men waiting to die. They were too ill or crippled to care for themselves, and some had to be strapped in their beds to keep them from falling out. Since 1929 when the Depression began, counties had started sending their elderly poor to the hospital instead of taking care of them at the county poor farms.[43] Patients in ward 8 were considered incurable and only allowed into a small, enclosed grassy area in the inner court. Most of the men just sat and absorbed the sunshine. James' most depressing impression was of old men sitting silently, staring into space with nothing but blank stares on their faces.

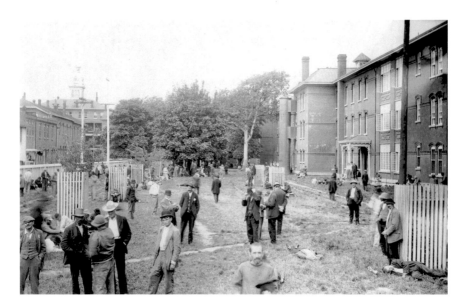

Many of the patients were unable or unwilling to participate in recreational or work activities. These men were confined to a fenced yard outside their ward in 1910. *Oregon State Archives.*

The 1,100 female patients were not allowed parole to wander around the hospital or the grounds as the men were. A fence enclosed their small patch of ground outside their wing of OSH. "When they first come out they scream and dance around without restraint. They are outside on nice afternoons about two hours and they act pretty wildly most of the time. Some of them, of course, are quiet and peaceful, sitting silently."[44] Clothing varied from woman to woman. Some looked just as fashionable as anyone on the outside. Others wore coveralls that fastened in the back so they couldn't take them off.

The ladies' living quarters were neater and decorated with handmade pillows, curtains, and quilts. Their wards were constructed the same as the men's with long hallways, small sleeping rooms on each side, and small parlors for the women to enjoy. The Dome building had two wards for women, but the main hospital housed the majority. They were allowed to eat from regular dishes, unlike the men, who only got aluminum pans.

There were three ward attendants in a forty-eight-bed male ward and five ward attendants in a forty-four-bed female ward during the day. At night the ratio of attendants to patients dropped to one to twelve and one to seven. The American Psychiatric Association recommended in 1936 one employee for every four patients. The low number of staff was "said to account for the considerable amount of mechanical restraint used in the receiving ward."[45]

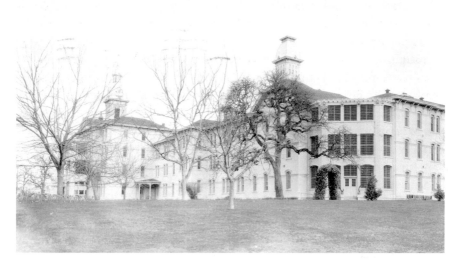

The hospital was painted white in 1910. The corners of the J building were remodeled in 1915 to relieve overcrowding. *Willamette Heritage Center, #2011.006.0672.*

Whole wards of patients who should have considerable personal attention are left without any attention for periods that are altogether far too long. Far too many are fastened in their rooms so that they will not wander about and get into other people's beds or fall down or do something that is annoying. Disturbance and bad odors were noted in some places but not to any extraordinary degree. It is customary to change patients who are wet up to three times, but sheets are likely not to be available for a fourth change.[46]

James was lucky that his case was not as severe as others. By the end of the 1930s several new therapies were becoming popular across the United States and in Oregon: insulin coma, Metrazol convulsive therapy, electroshock, and prefrontal lobotomy. They all damaged the brain in different ways. Usually the patient was left simple-minded but much easier to handle.[47]

In November 1937 insulin and Metrazol were first introduced into Oregon's treatment options. The chemicals were injected into patients multiple times over several weeks and produced intense seizures. In the beginning it was believed the drugs would increase the number of patients cured or at least show improvement.[48] The treatment was used primarily on patients with "dementia praecox." Today we know it as schizophrenia. Schizophrenia showed up primarily in young adults and produced delusions

and personality and emotional changes. The victims were unable to distinguish between what had really happened and what was only a piece of their imagination.[49]

Insulin, a hormone discovered in 1922, was injected subcutaneously in increasing amounts until the patient experienced a seizure and a near-death coma. The coma lasted about four hours. Usually the patient received many such treatments before he was cured or the physicians pronounced the patient incurable.[50] Insulin was used primarily on newly diagnosed patients or those who were termed "the cream of the crop." Autopsies of patients treated with insulin coma showed "widespread degeneration and necrosis of nerve cells."[51] The massive amounts of insulin brought the patient very near to death by starving the brain cells of the sugar necessary to survive. Using insulin to produce a coma required patients to be closely monitored by trained nurses and physicians, all of which was very costly in time and money.

Patients woke up from the coma in an infantile condition, needing increased amounts of care and attention, and this was perceived as an improvement over their previous behavior. However, a cure required as many as thirty to forty such treatments before the brain was damaged enough to stop nerve cells reverting to their previous unstable paths. European hospitals reported cure rates of 70 to 80 percent.[52] In reality the cure rate was much lower, and those judged cured were never again fully functioning human beings.

The number treated was not verified in hospital reports, which stated that only one was discharged as cured. A thirty-six-year-old male patient, after lying in one position for two years, was able to leave the hospital after only fifteen insulin treatments. Inflated cure rates were not reserved for institutions outside Oregon, as a year later an *Oregonian* article reported that 60 percent of the treated patients were cured and discharged.[53]

Although insulin coma treatment required higher levels of nursing attention, it was an enormous boon to the hospital. The physicians finally had something they could do that required skill and training and had an observable result. Nurses found the coma patients easier to control in the hospital setting as they slept large amounts of time.

Metrazol, a carbon (or camphor) compound, was introduced into the United States a few years after insulin and was injected directly into a vein. A seizure followed almost immediately.[54] If no improvement was seen after twenty treatments given three times a week, the patient was diagnosed as incurable.[55] Metrazol was a more drastic treatment and used primarily on patients with more severe symptoms and those who had been ill the longest.

It had the added advantage of only requiring one physician to treat fifty or more patients at a time.[56] It did not seem to help patients with schizophrenia as much as it helped those with manic-depressive psychosis.[57] Metrazol did have one huge disadvantage—it caused such severe seizures that patients often fractured bones, broke teeth, suffered spinal fractures, and tore muscles. Autopsies showed hemorrhages in lungs, kidneys, spleen, and brain.[58] In 1938, after four months using Metrazol on twenty-eight men at OSH, four were discharged and eighteen showed "improvement." Nineteen women were treated, and eleven showed improvement. None were discharged.[59]

Dr. John C. Evans, superintendent of OSH in 1938, stated, "We are just groping in the dark and hoping we have found a permanent cure."[60] He continued, "Some of our dementia praecox patients refuse to feed or care for themselves, but after treatments, they do all their own work."[61] Doctors didn't mention that patients had to be physically forced to endure Metrazol treatment after experiencing the first dose. A patient described it as similar to "being roasted alive in a white hot furnace" or as if "the skull bones were about to be rent open and the brain on the point of bursting through them."[62] However, it was cheaper and easier to use by the hospital than insulin, and by 1941, nearly thirty-seven thousand patients in the United States had been treated with Metrazol.[63]

The new treatment didn't reduce the amount of mental illness in Oregon. The Oregon Mental Hygiene Society report dated 1937 reported a 48 percent increase in mental illness in Oregon during the previous fifteen years.[64] OSH continued to add buildings and modernize its facilities.

Elderly patients and those with physical illnesses, in addition to their mental problems, died while in the hospital. With a population of nearly 2,677 patients, many of those deaths were of people without relatives to take care of burial details.[65] A small room attached to the boiler building was used as a morgue, but there was no refrigeration for the bodies. An oil-burning crematory and an informal columbarium were inside the building. (A columbarium is a place for the storage of urns holding a deceased's cremated remains.)

James seemed to enjoy his stay at the hospital even if it was somewhat boring. He stated at the end of his hospitalization in 1936, "I'm hoping to get out pretty soon. I think I'm completely cured but then nearly everybody here will tell you that he's not crazy and never should have been sent here in the first place. I have hope though, that my incarceration won't last much longer."[66]

NOTES

1. "A Survey of the State Mental Institutions of Oregon, 1940," United States Public Health Services, Thomas Parrain, Surgeon General, Washington, D.C.
2. Paul H. Hauser, "Treading the Borderline, Part 1," *Oregonian*, June 14, 1936.
3. "A Survey of the State Mental Institutions of Oregon," 1940.
4. Ibid.
5. *Oregon Journal*, August 30, 1931.
6. *Oregonian*, January 7, 1931.
7. *Oregon Journal*, August 30, 1931.
8. *Oregon Journal*, June 15, 1931.
9. *Oregonian*, August 2, 1931.
10. *Oregonian*, October 8, 1933.
11. *Oregonian*, September 13, 1931.
12. *Oregonian*, October 1, 1933.
13. Hauser, "Part 1," June 14, 1936.
14. Ibid. Also Dr. J.C. Evans, "Asylum Finds Scant Room for Newcomers, 1938," OSH Vertical file, Oregon Historical Research Library, Portland, Oregon.
15. Hauser, "Part 3," June 28, 1936.
16. Hauser, "Part 4," July 5, 1936.
17. Ibid.
18. *Capital Journal*, January 26, 1938.
19. Hauser, "Part 4," July 5, 1936.
20. Hauser, "Part 1," June 14, 1936.
21. Ibid.
22. "A Survey of the State Mental Institutions of Oregon," 1940.
23. Ibid.
24. Ibid.
25. Hauser, "Part 2," June 21, 1936.
26. Ibid.
27. Ibid.
28. Hauser, "Part 5," July 12, 1936.
29. Drug Room Inventory, June 30, 1931, Oregon State Hospital Museum Project.
30. Hauser, "Part 3," June 28, 1936.
31. "A Survey of the State Mental Institutions of Oregon," 1940.

32. Ibid.

33. Hauser, "Part 3," June 28, 1936.

34. Ibid.

35. "A Survey of the State Mental Institutions of Oregon," 1940.

36. Hauser, "Part 5," July 12, 1936.

37. Ibid.

38. *Oregonian*, October 10, 1933.

39. *Oregonian*, October 9, 1933.

40. *Oregonian*, November 11, 1928.

41. *Oregonian*, October 10, 1933.

42. Hauser, "Part 5," July 12, 1936.

43. Ibid.

44. Ibid.

45. "A Survey of the State Mental Institutions of Oregon," 1940.

46. Ibid.

47. Robert Whitaker, *Mad in America: Bad Science, Bad Medicine, and the Enduring Mistreatment of the Mentally Ill* (Philadelphia: Perseus Books, 2002), 73–74.

48. *Oregon Journal*, April 14, 1938; *Statesman Journal*, April 10, 1938, states that the treatments had been going on for six months, beginning in September 1937.

49. Mary Diduch, "Telltale Forgetting: Faulty Memory Is a Hallmark of Schizophrenia," *Psychology Today*, Spring 2012.

50. *Oregon Journal*, April 14, 1938.

51. Whitaker, 85.

52. Ibid., 86.

53. Herb Penny, "Only One in Series of Changes," *Oregonian*, March 30, 1952.

54. *Oregon Journal*, April 14, 1938. It was also marketed as Cardiozol in the United States.

55. Ibid.

56. Whitaker, 92.

57. Ibid., 93.

58. Ibid.

59. *Oregon Journal*, April 14, 1938.

60. Ibid.

61. *Capital Journal*, April 10, 1938.

62. Whitaker, 95.

63. Ibid., 96.

64. *Oregonian*, January 18, 1937.

65. "A Survey of the State Mental Institutions of Oregon," 1940. According to the survey there were 2,677 patients on November 1, 1940.
66. Hauser, "Part 5," July 12, 1936.

Chapter 6

THE TRIUMPH OF
DR. BETHENIA OWENS-ADAIR

The history of the Eugenics Movement shows us that absolute power unhampered by conscience or compassion results in abuse of those who are the most defenseless. In Oregon it was those judged to be mentally ill or homosexual.

Between 1917 and 1983 it's estimated 2,648 Oregon citizens were forcibly sterilized by the state.[1] Oregon became notorious for targeting young people labeled delinquent, women who'd given birth to illegitimate children, and homosexual men. Most of the operations were castrations for men and ovariotomies for women—the most severe forms of sterilization.[2]

Eugenics is the applied science of a biological/social movement that advocated sterilizing, or preventing the procreation of undesirable human populations, to improve the genetic composition of humanity. The philosophy became widely popular in the mid-1920s and continued until 1945 when the Holocaust was discovered in Germany. Eugenics theory rested on the presumption that people could measure and evaluate what constituted better or best in another human being. In the early 1900s intelligence as perceived by social class, education, income, and race became the primary focus of the Eugenicists.

Eugenics proponents believed that science could predict the birth of superior or inferior people. Regulating and reducing the reproduction of the inferior group would advance the human race by decreasing the costs associated with supporting the mentally ill, mentally deficient, and criminal elements of society. As applied in Oregon it also applied to victims of poverty

and abuse and those termed sexually deviant. For fifty years five men ruled as the Board of Eugenics in Oregon.[3] Their prejudices, personal opinions, political affiliations, economic status, and gender governed the lives of thousands of powerless Oregon citizens.

The Oregonian most responsible for promoting sterilization of the insane and feebleminded in Oregon was Dr. Bethenia Owens-Adair. Bethenia Owens was born on February 7, 1840, in Missouri and grew up in Clatsop County, Oregon. She was married in 1854, at the age of fourteen, to Legrand Hill. A year later she gave birth to a son. In an unusual move for her times, at age eighteen she divorced her husband and took back her maiden name. She became a successful businesswoman in Roseburg and eventually graduated with a medical degree from the University of Michigan in 1880. She was a woman of unusual tenacity and intelligence.

Before becoming a physician she was a friend of Jesse Applegate, the Sage of Yoncalla and resident of Douglas County. Applegate served as a delegate to the legislative committee of the provisional government of the Oregon Country in 1845 and became well known throughout Oregon for his wise counsel and correspondence. Letters addressed to her from him imply a profound friendship between the two even though the age gap was substantial. In 1872 Jesse was fifty years old and Bethenia was thirty-two. Jesse's last letter of November 5, 1876, gives an insight into her character as seen by him:

> *You are in the glory of womanhood endowed physically with perfections enough to excite the admiration of the opposite sex, and the envy and jealousy of your own. You have an intellect strengthened by a powerful will which has overcome all obstacles to your upward course, hardest task of all, you have crushed out love and tenderness from your woman's heart.*[4]

Cynthia Ann Applegate, Jesse's wife, died in 1881, and after a short stay in the Oregon State Insane Asylum, Jesse died in 1888. Rejected by Applegate, Bethenia married Colonel John Adair in 1884. They had a young daughter who died in infancy, and the couple divorced in 1907. From that date forward she dedicated her life to Oregon's reform movement. She died in Astoria on September 9, 1926, at the age of eighty-six. The majority of her estate was left to the study of Eugenics.[5]

Besides advocating for women's rights, Dr. Owens-Adair believed that the scientific and systematic sterilization of the mentally deficient would improve the race and reduce the number of criminals and insane.

We inherit from our parents our features, our physical and mental vigor, and even much of our moral character...Morbid qualities of a mild character in the parents may be exaggerated in the offspring. Thus, inebriety with its ordinary perversions in the parents created insanity in the child...More than eighteen hundred years ago we were told that the sins of the fathers are visited upon the children...Had we but heeded that warning, and studied the solution of the problem, we should not today require the use of jails, penitentiaries and insane asylums. But for centuries, this warning has been allowed to go unheeded, and men and women in their ignorance and willfulness go blindly on, propagating disease, insanity and wretchedness into this world.[6]

Jesse Applegate (1811–1888) was one of three brothers who blazed the Applegate trail from California to Oregon. He was confined to the hospital for one year from 1886 to 1887. *Douglas County Museum.*

In a 1904 letter to the *Oregonian* she stated, "The greatest curse of the race comes through our vicious criminal and insane classes."[7] She also proposed legislation requiring mental and physical examinations before marriage. Her "Hygienic Marriage Bill" passed the legislature in 1921 but was later repealed in a voter referendum.[8]

Dr. Owens-Adair sponsored the first Oregon law authorizing human sterilization of "confirmed criminals, insane persons, idiots, imbeciles and rapists," which passed the legislature in 1909. Oregon Governor George Chamberlain felt the law was too general and vetoed it. Undeterred, Dr. Owens-Adair continued her campaign. She was the leader for progressive reform in Oregon and enjoyed widespread support throughout the state.

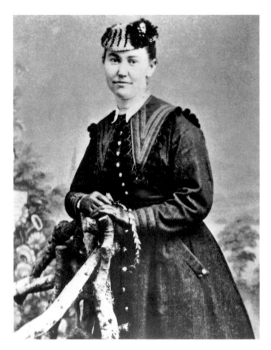

Dr. Bethenia Owens-Adair (1840–1926) was a major supporter of the Eugenics Movement in Oregon beginning in 1904. *Douglas County Museum.*

Dr. Owens-Adair stated, "I personally believe that every person, male or female, who is a potential parent and has been committed to a state institution as insane, epileptic, feeble-minded, idiotic, or for criminality, should be sterilized at least by vasectomy or salpingectomy."[9]

Newspaper articles about Eugenics began appearing in Oregon newspapers as early as 1907. Newspapers had been attributing the actions of the insane and criminals to heredity for many years. At first many of the articles renounced the Eugenics Movement, but as time went on more and more positive articles appeared.

The *Oregonian* featured a long article on Mrs. La Reine Helen McKenzie Baker, a leading champion of the Eugenic creed in the United States, when she visited Portland in April 1912. Baker believed that in order to improve the human race, marriages must be perfect mentally, physically, and spiritually. Certain kinds of marriages must be prevented: those of insane persons, imbeciles, naturally deformed persons, club-footed persons, persons infected with certain systematic diseases, and criminals. This would be an economic and humanitarian advantage. She believed certain types of people should be sterilized and states should require medical examinations of people applying for marriage certificates. She also advocated smaller and more perfect families.[10]

After a particularly nasty homosexual scandal rocked Portland in 1913, the Oregon legislature passed another Eugenics law, which was signed into law by Governor Oswald West on February 18, 1913.[11] It was repealed in a referendum vote due to the efforts of the Anti-Sterilization League and the Portland reformer Lora C. Little.

Lora Little distrusted the Progressive Reformers and especially the scientific arguments used by physicians to force medical procedures on people. Her own son had died after a smallpox vaccination, and she was determined to fight against vaccinations and forced sterilizations.[12] She launched a well-coordinated attack on the medical profession and sterilization in particular. Little wrote, "Eugenics laws are asked for by persons who think they can set themselves apart from their kind and make themselves dictators over their less fortunate fellows."[13] In conjunction with other Portland radicals she campaigned against the involuntary sterilization act and, "as vice president of the Anti-Sterilization League, was responsible for collecting enough signatures to refer the law to the voters."[14] In a surprising turnabout, the special fall election found 56 percent of the voters voted against sterilization on November 4, 1913.[15] This was a major triumph in a state governed primarily by Republican interests, who were rarely opposed.

Better Baby Shows were sponsored all over Oregon, and the winners' photos were displayed in the newspapers. Judged similar to livestock shows, "leaders urged each other, organizations, and the government to give equal attention and resources to the nation's children as were given to farm crops and livestock."[16] On June 19, 1913, a Eugenics contest held at the Portland Multnomah Hotel featured first- through third-place winners in three categories: "One to two years, boy and girl," "two to three years, boy and girl," and "three to four years, boy and girl."[17]

The Parents' Education Bureau (PEB) located at the Multnomah County Courthouse, room 551, conducted baby examinations twice a week on Wednesdays and Thursdays from 1:00 to 2:00 p.m. by appointment only. The National Congress of Mothers and the Oregon Parent-Teacher Association sponsored the PEB. Gustav Ernest, age nine months, and Donald Wilson, age seven months, both scored 100 percent in June 1913.[18] Western babies were compared to eastern babies, and urban babies were compared to country babies. "[B]abies in Oregon proved to be six months in advance of the standard."[19]

County fairs were especially popular for baby contests right next to the stock and vegetable contests. Mildred Emmett, age twenty-three months from Corvallis, took first prize at the 1913 Benton County Fair.[20] David Jackson Grant, age two, scored 99.6 percent at the Polk County Fair the same year.[21] Out of eighty entries, sixty scored more than 90 percent. A Eugenic baby contest was held at the Yamhill County School Fair in McMinnville on September 24, 1913. Thirty infants were entered in the 1913 Gold Hill Industrial Fair.

"State fairs eagerly sought a better crop of children."[22] The 1913 Oregon State Fair sponsored a Eugenics contest to find Oregon's most perfect babies. Specialists administered physical and psychological tests to name thirty-eight prizewinners.[23] Scorecards typically featured three categories: physical (eight hundred points), mental development (one hundred points), and measurements (one hundred points).[24] "Children's perceptiveness, cognitive development, and temperament were rated. Mental, emotional, social, psychological, and behavioral development were indistinguishable to untrained eyes."[25] The physical examinations typically assessed "irregularities of features; symmetry of the head; condition of skin, scalp, hair, skull; and everything below the head—neck, arms, hands, chest, abdomen, genitals, spine, legs, feet, posture, and gait…Whole points or fractions could be deducted when the baby didn't match the printed criteria, or when judged to be somehow substandard or deficient."[26]

The results of the Better Baby contests were advertised in Oregon newspapers. This photo shows the results of the 1913 Benton County Fair. *Oregonian.*

The contests became so popular that in 1914 the Oregon State Fair Board proposed paying the expenses to send the grand champion winners from the 1913 Oregon State Fair to the International Eugenics Contest at the World's Fair in San Francisco. O.M. Plummer, head of the Eugenics Movement in Oregon, urged the board to allocate $200 for the children and their mothers to travel to California. An additional $1,000 was budgeted to cover the annual Eugenics exhibition at the upcoming 1914 state fair.[27]

The 1925 Multnomah County Fair had a baby show "conducted under competent supervision" on

the last day of the fair at 3:00 p.m. This baby show was in direct contrast to the Better Baby Contests, "which represented a serious, practical demonstration in eugenics."[28] The 1925 baby show was a more traditional beauty contest. There were ten categories and a ten-cent entrance fee for each:

1. Prettiest baby, under one year.
2. Baby, under one year having best head of hair.
3. Smallest baby, under one year.
4. Fattest baby, under one year.
5. Prettiest brunette, under two years.
6. Prettiest blonde, under two years.
7. Prettiest pair twins, under two years.
8. Prettiest trio triplets.
9. Most attractive baby boy, under two years.
10. Most attractive baby girl, under two years.[29]

"Teenagers (as old as 17 and 18) worked for two years on physical self-improvement preparing for the first National 4-H Health Contest, beginning in 1922."[30] The 1938 Marion County Healthiest 4-H Club Boy and Girl Contest awarded four children 1,000 percent. Points in the various categories added up to one thousand points or 1,000 percent. David Melson won the boys' category, and three girls shared the winning spot in the girls' category. There were 63 competitors out of the 1,900 members in seventy-four Oregon health clubs.[31]

The winners from the county fairs vied against each other at the state fair. Those winners went on to compete at the Pacific International Fair and perhaps eventually in Chicago. Such competitions "received prolific publicity as the organization conducted its National Tours of top exhibits."[32] The idea of perfect health spread to schools, and standards were developed to compare students, schools, and states against each other. Prior to this time, physicians had no idea what was typical for a healthy baby or a healthy child. These contests helped establish standards and criteria for years to come.

In October 1915, in Cold Spring Harbor, New York, Mrs. Mary Harriman (widow of E.H. Harriman, millionaire railroad tycoon) launched the multimillion-dollar Eugenics Record Office, headed by Charles Davenport, to ascertain "what is the matter with the human race?" It went on to collect hundreds of thousands of medical histories from Americans. John D. Rockefeller, Theodore Roosevelt, and Andrew Carnegie were the major financiers of the national Eugenic Society. Alexander Graham

Bell and other prominent scientists provided assistance and support. The organization proposed to sterilize 92,400 individuals in the United States within the next year. Davenport wrote a model sterilization law that would eventually be adopted by twenty-two states.

Scientists across the United States tried to bring common sense to the subject. An Oregon editor predicted, "The philanthropic foundation, when it comes to bettering humanity, is a farce and threatens to become a dire tragedy."[33]

Professor William E. Ritter, head of the Scripps Institute for Biological Research in Berkeley, California, attacked Eugenics for leaving out man's soul and focusing solely on his physical body:

> *Beware of eugenic doctrine, the spirit of which is largely that of man's lower physical nature, whose knowledge and faith in mankind are more secure at touching his germ cells than at touching his mind and morals. Eugenic science which is not large enough to encompass the whole of man's nature is not large enough to pass muster as sound biology.*[34]

Besides any number of statistical mistakes, Eugenicists ignored "poverty, disease, under nutrition, ignorance and other problems that its proponents linked to 'feeble-mindedness' or 'criminality' among the poor."[35] They provided pseudo-scientific records "proving" that mental illnesses such as schizophrenia, bipolar disorder, and depression were inherited just like eye or hair color. Although the knowledge of DNA was still far in the future, scholars proposed the theory that "germ plasma" carried inherited factors from one generation to the next.

In 1915 the annual convention of the American Association for the Advancement of Science focused on Eugenics. "Dr. G.H. Parker, of Harvard, advocated the sterilization of all defectives, which he declared are steadily increasing."[36] Professor Stuart Paton, of Princeton, wanted to build a National Brain Institute to study the brain, the most important part of the body.

Between 1914 and 1918, World War I distracted voters from the issues, and Lora Little had departed from Oregon. Opposition to Dr. Owens-Adair's newest version of a compulsory sterilization law was muted and unorganized. Chapter 279 of the Oregon General Laws passed the legislature on May 21, 1917, creating the Oregon Board of Eugenics.

The Oregon Board of Eugenics was given the power to sterilize the "feeble-minded, insane, epileptic, habitual criminals, moral degenerates and

sexual perverts" housed in public institutions.[37] The supervisors of the State Board of Health, OSH, EOSH, the penitentiary, and the Institution for the Feeble-Minded composed the board. They were responsible for evaluating the mental and physical conditions of patients who could potentially reproduce additional defective citizens.[38] The law was amended in 1919 to provide an opportunity for the candidates to appeal the board's decisions.

Dr. R.E. Lee Steiner, superintendent of the Oregon State Hospital, wrote the following in 1918:

> *The science of eugenics has passed the "fad" period and already has assumed proportions that make it a telling factor in the evolution of a sane and sound manhood and womanhood. The relations between cause and effect are coming to be understood more clearly and persistent and intelligent efforts are being exerted to determine the principles by which the highest form of human life may be developed and conserved. No one now doubts the possibility of inheriting tendencies to mental and moral weakness and to physical fraility* [sic].[39]

Later in the report he noted that the hospital's surgical department had done a moderate number of operations for the "unsexing" of certain degenerates and sexual perverts for the State Board of Eugenics in addition to its ordinary surgical work. No mention was made of sterilizations on OSH patients.

By 1920 OSH had performed thirty operations for sterilization in the OSH Dome building surgery center under the direction of the State Board of Eugenics. Again Superintendent Steiner wrote:

> *No untoward or unfavorable results have occurred, and the operations have been beneficial in all cases. It has been rather difficult for the public as well as the patients and relatives to get the right point of view and appreciate the immediate and remote benefits to be derived from this means of preventing the increase of insanity; but I think there is reason to hope that their increasing enlightenment will cause these operations to be resorted to much more extensively in the future.*[40]

He was correct.

The first twenty patients sterilized in Oregon were targeted because of their sexually deviant behavior, not their mental illness.[41] Sexually deviant behavior was defined as people engaged in prostitution (or having sex outside marriage) or homosexuality.

The board approved seventeen cases submitted by the Oregon State Hospital staff in the first year. Of these cases, twelve of the thirteen men were castrated, and all four women received ovariotomies. According to State Hospital Superintendent R.E. Lee Steiner, sixteen of the men and women who received castration "were flagrant masturbators or sex perverts."[42]

According to Harry Laughlin in his 1923 edition of *Eugenics in Race and State*, ten states had sterilization laws in 1921, and up to that time 3,233 people (1,853 men and 1,380 women) had been legally sterilized in the United States.[43] Of these 2,700 were mentally ill, 403 were feeble-minded, and 130 were criminals. "Among these ten states the law is functioning in a very satisfactory manner…In Oregon and Nebraska special executive machinery of proven competency is entrusted with the enforcement of the law."[44] He listed the total number of sterilizations in each state up to 1923 as follows:

California	2,558
Connecticut	27
Indiana	120
Iowa	49
Kansas	54
Michigan	1
Nebraska	155
New York	42
North Dakota	23
Oregon	127
Washington	1
Wisconsin	76[45]

In 1921 the Oregon Supreme Court ruled that the 1917 sterilization law was unconstitutional because it violated due process. By that time 125 men and women had already been sterilized. Advocates quickly proposed a new law in 1923 stressing the therapeutic nature of the procedure rather than the punishment aspects and applied it to all citizens, not just those incarcerated in institutions.

Oregon General Laws, 1923, chapter 194 passed, and on February 24, 1923, Governor Walter Pierce signed it into law.[46] The 1923 law provided for voluntary and compulsory sterilization as may be best suited to the condition of the person. It provided for the "betterment of the physical, mental, neural or psychic condition of the person, or to protect society from the acts of such person, or from the menace of procreation by such person, and not in any manner as a punitive measure."[47] The Board of Eugenics

ultimately decided who would be sterilized and what operation would be applied to each individual.

A February 25, 1925 amendment added the stipulation that the law also applied to "any person convicted of rape, sodomy or the crime against nature, or any other crime specified in Sec. 2099, Oregon Laws, or of attempting to commit any of said crimes."[48] By 1925 OSH had performed 120 operations, EOSH had performed 53, and the Institution for Feeble-Minded had performed 140 for a total of 313 reported sterilizations.[49] By 1925 there were now twenty-three states with sterilization laws. California had operated on 4,636, Kansas was second with 335, and Oregon was third with 313.[50]

The *Oregonian* of May 2, 1926, featured the story of a woman at OSH who had recently given birth to her fifteenth child. All seventeen members of her family had been or were now state charges. The father had been in prison before being transferred to the asylum, where he had recently died. One child was in prison. Some were inmates of the state training school for boys, state industrial school for girls, and state home for the feeble-minded. Other family members were inmates in the state institutions of Idaho and Washington. The mother was a mental derelict and would not live long. Superintendent R.E. Lee Steiner stated that the mother would not be allowed to leave the hospital until she was sterilized. Dr. Steiner and Dr. J.N. Smith (superintendent of the Institution for the Feeble-Minded) "both said repeatedly that much of the crime now rampant in different sections of the country is due to mental deficiency and disease. The cure, they said, is the application of a drastic Eugenics law, including authority for sterilization without the consent of the person submitting to the operation."[51]

Further efforts to challenge Oregon's Eugenics laws stopped in 1927 when the U.S. Supreme Court considered the case of *Buck v. Bell* and ruled such laws were constitutional. Supreme Court Justice Oliver Wendell Holmes Jr. stated, "Three generations of imbeciles is enough."[52] The Oregon legislature finally repealed the 1923 law fifty years later.

In her book *Human Sterilization: Its Social and Legislative Aspects*, published in 1922, Dr. Owens-Adair contended "the knowledge of degeneracy, its causes and cure, is the greatest problem that faces our nation today" and that the "first step toward purification of our nation is to eradicate disease and degeneracy."[53] She used non-specific anecdotal stories to illustrate her statements, as in, "The trail of feeble-minded is inevitably transmissible. I know of the case of a feeble-minded woman in a state institution who has with her there her four children, not one of whom has sense enough to feed itself."[54]

She admitted that castration made prison discipline temptingly easy but stated, "I do not think however, that castration, even if it were thought of as a punishment, is a punishment disproportionate to the crimes of rapists and sodomists."[55] Nor did she believe that it was necessary to procure the consent of such people before castrating them. Results of such operations were invariably reported in positive terms by the institutional supervisors: "He is now able to control himself in every way and mixes freely with the other inmates of the prison." Another report regarding John H., age seventeen, who was letting prisoners commit sodomy on his person, stated,[56] "The operation apparently has had the desired effect. We have had no further trouble with the boy."[57] In another case of a thirty-one-year-old, the report stated, "He has caused us no trouble since the operation. We are highly pleased with the result."[58] The feelings and conclusions of the patients were rarely considered or reported, only the benefit to the institution. The last court-ordered sterilization of a prison inmate took place in 1953.[59]

Dr. Owens-Adair had watched with great joy when Governor Oswald West signed into law the 1913 sterilization bill. Little mention was made of an additional portion of the bill, which proposed a change in Oregon's marriage laws.

The General Laws of Oregon, 1913, chapter 187, had required a physical examination by a physician to certify that a man was free of venereal disease (specifically syphilis and gonorrhea) before he could obtain a marriage license. It was an examination based on the assumption that symptoms would be visible if the person had a disease. However, that was not always true. At that time there were no specific laboratory tests that could definitely diagnose venereal disease. Protesters argued that couples simply traveled to Washington to get married, and the law was useless as a guarantee against disease when it only applied to men and did not provide for a thorough examination. Dr. David N. Roberts, secretary for the State Board of Health, stated, "The present law gives a false sense of security. It is not being enforced properly and cannot be for the fee allowed by law."[60] As it was part of the sterilization law, it was also repealed by the 1913 referendum vote.

In 1920 the University of Oregon conducted a survey of mental defect, delinquency, and dependency under the direction of the National Public Health Service at the request of the Oregon state legislature. The report was used to support Owens-Adair's senate bill No. 174, the Hygienic Marriage Law proposed in 1921. "There were in Oregon...65,423 individuals who were or recently had been social liabilities either in communities or in public institutions, demanding the support of the state."[61] Of those, 29,847

were classified as mental defectives, delinquents, and dependents. The new law provided for examination of venereal disease "and mentality" for both women and men. Physicians would be responsible for certifying all applicants' mental and physical fitness for marriage. In the general election of 1921 the law failed by a majority of 65,793 no to 56,858 yes votes.[62]

According to the 1923 manual *General Information: State Institution for Feeble-Minded*, two hundred of the three hundred Oregonians sterilized had been released from their respective institutions, making room for additional patients. The operation cost the state $15 for men and $35 for women. The Oregon State Institution for the Feeble-Minded required patients to be sterilized and a $1,000 bond to be paid as part of their release process.[63] Sterilizations were performed at the Oregon State Hospital, Eastern Oregon State Hospital, and the Institution for the Feeble-Minded.[64]

In 1928 OSH superintendent R.E. Lee Steiner wrote the following:

> *Sterilization of the insane of childbearing age is very important, not only to prevent the development of insanity in the offspring, but young women recovered from one attack greatly increase the liability of another breakdown if subjected to the stress of childbearing. The manic depressive cases whose psychosis comes in attacks of excitement or depression with lucid intervals of months or years, are at home during the intervals between attacks and bear children, often having an infant at the breast when again committed. We try to persuade all such cases to be sterilized as a protection to both mother and child.*[65]

The 1930 OSH superintendent's report to the Board of Control had a Eugenics statement indicating 193 patients had been rendered sterile in the previous two years and lamenting the law necessitating the insane patient's permission before performing surgery. The report by Dr. Steiner advocated a "suitable national marriage law with the end in view of preventing the mating of people who are distinctly psychotic, feeble-minded, or those having strong criminal tendencies, or degenerates of every character." He believed that the numbers of patients in state hospitals would become proportionately less as time passed.[66]

Part of the law was changed in 1935, scrapping patient consent and inserting the right to sue if the patient opposed the proposed operation. Governor Charles Martin offered to pardon any sex offender who volunteered to be castrated.[67]

In 1933 Nazi Germany officially adopted the United States Eugenics laws for its own sterilization program.[68] It wasn't until the end of World War II

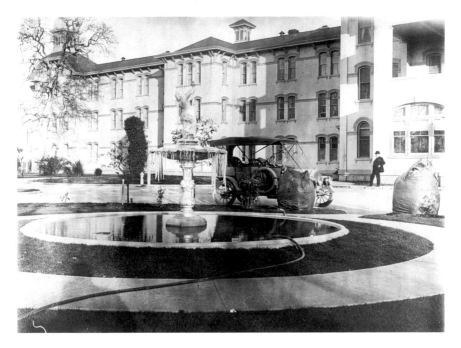

While superintendent of OSH, Dr. R.E. Lee Steiner was a major advocate for the sterilization of Oregon's institutionalized patients. *Oregon State Hospital.*

(1938–1945) with the discovery of the Nazi extermination camps that the world finally understood the horrors Eugenics theory could cause.

It's claimed that 59 percent of the 509 sterilizations performed at OSH between 1918 and 1941 were salpingectomies (removal of the fallopian tubes) and the rest ovariectomies (removal of the ovaries).[69] The majority of the men were castrated (68 percent) while the remainder received vasectomies.[70] If birth control was the real goal, vasectomies would have been enough to accomplish their purpose and castrations would not have been necessary.

In 1936 OSH Superintendent R.E. Lee Steiner wrote the following: "Sterilization has been 'advocated for all cases of insanity.' Nevertheless it was carried out in but few cases because of legal restrictions; the patient and his best friend must both sign the petition."[71] Later he went on to advocate a change in Oregon's marriage laws to prevent marriage between epileptics, those who were feeble-minded, mentally sick, chronic criminals, and degenerates of every sort. "Such an act would be a most potent factor in the program of prevention."[72]

The men serving on the Board of Eugenics were intensely verbal about their support of Eugenics theory and their animosity toward the mentally ill

in Oregon. Dr. John C. Evans, superintendent of OSH from 1937 through 1948, supported the Oregon sterilization law and believed it should also be extended to those outside Oregon's institutions. He disliked the law, "which he held weak in that it deals only with persons already locked up and not high grade morons, potential and prolific breeders of the unfit."[73] He also supported the proposed marriage laws to be voted on in the fall of 1938 and believed that the physical exams required before marriage should be extended to include women and both sexes should undergo mental exams as well. This would determine whether women were epileptic or unfit in any way for motherhood.

OSH superintendent John C. Evans stated in 1938 that heredity was the major cause of insanity in Oregon and the world.

> *Heredity is undoubtedly the outstanding single cause of insanity. By this I do not mean that the mental disease is directly transmitted, but the instability and the tendency toward the possible development of insanity is present. As yet there is no yard-stick, nor method whereby any one can definitely state just how potent the influence or heredity is in transmitting from the parent to the offspring this tendency. There is always a difference of opinion in the minds of psychiatrists, which is the more important in causing mental sickness—heredity or environment. My opinion is that they are both important and both factors must be considered...I sometimes wonder what the public attitude would be if insanity were contagious.*[74]

The largest newspaper in Oregon, the Republican-controlled *Oregonian*, supported Eugenics and used its power to inflame public opinion. In a news article headlined "Fecund Mental Derelicts of Oregon Called Menace by State Health Official," Dr. Floyd South, a member of the Oregon State Board of Health and the Board of Eugenics, stated on June 17, 1938, "Feeble-minded, insane and otherwise mentally and physically incompetent persons in Oregon are reproducing twice as fast as normal persons."[75] He went on to state that within two hundred years half the state's population would be confined to public institutions if rigid sterilization laws were not enforced. This applied to the insane as well as "mentally weak persons."

Eugenics also targeted immigrants. An Oregon newspaper headline warned "America Menaced by Alien Influx" and maintained that a flood of aliens was imminent. In 1921 Commissioner R. Frederick A. Wallis of the Ellis Island immigration station stated that Eastern Europe today "is in the grip of four epidemics—typhus, typhoid, dysentery and tuberculosis."[76]

He believed that immigrants were dangerous to the health of all Americans, and he sought to stop immigration by testifying in front of the United States Senate Immigration Committee. Eventually new immigration laws were passed severely restricting who was allowed to move to America.

In 1940 Dr. Richard B. Dillehunt, dean of the University of Oregon Medical School and chairman of the committee appointed by Governor Charles H. Martin to analyze Oregon responsibility to the insane, wrote a series of articles for the *Oregon Journal* reporting his findings. He believed marriage laws and sterilization could prevent mental illness. He stated, "Idiots, imbeciles and morons are singularly moved by the primitive biologic impulses and spawn prodigiously. Here is a place where social groups and others might get together and make an effort: for, mark my word, with the prolificacy and multiplication of the feeble-minded, such social groups might soon find themselves on the defensive instead of in a position to help."[77]

In records released by the Cold Spring Harbor Laboratory, there were 1,450 sterilizations performed in Oregon through 1940. In the "insane" category 287 were male and 321 were female. In the "feeble-minded" category 235 were male and 506 were female. In the "others category" 30 were male and 71 were female.[78]

In 1948 the Board of Eugenics started requiring that a guardian, close relative, or personal friend sign a permission form before sterilization could be performed.[79]

By 1954 the biennial reports of the OSH showed that at least 315 patients had been sterilized over the previous thirty-six years. In a quick preview of the reports between 1918 and 1954 half are missing the sterilization counts and half include it. Sterilizations included vasectomies (22), bilateral salpingectomies, or removal of the uterus and the fallopian tubes (125), castrations (46), hysterectomies (21), ovariotomies (9), simple sterilizations (74), and tubal ligations (18).[80]

The 1965 "Summary of Oregon Statutes Pertaining to Mental Retardation and Mental Illness" states that a copy of the order of the board must be served upon the person or his legal guardian, spouse, or next of kin if the person was insane or feeble-minded (ORS 436.090). Additionally, it stated that written notice must be given the board telling why sterilization should not be performed. It further stated:

> *The board in examining all persons for sterilization shall examine the mental and physical history of that person and his family. If a majority of the board feels that person would produce children having an inherited tendency toward*

mental retardation or mental illness, or would probably become wards of the state or menaces to society, the board may order the person sterilized in a manner to produce the most beneficial results. (ORS 436.050)[81]

The law specifically stated that the sterilization was not to be done as punishment. The board was required to have the consent of every insane or mentally incompetent person or their legal counsel before the operation could be done. Between 1907 and 1963 over sixty thousand individuals were forcibly sterilized under Eugenic legislation in the United States.[82]

In 1967 the Oregon State Board of Eugenics was renamed the State Board of Social Protection. Board members now consisted of a physician, a faculty member of the University of Oregon Medical School, a clinical psychologist, a psychiatrist, a social worker, and a member of a state organization on mental illness.[83] Its duties were changed to read:

The Board examines individuals for whom sterilization has been recommended; if, in the judgment of a majority of the board, procreation by the individual would produce children who would have an inherited tendency to mental retardation or mental illness, or who would become neglected or dependent children as a result of the parent's illness or retardation, the board orders the type of sterilization best suited to the person's condition.[84]

In practical application the young victims were often barely able to read or write and unable to fully understand what the operation entailed. "By 1970, the only class of state wards considered for sterilization were patients of the state mental hospitals."[85] Only 217 sterilizations were completed between 1967 and 1978, when the last sterilization took place.[86]

Jenette Eccleston states it best: "Whether or not the perceived socioeconomic status, race, ethnicity, disability, sexual deviance, or delinquency determined an individual's reproductive future, the perception of their sexual practices as a potential menace to society factored into the detection, detention, and sterilization of thousands of Oregonians."[87]

The admitted number of people sterilized between 1921 and 1983 under Oregon's law varies from 2,341 to 2,648.[88] Approximately 65 percent were women and 35 percent were men. One-third were diagnosed as mentally ill. The surgery center at the Oregon State Hospital served as the main facility for the operations. The last case was considered in 1981, and Senator John Kitzhaber pushed the legislature to abolish the State Board for Social Protection in December 1983.[89]

The staircase circled the inside of the Dome up to the third story. This shows the door leading into the surgical center. *Photo by author.*

On December 2, 2002, Governor John Kitzhaber apologized to the nearly 2,600 Oregonians who were sterilized as part of the Eugenics Movement. *Oregon Governor's Office.*

Men who were castrated as young as age sixteen suffered the lack of facial and body hair and eventually high blood pressure throughout their whole lives. Many didn't know what was happening to them or suffered severe pain during the surgery as a result of inadequate anesthesia. At least one hundred young girls living at the state training school for delinquent girls were sterilized before 1941.[90] At least one Oregon woman died as a result of a forced hysterectomy.

In August 2002 news that Oregon's Eugenics records had been shredded provided incentive for Oregon to acknowledge what had been done to thousands of Oregonians against their will.[91] On December 2, 2002, Oregon became the second state to issue a public apology. Governor John Kitzhaber apologized to the 2,600 Oregonians sterilized during the previous sixty years in a ceremony held at the state capitol.[92] "The state forcibly sterilized children, the governor told the crowd, as well as people with mental disorders, disabilities, epilepsy and criminal records. Nearly all of them were 'vulnerable, helpless citizens' entrusted to the care of the state by their families or by the courts."[93]

Notes

1. Laurence M. Cruz, "Eugenics Yields Dark Past," *Statesman Journal*, December 1, 2002.
2. Also known as oophorectomy, ovariectomy, or ovariotomy. Definition: removal of a woman's ovaries.
3. I.L. Patterson, et al., "State Institution for Feeble-minded" (Salem, OR: Board of Control, 1929), 6, Oregon Historical Society Research Library, Portland, Oregon.
4. Bethenia Owens-Adair papers, Mss. 503, Oregon Historical Society Research Library, Portland, Oregon.
5. Ibid.
6. Linda Curry, "Owens-Adair Began Local Survival of the Fittest," *Willamette Week* (Portland, Oregon), December 4, 1976.
7. Mark Largent, "The Greatest Curse of the Race," *Oregon Historical Quarterly* 103, no. 2 (Summer 2002): 193. This article has become the defining scholarship on the Oregon Eugenics Movement.
8. Jenette Eccleston, "Reforming the Sexual Menace: Early 1900s Eugenic Sterilization in Oregon," undergraduate research paper. Department of History, University of Oregon, 2007.

9. B.A. Owens-Adair, *Human Sterilization: Its Social and Legislative Aspects* (Ann Arbor: University of Michigan Press, 1922), 23.

10. L.A. Fernsworth, "Human Scrubs to Be Thing of Past," *Oregonian*, April 14, 1912.

11. Largent, 197.

12. Robert D. Johnston, "The Myth of the Harmonious City," *Oregon Historical Quarterly*, Special Issue: Aspects of Portland History 99, no. 3 (Fall 1998): 272.

13. Ibid., 276–77.

14. Ibid., 280.

15. Ibid., 281. See also William Montavon, *Eugenic Sterilization in Laws of US* (Washington, D.C.: National Catholic Welfare Conference, 1930).

16. Annette K. Vance Dorey, *Better Baby Contests: The Scientific Quest for Perfect Childhood Health in the Early Twentieth Century* (Jefferson, NC: McFarland & Co., 1999), 27.

17. *Oregonian*, June 20, 1913.

18. Ibid.

19. Dorey, 53.

20. *Oregonian*, October 6, 1913.

21. Ibid.

22. Dorey, 27.

23. *Oregonian*, October 6, 1913.

24. Dorey, 46–47.

25. Ibid., 58–59.

26. Ibid., 60.

27. *Oregonian*, January 7, 1914.

28. Dorey, 77.

29. "1925 Multnomah County Fair Brochure," 76, Oregon State Archives, Salem, Oregon.

30. Dorey, 206–7.

31. *Capital Journal*, April 30, 1938.

32. Dorey, 206.

33. *Mail Tribune* (Medford, Oregon), October 14, 1915.

34. *Oregonian*, March 6, 1914.

35. Dan Vergano, "Genetics Journal Reveals Dark Past," *USA Today*, April 24, 2011.

36. *Oregonian*, January 1, 1915.

37. Eccleston, 14.

38. Part 8450 of the law stated: "It shall be the duty of the State Board of Eugenics to examine into the innate traits, the mental and physical

conditions, the personal records, and the family traits and histories of all persons so reported so far as the same can be ascertained, and for this purpose said board shall have the power to summon witnesses, and any member of said board may administer an oath to any witness whom it is desired to examine; and if in the judgment of a majority of the said board procreation by any such person would produce children with an inherited tendency to feeble-mindedness, insanity, epilepsy, criminality or degeneracy, and there is not probability that the condition of such person so examined will improve to such an extent as to render procreation by any such person advisable, or if the physical or mental condition of any such person will be substantially improved thereby, then it shall be the duty of said board to make an order directing the superintendent of the institution in which the person is confined and if not so confined, directing the state health officer to perform or cause to be performed upon such person a type of sterilization as may be deemed best by such board."

39. "Eighteenth Biennial Report of the Oregon State Hospital for the Biennial Period Ending September 30, 1918, Third Biennial Report to the Oregon State Board of Control, Salem, Oregon," Oregon State Archives, Salem, Oregon.

40. "Nineteenth Biennial Report of the Oregon State Hospital for the Biennial Period Ending September 30, 1920, Fourth Biennial Report to the Oregon State Board of Control, Salem, Oregon," Oregon State Archives, Salem, Oregon.

41. Eccleston, 14.

42. Ibid., 14–15.

43. Harry Laughlin, "The Present Status of Eugenical Sterilization in the US," reprinted from *Eugenics in Race and State*, vol. 11, published 1923, 290.

44. Ibid., 287.

45. Ibid., 290.

46. Largent, 201.

47. Harry H. Laughlin, *Eugenical Sterilization* (New Haven, CT: American Eugenics Society, 1926), 42.

48. Ibid., 42.

49. Ibid., 42 and 58. Of those 313 people, 216 were women and 97 were men. Of the 97 only 6 were vasectomies and 91 were castrations.

50. Ibid., 60.

51. *Oregonian*, May 2, 1926.

52. Vergano, "Genetics Journal."

53. Owens-Adair, 10.

54. Ibid., 14.

55. Ibid., 20.

56. *Oregonian*, June 30, 2002.

57. Ibid.

58. Owens-Adair, 145.

59. Sullivan, "Legacy of Forced Sterilizations."

60. *Oregonian*, August 13, 1916.

61. Owens-Adair, 112.

62. Ibid., 233.

63. Patterson, 6.

64. Montavon.

65. "Twenty-Third Biennial Report of the Oregon State Hospital for the Biennial Period Ending September 30 1928, Eighth Biennial Report to the Oregon State Board of Control," Salem, Oregon, Oregon State Archives, Salem, Oregon.

66. "Twenty-Fourth Biennial Report of the Oregon State Hospital for the Biennial Period Ending September 30, 1930, Ninth Biennial Report to the Oregon State Board of Control, Salem, Oregon," Oregon State Archives, Salem, Oregon.

67. Sullivan, "Legacy of Forced Sterilizations." Largent postulates that Governor Pierce was tied to the Oregon Ku Klux Klan and its philosophies influenced Pierce's decisions regarding who was sterilized in Oregon. Largent, 202.

68. Sullivan, "Legacy of Forced Sterilizations."

69. O. Larsell, "History of Care of Insane in the State of Oregon," *Oregon Historical Quarterly* 46, no. 4, 315.

70. Largent, 203.

71. "Twenty-Seventh Report of the Oregon State Hospital for the Period Ending June 30, 1936, Twelfth Report to the Oregon State Board of Control, Salem, Oregon," Oregon State Archives, Salem, Oregon.

72. Ibid.

73. *Capital Journal*, January 26, 1938.

74. Dr. J.C. Evans, "Asylum Finds Scant Room for Newcomers, 1938," OSH Vertical file, Oregon Historical Research Library, Portland, Oregon.

75. *Oregonian*, June 18, 1938.

76. *Oregonian*, January 6, 1921.

77. *Oregon Journal*, December 2, 1940.

78. http://www.eugenicsarchive.org/eugenics/list2.pl.

79. Board of Control Correspondence for OSH, letter dated March 2, 1948, from Roy H. Mills to Ruth Jens, MD, Oregon State Archives, Salem, Oregon.

80. Biennial Reports of the Oregon State Hospital to the Board of Control for 1918, 1920, 1924, 1928, 1934, 1936, 1948, 1950, and 1954, Oregon State Archives, Salem, Oregon.

81. George Wittemeyer, "A Summary of Oregon Statutes Pertaining to Mental Retardation and Mental Illness," Oregon State Board of Control, September 1965.

82. Vergano, "Genetics Journal."

83. Largent, 205.

84. *Register Guard* (Eugene, Oregon), August 1, 2002.

85. Largent, 206.

86. Alan Gustafson, "Sterilization Once Controlled Undesirables," *Statesman Journal*, April 30, 1990.

87. Eccleston, 22.

88. Lombardo, 293, and Josephson, 1. See www.uvm.edu/~lkaelber/eugenics/OR/OR.html. Other references state that 2,432 persons were sterilized in Oregon between 1917 and 1967. See Gustafson, "Sterilization Once Controlled Undesirables."

89. Montavon.

90. Lawrence Cruz, "Some Oregonians Have Sad Memories of Forced Sterilization," *Statesman Journal*, December 1, 2002.

91. Editorial, *Register Guard*, August 1, 2002.

92. Julie Sullivan, "State Sorry for 'Great Wrong,'" *Oregonian*, December 3, 2002.

93. Ibid.

Chapter 7

THE TRAGEDY OF GEORGE NOSEN

On the night of Wednesday, November 18, 1942, the staff at the Oregon State Hospital became aware that something catastrophic was happening just one hour after a supper of scrambled eggs. That's when the first death occurred. Of the 2,728 patients given the eggs, the first person began acting ill within fifteen minutes of eating. Later Governor Charles A. Sprague stated, "So far as he knew, the mass poisoning was the 'worst catastrophe' ever to occur at an Oregon state institution."[1]

At first everyone suspected the eggs were the problem. A total of 6,780 pounds of frozen yolks, part of a federal surplus commodities program, were packed in two-gallon tin containers and had been shipped to Oregon institutions the previous February.[2] The surplus commodities program helped augment the seven cents a day allocated to feed each patient.[3] Without the subsidy the patients would only be given one egg a week and no meat at all.

M.A. Clevenger, regional director of the Agricultural Marketing Administration, stated, "Frozen egg yolks can be held in prime condition for an indefinite period in temperatures ranging from minus five degrees Fahrenheit to zero Fahrenheit. They may be stored for a 30 to 60 day period if the temperature does not go above five degrees to ten degrees."[4] It was discovered that portions of the original shipment had been consumed in Washington and no one had suffered any ill effects. Tests revealed no bacteria or poison in the raw eggs still held in the hospital. Tests by Dr. Joseph Beeman, toxicologist for the University of Oregon Medical School in

Portland, determined that the scrambled eggs eaten by the patients contained sodium fluoride, a poison used in roach powder.[5] Somehow the poison was put in the eggs between the time they were taken out of the freezer and when they were served to the patients.

Within fifteen minutes after eating supper, patients began complaining of nausea, cramps, vomiting blood, experiencing respiratory problems, and were unable to stand because of violent leg cramps and paralysis. "Their breathing grew labored. Some were contorted with pain. The lips of others turned blue with numbness. Still others retched blood."[6]

The first death occurred an hour later. By 10:00 p.m. ten patients had died. By midnight thirty-two had died. By 4:00 a.m., forty had died. Eventually forty men and seven women from four wards were dead. The wards most severely affected housed the hospital's workers—those who ran the laundry services, the kitchen services, and all the other important services necessary to run a large institution. Superintendent John C. Evans said, "We've been operating on a shoestring. The labor shortage has been critical. And to lose many of our best patient-workers made it that much worse. For instance, I can't see how we can operate our laundry at all."[7]

Making it even more difficult, the wards were widely separated from each other and several of them didn't have telephones. A total of 467 patients were stricken and 47 of them died. Superintendent Evans stated, "Our best patients have died."[8]

Bodies of the victims were stored in the small hospital morgue, the chapel, and hallways until they could be released to their respective county morgues or private mortuaries. The chapel, thirty by fifty feet, had bodies stacked from one end to the other. Beds for the sick were at a premium. Doctors and

On November 18, 1942, 467 patients at OSH were accidentally poisoned and 47 died. *Oregonian, December 20, 1942.*

nurses from all over the Salem area were called to come assist during the crisis. The last death occurred late on Thursday afternoon.

Heroes came to light. R.C. Tillett, a ward attendant where fifteen men died, probably saved one man's life by tasting the eggs and warning him not to eat so much. Mrs. Alie Wassell, a ward nurse, also tasted the eggs and ordered the patients to stop eating. Her ward was the only ward where no one died. She became very ill but started recovering on the second day.[9] It took several weeks before all the patients recovered.

Suspicion immediately focused on the kitchen staff and the patients working there. The only place sodium fluoride poison was stored in the hospital was in galvanized iron cans in a locked basement storage area under the kitchen. There was no special marking on the container of roach powder to indicate it contained poison. The state police indicated that only one pound of the poison could kill two thousand people. Because five or six pounds of poison went into the eggs, patients started vomiting immediately, which probably saved their lives.[10]

Most of the kitchen's patient workers suffered from alcoholism or dementia praecox (schizophrenia), making their sworn testimony suspect. Mary O'Hara was head cook for all 2,728 patients, and her assistant, A.B. McKillop, was in charge of preparing the scrambled eggs. On the afternoon of November 18, McKillop handed his keys to patient George Nosen and asked him to go downstairs and fetch some powdered milk. Nosen, age twenty-seven, from Medford, voluntarily entered the hospital in August 1942 after being injured when five two-hundred-pound sacks of feed fell on him several years earlier. "His brain was damaged, resulting in problems ranging from chronic seizures to personality changes."[11] In addition to epilepsy he was diagnosed as a "paranoid schizophrenic, a severe form of mental illness characterized by irrational suspicions, fears and delusions."[12] Nosen retrieved seventeen pounds of white crystalline powder from the basement, and the cook dumped six pounds in the scrambled egg mixture.[13]

At first McKillop and O'Hara lied to investigators and denied knowing anything about the poison. However, when tests determined that there wasn't any milk powder mixed into the scrambled eggs, McKillop finally admitted the truth on Saturday night. Because they were so understaffed and not knowing it was against the rules, he gave his keys to Nosen and asked him to bring up the milk powder. Nosen had accidentally gone to the wrong room and brought up roach powder instead. McKillop and O'Hara had been too frightened to admit their mistake.

Both cooks were arrested on Sunday. Initially they were suspected of being part of a terrorist plot as the United States had entered World War II almost

one year earlier. McKillop's bail was set at $10,000, and Mary O'Hara's bail was set at $5,000. McKillop, sixty-four years old and born in Ireland, was married and the father of three children. He'd only been working at the hospital since July. After hours of testimony the Marion County Grand Jury refused to bring criminal indictments against either McKillop or O'Hara.

The grand jury report also mentioned that the chief cook, Mary O'Hara, could neither read nor write. They discovered that McKillop had never been told of the hospital rule forbidding keys be given to patients for any reason.

Two OSH cooks were arrested but were later exonerated for the accident. Oregonian, *December 20, 1942.*

Instead they brought a scathing report against the hospital. "The Oregon State Hospital should have more employees and only paid workers of the institution should have keys to rooms containing poison."[14] The hospital was "grossly lacking in employees in view of the enormous amount of work required…together with the fact that all of the employees were greatly underpaid."[15] In addition they recommended the legislature pass a law requiring all poisons to be labeled or colored. The hospital housed 2,728 patients in buildings meant to accommodate 2,000.[16] During the day one attendant cared for 16 inmates, and at night a single attendant was responsible for 150 inmates. There were only 8 physicians and 1 dentist for this small city of 2,700 very sick people.[17] Oregon spent forty-five cents a day per patient in 1941 compared to California, which spent eighty-one cents per day. That translated into poorer recreational facilities, poorer food, inadequate living accommodations, and increased use of restraints. Patients were kept in restraints from a few hours up to eight years.[18] The inadequate number of attendants made it necessary to keep patients trussed in camisoles; strapped to beds, chairs, or water pipes; bound by leather wristlets, muffs, anklets, or shoulder straps; or confined by straitjackets and restraint sheets.

Superintendent John C. Evans believed the direct cause of the poisoning was the lack of paid employees at the hospital.[19] With only three cooks to do the cooking for three thousand staff and patients every day, they had to rely heavily on patients to help them.

Attendants were paid $67.50 a month if they were male or $65.00 a month if they were female. Free room and board was provided on campus, but no allowance was provided if they wanted to live off campus. Benefits were so poor that OSH experienced "a 108.68 percent turnover in staff during the current biennium."[20]

Two years earlier in December 1940, Governor Charles A. Sprague had initiated a six-year $600,000 program to relieve the overcrowding. The first project was building 72, costing $325,000.[21] It was finished by 1942 when the tragedy took place, but with an average increase of 100 patients a year, it still meant OSH was severely overcrowded. In addition, $20,000 was allocated for physicians' cottages and $46,000 for remodeling of the old administration building (the J building) and its wards.[22] Staffing was increased by 1 psychiatrist, 1 physician, 4 nurses, and 6 night attendants. By 1942 there was still only 1 physician for every 300 patients when the psychiatric association recommended a 150-to-1 ratio.[23]

An interesting analysis completed two years earlier highlighted the age proportion of the patients. People under age twenty constituted 34 percent of the general population and contributed 5 percent of OSH commitments. People between the ages of twenty and forty-four constituted 38 percent of the general population and contributed 45 percent of OSH commitments. People between the ages of forty-five and sixty-four constituted 20 percent of the general population and contributed 30 percent. People over age sixty-five constituted only 6 percent of the general population and contributed 20 percent of all OSH admissions—a number far above what should be acceptable.[24]

The hospital needed an immense amount of work. "We went into recreation rooms that had all the aroma and appearance of a Third-street card room; inspected fire escapes that might be of use to a clear-headed athlete; walked through exercise rooms so crowded with beds that more than ten persons in the room would call for traffic signals."[25] Dr. John C. Evans, OSH superintendent, firmly believed that the average person preferred to give the problems and difficulties of the hospital as wide a berth as possible—just as people did when it was believed the mentally ill were possessed by devils and spirits.

Superintendent Evans was adamant about the necessity of new buildings: "We've an obsolete old plant and it's a disgrace to the state of Oregon." After urging citizens to consider a mental illness in the same category as a

physical illness, Dr. Evans stated, "Liquor and social diseases were major causes for their patients' conditions."[26]

Fire was an ever-present concern. The narrow halls had floors soaked with years of oil applications, while the old-fashioned iron fire escapes were nearly inaccessible. The newly installed overhead sprinkler system was all that stood between the patients and a catastrophe.[27]

The overcrowding contributed to a smaller tragedy when an inmate strangled three other patients and then committed suicide in the spring of 1940.[28] There weren't enough attendants to adequately supervise the patients and ensure their safety. The 170 hospital attendants were required to work a twelve-hour, six-day week to care for the 1,460 male and 1,270 female inmates.

The hospital community was severely shaken by the tragedy. The *Tarrytown Tattler*, a hospital newspaper, usually came out once a month and printed articles from each of the wards. Patient L.M. wrote in February from ward 39, the women's ward hard hit by six deaths:

> *Ward News—There are many new faces on Ward Thirty-Nine and every bed is occupied at the present time. Among the flowers sent from the greenhouse were pussy willows, indicating that spring is almost here. Our radio is home again. We were glad to get the loan of the other one while ours was being repaired, but we like our own the best. Birthdays and pretty Valentines made many of our ladies happy on February 14th. A fine collie dog likes to escort the ladies of Ward 39 to and from church and the shows, but a little brown dog refused to let him come up the steps that led to the kitchen so the collie waits below the steps until we come out.*[29]

Elizabeth Silva, an attendant in ward 39, wrote this little article describing how over one hundred women were served and seated at meals:

> *Dining Room Service on 39—The tables are set with cups, spoons, knives and forks, bread, tea or coffee, milk, vinegar, salt, pepper, sugar and syrup. When the containers come up they are set on the two serving tables and the trays are set up for the sick patients. Ladies are called to serve. Then the bell is rung and the doors are opened. The patients stand in two lines and enter the room as the bell rings. Each patient takes a plate from the stack and as she passes the containers she is served from each container by the lady in charge. After eating each patient carries her dishes to the serving tables. After the plates have been scraped they are stacked to be washed by the dining-room ladies. We have over a hundred ladies on this ward and they*

are all served and seated in a very few minutes. This insures a full helping
for each one and enables the patient to leave the table when through eating.[30]

An unknown writer from ward 41 wrote, "Anderson celebrated his birthday Thursday, November 14. He is 21 years old. Van Scott was transferred to carpenter shop where he is making good."[31]

As in any small town or community, when bad things happen people like to have someone to blame. It was easy to criticize patient George Nosen, who suffered persecution over his mistake for the rest of his life, for the poisoning incident. "Nosen was anything but a meek target of abuse, however. A thin, chain-smoking man, he frequently started fights with real and perceived enemies at the state hospital."[32] He lived at the hospital continuously from 1971 until he died in October 1983 at the age of sixty-eight.[33] He'd tried to live in three different community settings before 1973 but always returned to the hospital. He was living in the geriatric ward when he had a scuffle with another patient while all the ward attendants were in a staff meeting. He collapsed after being struck repeatedly in the head and stomach and died a few minutes later.[34] Dr. Peter Batten, Nosen's clinical psychiatrist and Marion County medical examiner, listed his death as a homicide.[35]

The forty-seven who died from the poisoning were as follows:[36]

Barkell, Cecil, age 42, Sheridan
Bates, Marion Otto, age 43, Quincy, Illinois, ward 23
Beal, Albert, age 42, Portland
Beasley, James, age 71, Roseburg, ward 23
Becker, Henry, age 34, Portland
Berg, Joe, age 55, Portland, ward 41
Bergstrom, Otto, age 61, Portland, ward 23
Brown, Thomas H., age 60, Klamath Falls, ward 23
Buckland, John, age 71, Hillsboro, ward 28
Burnette, Harold, age 38, Medford, ward 23
Carlson, Selma, age 56, address unknown, ward 39
Curtis, Willard, age 33, Marshfield
Dean, John, age 41, address unknown
Dixon, Wycke, age 79, Corvallis, ward 28
Donovan, Marjorie, age 18, Junction City, ward 39
Dosek, Stefan, age unknown, Portland, ward 28
Faganello, Joe, age 55, Klamath Falls
Feldman, Walter, age 54, Portland, ward 23
Freer, Frank, age 52, Klamath Falls

Garrett, Rodney, age 37, Dallas, ward 23

Gillette, Otis, age 51, Portland

Goodin, John, age 48, Cornelius, ward 41

Hanel, D.F., age 42, Klamath Falls, ward 41

Hantok, John, age 58, Portland

Hassel, Adolph, age 58, Oregon City

Jorgenson, Roy, age 50, Portland, ward 41

Juba, Anthony, age 39, Kelso, Washington, ward 41

LaMascus, Anna, age 44, Portland, ward 39

Maki, Anna, age 53, Portland

Mielczarek, Sczepan, age 51, Portland, ward 28

Moore, William Budd, age 65, Ashland, ward 23

Moses, Edward, age 66, Portland, ward 41

O'Leary, John, age 66, Portland, ward 41

Pederson, Anton, age 54, St. Johns, ward 28

Phelps, Clifton, age 34, Portland, ward 23

Pointer, Frank, age 55, address unknown, ward 41

Pool, James, age 57, Salem, ward 28

Sellwood, Estella, age 50, Portland, ward 39

Shipley, Beatrice, age 67, Silverton, ward 39

Smith, Madeline, age 21, Portland, ward 39

Stasek, Joe, age 56, Scio, ward 23

Stone, Charles, age 56, Portland, ward 41

Thompson, Thomas, age 55, Portland, ward 23

Uber, George, 52, Halsey, ward 23

Updegraff, Lester, age 39, Portland, ward 28

Wise, Carl, age 74, Bridal Veil, ward 23

Zollman, Pinkus, age 62, Portland

Notes

1. Richard Nokes, "Victim Tells How Poison Meal Brought Paralysis," *Oregonian*, November 20, 1942.
2. *Capital Journal*, November 19, 1942.
3. Editorial, "Niggardly Appropriations Preclude Proper Treatment for Oregon Insane: Food, Housing Problems Also Acute," *Oregon Journal*, November 13, 1940.

4. *Capital Journal*, November 19, 1942.

5. *Oregonian*, November 20, 1942.

6. *Statesman Journal*, October 2, 1983.

7. *Capital Journal*, November 19, 1942.

8. Nokes, "Victim Tells."

9. Ibid.

10. *Oregonian*, November 23, 1942.

11. Alan Gustafson, "Blame Stayed with Patient After Deaths," *Statesman Journal*, November 18, 1992.

12. Ibid.

13. Allan Gustafson, "It Was a Terrible Error," *Statesman Journal*, November 18, 1992.

14. *Oregonian*, March 5, 1943.

15. Ibid.

16. *Life Magazine*, December 7, 1942, 44.

17. *Oregon Journal*, September 11, 1940.

18. Richard Nokes, "Skeletons in Our Closet," *Oregonian*, December 20, 1942.

19. Ibid.

20. Ibid.

21. F.T. Humphrey, "Improvement Program Set for Hospital for Insane by State Board of Control," *Oregon Journal*, December 13, 1940.

22. Ibid.

23. Nokes, "Skeletons."

24. Robert Lang, "Program for the State Hospitals," *Oregon Journal*, December 12, 1940.

25. Victor H. Jorgensen, "It Doesn't Matter, They're Crazy," *Oregonian*, April 14, 1940.

26. *Oregonian*, March 27, 1940.

27. Editorial, "Obsolete Buildings Used to House Oregon's Insane Patients at Salem Are a Disgrace, a Bid for Disaster," *Oregon Journal*, November 10, 1940.

28. Jorgensen, "It Doesn't Matter."

29. *Tarrytown Tattler*, Vol. IV, no. 4, February 22, 1942, 8.

30. Ibid., 6.

31. *Tarrytown Tattler*, Vol. I, no. 5, November 1940, 1.

32. Gustafson, "Blame Stayed."

33. Ibid.

34. *Statesman Journal*, October 2, 1983.

35. Gustafson, "Blame Stayed."

36. Richard Nokes, "Poison Toll Reaches 47 While Doctors Battle to Save Many Stricken," *Oregonian*, November 20, 1942; *Oregonian*, November 19, 1942.

Chapter 8

THE CASE OF REVEREND DAVID C. SNIDER

Reverend David Snider was voluntarily admitted to Oregon State Hospital in 1947, 1954, and 1957. During those years he experienced many of the various treatments OSH had to offer, and in 1957 he wrote about his experiences for the Portland *Oregon Journal.* He'd earned an AB degree from Mount Morris College in Illinois and had been a pastor for the Church of the Brethren in Wisconsin, Minnesota, California, and Oregon.[1]

He was first admitted to OSH on July 8, 1947, and left on September 9, 1947. He swore his admission was an accident. The physician tricked him into signing voluntary commitment papers when he was only suffering from overwork and exhaustion. After being taken to the hospital, he waited three weeks before seeing a physician. As a patient in ward 392 he'd been forced to walk 150 feet naked and cold from the hydrotherapy tub to his room, resulting in a bad chest cold. Only by disobeying the rules was a nurse able to procure medication for him.

A month later, several drunken attendants tried to break his bedroom door down. Fortunately, the day crew came on duty and scared the drunks away. Snider watched an old man bleed to death when the man fell out of bed and injured his head. The attendant in the office (one of the same group that tried to attack Snider in his room) was too drunk to hear the man's cries for help.[2]

During his 1954 stay at OSH he experienced electroshock treatments. Snider maintained that his assignment to ward M was because of another drunken attendant. While in ward J he'd observed the attendant drinking on

the job. Worried that Snider would expose him, the attendant locked Snider in solitary confinement. When Snider was finally released, the attendant refused to let him use the bathroom, and a fight ensued with five other patients beating Snider up. "The outcome of this fracas resulted in my being forced against my will into Ward M. There I was given two of those severe shock treatments on my first day in the ward. I was given a series of these. (The same device is used almost to the exact copy as is used in the electrocution of criminals. Just not quite as much 'juice,' that's all.)"[3] Because the drugs they gave him caused the shakes, he only pretended to swallow them.

In 1940 electroconvulsive therapy (ECT) was introduced in the United States as a cheaper and more popular alternative to insulin shock. Similar to the electric chair, only using less current, patients were strapped to a table where two silver electrodes were placed on the temples and a jolt of electricity was sent through their brains, causing severe muscle spasms. The whole procedure took about ten seconds, but it took about an hour to recover.[4] Patients regained consciousness in a dazed but manageable condition. Doctors recognized that the intellectual and memory portions of the brain were being changed but felt the benefits outweighed the dangers for patients who had no other options.[5] Electroshock quickly became a staple of hospital therapy.

The first time electric shock treatments were mentioned in OSH reports was in 1946 when the biennial report noted six thousand treatments had been administered in the previous two years.[6] By then OSH was routinely administering atropine (curare) as a muscle relaxer to keep patients from breaking bones from the shocks. As long as breathing was supported, curare could be administered to paralyze or relax the skeletal muscles and spare the smooth muscles of the heart and intestinal tract. Electroshock was used on thirty to forty patients twice a week for up to a series of five to fifteen treatments. Through the 1940s and 1950s electric shock therapy, also called electroshock, was very popular. It was primarily used for depression. It was discovered that patients required a long series of treatments to be successfully cured.

Even with the use of atropine, occasionally patients suffered severe injuries. On June 5, 1947, David Warden was voluntarily committed to OSH, and his mother, Clara Warden, signed a permission form allowing the hospital to administer electroshock therapy. The treatments began twelve days later, and a series of eight was completed on July 3, 1947. He began complaining of back pain on July 26. Tests revealed a seriously injured back, and he was put in a cast. He remained in the hospital until October. In December his

mother requested compensation for lost wages due her son because of the back injury. The compensation was denied.[7]

Reports state 6,854 electroshock treatments were administered over the next two years and 12,645 treatments were performed between 1949 and 1950.[8] Electroshock treatments continued with 16,428 between 1951 and 1952 and 22,387 between 1952 and 1954. According to the 1956 biennial report, 16,378 treatments had been given to 3,644 patients in the previous two years.[9]

Shock therapy was divided into two different categories: convulsive shock and insulin. Convulsive shock therapy included the use of electricity, Metrazol, and carbon dioxide. Electronarcosis was a milder form of electroshock involving the passage of an electric current through the brain but inducing no or limited convulsions. A special kind of psychotherapy was introduced for neurotics that involved the inhalation of carbon dioxide, forcing the patient to reveal his fears to the therapist.[10] Convulsive shock therapy was divided into electric shock, electronarcosis, Metrazol, Metrazol/ICT, carbon dioxide, combined Reiter, brief intensive electric shock, hypnosis, desoxyn interviews, desoxyn/sodium amytal interviews, sodium pentothol interviews, and sodium amytal interviews.[11]

Snider maintained that it was occasionally used as a way to punish him and other inmates.[12] It's estimated that nearly fifty electric shocks a day were administered to patients at OSH in the early 1950s.[13] By 1958 electric shock therapy decreased when it was discovered the treatment didn't have lasting effects.[14] Dr. Dean Brooks stated in 1983 that there was very little electroshock used by then, but it was used occasionally "as a last resort, mostly in depression."[15] Only about fifty patients were administered shocks in 1983.

During Snider's second stay at OSH, Dr. Charles Bates was the superintendent. Hired to replace Dr. John C. Evans, Dr. Bates took office on August 7, 1948. Dr. Evans left on a medical leave of absence on February 10, 1948, and Dr. Bates took over in a temporary capacity at that time. When it became apparent Dr. Evans was not returning, the position was made permanent. Dr. Bates had started working at OSH in 1914 as a psychiatric intern when Dr. R.E. Lee Steiner was superintendent.[16] Dr. Evans had worked at OSH for thirty-five years. He served until his resignation on December 31, 1954.

David Snider's third stay represented a fundamental change from ten years earlier. Patients were admitted via four routes in 1957: voluntary, returned parolee, court commitment after a finding that they needed treatment, or by court order for observation and diagnosis.[17]

A patient entering OSH followed a set procedure. After receiving an admittance slip from the administration building he entered the admission ward and was assigned a case number. His name and the kind of commitment were recorded. He and his family were interviewed to provide a case history. After he was assigned a bed he was given an X-ray, urinalysis, weight check, and examination for scars or other physical conditions. All new patients were immediately given a bath. His clothing was taken away to be marked and returned the next day. He could choose to wear state clothing if he desired.[18] He was also given a work assignment. The length of stay in the admission ward varied, but after classification patients were transferred to custody or treatment or both.

Dr. William G. Burrows, resident staff physician, described various mental illnesses as defined in 1955: "Persons suffering from psycho-neurosis are uncomfortable, unhappy and sick, but they do not lose touch with reality." He went on to describe the two main types of psychosis: "1. Functional psychosis—nothing physical is present to cause the illness, but patients retreat from reality. In this category are the schizophrenics, the paranoids and the manic-depressives. 2. Organic psychosis—there is a break with reality, but a physical cause can be found. A common symptom is old age when, because of hardening of the arteries, the brain doesn't receive sufficient oxygen."[19]

Dr. Dean Brooks was superintendent from 1955 to 1982 and believed that OSH had three roles to fulfill: care and treatment for patients, training personnel to care for the mentally ill, and research into mental illness.[20] Nearly 53 percent of all admissions in 1956 were voluntary. Compared to a voluntary admission rate of 20 percent in 1947, this signified how much the public had accepted OSH as a place to get well, not just a place to warehouse undesirables.[21] With almost 3,500 beds, OSH was still considered to be 37 percent overcrowded.[22]

Comparing his stay in 1947 with his stay in 1957, Snider found positive changes. Open wards had been introduced on February 8, 1956, physical restraint was used less often, and the food was better with the rationing system initiated by Al Richardson at the penitentiary and adapted to OSH.[23] The ration form of feeding guaranteed that each patient received a certain amount of meat, eggs, and green vegetables each day. Even if regular OSH funds were cut, food allocations could not be cut.[24] In spite of improvements, it was still impossible to provide enough protein and food for people on special diets with a food budget of 54 cents per patient per day.[25] The hospital cafeteria served 1,200 staff and working patients each day. OSH spent approximately $31,500 per month for food and used $12,700

per month of Cottage Farm produce. Staples needed for one meal included the following:

1,513 pounds of potatoes
290 gallons of fruit
300 gallons of vegetables
1,262 pounds of bread
325 gallons of milk
1,601 pounds of meat
520 gallons of coffee or tea
2 sacks of flour for gravy
270 pounds of butter or margarine
504 pies or 550 pounds of cake

In 1955 there were 2,890 admissions compared to 1,700 in 1950, including 1,150 readmissions.[26] In addition to 413 deaths, 2,387 patients were discharged or paroled. The senile and elderly population (those over sixty years of age) had grown to 1,200 patients. Of first admissions, 21 percent were senile, 20 percent were alcoholics, 22 percent were schizophrenics, 7 percent suffered from other psychoses, and 20 percent were miscellaneous, such as personality disorders and mental deficiency.[27]

The hospital looked better, smelled better, and had a better atmosphere. It was still very overcrowded despite a multimillion-dollar construction program. Ward 7 looked exactly the same as it had ten years earlier. It remained the most crowded of the sixty wards in the hospital, with forty-six of the seventy-two patients confined to beds. Tranquilizing drugs kept the patients quieter, and 2,500 sheet changes a week helped keep the smell down.[28] Ward 21, holding fifty-two bedridden elderly women, still occupied the temporary building originally used for tuberculosis patients. State funds only allowed $8.85 annually for clothing, so many of the patients wore only hospital gowns tied or pinned in the back.

In 1954, OSH was only conditionally approved by the American Psychiatric Association (APA) because of deficiencies in organization, food management, and the number of personnel.[29] In 1958 the APA approved the hospital to give full training to student psychiatrists. It recommended, "Overcrowding in the 3,500 patient hospital should be reduced, that older buildings should be replaced, and that all staff positions should be filled."[30] It also suggested that patient records be indexed and the physical therapy department be expanded.

Snider first saw children, patients under age eighteen, in the hospital in 1957. Almost thirty boys and girls who had nowhere else to go were now in the hospital. Some were "mentally ill, some mentally retarded, some merely incorrigible runaways from Woodburn. They're in OSH simply because there was no other place for the courts to commit them—no psychiatric wing for children, no room at Fairview, or Woodburn, or Hillcrest."[31] Most were childhood schizophrenics. There was no children's ward; instead, the children were scattered throughout the hospital. The youngest ever admitted was five years old.[32] It wasn't until late in 1959 that OSH created a school for the children confined to the hospital.[33]

The legislature only approved the addition of almost half the additional doctors the hospital had requested earlier in 1957, six instead of ten, and the legislature refused to allocate money to enlarge the outpatient clinic or keep clinic director Dr. Reid Kimball. There were twenty-three physicians on staff in the spring of 1957, and four more were hired in the fall. The budget for drugs was doubled, and the number of social workers increased from three

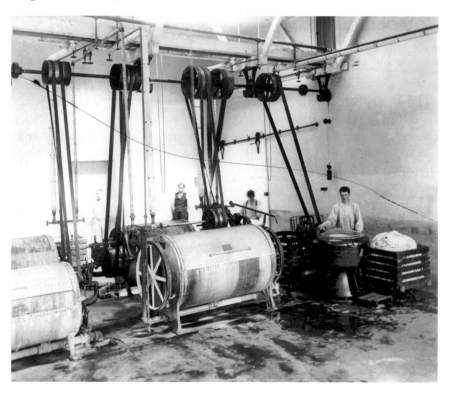

The laundry department required a large working patient population to wash the seventy thousand pieces of clothing, weighing 100,000 pounds, each week in 1959. *Oregon State Archives.*

to eleven. The American Psychiatric Association standards recommended fifty-four social workers per 3,300 patients. Also a psychologist and two industrial therapists were hired to "find jobs to fit patients instead of patients for jobs." In 1959 OSH won its first three-year accreditation by the Joint Committee on Accreditation of Hospitals.[34]

Snider's work assignment made it necessary for him to be on his feet in spite of an injured right knee. Subsequently, he fell and then required a wheelchair. The staff was unable to "bend the rules" because of his condition and had assigned him work similar to everyone else.

Work was considered part of every patient's treatment. Patients who worked in the laundry processed seventy thousand pieces of clothing, weighing 100,000 pounds per week.[35] Female patients working in the sewing room made the following each week:

20 dresses
45 shirts
50 nightgowns
2 doz. aprons
5 doz. towels
2 doz. pairs slippers
2 doz. sheets
4 doz. dishtowels
2 doz. slips
24 suits of underwear
curtains, surgical gowns, binders, aprons and restraint sheets as needed.[36]

Patients who worked at the hospital Cottage Farm produced much of the fruits (165 tons) and vegetables (663 tons) used to feed staff and patients in 1955. The farm also produced 22,998 pounds of beef, 187,712 pounds of chicken, and 111,118 dozen eggs per year.[37]

All the potted plants and cut flowers used in the wards, dining rooms, reception rooms, and hallways were produced in the hospital florist department. It also produced thousands of plants for the hospital flowerbeds, the state fairgrounds, and other institutions and commissions. All hospital landscaping shrubs were grown in the greenhouse nursery.

A new "ward adoption" program was implemented in thirteen hospital wards by various churches and civic groups. The adoption program "began in 1954, when Jason Lee Methodist guild, Salem, scheduled regular visits and parties with the most regressed, most backward group of women in the

hospital."[38] The group adopting a ward provided the patients with attention, recreation, small needs, and sometimes jobs when they were released. The guild decorated the wards with curtains, upholstery for chairs, and pictures and paint for the walls. It also brought the most important gifts of all: time, friendliness, and personal interest. By 1958, twenty-four women's church groups were involved in the adoption program. Once a month they would hold a party with treats, usually cupcakes.[39] The volunteers attended classes for two or three months to prepare for their hospital duties.[40] They were especially helpful in teaching handicrafts, games, square dancing, music and drama, letter writing, singing, and assembling scrapbooks.[41] Another fifty volunteers played games such as checkers, put together jigsaw puzzles, and occasionally organized classes with the patients for at least two hours a week. By increasing the number of non-patients entering the hospital, the stigma and fear of mental illness was reduced.

In the five open wards, patients were allowed to move about freely, set up their own regulations, and move more rapidly toward health and discharge. In ward 11, a sign announced the following: "This is an open ward. We come and go as we please. We are not ashamed to be here. Therefore do not hesitate to join us whenever you are in misery or despair needing psychiatric help."[42]

Snider had many good things to say about the employees and attendants. They were only required to have an eighth grade education and were given a week's training course before working in the hospital. "They are supposed to be able to care for the patients in their charge with the utmost concern for their welfare, always to be patient with them, to be sympathetic, kind and devoted to the utmost possible advancement of the patient toward rehabilitation."[43] Many of the attendants worked hard to live up to this ideal in spite of the fact that they were paid very little for their efforts. He believed they were hampered by a lack of decent equipment and by rigid rules and routines. OSH had a 42 percent turnover rate for attendants working at the hospital. "The overall ratio of employees to patients—1 to 10 in 1947—gradually is being reduced. It's 1 to 3.8 now" in 1957.[44] The program allocated one doctor for 150 patients, one clinical psychologist for 2,200 patients, and one registered nurse for 70 patients.[45] Of the nearly $4,000,000 budgeted for OSH each year, 75 percent went for wages and salaries.

It cost approximately $63 a month to care for a patient at the Oregon State Hospital between 1950 and 1951. That was $12.57 less than it cost per patient at Fairview and $6.25 less per patient than at Eastern Oregon State Hospital. Food at $0.30, capital costs at $1.40, payroll at $41.65, and

all other expenses of $19.49 created a cost of $61.14 in July 1951. The hospital had a population of 3,016 at the beginning of the month and a population of 3,012 at the end of July 1951. There were 130 admissions, 11 returned escapees, 54 returned paroles, 72 patients discharged, 89 paroled, 16 escaped, 19 died, and 3 transferred during that month.[46]

There were primarily nine methods of therapy used in Oregon in 1955:[47]

1. Psychotherapy—counseling directly with patient by doctor.
2. Electrotherapy—electric shock therapy.
3. Insulin coma—lowering blood sugar by insulin.
4. Nutritional therapy—use of right food and vitamins.
5. Milieu therapy—healthful social living.
6. Chlorpromazine and reserpine—produced a calming effect on patients diagnosed as neurotics, schizophrenics, or senile patients resulting in a 67 percent improvement rate.[48]
7. Attitude therapy—personnel of a patient's ward instructed to act in a certain way.
8. Sedatives and hydrotherapy (warm baths)—used to calm patients.

Occupational therapy (OT) was first introduced at OSH in February 1950.[49] It consisted of one therapist, one room, and one basket. Prior to that special patients were assigned to sewing, rug making, and basket weaving. In 1952, occupational therapy was expanded to include professionally made handcraft products. A special loom provided mental relaxation for certain patients. By 1958, staff had increased to include at least three full-time attendants, and the program had moved from a room on the fourth floor center to two large basement rooms in the 40 building.[50] Rags provided opportunities for ripping, cutting, sewing, and winding to make rugs for patient use. Besides rag rugs, the patients worked with ceramics, copper enameling, leather, wood, gardening, needlework, printing, and oil painting.[51] The OT Department also provided other services such as making pictures and nametags for employees and re-covering lampshades.

Hydrotherapy became standard treatments at OSH by 1936 when 2,760 treatments were administered. Continuous bath therapy consisted of a dozen patients at a time being confined to tubs of water for extended hours. Temperature was maintained at 98.6 degrees by central control panels.[52] Various kinds of water therapy were used by 1948 when 15,008 treatments were administered.[53] It included needle sprays with showers, wet sheet packs, whirlpool baths, saltwater baths, sitz baths, cold compresses, hot compresses,

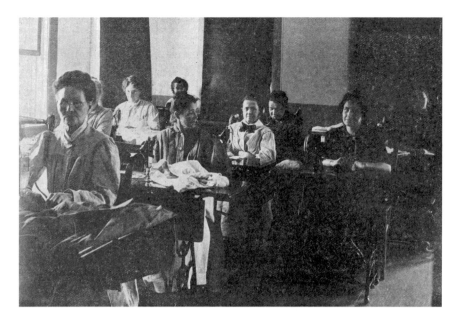

Everyone was encouraged to participate in occupational therapy. These patients were sewing. *Oregon State Archives.*

medicated foot baths, arm baths, prolonged baths on wards, fomentations (a substance used as a warm moist medicinal compress or poultice), and hypodermoclysis (used to rehydrate elderly patients).

Various kinds of physiotherapy began as early as 1928 when ultraviolet lights were introduced at OSH.[54] Over the next thirty years ultraviolet light rays (air or water cooled), infrared rays, diathermy (a method of heating tissue electromagnetically or ultrasonically for therapeutic purposes), radiant heat, vibrator, and Swedish massage were added as types of treatments given to patients.[55] An additional kind of heat therapy involved putting the patients in individual heat cabinets for extended periods of time.

Metrazol was introduced to OSH in 1938 about the same time as insulin coma therapy.[56] It was used primarily on patients with early cases of schizophrenia. It was not as popular as insulin or electroshock. Reports from 1938 through 1956 show that the most treatments were given in 1954 when 2,471 Metrazol seizures were administered.[57] Injections of Metrazol, an intravenous liquid, caused the patient to suffer a very severe convulsion that hospital attendants referred to as a king-sized shock.

By far the most popular form of shock treatment involved the use of insulin. In the summer of 1937 OSH sent a small group of medical personnel to Steilacoom, Washington, to investigate the use of insulin shock in treating

schizophrenia. The Washington State Hospital reported a cure rate of 50 percent or better. Superintendent John Evans wrote a letter to the Board of Control requesting additional staff (one doctor, two graduate nurses, and at least two extra employees) in order to institute the new treatment.[58] The use of insulin was first mentioned in 1938 when Superintendent Evans stated that the drug bill for OSH had increased by approximately one-third because of the use of Metrazol and insulin.

In 1953 Betty Jackson was one of ten patients given insulin injections for three months in 1953. "It was like torture in a way," she said.[59] She stated that it was cruel, degrading, and extremely painful. The doctors didn't give her or the other patients any choice about the treatment and very little in the way of justification. Risks included convulsions, coma, and death. Mortality rates ranged from 1 percent to 10 percent.[60]

Insulin treatments were usually prescribed for paranoid schizophrenics who were asocial much of their lives. "A daily dosage is given, except for week ends, over a four-month period. The dosage is built up until the doctors determine the level which will produce a coma, then is decreased as low as the patient will tolerate and still remain in the coma."[61] The patient goes through three stages: first he becomes drowsy; then he loses contact with reality and he loses control of his body, flinging his arms around; and the last stage is a coma when he becomes quiet. Glucose is given to the patient to bring him out of his shock.[62]

Just before Superintendent Charles Bates retired in 1954, he told the *Oregon Statesman* "that insulin coma therapy was the biggest advance in psychiatric treatment during his 42-year career at the institution."[63]

By 1950, a total of 9,309 insulin treatments had been administered in the previous two years. By 1952, that had increased to 12,841 and by 1954 to 23,316. Therapy was identified as treatments, comas, sub-coma insulin, sedation insulin, pre-comas, prolonged comas, grand mal seizures, convulsive seizures, accidents, and ACTID insulin. OSH reported a 65 percent recovery rate in ward M, although that is slightly skewed as many of the patients were readmitted, retreated, and discharged again. The use of insulin decreased rapidly in 1956 when only 506 patients received 8,440 treatments.[64] As of 1953 the only treatments available were electroshock, insulin coma, hydrotherapy, and occupational therapy.[65] OSH biennial reports stop itemizing treatments after 1956.

Antabuse was introduced in 1951 at OSH as a treatment for alcoholism. If a patient drank alcohol while taking Antabuse he would likely become violently ill. In the most severe reactions the blood pressure shot up and then

dropped, causing severe shock. More common reactions resembled a bad hangover and included flushing, a throbbing headache, nausea, and vomiting. The patient was required to volunteer before treatment could begin.[66] The cure only lasted as long as the patient took the medication. Dr. Dean Brooks, assistant to the superintendent of OSH in 1951, stated that it only cured about 30 percent of the cases. Male alcoholics outnumbered the women by seven to one. About 19 percent of all new admissions were alcoholics.[67] Once he entered the hospital a patient was taken off alcohol immediately, started whirlpool treatments, given sedatives and insulin, served nutritious food, and prescribed exercise. It took nearly a week of delirium tremors or seeing pink elephants, snakes wearing silk hats, or bedbugs nine feet tall before an alcoholic was off alcohol enough to start Antabuse.[68] Penicillin was also routinely administered. Alcoholics also participated in group therapy during Antabuse treatment.[69]

By 1958 hydrotherapy was mostly discontinued, insulin shock was discontinued, and psychotropic drugs, sedatives, and tranquilizers became the primary treatment of choice.[70] In 1957 the hospital's use of tranquilizers increased dramatically, creating a shortfall of $24,000 in the budget. Before tranquilizers and antipsychotic drugs were developed, "people would come in extremely disturbed and we could lose people. They would die from exhaustion or dehydration because they went 24-7, exhausted themselves, and we didn't have effective medication."[71] Superintendent Dean Brooks proceeded to request $150,000 in the 1957–59 budget for drugs.[72] Tranquilizers and other drugs helped patients, mostly those who were classified as manics, agitated schizophrenics, and noisy senile psychotics. "They quiet patients. They calm some down enough so that they will talk, and their doctors can for the first time 'reach them.' Many are made more comfortable."[73] The two drugs found useful were Thorazine (trade name chlorpromazine) and Reserpine (rauwolfia serpentina).[74] Smith, Kline and French Laboratories donated $5,000 worth of Thorazine to the hospital to conduct drug trials on patients. Chlorpromazine hydrocholoride was marketed by Smith, Kline and French as both Thorazine and Stelazine to reduce the symptoms of psychosis.[75] Of the twenty patients put on the drug for four months, eight were released as cured and only one was readmitted.[76] Thorazine was a central nervous system depressant, actually blocking the frightening impulses overwhelming patients. Dr. Reid Kimball tried the drugs on one hundred patients at OSH in 1957 and had the following results: 14 percent much improved, 71 percent partly improved, and 14 percent unchanged.

Sometimes there were problems in the administration of drugs. On March 18, 1958, a patient died because an unsupervised student nurse gave the wrong amount of chloral hydrate (a sedative) to fourteen patients in ward J. Only because of prompt action did the other thirteen patients survive. Instead of giving the patients two teaspoons of the medication, she gave them four times that amount by misreading a metal medicine container and reading tablespoons instead of teaspoons. Measures were taken to prevent future errors, including substituting glass containers for the metal ones.[77]

Additional drugs were developed and included in the hospital's pharmaceutical therapy. Patients were given Prolixin (an antipsychotic) and Mellaril for schizophrenia in the late 1960s.[78] Drug therapy was not always successful. A fifty-nine-year-old patient, Rolland J. Simshauser, committed suicide six days after being committed to the hospital and starting both drugs.

By the middle 1950s television was recognized as a treatment tool in the hospital. It was especially useful at keeping the patients occupied and quiet in the forensic ward, where patients were not allowed leave except for medical appointments. Dr. H.L. Nelson, in charge of the men's treatment ward, stated that fewer disturbances were reported after televisions were introduced into the hospital.[79] For the elderly and senile patients, television provided a way to occupy their time. Half the women's wards and sixteen of the twenty-three male wards had televisions installed by January 1954.[80] By 1958 every ward had a television set, and two of them had color sets.

The hospital library was an important part of a patient's therapy. There were 5,869 volumes in the library staffed by five patients, three paid assistants, and the director, Mrs. Boehmer. Between January and June 1960, 379 books were checked out. Patients mostly read fiction, but there was also great interest in books that would aid them when they were released. Ward 38, the maximum-security ward for men, had the highest number of readers. In 1955 the library book carts distributed a total of 23,794 books.[81]

At the end of his articles Snider summarized eight points: [82]

1. The attitude toward the patients had improved from 1947 to 1957.
2. OSH needed to increase staff training to reduce the use of restraints.
3. OSH needed to increase physician contact with patients.
4. OSH needed to increase the use of hydrotherapy and decrease the use of electroshock.
5. OSH needed to reduce nurses' and attendants' adherence to routine and doctors' orders.
6. OSH needed to remove locked doors from all but the most violent patients.

7. OSH needed to increase appropriations to the hospital for salaries and education.
8. OSH needed to increase volunteer help at the hospital.

OSH celebrated its diamond jubilee on October 23, 1958. Over 1,000 staff worked to care for the nearly 3,500 people (1,688 men and 1,810 women) in the hospital. That included 18 doctors, 8 resident doctors, 3 registered occupational therapists with 6 aides, 2 recreational therapists with 3 aides, and 2 full-time chaplains.[83] The first full-time chaplain, Reverend John M. Humphreys, was hired on November 19, 1956.[84] Superintendent Dean Brooks stated that the most significant change in recent years was the public's attitude toward the mentally ill. "Mental illness can be cured. During the month of January (1959) 116 men and 57 women were discharged and 49 men and 39 women paroled. Good luck!"[85]

When Snider was released he returned to his life on the outside. In 1951 the Oregon attorney general, George Neuner, ruled on whether a discharged patient retained his civil rights. "It is our opinion that if a patient from the Oregon State Hospital has been discharged therefrom by the superintendent as fully recovered, no presumption of the continuance of his mental condition can arise from the prior adjudication and he is entitled to his full rights as a citizen."[86] His civil rights were restored, including the right to vote, hold public office, enter into contracts, and marry.

NOTES

1. David C. Snider, "Ex-Patient Lists Ills," *Oregon Journal*, June 23, 1957.
2. David C. Snider, "Shock Punishment Used," *Oregon Journal*, June 24, 1957.
3. Ibid.
4. Rolla J. Crick, "Wonder Drugs Reduce Restraints: Hospital Uses Shock Treatments," *Oregon Journal*, December 7, 1955.
5. Robert Whitaker, *Mad in America* (Philadelphia: Perseus Publishing, 2002), 99.
6. "Thirty-Second Report of the Oregon State Hospital for the Period Ending June 30, 1946," Oregon State Archives, Salem, Oregon.
7. Board of Control Correspondence for OSH, letter dated December 26, 1947, from William C. Ryan, supervisor of state institutions, to Mrs. Clara Warden, Oregon State Archives, State of Oregon.

8. "Thirty-Third Report of the Oregon State Hospital for Period Ending June 30, 1948," Oregon State Archives, Salem, Oregon; "Thirty-Fourth Report of the Oregon State Hospital for the Period Ending June 30, 1950," Oregon State Archives, Salem, Oregon.

9. Reports of the Oregon State Hospital for Biennial 1952, 1954, and 1956, Oregon State Archives, Salem, Oregon.

10. Herb Penny, "Only One in Series of Changes," *Oregonian*, March 20, 1952.

11. "Thirty-Sixth Report of the Oregon State Hospital for the Period Ending June 30, 1954," Oregon State Archives, Salem, Oregon; "Biennial Board of Control Report for OSH in 1954," Oregon State Archives, Salem, Oregon.

12. Snider, "Shock."

13. Perry Strawn, "100 Years of Steady Progress," *Statesman Journal*, October 16, 1983.

14. *Oregonian*, October 19, 1958.

15. Ann Sullivan, "Hospital Marks Centennial as State Institution," *Oregonian*, October 17, 1983.

16. "Sixteenth Biennial Report of the Oregon State Hospital for the Period Ending September 30, 1914, First Biennial Report to the Oregon State Board of Control, Salem, Oregon," Oregon State Archives, Salem, Oregon.

17. Rolla Crick, "Mental Ills Differ; New Patients Reveal Variety," *Oregon Journal*, December 6, 1955.

18. Ibid.

19. Ibid.

20. *Oregonian*, February 2, 1957.

21. Tom Humphrey, "Treatment Methods, Care, Food Reflect Vast Change," *Oregon Journal*, July 7, 1957.

22. "Oregon State Hospital Data on Mental Health, 1956," Oregon State Library, Salem, Oregon.

23. Ben Maxwell, "State Hospital Formulates Plans for Observing Diamond Jubilee," *Capital Journal*, October 18, 1958.

24. *Oregonian*, October 19, 1958.

25. Humphrey, "Treatment Methods."

26. "Oregon State Hospital Data, 1956."

27. Ibid.

28. Humphrey, "Treatment Methods."

29. The report notes that of 132 hospitals inspected in the United States through 1955, only 9 were fully approved and OSH was one of 32 conditionally approved.

30. *Oregonian*, September 16, 1959.

31. Humphrey, "Treatment Methods."

32. *Oregonian*, October 19, 1959.

33. *Oregonian*, September 16, 1959.

34. Ibid.

35. "Oregon State Hospital Data, 1956."

36. Ibid.

37. Ibid.

38. Anna Olds, "Patients of Mental Hospital Adopted," *Oregonian*, December 15, 1957.

39. Walt Penk, "Statehouse High Lights," *Oregon Journal*, October 26, 1958.

40. *Oregonian*, January 21, 1952.

41. *Oregonian*, January 6, 1952.

42. Humphrey, "Treatment Methods." A caption under a picture states that ward 11 was the first of eleven open wards, yet the story states there were only five open wards.

43. David C. Snider, "State Hospital," *Oregon Journal*, June 25, 1957.

44. Humphrey, "Treatment Methods."

45. Olds, "Patients of Mental Hospital."

46. Part of monthly reports compiled in a 4-A Report for the years 1951–1953, "Hospital Snapshot, July 1951," Oregon State Hospital Museum Project.

47. Sullivan, "Medical Specialists at Oregon State Hospital."

48. Crick, "Wonder Drugs."

49. R.H. Miller, "75th Anniversary Edition," *Lamplighter* (Salem, OR: OSH Publication, 1958).

50. Penny, "Only One in Series."

51. "From Rags to Riches," *Lamplighter*, January 25, 1953, Oregon State Hospital Newsletter.

52. Penny, "Only One in Series."

53. "Thirty-Fifth Report of the Oregon State Hospital for the Period Ending June 30, 1948," Oregon State Archives, Salem, Oregon.

54. "Twenty-Third Biennial Report of the Oregon State Hospital for the Biennial Period Ending September 30, 1928, Eighth Biennial Report to the Oregon State Board of Control, Salem, Oregon," Oregon State Archives, Salem, Oregon.

55. Penny, "Only One in Series."

56. Board of Control Report, 1928.

57. Board of Control Report, 1954.

58. Board of Control Correspondence for OSH, letter dated August 4, 1937, from J.C. Evans to Mr. Dan'l J. Fry, Oregon State Archives, Salem, Oregon.

59. Alan Gustafson, "Some Patients' Bad Memories Haunt State Hospital's History," *Statesman Journal*, October 15, 2007.

60. Ibid.

61. Crick, "Wonder Drugs."

62. Ibid.

63. Gustafson, "Some Patients."

64. "Thirty-Sixth Report of the Oregon State Hospital for the Period Ending June 30, 1954," Oregon State Archives, Salem, Oregon; "Thirty-Seventh Report of the Oregon State Hospital for the Period Ending June 30, 1956," Oregon State Archives, Salem, Oregon.

65. C.L. Brown, "Oregon State Hospital During the 1960s," *Oregon Historical Quarterly* 109, no. 2 (2008).

66. *Oregonian*, September 23, 1951.

67. Paul Harvey Jr., "Cure by Hangover? State Hospital Pioneers New Cure of Alcoholics," *Capital Journal*, September 20, 1951.

68. *Oregonian*, September 23, 1951.

69. Report of Oregon State Hospital for 1954.

70. *Oregonian*, October 19, 1958.

71. Brown, "Oregon State Hospital."

72. Board of Control Correspondence for OSH, letter dated January 30, 1957, from D.K. Brooks to William C. Ryan, Oregon State Archives, Salem, Oregon.

73. *Oregonian*, October 19, 1958.

74. Sullivan, "Medical Specialists."

75. Brown, "Oregon State Hospital."

76. *Oregonian*, February 2, 1957.

77. Board of Control Correspondence for OSH, letter dated March 24, 1958, from D.K. Brooks, MD, to William C. Ryan, Oregon State Archives, Salem, Oregon.

78. Board of Control Correspondence for OSH, letter dated June 19, 1968, from J.H. Treleaven, MD, acting superintendent, to Kenneth D. Gaver, MD, Oregon State Archives, Salem, Oregon.

79. *Oregonian*, January 11, 1954.

80. Ibid.

81. Ben Maxwell, "Mental Hospital Patients Maintain Reading Habits," *Oregonian*, July 3, 1960.

82. Snider, "State Hospital."

83. Maxwell, "State Hospital"; *Oregonian*, October 19, 1958.

84. *Oregonian*, November 19, 1956.

85. Maxwell, "Mental Hospital Patients."

86. *Oregonian*, June 4, 1951.

Chapter 9
THE CASE FOR LOBOTOMY

A new treatment that promised to solve the problem of patient violence, overcrowded wards, and chronic cases of mental illness was sweeping the country. "Leucotomies" were first performed in Europe; however, Walter Freeman, an ambitious American physician, popularized the surgery in the United States. Freeman coined the term "lobotomy" for his surgeries. "By 1949, doctors were operating on 5,000 patients each year" in the United States.[1] Freeman perfected the "trans-orbital lobotomy," in which a thin surgical instrument that closely resembled an ice pick was used to poke a hole in the bony orbit above each eye between the upper lid and eye and then insert it seven centimeters deep into the brain by hitting the end of the instrument with a hammer. "At that point he would move behind the patient's head and pull up on the ice pick to destroy the frontal-lobe nerve fibers."[2] He could do the entire surgery in twenty minutes. Besides being used to alleviate mental illness, it was also used to relieve unremitting pain.[3]

A pre-frontal lobotomy involved drilling holes in the skull in order to access the brain. Once the brain was visible the surgeon could sever the nerves "using a pencil-sized tool called a leucotome. It had a slide mechanism on the side that would deploy a wire loop or loops from the tip." The surgeon could slide the leucotome into the pre-drilled holes in the top of the skull and into the brain and then use the slide to make the loops come out. This in essence severed the nerves by removing cores of brain tissue.[4]

The surgery became so popular in state mental hospitals that by 1951 over eighteen thousand patients had been operated on in the United States.[5]

Parents, spouses, and relatives of patients read the glowing newspaper reports and immediately began clamoring to have their family member operated on in the desperate hope of a cure. The newspapers failed to mention the aftermath of such surgeries. Individuals had concave holes in their heads just above the eye and walked around mute, introverted, and placid.[6] However, by the end of 1955, physicians began having doubts about the value of the surgery, and the psychopharmacological revolution was beginning. By then the most severe cases had already had the operation.

The first brain surgery approved by the Oregon State Board of Control was performed in June 1947. It was an OSH patient named Frances Kochan, paroled from Eastern Oregon State Hospital in the care of her father so she could be taken to Portland for a pre-frontal lobotomy.[7] Dr. John Raaf performed the surgery at Good Samaritan Hospital. Three months later a social worker visited Frances at her home and interviewed the family. Frances could now dress herself and refrained from tearing her clothing off. She had not totally "lost all her aggressive temper, but instead of being combative and assaultive, she now argues about things." The social worker concluded her report with the following:

> *It would seem this patient is much more tractable since her operation. In her present state she will probably be capable of remaining at home, but it will be necessary for her to have supervision at all times…She has to be watched like a child, and told what to do all day long, and she can be quite critical and sarcastic if things don't suit her…the mother inquired about the possibility of bringing her back to the hospital if necessary.*[8]

On the same day a second surgery was performed on a fifty-year-old woman from Fairview. She was expected to be calmer, easier to manage, and even able to perform small tasks afterward. Dr. Raaf stated, "At least six lobotomies have been performed in Portland during the last two years with generally satisfactory results."[9] In almost every case the patients undergoing the surgery were described as violent, resistant, hyperactive, untidy, or kept in restraints for long periods of time. Case files indicated previous repeated treatments with electroshock, insulin shock, and Metrazol. Sometimes patients had been subjected to all three kinds of treatment before having surgery.

The Board of Control determined that whenever possible, relatives would pay the cost of the operation. A letter dated August 26, 1947, from Superintendent John Evans described the brain surgery as consisting of "trephining the skull in the temporal frontal region" with a specially

constructed instrument, "a thin, sharp knife like blade about four inches in length."[10] The knife is "inserted into the frontal lobe of the brain cutting from below upwards and severing the nervous pathways from the frontal lobe to other parts of the brain." He particularly recommended the surgery for patients diagnosed with depression, having to be tube fed, or resistant to obeying ward restrictions. Arrangements were made for Dr. York Herron, a brain surgeon in Portland, to do the surgery at the hospital for $200 each.

Regulations were drawn up to govern the lobotomy surgeries at OSH: 1) Hospital staff must recommend the patient for surgery, 2) The lobotomy surgery must be recognized as beyond the experimental, 3) Dr. York Herron was to perform the surgery for $200 and train OSH physicians to do future surgeries, 4) The patient's family must pay as much of the cost as possible, and 5) The patient's legal guardian must give written permission for the surgery. Each patient was considered individually, and a lobotomy was only suggested for the most hopeless cases after all other treatments had failed. By July 21, 1949, Dr. Herron was retained by OSH to perform all lobotomies.[11]

Hospital officials requested information from Washington State's Western State Hospital about the trans-orbital lobotomies performed by Dr. Walter Freeman at its facility. Washington reported positive results and stated that eight out of thirteen patients were paroled within two weeks after the surgery.[12]

On October 15, 1947, three patients were approved for lobotomy operations. Ruth had been in the hospital for thirteen years and was held in full restraints at all times. It was hoped the surgery would "make her more cooperative and relieve the ward personnel."[13] The second patient was Doris, who had been in the hospital for four years. "She will not answer questions, shows fear, is very self critical, and talks very little." Her parents requested the operation and volunteered to pay for it. The third patient was Betty, who had been in and out of the hospital since June 12, 1935. She remained depressed and aggressive and was beginning to hallucinate. Her husband volunteered to pay the operation's cost.

One of the very first patients to experience a lobotomy was Roy DeAutremont. Roy, his twin brother Ray, and younger brother Hugh were convicted of first-degree murder after an unsuccessful train robbery attempt on October 11, 1923, left three men dead. The brothers escaped and evaded an international manhunt for almost four years. All three were convicted of first-degree murder and sentenced to life imprisonment in 1927.

A year before the train robbery, Roy was listed as an attendant at the hospital in the superintendent's biennial report dated September 30, 1922,

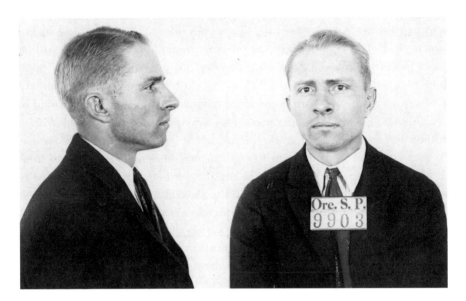

Roy DeAutremont, convict #9903, was transferred to OSH and given a trans-orbital lobotomy in 1949. *Oregon State Archives.*

with a salary ranging from $45 to $57.50. Sometime during the previous two years he had earned $326.25, indicating he had worked at the hospital for about six months.[14]

After being incarcerated in the state prison for twenty-two years, Roy was transferred to OSH on July 11, 1949, diagnosed with advanced schizophrenia (dementia praecox, mixed type).[15] He was at OSH for four months before having a trans-orbital lobotomy on November 8, 1949. After the surgery the physician wrote, "Patient is quieter and less untidy. Is non-productive and introvertive [*sic*]. Improvement estimated at 25 percent."

Fifteen years later, on June 16, 1964, Superintendent Dean Brooks recommended that Roy have hospital ground privileges. Dr. Brooks felt Roy was not a flight risk. In fact he stated, "I doubt that we could drive DeAutremont away from here."[16] Roy died August 17, 1983, at the age of eighty-three.[17]

Sometimes just one lobotomy wasn't enough. Onni H., admitted to OSH in 1923 at age thirteen, was diagnosed as mentally deficient but violent and difficult to control. He was given a trans-orbital lobotomy on November 17, 1949. The results were unsatisfactory, and the hospital performed a second surgery, a pre-frontal lobotomy, four months later on March 25, 1950.[18] He was much improved and considered no longer violent. Restraints

were unnecessary in the daytime (perhaps they were still required in the nighttime), and the "patient is able to feed and care for himself: plays cards, and is no longer a handling problem."[19] In a letter dated December 13, 1951, Superintendent C.E. Bates stated, "This young man was a violent, feeble-minded patient who was one of our very difficult handling problems, but about a year and a half ago with the permission of his relatives we performed a lobotomy operation and since that time Onni has had no restraint, has the freedom of the ward, and is a well behaved and cooperative person."

The OSH biennial reports dated between 1948 and 1954 reported the various brain surgeries performed by surgeons but not the names of the patients. Dr. York Herron performed approximately one operation per month at OSH in 1949. Dr. Veich, who "worked under Dr. Walter Freeman, one of the noted brain surgeons in the United States on lobotomy operations," was also performing lobotomies at OSH.[20] Between 1947 and 1948 there were 13 trans-orbital lobotomies. Between 1949 and 1950 there were 43 pre-orbital lobotomies, 17 trans-orbitals, and one removal of a trephine plug. Between 1951 and 1952 there were 31 pre-frontal lobotomies, seven trans-orbitals, one craniotomy, and one operation with multiple burr holes. And between 1953 and 1954, the last year with lobotomy reports, there were 17 pre-frontal, one trans-orbital, two trephine surgeries, and one surgery to remove the frontal bones.[21] For the seven years between 1947 and 1954, OSH performed 135 brain surgeries inside the surgical center on the second floor of the Dome building.

In reviewing the proposed lobotomy cases presented to the

This metal operating table was used in the OSH surgical center to give patients lobotomies and other operations. *Photo by author, Museum of Mental Health.*

Oregon State Board of Control by OSH staff, a significant percentage were diagnosed with schizophrenia or some type of psychosis. Almost all were described as being difficult to control (assaultive and violent) and being held in restraints at least part of the time. Statements in several patient files declared that a patient was presented to the staff and that they voted in favor of a lobotomy 'in the hopes that such an operation would make her more cooperative and relieve ward personnel…[H]e constitutes the worst kind of ward problem."[22] A few were diagnosed as quite depressed and/or delusional and the family had requested the surgery in the hope it would alleviate the condition. Patients were, for the most part, long-term residents of OSH. The length of stay in the hospital averaged six and a half years.[23]

The surgeries had varied outcomes. In a letter dated June 15, 1950, addressed to Governor Douglas McKay, William Ryan, supervisor of Oregon's state institutions, reported on fifty-eight lobotomy surgeries performed at OSH between November 1, 1947, and April 10, 1950.[24] Only one patient was fully discharged, and fifteen were conditionally paroled. Two were being considered for parole, two were improved enough to work outside with yard crews, fourteen were easier to handle on the wards and care for themselves within that environment, and eleven showed no improvement at all. Two died after the surgery. Patient ages ranged from thirteen to forty-nine. The surgery could easily be considered a 78 percent improvement rate by the staff and attendants who were required to care for the patients. As in the case of Frances K., she no longer tried to run around naked or assault people, but she still needed constant care and would for the rest of her life. Patients were most often left marginally functioning human beings no longer capable of experiencing emotional connections with others.

Survivors of lobotomy often exhibited the following changes:

> *having no sense of smell*
> *impaired visual-spatial perception*
> *a chronic facial tic and a low, quiet grunting throaty utterance*
> *blunted, shallow "sing song" affect juxtaposed against explosive and
> sometimes violent rages*
> *an absence of social skills or interest in relationships*
> *comfort living in squalor and filth, wearing dirty clothes and eating spoiled
> food sans souci*
> *marked short-term memory loss*
> *abysmal personal financial management including numerous bankruptcies*
> *use of biting, nasty sarcasm in place of real discussion deficit in abstract thinking*[25]

This photo shows the windows in the second-story surgical center from the outside of the eastern extension of the Dome building. *Photo by the author.*

In 1952 a reporter from the Portland *Oregon Journal* observed a lobotomy performed by Dr. Russell Guiss at OSH. The surgeon began by drilling "above the eye and level with the ears, about at the normal hairline. The student nurses could hear the 'crunch' of the bit biting into the woman's skull."[26] An hour later he was finished, and after a week the stitches were removed. After the successful operation, the patient was a child again. She could not read, reason, or even eat properly. She had no sense of shame and no civilized toilet habits. She had to learn them all over again. She learned quickly and in a month was behaving well, feeling fine, and had become a "good citizen of the wards."[27]

A few months later another reporter was present during the 100th prefrontal lobotomy at OSH. The patient was ready to start his new education one day after the surgery.

> *He'll have to be taught to feed himself, dress himself and be toilet-trained the same as a child. He will be able to learn or relearn much faster than a child. There is a one chance in five that he may be able to leave the hospital in time and return home; he may be able to work, perhaps even to the extent of holding down a full-time job.*[28]

The Oregon Psychosurgery Review Board was created in 1973 to approve or decline suggested surgeries. Between 1973 and 1981 physicians sought

approval for six lobotomies and the board approved only one, which was performed outside the hospital. The operation was a failure, and in 1981 the surgery was banned in Oregon.

Even after the advent of neuroleptic drugs, hospitals outside Oregon continued to perform psychosurgery (stereotaxis and cingulotomies) with electrode needles as late as 1991.[29] By 1991 at least fifty thousand people had been lobotomized in the United States.[30]

NOTES

1. Alex Beam, *Gracefully Insane: Life and Death Inside America's Premier Mental Hospital* (New York: Public Affairs, 2001), 87.
2. Robert Whitaker, *Mad in America* (Philadelphia: Perseus Publishing, 2002), 133.
3. *New York Times*, June 17, 1948.
4. www.psychosurgery.org/about-lobotomy.
5. Roy Porter, *Madness: A Brief History* (Oxford: University Press, 2002), 203.
6. C.L. Brown, "Oregon State Hospital During the 1960s," *Oregon Historical Quarterly* 109, no. 2 (2008): 283.
7. *Oregonian*, July 10, 1947.
8. Board of Control Correspondence for OSH, Clinical History of Frances Kohan dated September 30, 1947, Oregon State Archives, Salem, Oregon.
9. *Oregonian*, July 10, 1947.
10. Board of Control Correspondence for OSH, letter dated August 26, 1947, from Dr. J.C. Evans to Roy H. Mills, secretary to the Oregon State Board of Control, Oregon State Archives, Salem, Oregon.
11. Board of Control Correspondence for OSH, letter dated July 21, 1949 from William C. Ryan, supervisor of state institutions, to Dr. Gerhard B. Haugen, Oregon State Archives, Salem, Oregon.
12. Board of Control Correspondence for OSH, letter dated September 23, 1947, Oregon State Archives, Salem, Oregon.
13. Board of Control Correspondence for OSH, staff meeting dated October 15, 1947, Oregon State Archives, Salem, Oregon.
14. "Twentieth Biennial Report of the Oregon State Hospital for the Biennial Period Ending September 30, 1922, Fifth Biennial Report to the Oregon State Board of Control," Oregon State Archives, Salem, Oregon.

15. Board of Control Correspondence for OSH, list of trans-orbital lobotomies dated June 15, 1950, for 1949–50, pg. 1, Oregon State Archives, Salem, Oregon.

16. Board of Control Correspondence for OSH, letter dated June 16, 1964, from D.K. Brooks, MD, to J.H. Treleaven, MD, Oregon State Archives, Salem, Oregon.

17. State of Oregon Death Index for 1983, Oregon State Archives, Salem, Oregon.

18. Board of Control Correspondence for OSH, list of trans-orbital lobotomies dated June 15, 1950, for 1949–50, p. 1, Oregon State Archives, Salem, Oregon.

19. Ibid., 6.

20. Board of Control Correspondence for OSH, letter dated November 18, 1949, from William C. Ryan, supervisor of state institutions, to Mr. Rudy Wilhelm Jr., Oregon State Archives, Salem, Oregon.

21. Biennial Board of Control Reports for Oregon State Hospital for 1948, 1950, 1952, and 1954, Oregon State Archives, Salem, Oregon.

22. Board of Control Correspondence for OSH, recommendation dated October 20, 1947, for lobotomy of Ruth Duncan, Oregon State Archives, Salem, Oregon. A three-month postoperative report stated that the patient's improvement was only temporary and she was put back in full restraints. However, a six-month report stated she had shown a moderate amount of improvement. She was beginning to take an interest in her personal appearance and was not as hard to handle on the ward as she was formerly.

23. Board of Control Correspondence for OSH, list dated June 15, 1950, of pre-frontal lobotomies for 1949–50, Oregon State Archives, Salem, Oregon.

24. Board of Control Correspondence for OSH, letter dated June 16, 1950, from William C. Ryan to Governor Douglas McKay, Oregon State Archives, Salem, Oregon.

25. "Mary H's Psychosurgery Travesty-Oral Histories," Archives of the New York Times, see www.psychosurgery.org/oral-histories/mary.

26. Alan Gustafson, "Some Patients' Bad Memories Haunt State Hospital's History," *Statesman Journal*, October 15, 2007.

27. Ibid.

28. Ibid.

29. Samuel Chavkin, "Brain Surgery for Protest Movement," *New York Times*, December 8, 1991.

30. "Psychosurgery, Remembering the Tragedy of Lobotomy—About Lobotomy," Archives of the *New York Times*, see www.psychosurgery.org/about-lobotomy.

Chapter 10
IN AND OUT OF THE CUCKOO'S NEST

Dean K. Brooks was the best known and best liked of all OSH's superintendents. He was hired on October 29, 1947, as a psychiatrist under Superintendent John C. Evans. Superintendent Evans wrote on October 20, 1947:

> *This is to inform you that Dean K. Brooks, M.D. was given employment at this hospital while I was away hunting deer in Eastern Oregon. He has been here since the first of the month and his work has proven to be very satisfactory, therefore, I request that the Board of Control appoint him as a member of our medical staff at the minimum salary.*[1]

He was thirty-one years old, married, and had two of his eventual three daughters, ages four and one. He had graduated from the University of Kansas Medical School in June 1942 and just finished active duty with the U.S. Navy in June 1946. He'd come to Oregon after working at the Veterans Administration Hospital at American Lake, Washington, from June 1946 to October 1, 1947. He was part of the big push after World War II to develop treatments for the huge number of war casualties suffering from mental illness and to improve conditions at state mental hospitals that had suffered from lack of funds and supplies during the war.

Immediately assigned to the male receiving ward in the Dome building at OSH, he was also put in charge of seven wards of patients, meaning a total of about 500 people. Full-time staff had increased from 306 in 1940 to 562

in 1951.[2] At that time there were only 7 physicians to care for 2,700 patients.[3] By 1951 there were 11 physicians working at OSH under Superintendent Charles Bates, only one of whom was a woman. Dr. Ruth Jens had joined OSH about six months after Dr. Brooks. As time went on additional psychiatrists were hired and the hospital population continued to increase. Dr. Brooks faced enormous challenges when he became superintendent. The pay scale for aides started at $198 a month. Nurses started at $280 a month. Even though 57 new aides were hired when building 50 was opened in 1955, the hospital still only met 85 percent of the requirements set by the American Psychiatric Association.

At the admissions building men came in on the ground floor and women came in on the top floor. In 1953 physicians admitted over one thousand patients a year, approximately three or four a day. The patients' ability to be cooperative with staff and take care of themselves often determined where they were transferred after the admissions process was completed. There were over thirty wards and only two treatment wards (one for men and one for women) in the whole hospital. The only treatments available at that time were electroshock, insulin coma, hydrotherapy, and occupational therapy. Nearly a third of the admissions were elderly people suffering from what was then known as Chronic Brain Syndrome (now known as Alzheimer's or senile dementia). This was before community nursing homes were available. Another third involved schizophrenic patients who were admitted, released, and readmitted as some experienced remission and relapse. If no one worked to get patients released and to provide support for them and their families at the community level, inmates became institutionalized and were unable to adjust to living outside OSH. Wards built to house thirty people often housed eighty, mostly elderly women with Alzheimer's who received no treatment at all. Patients were often put in restraints and chained to beds or water pipes just to keep them safe because there wasn't enough staff to care for them. At that point there were only sixteen physicians for over three thousand patients.

Local counties weren't happy in 1953 about patients being returned to their communities because they had to pay part of the cost. Social security and federal funds paid for some of it, but communities had to be willing to change their long-term habits of just shipping people off to OSH.

The rest of Oregon didn't fare any better. There were only ten psychiatrists in Portland and one in Salem. The only recourse for families was OSH or keeping the patient at home. Medicare and/or Medicaid funds didn't begin to help pay for treatment until after 1965. Patients with mental illness could

Dr. Dean Brooks was superintendent of OSH from 1955 to 1982. *Oregon State Hospital.*

cause significant distress to their families, and once the patient was admitted to the hospital the family learned to live without them. It was difficult for a family to adjust to having the family member back, and they needed community support.

Dr. Brooks was appointed superintendent of OSH on January 1, 1955, to replace Dr. Charles Bates, who had been in charge for the previous seven years.

Superintendent Brooks was credited with creating "a climate at the hospital, one of participation,"[4] not just dictating changes to the staff but involving them in committees and helping to make administrative changes in a spirit of collaboration. An important move was to bring Dr. Maxwell Jones

in as hospital research and education director to challenge the way things were done. Dr. Jones tested everyone's assumptions and helped establish the new therapeutic communities in 1961.

Dr. Jones' first experiment started in ward 9, one of the most difficult and troublesome of all the male wards in the hospital. Patients ranged from age nine to age seventy-five. Some were rapists and murderers. Restraints were used often, and shock therapy was used on patients as many as three times a week. The door to the quiet room was scarred from being hit so many times. Patients "had never done anything but sit, fight, and argue for years."[5]

The experiment spread to ward 6, the ward next door, which housed senile and elderly women. Soon paint covered the sunroom adjoining the two wards, while colorful murals decorated the walls and a piano became available for impromptu music. The quiet room was converted into a shop; patients happily prepared jelly donuts and participated in crafts. The women challenged the men to look better physically and act better socially. Both wards now ate together, assisting members who needed help and encouraging better behavior.[6]

Dr. Brooks maintained a patient council where representatives from each ward came and talked about the problems patients had with food, clothing, or whatever bothered them. In the morning when Dr. Brooks arrived in his office he would open letters from patients or patients' families before he'd read a letter from the governor.[7] He was always reminding people of a patient's humanity. Every person was an individual, not a case number or a diagnosis. He even preferred patients and staff address him as "Dean" instead of "The Superintendent."

He developed a residency-training program for psychiatrists. He believed a teaching hospital was more likely to use the newest and most educated methods to help people. Student nurses from all over Oregon spent three-month rotations working at OSH, and many came back to work there.

At that time electroshock therapy and insulin-coma therapy were popular treatments. Based on Dr. Brooks' own experiences, he still maintained thirty years later that electroshock therapy was a much-maligned treatment, misunderstood by the public, and the only treatment available in some cases. "He doesn't think they have any long-term 'deleterious effects.'"[8]

During his time at OSH Dr. Brooks saw the introduction and success of tranquilizers and antipsychotic drugs on patients who had been long-term chronic invalids. He credited the development of drug therapy with reducing the number of patients at OSH, from 3,800 in 1958 to 650 in 1980.[9] During his administration OSH did not perform any lobotomies. The last lobotomy

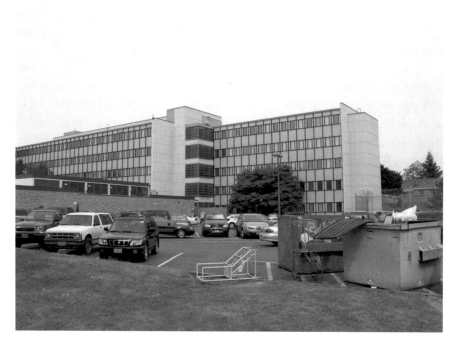

Eola Hall, or building 50, was opened in April 1949 and held 675 beds, mostly for the geriatric population. *Photo by Tom Green, National Register of Historic Places.*

performed in Oregon took place after 1973 at the University of Oregon Medical School.[10] He also identified six other advances that took place while he was superintendent:[11]

1. Nursing homes for the elderly.
2. Community mental health programs.
3. Additional psychiatrists going into private practice.
4. Federal money paying for local mental health clinics.
5. High price of hospitalization.
6. Public awareness that mental illness could be treated.

The last new building, costing $1,500,000 to construct and $263,000 to furnish, was opened in October 1955.[12] Hollis Johnston was the Portland architect, and the general contractor was Ross B. Hammond of Portland.[13] The five-story treatment facility, also known as the 50 building, contained 675 beds and was originally designed to hold the large geriatric population at OSH.[14] All the patients from ward 41 in the basement of the J building and

those in ward 11 of the same structure were transferred.[15] Three hundred patients were moved from the first and second floors of the old infirmary building erected back in 1892.[16] The move eliminated the deplorable conditions where ninety-nine elderly women were "living in a ward that had only four regular and two makeshift toilets" and inadequate bathing facilities.[17] The elderly patients were mostly confined to their beds and had to be hand fed, requiring a large amount of staff and physicians. As the hospital's geriatric population started to decline in 1963, the 50 building was reorganized to contain one of the new geographically designated psychiatric units, part of the medical surgical unit, and the hospital improvement project. This totally eliminated patients sleeping in the hallways of the hospital.

That same year a dormitory with space for seventy student nurses was built for those participating in the nurses' training program.[18] New boilers were installed in the heating plant, and older buildings were remodeled with fire-resistant materials. All the wards were upgraded with paint, new furniture, and small kitchens with refrigerators and ranges. A new tuberculosis hospital was erected to care for tuberculosis patients with mental illness.

In 1957 OSH began eliminating subsidies for staff physicians and their families, thus terminating a nearly seventy-five-year tradition begun in 1883. By that time most physicians were living off campus, and the subsidy was no longer regarded as a popular or customary privilege by either the staff or the public. The cottages on campus continued to serve as housing for various employees through the late 1960s and early 1970s. Eventually they were converted into offices and storage facilities. In 2009 many were converted into living facilities for patients waiting to be discharged.

A big improvement in 1957 involved the ration system of feeding patients, inmates, and residents in all Oregon institutions. A food consultant supervised the system and helped ensure OSH patients had a well-balanced diet throughout the year. Staff and residents ate meals in the same cafeterias off the same menus, ensuring that everyone enjoyed the same meals. As a result of an investigation brought by Superintendent Dean Brooks, the administration of meals was changed to more closely accommodate the needs of the patients instead of the staff.

Another tradition ended in 1957 when OSH transferred its laundry services to the penitentiary. This consolidation continued until complaints accumulated that the prison service damaged patients' clothing. Clothing came back torn, shrunken, faded, and misshapen. As the hospital population decreased, individual washers and dryers were distributed around the facility for the patients, and only institutional linens continued to be processed at the prison.

In 1958 OSH hit its peak population with 3,545 patients living on campus. "The advent of psychotropic drugs which soothed the spirits and actions of some forms of mental illness, plus an increased emphasis on keeping people out of institutions, reduced the hospital population enormously."[19] Tranquilizers "made life reasonable in many of the formerly violent wards. They quiet patients. They calm some down enough so that they will talk," and their doctors can help them.[20] Lithium was introduced in the 1970s, successfully treating manic depression (now called bipolar disorder).[21] In 1990 Clozapine was discovered to successfully treat schizophrenia.

In the spring of 1959 the second-story addition to the administration building was completed, increasing space for records storage, office space, and meeting rooms for administration. This was the last major construction project at OSH until the new hospital was built in 2011.

In 1960 the Cottage Farm operation was transferred from OSH to the Oregon Fairview Home operation. OSH also joined with the National Institute of Mental Health in reporting all statistical data in a uniform manner comparable to other U.S. mental health institutions.[22] F.H. Dammasch State Hospital was opened on March 5, 1961, in the Portland area with a projected patient capacity of 375 (and a top capacity of 399).

Superintendent Brooks worked with Governor Mark Hatfield to create the Mental Health Division (MHD) within the Board of Control in 1961 to work in collaboration with county governments to promote the development of a system of community mental health programs. Governor Hatfield incorporated all mental health institutions, the child guidance programs, the alcohol and drug treatment programs, and the programs covering mental retardation into the same division. The MHD assumed control and coordination of institutional and community mental health services. Counties set up their own programs and received grants to carry out specific functions.

A major catastrophe hit Salem on October 12, 1962, when the Columbus Day Storm devastated Oregon. The storm crossed the California-Oregon border at noon and blew up the Willamette Valley from the south at about 40 miles per hour, destroying everything in its path and reaching Salem at mid-afternoon. Wind gusts reached 90 miles per hour, and sustained winds reached 70 miles per hour. The Mount Hebo Air Force Station in the Oregon Coast Mountain Range recorded 130 mile-per-hour gusts for long periods of time. In Salem alone there was $4 million in damage. There was little warning for shoppers hit by shattered glass windows and flying debris. Cars were blown around like toothpicks, and trees were toppled like dominoes.

In Portland gusts reached 116 miles per hour at the Morrison Street Bridge. In a little under thirteen hours over eleven billion board feet of timber was blown down in northern California, Oregon, and Washington combined. Nearly $200 million of damage occurred in Oregon alone. Forty-six fatalities were attributed to the storm, as were hundreds of injuries.

Superintendent Brooks standing on the roof of an OSH building after it was damaged by the Columbus Day Storm on October 12, 1962. *Oregon State Archives.*

OSH was hit especially hard. The magnificent trees shading the campus blew into buildings and over cars. Branches punctured windows, and wind gusts tore off the J building's roof. The cupola was nearly shattered and punctured in several places. A hospital engineer, hearing over the radio that a bad storm was coming, rushed to the stores, bought as much plywood as he could, and had others buy many extra gallons of gasoline for the emergency generators. Material to repair the J building cost $14,614, material for the Dome building cost $1,350, Warehouse #1 cost $4,502, and other damage to buildings totaled $21,034. Just to remove the metal roofing off the J building and the dome building cost an additional $4,250. Labor costs to remove debris were $25,000. Total damage cost to the hospital from the storm totaled $75,863. The highest cost to any other state institution was $8,147.[23]

The Columbus Day Storm was classified as an extra tropical storm system that hit land. It was the remains of Tropical Storm Freda, which had formed five hundred miles out in the Pacific Ocean and was the equivalent of a category four hurricane. It took months to repair all the buildings at OSH

and remove all the debris. Electricity and gas mains were destroyed. People who lived through the storm would never forget where they were or what they were doing when the storm hit. It was the worst storm to ever hit the West Coast in the twentieth century.

On June 30, 1963, 324 elderly patients were transferred to public welfare–sponsored nursing homes and/or homes for the aged. Instituted under Superintendent Brooks' administration, this was an important step in reducing the huge population of elderly patients at OSH. This program continued until only the elderly with severe mental illness remained at the hospital.

In 1962 Superintendent Brooks established the most comprehensive change at OSH since its inception in 1883. The hospital was decentralized and residents were reorganized into six geographic units related to their resident origins. Three additional units were developed to better serve the hospital's needs: a medical-surgical unit, a psychiatric security unit consisting of four wards, and a social living and rehabilitation unit.[24] Only a few patients were truly dangerous, and they were confined in the security wards. Additional training and educational opportunities were developed for social workers, psychiatrists, psychiatric aides, and mental health researchers.

The therapeutic community units were instituted the same day Dammasch State Hospital opened and patients were transferred there. The move created a major shuffle at the hospital as, regardless of diagnosis, patients were moved into wards identified by their home counties. The ward's assigned treatment team would then be able to coordinate the patient's release and treatment at his/her home. Staff was assigned to a ward and stayed there, becoming part of a team—a social and community unit. Patients in each unit did the household chores, worked together, made group decisions, and learned how to get along with each other. They even voted on which patients should be given outside privileges. Of the nearly five hundred patients who used to be bedfast, only ninety remained in that condition. By 1964 there were thirty-one doctors, or one for every sixty-six patients.[25]

Ward M was composed of forty men ranging in age from teenage to elderly. Dr. George Sakuria, senior ward physician, conducted daily group therapy sessions. Dr. Robert E. Taubman conducted twice-weekly sessions with eight patients and a social therapist. The men felt free to discuss their problems. If patients shirked their share of work, the rest of the community confronted them about the problem.[26]

The Rehabilitation and Social Living Unit was a very new concept. Patients from the chronic wards were brought together and given classes on how to get a

job, use public transportation, and live in an apartment. They were taught how to cook their own meals and wash their own clothes, and when they were ready Superintendent Brooks would move them out into the community with support from a social worker. Usually they would be successful.

After two patients (Chester Hedrick and Vernon Street) escaped on December 26, 1960, Governor Mark Hatfield asked Superintendent Brooks to develop both a maximum- and medium-security plan for patients sent to OSH for observation by the courts.[27] The escape precipitated major changes in how the forensic population, those patients remanded by the courts, was viewed by the staff and the administration. "Until the new plan is put into operation, all such court-committed patients at the state hospital here will be placed in the maximum security ward. They will be kept there until it is shown that they are not security risks."[28] Dr. Brooks indicated that OSH usually had twenty to twenty-four forensic patients but only six or seven of them were security risks.[29] The plan resulted in the development of the Psychiatric Security Unit, which isolated the forensic population from the general hospital population. It included ninety-two beds in three wards for men: maximum, minimum, and an open ward. A fourth unit was devoted to maximum security for women. The hospital experienced nearly four times the admissions from the Oregon State Penitentiary (OSP) after March 1968, when OSP experienced a serious riot.[30] An additional thirty beds were opened in 1969.

By 1976 the Psychiatric Security Unit housed one hundred patients and had established protocols for patients being admitted through the criminal justice system.[31] Patients were sent to maximum security until they could be evaluated. Depending on the resulting psychiatric report, they would then be moved to medium or minimum security.

Two escapees, Tommy D. Hargrove and William L. Johansen, were recaptured in California in November 1968. The situation made news when it was discovered that California's laws made it impossible to hold the men as their crimes had taken place in Oregon, and Oregon was unable to extradite them. Superintendent Brooks explained, "Though the men have committed serious crimes, they were not classed as criminals because they had been adjudged not guilty by reason of insanity. Therefore, this was a civil commitment and extradition is only possible for criminal matters."[32]

At the end of 1966 Dr. Brooks submitted the biennial OSH business report to the Mental Health Division. In it he stated the hospital campus was 140 acres and had forty-four wards holding 1,589 patients. Over 2,000 patients a year came to the hospital for treatment. Most only stayed a short time before they were released.[33]

C.L. Brown arrived at OSH in 1965 as a sixteen-year-old female through the outpatient portion of the Marion County Unit. The outpatient treatment program had been developed and introduced by Superintendent Brooks in 1955. OSH was a beautifully landscaped campus with winding sidewalks bustling with patients, nurses, and physicians. Brown earned ground privileges, designated as a "number 2 card" by working with geriatric patients. Patients were granted work parole, which permitted them to join work details about the hospital; they also earned ground parole so they could have the freedom of the grounds. They could earn town parole just before discharge.[34]

OSH still had numerous greenhouses, its own library, fire trucks, a morgue, and a chapel with Sunday church services at that time. The tunnels were still used to transport all kinds of items from one place to another. Hot food carts transported food to the elevators connecting with various wards, and laundry was moved through the tunnels until it could be transported to the prison for processing. Patients, including Brown, were escorted through the tunnels to be tested for tuberculosis and have their photographs taken for identification.

Brown was in the hospital the day stacks of boxes were delivered to the wards. It was part of Superintendent Brooks' humanization project to help patients regain their pride and control over their lives. He had arranged for businesses to donate surplus articles to the hospital patients, and for the first time patients were allowed to retain their own shoes and clothing.

Superintendent Brooks had visited another hospital in 1963, and while he was there he suddenly recognized the institutional blindness large hospitals develop over time: always leaving the lights on so patients couldn't sleep, or requiring patients to put their shoes in baskets at night so they would have to fight to get them back in the morning. He returned determined to find OSH's bushel of shoes. It was through the patient councils that OSH's institutional blindness came to light. Patients had no hooks on which to hang their clothes or their towels when they showered. Humiliation and mortification could become part of a patient's dehumanization. Forcing patients to undress after a visit home and give up their own clothing only to be given state-issued clothing that didn't fit was a form of dehumanization. Dr. Brooks developed a task force that identified twenty-five areas of concern.[35] The first case involved the lack of toilet paper. An investigation discovered the cause and solved the problem.

The second major issue involved patient clothing. Patients had been required to relinquish their own clothing when they were admitted. A warehouse full of out-of-date clothing molded away unused. State-issued clothing failed to accommodate those who were outside the average sizes.

Before patients could keep their clothing the wards had to provide closets where patients could keep their clothes and personal belongings safely.

Elderly patients were dragged awake at 5:00 a.m. instead of waiting until later when they would have gotten up naturally. Some patients slept in their clothes because they didn't have any nightclothes. Patients slept on unbleached muslin while staff living on campus slept on percale. Staff members were given warm woolen blankets while patients were only allowed undersized blankets. Housekeeping conditions ranged from too antiseptically clean to filthy. The humanization program added napkins at meals, drinking glasses on the wards, doors on toilet stalls, and personal lockers for each patient.

"Deinstitutionalization" was a major issue in an employee feud with hospital administrators and the State Mental Health Division. "Deinstitutionalization of services for mentally ill patients in Oregon has been a growing practice since July 1, 1973, when legislation creating community mental health centers went into effect."[36] The employees were afraid they would lose their jobs as the hospital population declined. Instead they demanded a 50 percent staff increase and a decrease of the number of patients in each ward. Dr. Brooks stated that instead of fifty-four wards there were now fourteen. "The ratio of staff to patients is better than it was five years ago," Dr. Brooks maintained, and "the percentage of hospital employees injured because of aggressive acts of patients has not changed since 1972."[37] There were an average of six incidents a month, but many injuries were from breaking up fights and less than 4 percent required time off work. Staff requests were denied.

Brown was encouraged to participate in volleyball and softball during the summer or ping-pong in the winter. Weekly dances and movies were offered in the World War II–style Quonset hut located in the center of campus. Co-ed dances allowed teenagers to have the same experiences they would have had outside the hospital. Later Brown was able to be part of a successful camping and hiking trip offered to select patients.

None of the doctors or staff wore white coats or uniforms, except in the Forensic Unit. Being treated and accepted alike whether in line for meals, walking around campus, or part of group activities helped patients get well faster. Brown participated in one-on-one therapy, group therapy, and psychodrama. All male ambulatory patients were required to go to the large day room in the men's ward and attend psychodrama sessions.[38] During these sessions families were coached in different behaviors and better ways to solve problems while other patients watched. Drug therapy was also used. Thorazine, Stelazine, and Prolixin were given via intravenous injections to reduce psychosis.

Thorazine and Stelazine caused significant side effects. Brown experienced severe restlessness in her legs, requiring her to walk continuously to reduce the sensations. Stomping her feet also helped, causing this action to be called the Stelazine stomp. Another side effect were muscle spasms in her neck and shoulders, pulling her head to one side. The spasms interfered with mobility, causing patients to call it the Thorazine shuffle.

Objectionable behavior caused Brown to be transferred to ward 81, the high-security ward for women in the Psychiatric Security Unit. Patients were assigned to cells lining a long dark corridor in the J building. Each cell had a window with a metal screen, a single light bulb hanging from the ceiling, a metal nightstand, and enameled cast-iron pipes forming the head and footboard of the single bed. It was located in the oldest section of the hospital and retained the original radiators, skeleton key locks on the doors, and antiquated furniture. Patients weren't allowed matches, anything glass or breakable, or razors. Dishes and silverware were counted after each meal. Patients languished in their private worlds, often refusing to exit their assigned rooms.

When Clinical Director Dr. Joseph H. Treleaven assumed control of the Psychiatric Security Unit, drastic changes occurred that revolutionized care in ward 81. Staff members were encouraged to become part of the treatment team, while social workers arrived to conduct therapy sessions. The old furniture disappeared and bright modern furniture reappeared along with improved lighting. A patient council encouraged patients to take part in their own treatment and rehabilitation. He discouraged an "us versus them" mentality and invited staff to share their insights and frustrations. Patients were provided with "opportunities for independent action, decision-making, and responsibility."[39] Dr. Treleaven referred to this as "Milieu Therapy" in a paper he wrote in 1956. He wrote that Milieu Therapy's goal "was to combat the 'custodial' milieu which promoted passivity, dependence, and regression and to replace it with a 'flexible' milieu...able to promote personality growth or reconstitution by providing opportunities for independent action, freedom, decision-making and responsibility."[40] He believed that taking all decisions away from the patients kept them in a "very dependent position and caused them to lose their social functioning." Encouraging staff interaction improved the patients' chances of being released.

Brown spent seven months on ward 81 before she turned eighteen and was released to the Upward Bound Program at the University of Oregon, where she eventually graduated.

In 1968 OSH developed a better adolescent treatment program. Students continued to live in their community ward but went to a special program

during the day and evening, which included school, recreation, and therapeutic group activities.

Children had always been a part of OSH. However, as late as 1955, they were housed with the general population. An eight-year-old girl lived in the women's ward on December 6, 1955. "Attendants report the girl appears with cigarettes almost as if by magic despite close watch over her."[41] Often children were housed at OSH until room could be found at Fairview.[42] By 1963 a school had been set up for children under the ages of eighteen, but they were still housed with the general population.[43]

In March 1976, Superintendent Brooks instituted the first Child/ Adolescent Secure Treatment Program at OSH for children ages eight to eighteen.[44] (The youngest on ward 40 was six or seven.)[45] It included school, recreation, and therapeutic group activities. Dr. Jerry Zaslaw was head of the program and supervised about 130 staff and patients living in McKenzie Hall, a two-story brick building on the northwest edge of OSH's 148-acre campus.[46] The youngest 20 children lived on the first floor and the older 20 lived on the second floor. The staff rewarded good behavior with punches on student tickets. Children could then trade in their punches for treats. Dr. Zaslaw explained, "All of our kids are behind in their emotional development. A 17-year-old comes on like 11. A 14-year-old is emotionally about 3."[47]

It cost $1,600 a month in 1976 to keep a general patient in OSH. The Child/Adolescent Secure Treatment Program was nearly twice as expensive at $3,000.[48] A visitor watched a nurse spend a half hour feeding a seven-year-old boy whose fists had to be held because he couldn't quit hitting himself. The nurse spent a long time afterward rocking and holding him.[49] He watched a child race the length of a hallway and throw his arms affectionately around a youthful, bearded staff member.

The hospital newsletter described a cooking class for the adolescent unit. "They will be learning basic food preparation, such as reading measurements and recipes. The class will start with simple food preparations such as cookies, biscuits and bread, until they even make full meals."[50] The ultimate goal was to promote the basics of independence and self-reliance.

Superintendent Brooks was often seen rappelling down the side of the hospital walls as he prepared for his next mountain climbing trip. In 1972 he and mountain climber Lute Jerstad took fifty-one chronically ill patients into the Anthony Lakes Wilderness Area of eastern Oregon. The therapy trip was so successful that many of those patients were later released. Each patient was paired with a staff member, although who was a patient and

McKenzie Hall, building 40, housed the Child/Adolescent Secure Treatment Program in 1976. Approximately forty child patients lived in this building. *Photo by Laurie Burke.*

who was a staff member was not identified. *Life Magazine* writer John Frook and photographer Bill Epperidge chronicled the trip.[51] Further trips resulted in skiing, white-water boating, and mountain climbing. Dr. Brooks founded one of the most extensive wilderness adventure programs ever operated in a mental hospital as patients and staff hiked into areas such as Three-Fingered Jack or Anthony Lakes during the summers.[52] This encouraged his biggest gamble of all.

In January 1975, Superintendent Brooks announced that a movie, *One Flew Over the Cuckoo's Nest*, was being filmed at OSH. His courageous decision provided a rare opportunity for patients and staff to experience Hollywood film production right where they lived and worked. The film gave ninety patients and employees the opportunity to act or assist in its production. Jack Nicholson starred as the main character, Randle P. McMurphy. Milos Forman was the director. Saul Zaentz and Michael Douglas were the producers. Oregonian Ken Kesey (1935–2001) wrote the book in 1962 from the point of the view of a schizophrenic after research he did in the Veterans Administration Hospital in Palo Alto, California. It was published in 1962. For approximately eleven weeks, from January through March, the production company filmed inside the J building and various other buildings on campus. Producer Saul Zaentz estimated that $2 million of the $3.5 million budget would stay in Oregon. Dr. Brooks stated, "You know, this isn't a documentary about the Oregon State Hospital. It's an allegory. It's

about a man who is caught up in a system, rebels against it, threatens the order within and is therefore destroyed by it."[53] Dr. Brooks played the role of Dr. Spivey, the hospital superintendent, receiving acclaim for himself as an actor.[54]

When asked why he supported filming the movie at the hospital, he replied that he believed it would provide patients with healthy contacts outside the hospital environment.[55] Patients were thrilled to be able to earn money doing cleanup or as extras in the movie.

In response to the accusation that the film was controversial, Dr. Brooks replied that the "*Cuckoo's Nest* was not controversial because of the material or because it was set in a mental hospital, but because it has exploded into consciousness the things we have refused to look at."[56]

The movie won five Academy Awards, including best picture, in 1976. Louise Fletcher, who played the character of Nurse Ratched, won an Academy Award for best actress in the film. Her portrayal of the inhuman nurse "also became a

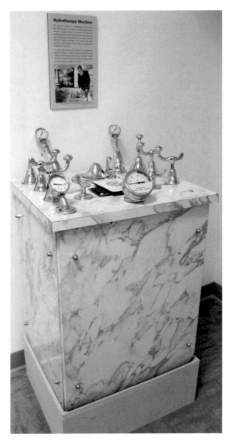

This is the control panel for the hydrotherapy apparatus used by Jack Nicholson in *One Flew Over the Cuckoo's Nest*, now on display in the OSH Museum of Mental Health. *Photo by author, Museum of Mental Health.*

cinematic icon, ranking fifth on the American Film Institute's list of the top 100 movie villains of all time."[57] Jack Nicholson won best actor. *One Flew Over the Cuckoo's Nest* became the first film in forty-one years to sweep the major categories of best picture, director, actor, actress, and screenplay. Some commentators believed that the decrepit buildings of OSH should have won an award, except they weren't props. Too many patients had to live in them.

In December 1975 when the film was released, the cast and crew met again at the benefit opening held at the Portland Bagdad Theater. Michael Douglas praised Dr. Brooks for his courage in allowing the filming and his

Cuckoo Stars On the firing line for newspaper and television reporters and photographers Wednesday are (from left) Jack Nicholson, Milos Forman, Saul Zaentz, Dr. Dean Brooks, Michael Douglas and Vic Heutschy. Subject of the press conference was filming of "One Flew Over the Cuckoo's Nest" at Oregon State Hospital. (Stories page 5, 15 Additional picture page 15.) (Statesman photo by John Ericksen)

On January 22, 1975, Jack Nicholson, Milos Forman, Saul Zaentz, Dr. Dean Brooks, and Michael Douglas were part of a Salem press conference announcing that the movie *One Flew Over the Cuckoo's Nest* would be filmed at the Oregon State Hospital. Michael Douglas stated that their prime concern was "finding the best looking hospital." *Statesman Journal.*

assistance in securing permission. "He went out on a limb for us, it's as simple as that…At first he was the only one really on our side, and he helped us cut a lot of red tape…What was most helpful was that Dr. Brooks saw the story for what it really was. It was an allegory about life in an authoritarian structure. It was not an attack on mental institutions."[58]

During the filming, Dr. Brooks diagnosed actor William Redford with leukemia and predicted he would die in eighteen months. His prediction was correct.

A report card published in 1976 by the National Association of Mental Health and the American Psychiatric Association showed Oregon ranking in the bottom half of the fifty states.[59] That included the amount of money spent per patient on public mental health patients. Oregon also ranked fourteenth from the bottom on the money spent on community mental health facilities.

One Flew Over the Cuckoo's Nest was filmed at OSH in 1975. This photo shows Saul Zaentz (producer), Superintendent Dean Brooks, and Michael Douglas (producer) at a news conference. *Statesman Journal.*

From January 1980 to 1982, Dr. Brooks also supervised Dammasch Hospital after Dr. Russell L. Guiss resigned as superintendent at Dammasch. The Portland hospital served mentally ill persons from Multnomah, Washington, Clackamas, Clatsop, Tillamook, and Columbia Counties. OSH served the rest of the state (except for eastern Oregon) and provided a treatment program for prison inmates, a unit for convicted persons found to be mentally defective, and a program for disturbed children and adolescents.[60] Dammasch had been subjected to intense scrutiny during the past year as charges of abuse and mismanagement surfaced.

In 1980 Dr. Brooks supervised four programs at OSH: a correction treatment program, a child and adolescent program for children ages eight

to eighteen, a general psychiatric program, and a forensic program. At that time it cost an average of $500 a week to treat a patient in the general psychiatric program and $1,000 a week in the children's program.[61]

Superintendent Brooks retired from OSH on January 1, 1982, at a salary of $55,000 a year.[62] He had worked at the hospital for thirty-four years and three months. For twenty-seven of those years he was the superintendent. "I've always rolled with the punches," he said, "and been willing to take some chances, but always remembering that my first priority was to serve the patients."[63]

Dean Brooks retired from practicing medicine on December 31, 1999. He never had a single complaint filed against him in his long and distinguished career as a psychiatrist.[64]

Thirty-seven years ago, a movie filmed at Oregon State Hospital helped it become an icon representing the evils of institutionalization and the dangers of using power in inappropriate ways. It will always be part of that story.

Notes

1. Board of Control Correspondence for OSH, letter dated October 20, 1947, from J.C. Evans, MD, to William C. Ryan, Oregon State Archives, Salem, Oregon.
2. Herb Penny, "Only One in Series of Changes," *Oregonian*, March 20, 1952.
3. Jerry Easterling, "Dr. Dean Brooks' Career One Laced with Gambles," *Oregon Territory Magazine*, April 13, 1980.
4. C.L. Brown, "Oregon State Hospital During the 1960s," *Oregon Historical Quarterly* 109, no. 2 (2008).
5. Ann Sullivan, "OSH Opens Long-Locked Doors of Wards," *Oregonian*, March 5, 1961.
6. Ibid.
7. Ron Cowan, "Cuckoo Is Pleasing to Brooks," *Statesman Journal*, November 23, 1975.
8. Easterling, "Dr. Dean Brooks' Career."
9. This number has been quoted in various sources; however, records indicate this is an approximation and that the population actually reached 3,545 in 1958. Ann Sullivan, "Decline in Mental Patient Population Reflects Changes in Treatment," *Oregonian*, October 17, 1983.
10. "State Care of Mentally Ill Marked by Tragedies," April 10, 1976, Oregon Historical Society Research Library, Portland, Oregon.

11. Easterling, "Dr. Dean Brooks' Career."

12. *Oregonian*, May 26, 1954.

13. *Oregonian*, October 12, 1955.

14. Ibid.

15. Rolla J. Crick, "Mental Hospital Beds to Move from Hallways," *Oregon Journal*, November 27, 1955.

16. Ibid.

17. Ibid.

18. *Oregonian*, October 12, 1955.

19. Sullivan, "Decline in Mental Patient Population."

20. *Oregonian*, October 19, 1958.

21. *Statesman Journal*, August 13, 1995.

22. "Major Changes and Improvements Within Board of Control Institutions, 1955–1965," Board of Control Correspondence for OSH, Oregon State Archives, Salem, Oregon, 6–9.

23. Board of Control Correspondence for Oregon Institutions, Oregon State Archives, Salem, Oregon. All these figures were in a special file marked "Columbus Day Storm."

24. Ibid.

25. Paul W. Harvey Jr., "Success Noted As State Hospital Disbands 'Death Ward' for Elderly," *Oregonian*, February 26, 1964.

26. Fred Martin, "Mentally Ill Learn to Face Life in Ward at Oregon State Hospital," *Oregonian*, January 21, 1962.

27. *Oregon Journal*, January 6, 1961.

28. Ibid.

29. Ibid.

30. Dean K. Brooks, MD, superintendent, "Oregon State Hospital, 1968, Mental Health Division-OSH," Board of Control Correspondence for OSH, Oregon State Archives, Salem, Oregon, 108.

31. Early Deane, "Maximum Security Patient Progresses, Looks Forward to Getting Out," *Oregonian*, December 12, 1976.

32. *Oregonian*, November 8, 1968.

33. Dean K. Brooks, MD, superintendent, "Oregon State Hospital Biennial Report, 1960–1962 to the Mental Health Division, OSH," Board of Control Correspondent for OSH, Oregon State Archives, Salem, Oregon.

34. Rolla J. Crick, "For Some, Mental-Hospital Offers Shield Against 'Terror' of World," *Oregon Journal*, December 8, 1955.

35. Dean K. Brooks, MD, "A Bushel of Shoes," Mental Health Association of Oregon Newsletter, January–February 1970, vol. 15, no. 1, 3–6.

36. Oz Hopkins, "Mental Patients 'Run Wild,' State Hospital Workers Say," *Oregon Journal*, September 14, 1974.

37. Ibid.

38. Brown, "Oregon State Hospital," 283.

39. Ibid.

40. Ibid.

41. Rolla J. Crick, "Mental Ills Differ; New Patients Reveal Variety," *Oregon Journal*, December 6, 1955.

42. Ibid.

43. Harold Hughes, "State Hospital Offers Latest in Treatment for Mental Illness," *Oregonian*, January 20, 1963.

44. James Long, "Abuse Common Link," *Oregon Journal*, December 10, 1976.

45. Ibid.

46. Michelle Roberts, "Betraying a Fragile Trust," *Oregonian*, September 19, 2004.

47. Long, "Abuse Common Link."

48. Long, "OSH Falling Apart."

49. Ibid.

50. "Off Center," vol. 2, no. 4, May 1, 1983.

51. *Life Magazine*, October 27, 1972.

52. Julie Tripp, "Mental Hospital Chief to Retire," *Oregonian*, July 31, 1981.

53. Ted Mahar, "Oregon Asylum Inmates in Movie," *Oregonian*, January 23, 1975.

54. *Capital Journal*, August 3, 1977.

55. Ken Margolis, "Salem Hospital 'Cuckoo's Nest,'" *Willamette Week*, March 11, 1975.

56. *Capital Journal*, August 3, 1977.

57. Editorial, "A Word from Nurse Ratched," *Oregonian*, June 25, 2005.

58. Ted Mahar, "'Cuckoo's' Cast Praises Oregon Doctor for Help," *Oregonian*, December 19, 1975.

59. Long, "OSH Falling Apart."

60. Linda Williams, "Brooks to Assume Dammasch Job Too," *Oregonian*, December 16, 1976.

61. Easterling, "Dr. Dean Brooks' Career."

62. Tripp, "Mental Hospital Chief to Retire."

63. *Oregonian*, January 1, 1982.

64. Rev. Dr. John Benjamin Tatum, "Dean R. Brooks, A Mini Biography," www.imdb.com/name/nm0111954/bio.

Chapter 11

THE CASE OF "TUNNEL THERAPY"

Throughout history tunnels have often been part of myths, mysteries, and folktales. So it is not strange that the tunnels connecting the buildings at OSH have some unusual stories surrounding them. The tunnels are mentioned regularly, if distantly, throughout the history of OSH. For most people in Oregon the fact that almost 2 miles (1.87 miles exactly) of tunnels cross back and forth under Center Street in Salem will come as a surprise.[1] However, after a few moments of thought and considering Oregon's considerable amount of rainfall, it made sense to have a way for patients and staff to get from building to building dry and in private without having to go outside or cross a very busy street.

The first tunnels were built in 1883 under the J building to facilitate a narrow-gauge railroad. Used to haul fuel to the boilers in the basement and food from the central kitchen to the various wards, it was a common design for large institutions at that time. As wings were added and new structures were erected, the tunnels were extended.

Superintendent R.E. Lee Steiner reported in the 1911 Biennial Report that he had already begun construction of a tunnel under Asylum Avenue in anticipation of expanding the Dome building on the north side of the street.

In order to save money, we have excavated the basement for the proposed addition on the south side [of the Dome building] *and started the construction of the tunnel leading to this building from the main building under Asylum avenue, which we hope to have completed by the time*

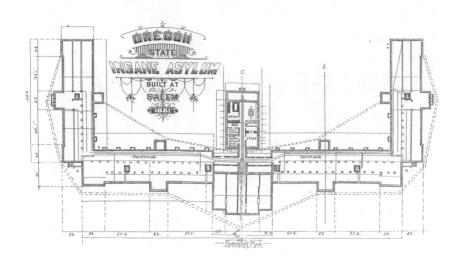

The basement plans show where the original tunnels and foundations were constructed under OSH. *Oregon State Library.*

> *the legislature convenes. It is our purpose to have the north basement*
> *excavated by the time an appropriation shall be made and the contract let*
> *for the building.*[2]

In 1904 the tunnel railroad tracks were extended out to the asylum hog house to carry leavings from dinner tables, which were loaded on small cars and run out to the hogs.[3]

One of the many myths associated with the tunnels involved the Oregon capitol building. The story maintained that a tunnel extended from the capitol all the way to the hospital for the governor and his staff to come and go secretly. Supposedly constructed during either World War I or, in other stories, during World War II, the tunnel would allow Oregon's power structure to escape if the state was ever attacked. Another myth suggested that tunnels connected the hospital and the prison. It made for a good story; however, such tunnels never existed.

In 1922 Superintendent R.E. Lee Steiner suggested they use $1,500 to build a much-needed room for file storage and supplies in a section of the basement tunnels under the bookkeeper's office.[4]

For the most part, the tunnels dropped out of Oregon history until 1957 when a hospital physician, Dr. William W. Thompson, used the term "tunnel

therapy" in a statement he made at a U.S. congressional subcommittee hearing investigating practices at Morningside Hospital. Morningside was a private hospital and closed down soon after this. Because the hospital had a federal contract to care for patients from Alaska, the federal committee had jurisdiction over the patients' care. Dr. Thompson was quoted as saying the following:

> At Salem we are concerned, from the lowest person on the staff to the highest, about "tunnel therapy." That is, in the service tunnel of the hospital, patients are making emotional relationships to other patients of the opposite sex. At times employees discovered intimate relations between patients in the tunnel, which are embarrassing to all concerned.
>
> This problem has two aspects. A public administrative one, in which the hospital might be justified in stopping all patients from having ground privileges because of the abuse of a few, denying patients access to the tunnel and various other restrictive measures.
>
> On the other hand, it may well be that, since the hospital functions to allow a person to make emotional relationships with people, that such activity going on in the tunnel is actually helpful to the patients involved and is actually a part of their motivation to becoming well and leaving the hospital.
>
> We have known patients who, after their discharge from the hospital, have married other ex-patients, probably on the basis of their increased ability to relate to people. The hazard, of course is pregnancy and I understand that it does occur occasionally.[5]

Hospital superintendent Dr. Dean Brooks disputed Dr. Thompson's statements and maintained that the term "tunnel therapy" was a colloquialism referring to misconduct coined by the patients, not the staff, and such relationships were not used as a method of therapy. The state's various newspapers immediately picked up the story, and it became front-page news.

The Oregon State Board of Control convened a special session two days later on September 20, 1957. In attendance were Secretary of State Mark Hatfield, State Treasurer Sig Unander, and Secretary William C. Ryan. Governor Robert Holmes, unable to attend, reiterated his statement to the press that there was and never had been "tacit approval" of any immoral or illicit activities by patients at OSH.

An investigation was immediately instigated. After searching records back five years and five hours of interrogating OSH patients and staff members, Hatfield reported that they could not find a single case of anyone becoming

Bamboo laundry baskets were used to haul laundry and other supplies from place to place in the tunnels. This photo was taken of a display in the OSH Museum of Mental Health. *Photo by author, Museum of Mental Health.*

pregnant while a patient at OSH. Seventeen patients were investigated who had given birth at the hospital in the previous five years. All had become pregnant outside the hospital.

There was neither "policy nor practice which permits illicit relations between patients. Both employees and patients are well aware of the penalties imposed in cases of misconduct."[6]

The board questioned Dr. Thompson, who presented a formal statement, which he read aloud. He maintained the quote was taken out of context when he was trying to illustrate the problems inherent in maintaining a balance between too much restriction and too much freedom in today's large mental institutions. He had heard of pregnancies occurring in other places, not at OSH. He believed that the chairman of the committee had deliberately misconstrued his comments.

Reverend John Humphries, director of the chaplaincy, reported that he had heard of several cases where patients had intercourse in the tunnels. However, in the year he had been at OSH he had never seen anyone nor counseled anyone who admitted to doing such a thing.

Father Paul McCann, who had served at OSH since 1953, did not believe any pregnancies or abortions had resulted from immoral behavior at OSH. He felt it was all just rumors.

Mrs. Anna Ritchie, head nurse on ward M for the previous five years, did not know of any sexual promiscuity on the hospital grounds. Various aides, ground crew workers, and therapists were also interviewed. All eleven employees, some having worked at the hospital since 1945, denied any knowledge of sexual activity occurring in the hospital or in the tunnels. Charles C. Robinson, a men's ward supervisor, believed that the lights erected in the tunnels prevented anyone from finding privacy. Even though the allegations were false, the myth of "tunnel therapy" continued to circulate throughout the hospital and occasionally among the outside population.

Superintendent Dean Brooks took photographers and reporters into the tunnels beneath the hospital. "There," he said, pointing at the cold cement floor as the cameras clicked away. "Do you imagine anyone wants to make love here?"[7]

In 1959 a sexually aggressive patient named Eugene Roberts escaped about 10:00 a.m. via an unlocked tunnel door. Racing through the tunnels he exited near Thompson Avenue Northeast, where he was caught about forty minutes later molesting a three-year-old girl. Her mother rescued the child and called the police. Roberts was fifty-four years old and had been a patient for twenty years due to an encephalitis infection. He had been working in the hospital yard with one hundred other men when he escaped.

With space at a premium, the tunnels were occasionally used for more than just a means of transportation. In 1964, space in tunnel 1 under Unit VI was used by the volunteer services. It was initially a temporary location for the patient "Toggery Shop" where they could receive, free of charge, whatever items of

This is one of the entrances to the tunnels going under the J building. *Photo by Laurie Burke.*

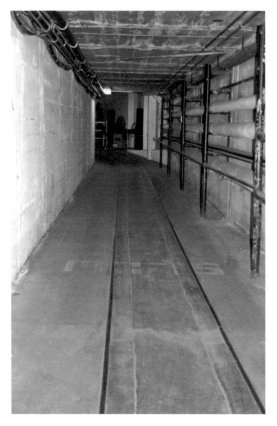

A narrow-gauge railway ran under the J building, Center Street, and to the many buildings on the north side of the campus. *Photo by Laurie Burke.*

clothing, grooming supplies, or other items donated by the community that they needed. It grew into a much larger program than anticipated. Over 15,896 articles were given to 1,817 patients just in 1963.[8] However, the conditions were not acceptable for continued use. There were no dressing rooms for people to try on clothing, no electrical outlets to use irons or sewing machines, no running water or bathrooms in or near the area, ventilation was bad, the floor was often wet, and the lighting in the tunnel was insufficient to prevent falls. The hazards outweighed the rewards, and the shop was soon relocated.

The narrow-gauge railway was still used as late as 1965 to transport people and products all over the hospital.[9] Patients were escorted through the tunnels to various buildings for tests, services, and therapy. Food was transported in hot food carts, and dirty linens were moved from patient wards to the laundry facilities. Pipes lining the tunnels carried everything from hot and cold water to computer wires.

Two patients, ducking into the tunnels to escape a rainstorm in 1965, wandered under the main J building. The older patient pointed to "what appeared to be concrete benches each embedded with an iron ring, and told me that patients had been chained to those rings long ago."[10] While the rings have been photographed, what they were used for is unverified.

Other stories maintained that patients were housed in the tunnels during the late 1950s when overcrowding reached historical proportions. While there was

This shows the 1883 rubble foundation under the J building. *Photo by Laurie Burke*

plenty of room under parts of the J building, then referred to as buildings 43 and 42, there was no flooring, only dirt. Building 43, a wing of the J building constructed in 1910, had only wooden supports holding up the two-story structure and had a dirt foundation. Building 42, another part of the J building, was also rumored to have housed patients in the dirt floor basement tunnels. In 1955 a newspaper article in the *Oregon Journal* recalls patients being housed in ward 41, located in the basement of the J building.[11] At that time patients were moved into the newest building on campus, the 50 building. In a hospital tour sponsored by OHS in 2008, participants were told that during "the hospital's peak population, excess patients had to be housed in the hospital's tunnel system."[12]

In 1976 OSH had an active Child/Adolescent Secure Treatment Program with up to forty patients at a time. During the Oregon rainy season the children and their counselors liked to go roller-skating, and the best place on campus was inside the tunnels. "Twenty skaters at a time can fly through the long fantastic concrete tunnels that run miles underneath the hospital."[13] The squealing and laughter would echo through the tunnels loud enough to warn any unwary pedestrian who might come along to get out of the way.

OSH guards regularly patrolled the tunnels, but the many entrances didn't really prevent anyone with persistence from getting inside. Nick Masselli,

currently an employment specialist at OSH, remembers the community atmosphere at OSH when he was a child: "After school I rode my bike through the tunnels on my way to meet my mother. She was a physical therapist in building 34. Sometimes the security guards chased me more in fun than anything else. I swam in the swimming pool under building 35 and played on the tennis courts. It was a very safe atmosphere for a kid."

The tunnels also occasionally provided access to the outside for unauthorized patients. In July 1990 a patient in the criminally dangerous unit, Dennis Perkey, escaped from his medium-security unit in the 50 building by taking an elevator down to the tunnels. Following the various signs stenciled on the tunnel walls he made his way outside and left the hospital grounds. He was eventually recaptured in Arizona and returned to OSH on January 5, 1991.[14] He was diagnosed with cancer in April 1991 and died in May.[15]

Almost up until the 2009 demolition began, bicycle riders whizzed

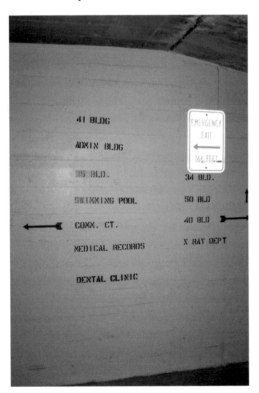

Signs in the tunnels often seemed confusing and contradictory. *Photo by Laurie Burke.*

by, dinging their bells in warning as they approached blind corners in case those walking by forgot to look up at the mirrors angled above them. Electric carts hauling material loaded in wagons let out mournful wails as they also approached the blind corners. Stenciled signs marked every intersection and pointed to destinations no longer in service.

When construction began in 2010 the tunnels were blocked off on the north side of Center Street. One short, blocked-off section was set up temporarily to store artifacts for the new Museum of Mental Health. On the south side the tunnels were incorporated into the foundations for the new hospital and no longer exist.

It was easy to believe when you were walking through the tunnels that they could go on for miles and miles. They echoed with one hundred years of pain and heartache. Today they are gone on the south side: filled in, blocked off, and forgotten.

NOTES

1. Other references mention that there were three miles of tunnels.
2. "Fourteenth Biennial Report of the Board of Trustees and Superintendent of the Oregon State Insane Asylum to the 26th Legislative Assembly" (Willis S. Duniway, State Printer, 1911), Oregon State Archives, Salem, Oregon, 8.
3. *Capital Journal*, January 2, 1904.
4. "Twentieth Biennial Report of the Oregon State Hospital for the Biennial Period Ending September 30, 1922, Fifth Biennial Report to the Oregon State Board of Control, Salem, Oregon," Oregon State Archives, Salem, Oregon.
5. *Oregon Statesman*, September 19, 1957.
6. Board of Control Correspondence for OSH, Minutes of State Board of Control dated September 20, 1957, Oregon State Archives, Salem, Oregon.
7. *Statesman-Journal*, November 20, 1981.
8. Board of Control Correspondence for OSH, Report dated August 13, 1964, from Volunteer Services, Oregon State Archives, Salem, Oregon.
9. C.L. Brown, "Oregon State Hospital During the 1960s." *Oregon Historical Quarterly* 109, no. 2 (2008): 283.
10. Ibid., 284.
11. Rolla J. Crick, "Mental Hospital Beds to Move from Hallways," *Oregon Journal*, November 27, 1955.
12. Alan Gustafson, "Site Is a Nest of Memories," *Statesman Journal*, September 14, 2008.
13. James Long, "Abuse Common Link," *Oregon Journal*, December 10, 1976.
14. Alan Gustafson, "Escapes Often Not Reported," *Statesman Journal*, April 7, 1991.
15. *Oregonian*, May 16, 1991.

Chapter 12
A HOSPITAL NOT A PRISON

Superintendent John Calbreath noted as early as 1900 in his biennial report that "it is unfair and unwise to place the criminal insane with the other classes, because of personal dangers, difficulty of management, danger of escape and their contaminating association." This was the first attempt at OSH to segregate those patients who were known to be criminals and insane from those who weren't. For the next 129 years authorities struggled with how to navigate the tightrope between security and treatment of the increasing number of criminals confined in OSH.

While Dr. John Evans was superintendent in 1940, Victor Jorgenson, a reporter for the *Oregonian*, visited the hospital, including the criminally insane ward. Photos showed wards so crowded, the beds were squared off in blocks of four—head to toe, rail to rail—with only a small passage running between the blocks. Two other photos illustrated how broken down the bedsprings were and how patients were forced to share a nine- by seven-foot room.

This overcrowding was held responsible by hospital authorities for much of the violence patients exhibited. On April 10, 1944, a ward attendant, Andrew Trimpey, noticed that part of a bed was missing and, fearing an escape attempt, notified the other three attendants and began searching the patients. This alerted patient Ervin L. Wakefield and three other conspirators that he was about to be exposed, and he attacked the attendants with a blackjack. Trimpey retaliated with a piece of wood and knocked Wakefield unconscious. Wakefield died a few hours later as a result of a brain hemorrhage caused by a blow to the skull. Two other patients and three attendants received serious injuries.[1]

This photo was taken on December 8, 2009, just after the campus reconstruction began. It shows the third-floor windows barring ward 48, the maximum-security portion of the Forensic Unit. *Photo by Laurie Burke.*

Gradually superintendents imposed more and more restrictions on the patients judged to be dangerous. Wards were built for them in the most decrepit parts of the J building as the numbers continued to increase. By the time Dean Brooks became superintendent in 1955, the pendulum had swung toward the side of extreme security, and there was an average of 3,367 patients in the hospital.[2] The patients in the criminal wards were the first to experience lobotomies and the many shock therapies so popular in the middle 1900s. For the most part they languished in their jail-like wards hopeless and desperately unhappy.

As of 1955 the superintendent of OSH was personally responsible for patients designated "guilty except for insanity." Under Oregon law, "defendants could be found guilty except for insanity if they suffered from a 'mental disease or defect' that drastically impaired control or judgment at the time of the crime."[3] The courts committed such patients "to the state hospital for custody, care and treatment for a period of time that was necessary to control the person's symptoms and return her safely to society."[4] Patient crimes ranged from shoplifting to murder. Patients were also committed to the hospital forensic wards through a civil commitment proceeding in front of a judge because they were believed to pose a threat to themselves or others.[5]

In addition convicts could develop mental illness after they were in prison. In 1955 the prison doctor would evaluate the problem and request a transfer to ward 38 at OSH. Only the Board of Control, which was created in 1913 to oversee the management of Oregon's public institutions, could order the transfer of a patient between the various state institutions. If the patient was still mentally ill and a danger to himself and others at the end of his prison sentence, he could be civilly committed to OSH through the court system just as any other citizen could be committed.

Ward 38, one of the high-security forensic wards, was the only ward at the hospital with bars and strong guards in 1955. It housed convicted criminals transferred from the prison. It was located on the top floor at the far end of a section of the J building. To prevent escapes, even ward attendants could not carry keys to come and go through the single barred entrance. Attendants were only allowed to exit through ward 31 next door. William C. Ryan, supervisor of state institutions, predicted on August 23, 1955, that OSH would require separate and larger wards for such cases in the near future.[6]

In 1961, the Mental Health Division assumed power over OSH and of the forensic patients confined there. By 1962 there were nine murderers confined in ward 38—a few were mere boys.[7] Even though treatment was

being emphasized in the rest of the hospital, the forensic patients were offered very little in the way of treatment. By law forensic patients could earn a little money for the work they did at OSH, but the law did not allow the civilly committed patients to earn money for the work they did.

OSH worked closely with the prison. Because there was such a shortage of workers in 1963, female convicts at the prison were offered the opportunity to participate in a very successful program at OSH. Nine women volunteered for the program and were bused each morning from the prison to the hospital and back again each night.[8] At the hospital they worked with geriatric patients confined to their wards who needed more individualized care than other patients.

In an effort to provide treatment for the criminally insane, the Psychiatric Security Unit (PSU), composed of three thirty-bed wards, was organized in 1964 for patients committed by Oregon's criminal courts. Also called Unit VIII, it was a special secure unit serving the entire state of Oregon designed to house mentally ill men who exhibited dangerous behavior. Unit VIII included ward 82, a minimum-security ward; ward 83, an intermediate-security ward; ward 84, a maximum-security ward; and a ward for sex offenders. Ward 82 was designated an open ward because patients were allowed to come and go as they desired. Patients were kept in these wards until they were no longer mentally ill or no longer dangerous—in essence creating an indeterminate sentencing system. Wards 82, 83, and 84 were remodeled three years later in 1967.[9] The average length of stay was six or eight months, although one man had been there for over sixteen years.[10]

In 1967 Unit VIII was located in the oldest part of the hospital on the top floor in the J building. The entry to the four wards was a peach-painted steel door at the head of a long flight of stairs. Three locked doors guarded ward 83, and four doors guarded ward 84.[11] It wasn't until the 1969–71 biennium that the Board of Control authorized the construction of the Psychiatric Security Program (PSP). It was originally suggested the new wards be located in the south wing of the Center building.[12]

In 1971 the legislature rewrote the Oregon law that covered criminal insanity to read: "A person is not responsible for a criminal act if at the time of the offense his mind is so impaired by disease or defect that he lacks substantial capacity either to appreciate the criminality of his conduct or to conform his conduct to the requirements of law."[13] Authorities continued to refer to the concept as "guilty except for insanity"; however, the law now covered a much larger group of criminal defendants and made it easier to plead insanity.

In addition the 1971 legislature created the Oregon Department of Human Resources, providing a variety of services to Oregon's population, including supervision of OSH. In 2001 the department was reorganized and the name changed to the Oregon Department of Human Services, which it still retains. It had the primary responsibility for supervising and administering Oregon State Hospital until 2011, when the newly organized Oregon Health Authority took control.

The number of patients admitted through the court system as "not guilty by reason of mental disease or defect" quadrupled between 1972 and 1976. In 1972 only twenty patients had been committed to OSH with that designation. In 1975 there were seventy-nine patients admitted.[14]

Dr. Joseph H. Treleaven, clinical director of the forensic program since 1971, stated that the designation was correct about seven times out of ten.[15] Unfortunately, every time a new patient was admitted to a full ward, it caused a chain reaction and moved patients down the line. This necessitated the remodeling of a ward to add thirty beds to the maximum-security section.

He maintained that it was a complicated matter to determine mental illness in an individual. Psychologists and psychiatrists tended to be treatment oriented and might be more focused on the individual's needs rather than the danger that individual might present to society. He believed that most hardened criminals were what psychologists called sociopaths, or persons with a total disregard for the welfare of others. Sociopaths committed to OSH by the courts rarely wanted treatment yet could not be returned to prison. In 1976 a bed in the secure ward cost $1,700 per month, which he believed could be better used by a patient wanting treatment. He also recognized that certain patients were too dangerous to be allowed free movement among society.

When patients ruled "guilty except for insanity" were committed to OSH, nurses, psychiatrists, psychologists, and other attendants worked with the patients to help them get well, not to punish them for actions they were unable to control. It was a precarious tightrope trying to allow the patients enough freedom to get well and enough security to keep them and society safe. "Program managers and staff juggle dueling responsibilities—dispensing therapy, which often includes doses of freedom for patients granted passes for community outings, and running a safe and secure institution. It's a tough balancing act in a cramped, woefully outdated facility that is part hospital, part prison."[16] Patients benefited from passes to visit family, go shopping, attend meetings, go to the library, and participate in rafting trips. Typically hundreds of patients participated in outings each month. Occasionally a patient took advantage of these opportunities and took an unscheduled leave.

This tightrope occasionally had unintended consequences and staff members working on the forensic wards suffered injuries caused by patients. Because of allegations by the Oregon State Employees Association (OSEA), the union representing psychiatric aides, that aides were being injured because of low staffing levels, emergency funds were allocated in 1974 to increase the number of employees working on the wards with forty to fifty patients. "Only three of four psych aides work on a ward on the day and swing shifts and there is just one psych aide on duty at night."[17] After many of the patients with more moderate problems were released into the community, the more violent patients were left and staffing levels were not increased to accommodate the intensified violence. As a protective measure psychiatric aides in the high-security wards were the only ones who wore "whites," or hospital uniforms, to make it easier to distinguish between staff and patients in case of a riot. A sure way to discern between staff and patients was to look at their feet. The patients usually wore house slippers, and the staff wore shoes.

The 1974 Comprehensive Employment Training Act (CETA) designated funds for twenty positions at OSH.[18] Five of those positions were for psychiatric aides to work in the forensic wards.

There was only one ward at OSH for women who had been identified as dangerous to themselves or others. Ward 81 was in a long, dark corridor with small rooms on either side. Metal screens covered the windows in each room, and a single electric bulb dangled from the ceiling. This part of the J building was so old that cast-iron pipes formed the head and foot of each bed and ancient radiators were located between the rooms. Patients weren't allowed matches, glass containers, or razors on the ward. This ward offered little in the way of treatment until Dr. Treleaven became clinical director in 1971. He used money allocated in 1969 to remodel and update ward 81. He assigned social workers to conduct group therapy, and bright modern furniture arrived to cheer up the ward. Occupational therapists were hired to supervise craft projects. Patients began participating in ward upkeep. All this allowed the staff to spend more time with patients, who were given more responsibility and input into their treatment plans by way of a ward patient council.[19]

Virginia (last name withheld for privacy) was typical of the patients confined to ward 81. While in prison, she had destroyed her cell by tearing out the plumbing; breaking the windows, light fixtures, and furniture; and ripping up her bedding. Then she was confined to a punishment cell, which she destroyed by ripping off the plaster and removing the plywood that

replaced it. At OSH she had to be strapped in restraints to her bed. Finally in 1964 heavy doses of tranquilizers effectively reduced her angry outbursts and allowed staff to involve her in treatment. She had been mentally ill since she was ten years old.[20] She began participating in ward activities after 1971.

In 1975 photographer Mary Ellen Mark and writer Karen Folger Jacobs spent four weeks living in ward 81 with the patients. While acknowledging the improvements in ward décor and treatment, their primary impressions focused on the patients themselves and how physically scarred and depressed the women were. Many had been in serious accidents, cut themselves, lacked basic medical care to remedy physical impairments, and seemed to have no incentive to care for themselves. "There's a general impression of poor or missing teeth, of eyes that don't focus properly, of clothes worn so sloppily they look like hand-me-downs from some undetermined era."[21]

In November 1977 the ward was once again remodeled, and high-security ward 81 became part of a co-educational treatment ward. Very few of the women from the ward successfully transitioned to the outside world. Two died soon after they were released.

In another part of the hospital was ward 35-C, also called LIT or Locked Intensive Treatment. It was a transition ward for thirty severely disturbed patients staffed by only three attendants.[22] Patients who were transferred out of Unit VIII were put in ward 35-C. Patients in the minimum-security wards who exhibited violence, either by hurting staff or other patients, were transferred into ward 35-C. The most exciting time of day in the ward was when snacks consisting of milk and peanut butter and jelly sandwiches were handed out. Trained staff dispensed medications four times a day.[23] It wasn't unusual for a few patients to get violent when their demands were thwarted. They lashed out against the staff or against each other. A patient might get frustrated and throw a cue ball, hopefully denting the wall instead of someone's head. "People will swing at you. They'll try to put out a cigarette in your face," a staff member remarked.[24]

In addition to patients judged "guilty except for insanity" in crimes like robbery, car theft, assault, and murder, there were mentally ill men convicted of sexual offenses. In 1955 the Oregon legislature passed Senate Bill 31. It provided a means for sex offenders to be sent to OSH for presentence examinations, although OSH did not have any treatment programs available for sex offenders at that time. Research had determined that 18 percent of sex offenders were likely to commit new attacks if released and were not considered treatable. At least 31 percent were not treatable because of their personality, age, or alcoholism. Treatment could be advantageous for

43 percent of the patients, and 8 percent could be released on parole and treated on an outpatient basis.[25]

The first patient designated "sexually dangerous" was admitted in September 1963 under Chapter 467 of the Oregon Laws. The new law instructed the authorities at OSH to arrange a separate and secure ward to house sexually dangerous individuals. The law allocated $136,797 to buy furniture and purchase supplies to carry out the provision. Further changes in the law followed in 1965 outlining the process of admitting, evaluating, and assigning housing to such individuals. It was decided that such a program should be in a completely separate facility and part of a separate treatment program.

In 1965 the applicable laws governing sex offenders were contained between ORS 426.510 through ORS 426.670. In summary the laws provided that if a district attorney suspected a person was sexually dangerous, he issued a complaint and the person was arrested. If the suspect was also mentally ill, he was transported to OSH with a summary of his record and presented for evaluation.[26] "The state must provide a completely separate treatment facility to receive, treat, study and retain in custody, sexually dangerous individuals committed to OSH."[27]

Funds were finally allocated in 1965 to build a secure unit at OSH for sex offenders. Three wards housing seventy male patients were designated maximum, medium, and minimum security (wards 38, 31, and 9, respectively). Remodeling and staffing costs totaled $219,349. This included one physician, one psychiatric social worker, one psychologist, one nurse, one occupational therapist, one secretary, four hospital technicians, and seventeen psychiatric security aides.[28]

By June 30, 1968, over seventy sex offender cases were received at OSH for evaluation. Of those cases, fifty (thirty-one court, nineteen voluntary) were accepted for treatment, and thirty-five of those were eventually paroled or discharged. Up through 1968, of those discharged, only one was re-arrested due to sexual misconduct.[29] Therapy consisted mainly of group therapy sessions.

In 1982 a new program for sex offenders in ward 47B was instituted that implemented the newest research and treatment techniques for this population. In 1983 OSH began offering a sexual aversion therapy program. "The treatments, which extend over two years, are designed to teach the inmate to control sexual impulses by consciously returning to a state of relaxation after he has been stimulated," said Dr. Jack Seidler, Oregon State Penitentiary's chief psychologist.[30]

Aversion therapy had only limited success, and many states mandated drug therapy as a requirement for parole. Depo-Provera was a drug

that created sexual apathy by reducing the level of testosterone, sperm production, and sexual appetite. In 1986, *Psychology Today Magazine* published a report featuring two Oregon psychologists using Depo-Provera.[31] The drug was originally developed and used in Europe as a contraceptive for women. The U.S. Federal Food and Drug Administration approved the drug for use in treating sex offenders but not for contraception. The drug had only a limited application in the field. Dr. Barry Maletzky, a Portland psychiatrist, stated that it was only useful in about 1 percent of all sex offenders. Side effects included headaches, cramps, and weight gain. It was a powerful anti-androgen that reduced a man's testosterone production and inhibited sexual functioning to some degree. Coupled with behavioral therapies, it was occasionally used to help men moderate their sexual fantasies.[32] A Johns Hopkins Hospital study found that 85 percent of the offenders taking Depo-Provera during a three-year time period did not offend again.[33] In the mid-1980s the Oregon legislature authorized a study of Depo-Provera. However, the authors attached so many restrictions to the study that no one ever qualified to participate in it.[34]

Physical castration came up for debate in 1991 as a treatment option for repeat sex offenders. State Republican leaders began advocating castration for willing individuals who wanted to reduce their prison sentences. Authorities disagreed whether castration was ethical or effective.[35]

As the pendulum swung toward treatment, offenders were allowed many of the same privileges allowed other OSH patients. In 1990 eight sex offenders participated in the hospital's popular outdoor recreation program. On March 27 the patients from ward 47B and three staff members went on a three-day ski trip at Big Lake Lodge at the base of Mount Washington near Camp Sherman.[36] Patients in ward 41B, housing thirty-one offenders from the prison system, were excluded from participating in the outdoor program. The sexual offenders program was closed for financial reasons after 1991.

Before Dr. Dean Brooks retired he helped Oregon develop a new and completely novel way to oversee the forensic population at OSH. The Oregon legislature authorized the development of the Psychiatric Security Review Board (PSRB) in 1977 to supervise persons who were found "guilty except for insanity." The board was created to toughen sentences for mentally ill criminals and was composed of an interdisciplinary team of five members who did not work for OSH: a psychiatrist, a psychologist, a criminal lawyer, a person from the parole/probation system, and a member of the general public. The board had the authority to discharge patients on an early conditional release program when they were deemed mentally

fit and no longer dangerous to themselves or others. Typically that meant a patient spent 2.4 years at OSH—nearly double that of the usual prison inmate.[37] If a patient committed a crime, had a mental relapse, or did not follow rules set down by the board, he could be sent back to the hospital. "The board can only hold patients for the maximum number of years that a person may have been sentenced had that person been sane and found guilty of the crime."[38] Many other states went on to develop their own boards in an imitation of Oregon's innovation. All forensic patients at OSH were under the supervision of the Oregon PSRB until the passage of Senate Bill 420 in 2012, at which time patients with less severe crimes were placed under the jurisdiction of OSH while they were housed in the hospital.

Dr. George Suckow, chief medical officer of OSH in 1983, had this to say about Oregon's PSRB: "Oregon is being held as a national example because we have our psychiatric security review board."[39] The board reviewed forensic cases, and it was its decision that determined when a forensic patient was well enough to leave. The board also monitored forensic patients after they were released.[40] Between 1997 and 2002 the PSRB averaged 71 new cases per year. By 2003 the number of new cases had grown to 110 per year. In 1999 Dr. Suckow, as an expert in forensic psychology, was asked by Lane County to examine Kipland P. Kinkel after he was arrested and charged with the murder of his parents and his classmates.[41]

Between January 1982, when Dr. Brooks retired, and 2010, OSH was to have six superintendents. For an institution as large and complex as OSH, such fundamental changes every few years seemed to adversely affect every aspect of its management. One of the primary effects was lack of coordination and leadership for the forensic population.

On August 1, 1982, Dr. James Bradshaw became superintendent at OSH. He had been associate superintendent for eleven years and acting superintendent for eight months following the retirement of Dean Brooks.[42]

Hopes for a new forensic center died in 1983 when state funds were channeled into the prison system and an economic depression hit. That same year a state task force concluded the hospital buildings were "aged, obsolete, unsafe and visibly deteriorating from years of neglect."[43]

A scandal erupted in November 1983 when Art Frank, a property control manager at OSH, delivered a five-hundred-pound bronze sculpture of Christ to Secretary of State Norma Paulus. An *Oregonian* news article published on November 10, 1983, identified Frank as the person finding the bust under some old wooden screens.[44] Unfortunately the article unleashed a storm of controversy concerning OSH's mismanagement and loss of dozens of

antiques. Superintendent James C. Bradshaw threatened to fire Frank. Instead Bradshaw and two other employees were put on administrative leave on November 21 while the state conducted an investigation into the problem.[45]

Superintendent Bradshaw was asked to resign and turned in his resignation thirty days later, and Art Frank kept his job. An investigation into other missing artifacts revealed that employees were "afraid to testify about the possible theft or appropriation of items from hospital wards, attics, and locked rooms." The final report criticized Bradshaw, who "appeared to have isolated himself from many of his own employees and to have assumed an attitude of uncooperative resistance to external direction."[46] Eventually the original list of 615 missing articles worth $222,684 was reduced to a list of 376 items worth $118,509.[47] The hospital's chief financial officer was fired and the director of support services was demoted.[48]

Dr. Robert J. Benning, previously director of Child/Adolescent Secure Treatment Program at OSH, was hired as superintendent.[49] He assumed leadership at the hospital until December 1987 when Dr. George W. Bachik was hired. Dr. Bachik had previously been superintendent at Idaho State Hospital, a 232-bed facility, for eight years. He began work on December 7 at a salary of $52,848.[50] He was hired because of his experience at moving patients out of the hospital into semi-independent group homes. At that time OSH had 710 patients, operated on a $6.7 million yearly budget, and specialized in "geriatrics, child and adolescent treatment, forensics, and general psychiatrics."[51]

The hospital was struggling to find acceptable community housing for forensic patients as they qualified to leave the hospital. While it was a problem finding any kind of group housing outside the hospital, it was even more difficult for convicts and sex offenders. In 1998 two group homes housing eight mentally retarded sex offenders from Fairview came under fire by neighbors. The men had records of severe sexual aggression—child molestation, rape, and public masturbation.[52] The two homes were on OSH grounds less than a block away from a Head Start program.[53] Head Start officials were relieved after meeting with supervisors and learning about the rules governing the patients. "Each home has three staff on duty during day shifts and two staff at night. We don't lock homes, but there are security alarms and it's staff secure. People must be under supervision at all times if they go to work or downtown or whatever."[54] Education and reassurance were often the only ways approval for group homes could be obtained.

After the escape of double murderer Michael McCormack in 1991, differences between the professional staff and the ward employees were

publicized in the local newspaper. The essence of the controversy involved the ongoing clashing views about security and treatment of the criminally insane. The line staff and nurses living with the patients eight hours a day felt their opinions and input were being ignored by the professional therapists. Therapists believed that criminal behavior could be excused by the patient's mental illness and tended to lose sight of the need to protect the public because their primary drive was to rehabilitate patients. Although trained to provide treatment, many of the therapists lacked the knowledge about how to determine risk to deal with the criminal aspects of their patients' behavior. Manipulative and intelligent con men like Michael McCormack and Robert Langley used their therapists' perceived weaknesses to secure unsupervised pass privileges. Attendants living and working within the forensic wards often had a different viewpoint. One worker stated after McCormick's escape, "Professional staff and supervisors downplayed security concerns, and were unwilling or unable to discipline unruly patients."[55] Superintendent George Bachik dismissed their concerns: "This is a hospital, not a prison. Treatment is our mission. We've got to get people ready to leave this place."[56]

Occasionally patients decided they were well enough to leave on their own. Dr. Bachik's focus on treatment over security facilitated the unauthorized leaves and ultimately led to his demise as superintendent.

In 1991, after an investigation revealed serious security flaws in the hospital's supervision of its forensic patients and the escape of twenty-three patients in the previous year, Dr. Bachik resigned. Dr. Stan Mazur-Hart was hired as superintendent on April 8, 1991, at a salary of $101,844 per year. The pendulum was now swinging back toward more stringent security. Dr. Mazur-Hart had been chief psychologist at OSH, served as acting superintendent for seven months in 1987, and had been superintendent at Dammasch State Hospital since December 1987.[57]

One of the first actions this "hardline" administrator took was to enclose the exercise yard used by forensic patients with more secure fencing and razor wire. He focused on improving staff security and safety levels. The use of restraints and seclusion for unruly patients increased. Increased staffing levels and security concerns became the primary focus of OSH administrators for the next twelve years.

Several staff members seemed to adopt their role as security guards rather than treatment providers. Between 1994 and 2003, while Dr. Mazur-Hart was superintendent, there were 126 accusations of patient abuse involving neglect, verbal abuse, and physical abuse—or about 12 per year.[58] Between 2001 and October 2004 records showed that staff beat, kicked, humiliated,

Dr. Stan Mazur-Hart was superintendent from 1991 to 2003. *Oregon State Hospital.*

and tormented patients in over 50 substantiated incidents of abuse.[59] It wasn't unusual for staff to address patients with demeaning names such as "retarded" or "zombie." Internal hospital investigations caused one staff member to resign and six staff to be fired.

In 1995 a young woman sued the hospital after being molested by two OSH employees. Superintendent Mazur-Hart confirmed her allegations after an investigation. However, the employee who supported her claim, Michael Donnelly, was subsequently removed from his position and eventually fired. Charges of retaliation against whistle-blower Donnelly were leveled against Dr. Mazur-Hart, even after he retired in 2003. One of the abusers was allowed to resign and the other was allowed to continue doing patient care until 1998.[60]

A serious event transpired in 2001 when Ben Bartow, age forty-one, died of a heart attack caused by an altercation with hospital staff. A group "tackled him after a disagreement over soda pop, then tied him to a restraint bed while he was unconscious."[61] Eventually they noticed he was dead. Bartow's family sued the hospital and collected $200,000. Steven J. Mathieu, attorney for the Oregon Advocacy Center, believed it was an avoidable death. "Oregon

State Hospital staff should have intervened to prevent the escalation. But because of the overcrowding and understaffing, staff were unable to pay as much attention to the warning signs as they should have."[62]

On April 2, 2002, eight employees were reassigned as the result of an investigation into racism complaints. Tyrone Waters, son of state Senator Avel Gordly, was diagnosed with paranoid schizophrenia in 1994 and had been a patient at OSH since October 5, 2001. Senator Gordly filed a complaint after hearing about some significantly derogatory remarks aimed at her son. Within two weeks of the complaint being filed, an OSH physician suddenly changed his diagnosis and judged Tyrone capable of standing trial. He was transferred back to Multnomah County Justice Center Jail. He had been arrested September 17, 2001, for aiming a pellet gun at police. Waters had been a patient in ward 48C, a high-security forensic ward.[63] The timing of the transfer was suspicious, and professional staff was held accountable.

In 2003 allegations against staff psychiatrist Dr. Charles E. Faulk, age fifty-three, emerged when a group of patients brought suit against the hospital. It was discovered that he had deliberately withheld medications from Neil Norton in June 2002 after accusing him of being "a pill seeker."[64] For seven months Faulk cut off Norton's medications and ignored staff warnings that Norton was not doing well. In January Dr. Faulk ordered six electroshock treatments be administered instead of returning Norton to his previous medications. Dr. Faulk was put on leave after it was determined that his actions violated Oregon's patient-abuse laws.

Dr. Faulk had been hired on July 15, 1984, to head the hospital's electroconvulsive therapy program and was paid $9,756 a month. After the 2003 suit was filed, it became known that he had nearly lost his own medical license for "habitual or excessive use of intoxicants or drugs" and had been on probation by the Oregon Board of Medical Examiners for the previous ten years. Other patients claimed Faulk had used derogatory language toward them. Superintendent Mazur-Hart concluded later that year that there was insufficient evidence to substantiate the abuse charges brought by the patients.[65]

Superintendent Mazur-Hart's conclusion was not acceptable to the patients or the community, and he resigned his position on July 22, a week later, and left the hospital on September 30, 2003.[66] "Patients responded to the resignation with cheers, song, and strong support for new leadership."[67]

As part of the Faulk investigation it was discovered that four of the twenty-two psychiatrists who treated the seven hundred patients at OSH had been disciplined or had their medical licenses restricted by the

medical board. Low salaries made it difficult to attract top psychiatrists to fill another five open positions.

When Dr. Mazur-Hart retired he stated that the hospital's advancements while he was superintendent were the "direct result of hard-working, dedicated employees, both clinical and non-clinical, both union and management staff."[68]

The number of patients in the forensic wards increased drastically after 2002, when U.S. District Judge Owen Panner ruled that the state had violated the rights of mentally ill criminals by making them wait in local jails until a bed became available. Now instead of waiting weeks or months to be transferred to OSH they were to be admitted within seven days of being declared unfit to stand trial. After the ruling, the hospital had no choice but to accept patients immediately.

The hospital was becoming overwhelmed with the number of patients being held in its forensic wards. It was decided a new emphasis on treatment was needed in 2003. On March 26, 2004, Dr. Marvin Fickle, age fifty-four, was hired as superintendent of OSH at a salary of $156,432.[69] Dr. Fickle had been chief psychiatrist for the Oregon Department of Corrections since 1999 and, prior to that, superintendent of Dammasch State Hospital. Before then, he had been the chief medical officer at OSH.[70] Superintendent Fickle led the effort to open OSH to the outside world. He guided hundreds of tours into the back corners of the hospital, gave even more newspaper interviews, and pushed for increased budgetary support from the legislature.

Superintendent Fickle stated, "It is scandalous in the way that the state has failed to keep up its services to the mentally ill. One small part of this is the state hospital. It's become a very difficult situation to work in and certainly to be a patient at, and it has gotten progressively worse over the years. Something needs to be done."[71] Superintendent Fickle reported that as of 2004 Oregon spent half of its annual $180 million budget for mental health on the Oregon State Hospital, which served less than 1 percent of those who needed psychiatric care.[72] Only by investing the $90 million in community-based mental healthcare could the state receive a matching amount from Medicaid funds. The number of patients found "guilty except for insanity" and placed under the jurisdiction of the Psychiatric Security Review Board had increased dramatically. Superintendent Fickle summarized the problem of finding outside housing for patients:

The Oregon Department of Human Services (DHS) has moved ambitiously forward in building a community-based system of housing and treatment

*for people discharged from the hospital, but even their best efforts can
scarcely meet the growing need for placements of both civilly committed and
forensic (PSRB) patients. The rising cost of housing, the objection of some
communities and licensing requirements, means that opening additional
resources takes time.*[73]

Authorities feared that even if the hospital were closed, adequate
community facilities would not be approved to replace it. The shortage of
group homes already delayed the placement of a significant number of
patients into facilities outside the hospital. The hospital's 1,150 employees
feared they would lose their jobs if the hospital was closed or massive changes
were made in programs.

Overcrowding became an explosive issue when 16 staff members and 18
patients in ward 50I, a medium-security ward housed in the 50 building, signed
a letter requesting Governor Ted Kulongoski inspect the living conditions in
the forensic wards. The July 2004 letter emphasized that the forensic program
was designed to hold 404 patients but was now crammed with 460.[74] Ward 50I
was a co-ed ward housing 44 patients in a space meant for 30. Such crowding
caused stress for the patients and hampered treatment options.

As a patient stated, "There's a lot of friction, a lot of frustration, a lot
of fights, a lot of confrontations." Patients complained about the lack of
privacy, rigid security, and boredom. Daily activities included television,
yoga and Pilates classes, and group therapy classes. While this ward had less
violence, the patients were just as unhappy.[75]

The forensic wards held 65 percent of the hospital's 735 patients in 2004.[76]
The program was very expensive, and overtime payments for the staff cost
75 percent of the $11 million personnel charge during the two-year budget
period ending on June 30.[77]

Located in the 123-year-old J building, maximum-security ward 48C
housed twenty-nine patients in 2004. One of the most famous patients at
OSH at that time was Ward Weaver. After his trial for murdering two young
girls in Oregon City in 2002 started, he became suicidal and was transferred
to OSH for evaluation in April 2004. Ninety days later he was judged
competent and returned to Clackamas County Jail. On September 22, 2004,
he avoided the death penalty by pleading guilty to the aggravated murder of
the two girls. The ward was filled with violent and dangerous patients.

While at OSH waiting for an evaluation, Weaver was in the same ward
as another notorious killer, Edward Morris, who was accused of killing his
pregnant wife and three children in Tillamook County in December 2002.[78]

During this period, a violent patient in the maximum-security ward punched Morris in the face.

Unable to describe the exact circumstances that caused the altercation because of privacy laws, Jim Sellers, a department spokesman, explained what generally happened in cases of patient violence. "State hospital staff try to protect people who are subject to threats as much as possible, short of locking them in a cell," Sellers said. "And if there is an incident, certainly hospital staff intervene. Medical attention would be administered."[79]

Altercations were not unusual inside the forensic program when so many highly volatile and dangerous patients were crowded together. Weaver had also been involved in a fight after another dangerous patient in ward 48C, Todd Van Dorn, took a swing at him. "I get this creepy feeling when [Weaver's] around. He was sending bad vibes off," explained Van Dorn.

Van Dorn was a problem patient, defying security protocols and abusing privileges. In December 2004 he attacked his psychiatrist with a pen and tried to stab him in the neck. He planned to use the assault to get transferred from OSH to the prison. Staff members came to the doctor's rescue and averted any serious injury.[80] Van Dorn was put in the seclusion and restraint rooms on a regular basis. This was Van Dorn's fourth stay at OSH. His PSRB jurisdiction ends in 2021, when he will be free.

Patient violence escalated in 2004 as 200 staff injuries were recorded from January through October.[81] There were only 185 in the whole twelve months of 2003.[82] Established procedures did not allow for a co-worker to drive a staff member to the hospital for treatment because the wards were so understaffed. OSH administration had maintained a disinterest in prosecuting or investigating staff assaults. State police and Marion County police were called for only the most serious felony assaults. There had been fewer than five criminal investigations into patient assaults since the early 1990s.[83]

Overcrowding was blamed as the cause of increased assaults against staff in 2004. According to Superintendent Marvin Fickle, restraints, seclusion, and isolation were very rarely used after he became superintendent in 2004. The decreased use of restraints and seclusion seemed in direct contrast to the increased violence.

Security was heightened at OSH in October 2004 after Douglas Ashcroft tore the toilet seat off in his room and hit a male staff member in the side of the neck with it and then punched him in the face. Ashcroft was arrested and charged with second-degree assault.

In December 2004 Todd Van Dorn beat and kicked a female staff member. The state police investigated the assault and planned to file charges. As a

result video cameras and TV monitors were finally installed in 48C and 48B, the two maximum-security wards.

At the end of 2004 the *Salem Statesman Journal* conducted a two-month investigation into conditions at OSH. It concluded that there were six factors that, combined with the volatile nature of patients in the Forensic Program, created an explosive situation:

1. Overcrowded and outdated facilities.
2. Systematic problems with court order committing alcoholics, drug addicts, and criminals who didn't belong there.
3. Overly strict policies and monitoring by the PSRB.
4. Failure to develop community housing for released patients.
5. Severe institutional understaffing.
6. Failure to investigate and prosecute patient assaults against staff.

Even after drug and alcohol dependency was disqualified as legal grounds for declaring someone mentally ill, courts continued to send these patients to OSH. The Oregon legislature had revised the state laws in the 1980s to exclude alcoholism, drug addiction, and certain sexual disorders from the definition of mental illness. The PSRB had been interpreting the law differently. In 2004 the Oregon Court of Appeals ruled the PSRB was in error and advised it to correct its procedures.

Positive events were openly acknowledged at OSH. The Oregon State Hospital Foundation was organized in 1993 to "promote excellence in mental health services and to improve the quality of life for State Hospital patients."[84] The foundation had donated $87,000 to the hospital since it was organized. In 2006 it gave a total of $9,494 to OSH for a variety of uses:

$2,900 for musical instruments
$400 to help pay for patients' education expenses
$650 to purchase a greenhouse so a ward could learn gardening skills
$344 for yarn spinning supplies
$100 to purchase aquarium fish
$4,000 for diversity activities in Portland and Salem

On October 2, 2006, the Oregon Department of Human Services announced that thirteen mental health excellence awards were being presented. Awards were offered to people and groups who worked hard to give outstanding advocacy, compassion, and professionalism.[85] Some of the

awards honored OSH staff members Debra Lamp, Lonna Chase, Kathy Roy, Mesme Tomason, and Cindy Koch.

After three years Dr. Marvin Fickle resigned as superintendent on October 1, 2007, and took a position as a psychiatrist in the hospital's forensic program for the criminally insane. During his tenure, patient violence had escalated, but he had successfully exposed some of the worst problems at OSH to the legislature and to the public. His "candid leadership style spurred efforts to replace the 124-year-old psychiatric facility."[86] He acknowledged that during the 3 years he had been superintendent he had accomplished his goal of getting the hospital back into the mainstream and not "some kind of a black box over there on Center Street." Dr. Fickle reminded the public that OSH was there to treat persons with mental illness, not to serve as a prison.

Robert E. Nikkel, Oregon mental health and addictions commissioner between 2003 and 2008 and assistant to the director of the Department of Human Services, which now operated OSH, praised Dr. Fickle. "Marvin Fickle helped the state craft the master plan for new hospitals, win a commitment from the Oregon Legislature and secure the greatest public understanding of mental health in our state's history."[87]

After a nationwide search, Dr. Roy Orr, age fifty-five, was hired on February 25, 2008, as superintendent at OSH for a salary of between $80,100 and $123,924. He had been with McKenzie-Willamette Hospital in Springfield, Oregon, for fourteen years. His job included supervising inpatient programs and overseeing planned improvements in hospital operations and patient care programs.[88]

The forensic program continued to draw headlines after escapes. In 2008 Thaddeus Ziemliak, age twenty-three, committed after shooting and killing his mother in 2004, escaped while visiting a store in Salem.[89] He was with another

Dr. Roy Orr was superintendent from 2008 to 2010. *Oregon State Hospital.*

patient and one staff member when he took off running from the Big 5 sporting-goods store parking lot on Lancaster Drive. After his escape he was recaptured two days later in Washington.[90]

While escapes garnered public attention, cases of patient abuse always held the headlines. The most highly publicized case of patient abuse at OSH occurred on October 17, 2009, when Moises Perez, a patient in ward 50F, a medium-security ward, was discovered dead.[91] Perez had been admitted in 1995, diagnosed with chronic paranoid schizophrenia, and was to remain in the hospital under supervision of the state Psychiatric Security Review Board until 2034. He had been found "guilty except for insanity" for attempted murder. He was forty-two years old, five feet eight inches tall, weighed three hundred pounds, had high blood pressure, and was in terrible physical shape.[92] No one had seen him since breakfast the morning of October 17, and his body was discovered in the evening when staff was distributing evening medications. The staff consisted of a registered nurse, a single attendant, and three "floaters" to supervise forty-two men in ward 50F. A subsequent autopsy proved that Perez had died from natural causes as a result of coronary artery disease.[93]

A representative of the U.S. Department of Justice's Civil Rights Division wrote, "OSH therapists, nurses and staffers consistently failed to provide Perez with adequate supervision, nursing, medication, medical care and psychiatric treatment during the last year of his life. His care failed to meet generally accepted professional standards and consistently fell well below constitutional and statutory standards."[94]

The state replied by noting twenty-five significant improvements in patient care made at the hospital since January 2008. These included "enhanced patient monitoring, increased medical and nursing staffing levels, and new standards for dispensing medications."[95] OSH had also committed $250 million to erecting a new hospital and $60 million to hiring five hundred new employees to reduce staffing shortages. The death of Moises Perez seemed to finally create recognition that change was necessary. After an extensive investigation into the Perez case, five employees were issued letters of reprimand. The reprimanded employees all stated overwork and understaffing made it difficult to follow the hospital's established policies regarding patient records and monitoring.[96] The Perez family filed a wrongful death lawsuit against the hospital in February 2011, asking for an unspecified amount of money.[97]

Superintendent Roy Orr was forced by Richard Harris, head of the Addictions and Mental Health Division of DHS, to resign as superintendent

on April 1, 2010.[98] "I asked for his resignation because it was time to make a change in leadership," Harris stated. It was felt that reform efforts had become "bogged down" at OSH since Dr. Orr had become superintendent. Dr. Orr's resignation came after he apologized to the hospital's advisory board for not notifying it of a scathing federal critique of the Perez case before it hit the presses. "The case has raised new and complex questions about whether the hospital can assume guardianship for a patient who refuses medical care, or take legal steps to compel such treatments."[99]

Dr. Roy Orr had helped reduce the use of seclusion and restraints to control violent patients, assisted in opening six cottages as transitional housing for patients, contracted with a software company for a new electronic record-keeping system for the hospital, and supervised the construction of the new buildings at OSH during his two years as superintendent.[100]

Greg Roberts became OSH superintendent on September 20, 2010. *Oregon State Hospital.*

By 2010 there were 503 patients in the hospital, and 344 of those were there because they were found "guilty except for insanity." The *Oregonian* conducted an investigation in 2010 that showed "a mental health system that is professionally inconsistent, financially inefficient, and often sadly inhumane."[101]

The treatment versus security pendulum seemed to cease swinging back and forth from one extreme to another when Gregory Roberts, age fifty-nine, was hired as superintendent on September 20, 2010, at a salary of $236,640.[102] He had worked previously as assistant director at the New Jersey Division of Mental Health Services, where he oversaw four adult psychiatric hospitals. He had a difficult job ahead of him as he supervised the construction of the new buildings and implementation of

a totally new kind of psychiatric service at OSH. In addition he had the usual problems associated with leadership of an institution holding such a large population of forensic patients.[103]

Within two years it was clear that OSH had once again established itself as a hospital. Superintendent Greg Roberts stated in January 2013, "We are a psychiatric hospital. Our job is to provide them with treatment so they can return to the community and do that in a safe and therapeutic environment."[104]

It was impractical to itemize every policy and legal change that affected OSH over the last thirty years. Hopefully this chapter gave an idea of the major shifts OSH experienced during that time as it struggled to find a balanced synthesis of both treatment and security. It is interesting to note the influence each superintendent was able to bring with him to the hospital operations and culture. Even in an institution as large as OSH, leadership is, and always will be, vital to the way patients experience treatment. Just as that anonymous writer "M" warned in 1882, the hospital leader must be the one with "the largest experience, attainments, and character," and the hospital must be "a means of cure, and who can administer the means of cure so well as the physician."[105]

NOTES

1. *Oregonian*, April 13, 1944.
2. "Thirty-Seventh Report of the Oregon State Hospital for the Biennial Period Ending June 30, 1956," Oregon State Archives, Salem, Oregon.
3. Michelle Cole, "The High Price of Oregon's Insanity Plea; Patients Sent to the State Mental Hospital Cost Millions," *Oregonian*, February 12, 2011.
4. Bob Joondeph, "A Hospital, Not a Prison," *Oregonian*, September 25, 2011.
5. *US Fed News Service*, June 7, 2007.
6. Board of Control Correspondence for OSH, letter dated August 23, 1955, from William C. Ryan, supervisor of state institutions, to Mr. M. George Bissell, Oregon State Archives, Salem, Oregon.
7. Harold Hughes, "State Hospital Offers Latest in Treatment for Mental Illness," *Oregonian*, January 10, 1963.
8. Ibid.
9. Board of Control Correspondence for OSH, Dean K. Brooks, MD, "Oregon State Hospital, Mental Health Division-OSH, 1968," Board Oregon State Archives, Salem, Oregon.

10. James Long, "Some Fake Insanity to Beat the Rap," *Oregon Journal*, December 9, 1976.

11. Ibid.

12. Brooks, "Oregon State Hospital, Mental Health Division."

13. Ed Mosey, "Confinement of More Criminals to State Hospital Stirs Concern," *Oregonian*, February 22, 1976.

14. Ibid.

15. Ibid.

16. Alan Gustafson, "Security Slips at Hospital Still a Problem," *Statesman Journal*, December 9, 2007.

17. Oz Hopkins, "Mental Patients 'Run Wild,' State Hospital Workers Say," *Oregon Journal*, September 14, 1974.

18. *Oregon Journal*, November 19, 1974.

19. C.L. Brown, "Oregon State Hospital During the 1960s," *Oregon Historical Quarterly* 109, no. 2 (2008): 288.

20. *Oregonian*, June 21, 1964.

21. Karen Folger Jacobs and Mary Ellen Mark, *Ward 81* (New York: Simon & Schuster, 1979).

22. James Long, "OSH Falling Apart—'But It's Only for the Mental Patients,'" *Oregon Journal*, December 6, 1976.

23. James Long, "35-C: Another World," *Oregon Journal*, December 7, 1976.

24. Ibid.

25. Board of Control Correspondence for OSH, letter dated February 28, 1955, from D.K. Brooks, MD, superintendent of OSH, to Senator John Merrifield, Oregon State Archives, Salem, Oregon.

26. George Wittemeyer, "A Summary of Oregon Statutes Pertaining to Mental Retardation and Mental Illness," published by Mental Health Division, Oregon State Board of Control, September 1965, Oregon Historical Society Research Library, Portland, Oregon.

27. Board of Control Correspondence for OSH, letter dated March 1, 1965, from Robert Y. Thornton, attorney general, to Mr. J.J. Peet, secretary, Oregon State Board of Control, Oregon State Archives, Salem, Oregon.

28. Ibid.

29. Board of Control Correspondence for OSH, Dean K. Brooks, MD, Mental Health Division Report, OSH, 1966–1968, Oregon State Archives, Salem, Oregon.

30. Adrianne Page, "Repeat Sex Offenders Urge Earlier Treatment," *Oregonian*, April 19, 1983.

31. Alan Gustafson, "Concerns Limit Testing of Drug," *Statesman Journal*, November 9, 1992.

32. Ibid.

33. Alan Gustafson, "Castration for Sex Offenders," *Statesman Journal*, April 30, 1990.

34. Jim Redden, "Sex Offenders," *Willamette Week*, March 8, 1990.

35. Ibid.

36. *Statesman Journal*, May 20, 1990.

37. Alan K. Ota, "Inmates Using Murder, Suicide to Escape the Terrors of the Deadliest Ward," *Oregonian*, October 28, 1987.

38. Alan Gustafson, "Neglected Wards," *Statesman Journal*, December 27, 2004.

39. Perri Strawn, "100 Years of Steady Progress," *Statesman Journal*, October 16, 1983.

40. Ibid.

41. Maxine Bernstein, "Court Restricts Psychiatrist's Opinion of Kinkel," *Oregonian*, March 6, 1999.

42. *Oregonian*, December 6, 1983.

43. Alan Gustafson, "Ward 50I: Prisonlike Setting," *Statesman Journal*, December 26, 2004.

44. Don Jepsen, "Mystery Bust Starts Historical Scramble," *Oregonian*, November 10, 1983.

45. Don Jepsen, "Historical Sleuth Quits Job at Hospital," *Oregonian*, November 12, 1983.

46. John Hayes, "Hospital Probe Stuns Officials," *Oregonian*, January 12, 1984.

47. John Hayes, "State Hospital Audit Finds New Problems," *Oregonian*, February 19, 1985.

48. Ibid.

49. *Oregonian*, December 28, 1983.

50. Sarah B. Ames, "Idaho Man to Direct Oregon State Hospital," *Oregonian*, October 24, 1987.

51. Ibid.

52. Editorial, "Moving Fairview Offenders to State Hospital a Sound Idea," *Statesman Journal*, April 8, 1998.

53. Alan Gustafson, "Group Home Rules Ease Concerns," *Statesman Journal*, November 15, 1998.

54. Ibid.

55. Alan Gustafson, "Former OSH Nurse Recalls Fear, Lack of Safety," *Statesman Journal*, March 21, 1991.

56. Ibid.

57. Alan Gustafson, "Three Killers Had Passes," *Statesman Journal*, March 21, 1991.

58. Alan Gustafson, "Patients Grasp for Hope in Hopeless Place," *Statesman Journal*, December 26, 2004.

59. Michelle Roberts, "Oregon's High-Priced Hospital of Hurt," *Oregonian*, October 24, 2004.

60. Michelle Roberts, "Whistle-Blower Forced Out, Records Suggest," *Oregonian*, September 19, 2004.

61. *Oregonian*, October 28, 2004.

62. Ibid.

63. *Portland Skanner* (Portland, Oregon), April 10, 2002.

64. Michelle Roberts, "Reports Detail Psychiatrist's Mistreatment of Patients," *Oregonian*, July 15, 2003.

65. Ibid.

66. *Oregonian*, July 22, 2003.

67. Michelle Roberts, "Superintendent of Oregon Hospital Resigns Amid State Investigation," *Oregonian*, July 22, 2003.

68. Ibid.

69. Alan Gustafson, "State Hospital Superintendent Plans to Retire Oct. 1," *Statesman Journal*, August 22, 2007.

70. Kim Christensen, "Top Psychiatrist Will Run State Hospital," *Oregonian*, March 16, 2004.

71. Gustafson, "Patients Grasp for Hope."

72. Roberts, "Oregon's High-Priced Hospital."

73. DHS News Release. Guest Opinion by Marvin D. Fickle, MD, superintendent and chief medical officer of the Oregon State Hospital.

74. Alan Gustafson, "Governor Asked to Inspect Hospital," *Statesman Journal*, July 16, 2004.

75. Alan Gustafson, "Staff, Patients Endure Prisonlike Conditions," *Statesman Journal*, December 26, 2004.

76. Gustafson, "Patients Grasp for Hope."

77. Ibid.

78. Ryan Frank, "Judge Halts Case, Sends Accused Man to Hospital," *Oregonian*, March 10, 2004.

79. *Oregonian*, May 7, 2004.

80. Gustafson, "Patients Grasp for Hope."

81. Roberts, "Oregon's High-Priced Hospital."

82. Alan Gustafson, "Workers in Harm's Way," *Statesman Journal*, December 28, 2004.

83. Ibid.

84. News Release by the Oregon Department of Human Services, "Foundation Awards Grants to Support Oregon State Hospital Patients," *US Federal News Service*, includes *US State News*, August 29, 2006.

85. Jim Sellers and Madeline Olson, "13 Mental Health Excellence Awards to Be Presented in Salem on Oct. 4," *US Fed News Service*, including *US State News*, October 2, 2006.

86. Gustafson, "State Hospital Superintendent."

87. Ibid.

88. Jack Moran, "Ex–Medical Center Chief Will Head Oregon Hospital," *Register Guard*, February 15, 2008.

89. Alan Gustafson, "State Hospital Escapee Found in Washington," *Statesman Journal*, November 11, 2006.

90. Gustafson, "Security Slips at Hospital."

91. Michelle Cole, "Advocates Want Investigation into State Hospital Patient's Death," *Oregonian*, October 20, 2009.

92. Michelle Cole, "Patient's Death Points to Persistent Problems at Oregon's State Mental Hospital," *Oregonian*, March 16, 2010.

93. Alan Gustafson, "Feds: Hospital Failures Alarming," *Statesman Journal*, February 24, 2010.

94. Ibid.

95. Ibid.

96. Michelle Cole, "Five Oregon State Hospital Employees Reprimanded for Care to Patient Moises Perez, Who Died Last Fall," *Oregonian*, June 17, 2010.

97. Michelle Cole, "Family of Dead Oregon State Hospital Patient Files Lawsuit in Federal Court," *Oregonian*, February 9, 2011.

98. Alan Gustafson, "It Was Time to Make a Change in Leadership," *Statesman Journal*, April 3, 2010.

99. Alan Gustafson, "A Vow to Improve Communication," *Statesman Journal*, March 19, 2010.

100. Gustafson, "It Was Time to Make a Change."

101. Cole, "The High Price of Oregon's Insanity Plea."

102. Michelle Cole, "New Superintendent Hired for Oregon State Hospital," *Oregonian*, August 4, 2010.

103. *Statesman Journal*, September 4, 2010.

104. Interview of Greg Roberts on January 22, 2013, at OSH by author.

105. *Oregonian*, July 17, 1882.

Chapter 13

FINANCIAL AND FORENSIC FAILURES

Between 1980 and 2012, Oregon State Hospital went through a series of dramatic changes in its leadership, its financial structure, and its patient population. In some cases those changes were positive, but in most cases they were negative. This chapter will clarify those changes and explain how they affected the overall operation of the hospital.

FINANCIAL FAILURES

Finances have always been a problem for OSH, not only its state budget but payments from the federal government as well. The Social Security Act of 1965, passed by the U.S. Congress, established Medicare benefits for Americans over the age of sixty-five. In 1975 Medicaid benefits were expanded to cover younger citizens with permanent disabilities who received Social Security Disability Insurance payments. "Medicaid Fee-for-Services funding gradually increased from the early 1980s until the mid-1990s, when it had become the primary funding mechanism for a range of services for adults."[1] The federal government also recognized that smaller living facilities were better for mental patients, so the act restricted many of the payments to mental health hospitals holding fewer than sixteen patients. The money was used as an incentive for states to build smaller community mental health centers and not use federal funds to pay for services that were traditionally

the states' responsibility.[2] This change caused significant financial difficulties for OSH as it cut payments for patients between the ages of eighteen and sixty-five and also gave the government the right to impose a variety of rules and regulations on programs that did receive funds.

In an effort to comply with federal guidelines and to manage its finances in a credible manner, the Oregon Mental Health Division, the administrative body supervising OSH, ordered a massive internal audit of all five state institutions under its control in 1983. The audit report was delivered in February 1985 and uncovered serious problems at OSH. The report cited concerns regarding control of hospital cash, checks and receipts, handling of personnel matters, documentation of purchasing, the administration of patient trust accounts, and control of inventory.[3] This was the first audit of OSH since the Board of Control was dissolved and the Mental Health Division was formed in 1961.

Among other things, the audit revealed that an unusually large number of OSH employees were related to one another. "A total of 117 workers, including some members of the management staff, out of 725 total workers were found to be either related by blood or marriage."[4] In response, Dr. Dean Brooks, retired superintendent, explained that it was a traditional practice of OSH to hire relatives and that many families had for several generations worked at the hospital. As long as OSH adhered to the state's established hiring procedures, Dr. Brooks didn't believe there was a problem. For example, when Nick Masselli, an employment specialist at OSH, was interviewed in 2012, he explained that not only had his mother worked at the hospital, so had his grandfather and two of his uncles. After growing up on the hospital grounds it was his opinion that this practice helped create an open, supportive, and friendly community atmosphere.

Federal officials also audited OSH annually to ensure it adhered to all the many rules and regulations. In February 1986, officials notified OSH that the government was terminating its Medicaid certification (and payments) because of deficiencies that "are an immediate hazard to patients."[5] Deficiencies centered on the shortage of nurses and the lack of required treatment records for patients. The termination would have cut OSH income by nearly $330,000 a month.[6] A year earlier Medicaid payments had been cut for three months at Dammasch Hospital until fourteen more staff could be hired.

Superintendent Robert Benning, hired on January 1, 1985, immediately had his staff put together an improvement plan to employ 19 nurses and 15 psychiatric aides for the 657 patients housed at OSH.[7] This was in addition

to the 74 registered nurses and 328 psychiatric aides already working at the hospital.[8] Nineteen of the newly hired nurses were assigned to the 235-bed forensic program. The federal officials extended the deadline to April 15 after receiving a copy of the improvement plan. An inspection team surveyed the hospital on March 16 and 17, after which OSH received a letter stating that all Medicare and Medicaid funds would not be reinstated at that time. Deficiencies in record keeping were cited as the cause.

A second blow hit the hospital a few months later in November 1986 when the Joint Commission on Accreditation of Hospitals (JCAH) notified OSH it was rescinding its accreditation. Inspectors had uncovered eighty-three flaws in 1985 and fifty in 1986. After extensive review and corrections, only two defects were noted three months later in the January 1987 inspection, and the JCAH reinstated the hospital's accreditation.

After the hospital made improvements in record keeping, federal officials reinstated Medicare payments for the child and adolescent programs in May 1986, and for the geriatric psychiatric program in January 1987.[9] It did not reinstate the corrections or forensic programs. In effect, government money now created a two-tiered structure.

The forensic program and the Corrections Treatment Program (CTP) were removed from the hospital's license because OSH could not meet government guidelines for staffing. The CTP included volunteer patients from Oregon's prisons with emotional disturbances, drug and alcohol problems, mental handicaps, or sex-offense records.[10]

In 1987 there were two significant events that affected OSH. On May 23, 1987, Superintendent Robert Benning resigned. George Bachik became superintendent in December, and in the same month, the public health division of the federal government conducted a surprise inspection. Citing problems with infection control, food service methods, furniture maintenance, and drug storage, the inspectors gave OSH until January 18, 1988, to correct the problems or again lose their Medicare and Medicaid funding.[11] The biggest repair cost was a $330,000 food heating system needed to ensure that food transported from the central kitchen stayed hot enough to keep down bacterial growth. After a $615,000 infusion of funds by the Oregon legislature to correct the deficits, the hospital passed a repeat inspection in January 1988. The money helped reinstate staffing for the wards housing the elderly and the children but left the forensic population and patients ages twenty-one to sixty-four unaffected. This again reinforced the two tiers of treatment: one for geriatrics and children and a lower one for forensics and corrections.

In October 1987 the *Oregonian* published a five-part series investigating and illuminating Oregon's mental health system. The number of patients in Oregon's institutions had dropped sharply between 1957 and 1987. "Despite the drop, the state's institutions suffer from insufficient staff, inadequate programs and conditions that critics call not only unhealthy, but also dangerous to inmates and staff members alike."[12] Low pay scales were cited as part of the reason for the low number of professional staff.

Staff shortages were also cited as the reason for the high number of violent assaults against staff and other patients. "According to figures compiled by the state for *The Oregonian*, 4,469 assaults by patients on other patients and on staff members were recorded during the 20-month period from January 1986, through August 1987, at Oregon State Hospital—an average of more than seven per day."[13] Most of the assaults took place in the geriatric program designed to care for patients over sixty-five years of age. Dammasch and OSH employees filed 340 injury claims in 1986. Injured employees claimed that poor staffing levels were the reason for so many injuries.[14] At the end of 1987 "Oregon's spending per capita on mental health programs ranked 35th among the states."[15]

The general psychiatric wards were just as dangerous. There were only four psychiatric aides and two nurses assigned to cover thirty to forty patients on the general wards consisting of a large day room, a porch, two bathrooms, a shower, and a long corridor of single and double rooms stretching about two-thirds the length of a football field. However, Superintendent George Bachik maintained the program was successful even though it was understaffed and outdated. "In spite of the horrible conditions, we do help people get better," he said. "People never hear that. They never hear that one 70-bed program treats almost 1,000 patients a year, and gets them better and gets them out."[16] Dr. George Suckow, program supervisor for the general psychiatric program, estimated that a patient's stay averaged two weeks.

As part of the national movement for deinstitutionalization in the late 1950s and early 1960s, many chronically ill patients were moved into group homes, foster homes, or semi-independent living facilities. Administrators involved in the movement believe it worked well in the 1960s; however, as the years progressed, serious problems became apparent. The first patients transferred to community facilities were the ones most likely to succeed. As more and more of the severely affected patients were transitioned, the necessary support was absent and they became part of a revolving door process.

A 1986 report by psychiatrists Fuller Torrey and Sidney Wolfe stated that federal and state officials "paid virtually no attention to the accumulating

data showing that the patients being emptied out of state hospitals were not being provided services."[17] It was subsequently discovered that money saved at the hospital level was not always used to fund community mental health services. Hospitals shrank too fast, and not enough community residential facilities were developed to absorb the thousands of mentally ill who were released. It was difficult to find community housing in 1987 for Oregon's forensic patients, especially after a recently released patient, William K. Maude, killed his mother.

The state subsidized three main types of residential care for the mentally ill: foster homes, group homes, and semi-independent living facilities. Foster homes provide the highest amount of care in small family-type settings. Group homes house six or more patients with professional staff providing services. Patients in semi-independent living programs live on their own with occasional visits by caseworkers, who provide support and training in daily living skills. Of the 34,400 people who required mental health services in Oregon in 1987, only 19,185 received some kind of counseling, outpatient, or residential care.[18]

Oregon's system for housing discharged mental patients was disorganized, poorly regulated, and in some cases dangerous. In addition, about 31,000 of the 34,400 mentally ill patients lived outside established state-financed residential care programs.[19] Patients typically paid about $300 (or whatever they got in government benefits) for three meals a day and a place to sleep. However, the law forbids these unlicensed boardinghouses from helping residents with their medications or assisting them in other ways. Many of the buildings had serious problems with sanitation and maintenance.

In May 1987, James H. Lloyd committed suicide while living in one of the unregulated room-and-boards housing many of Oregon's mentally ill. His death ignited an investigation into the system of boardinghouses funded by patients' welfare or social security paychecks and eventually got the boardinghouse he had lived in closed. According to Dr. Dean K. Brooks, retired OSH superintendent, many of the discharged patients "would be better off in an institution than where they are."[20]

Many of the patients in the general psychiatric wards at OSH had repeated admissions. In August 1988, Don Hunter, a patient in ward 35C, experienced his thirteenth admission in a period of three years and compared the hospital to a revolving door. Superintendent George Bachik believed the general psychiatric wards functioned successfully despite the fact that they were outdated, understaffed, and served nine hundred patients a year.[21] In a system needing 1.2 direct care staff per patient to meet established standards, OSH had about 0.6 direct care staff members per patient in 1987.[22]

Staff complained that the overcrowding made the hospital a very dangerous place to work or live. "The living conditions are terrible," said Roger Smith, director of the forensic program prior to September 1987. "Employees say they are too few to see, much less prevent, violence or even to defend themselves."[23] Jerry McGee, hired as director of the hospital forensic program in September 1987, told the *Statesman Journal* in 1988 that there had been "two suicides, two escapes and many threats of violence" during the past year.[24] McGee continued, "Staffing shortages and population increases too often incite patient violence and other disturbances. The OSH staffing ratio for the forensic program ranked 74 among 79 such units surveyed across the country" for the previous year.[25]

A cluttered equipment room at OSH stored a virtual arsenal of homemade weapons confiscated from patients. The violent side of the hospital was revealed in the four homicides from 1983 through 1988, twenty-four patient suicides from 1976 through 1988 (including three in 1988), and nearly two hundred staff injury claims filed during the 1986–87 year. Workmen's compensation claims totaled $387,865 during that year.[26]

Even as OSH built new wards to house the men sent there with "guilty except for insanity" judgments, the forensic population continued to grow beyond the hospital's capacity. In December 1987 the legislative Emergency Board approved $1 million to open the ninth forensic ward at OSH. The money covered twenty-five additional staff and construction costs.

Innovations and improvements were developed the next year. In January 1988, a new Oregon law went into effect providing streamlined commitment procedures for people who had been committed twice in the previous three years and demonstrated symptoms of further mental deterioration.[27] The law increased patient admissions but also allocated nearly $7 million to fund it. Part of the funds helped open small community health clinics such as the new Lane County Psychiatric Hospital. Unfortunately, it had to close in 2004 after the legislature cut its funds.

OSH passed its annual federal inspection in January 1989 and continued to receive nearly $17,400 a day in federal funds.[28]

A massive change occurred in 1991 after Oregon voters approved Measure Five limiting Oregon's property tax rates to 1.5 percent of assessed value. It also transferred the responsibility for school funding from the counties to the state in an effort to create an equal quality of education for all children. Because of the resulting decreased state income, the law necessitated massive cuts in public financed services. OSH suffered a significant cut, as it was one of the largest operations in the state. Governor Barbara Roberts' proposed

budget cut $30 million, or 19 percent, from the $155 million mental health budget of 1991–93.[29] Cuts included closure of a 35-bed ward for criminally insane patients, closure of a 35-bed ward for sex offenders, closure of a 40-bed psychiatric ward for adults, and closure of two 33-bed geriatric wards.[30] This meant the overcrowded hospital was losing 141 beds.

With the closing of the Adult Psychiatric Treatment Center, a forty-bed ward for adults, authorities were counting on private hospital participation to take over the acute care needs for patients requiring immediate treatment. Private hospitals failed to become involved in caring for the mentally ill, and patients continued to search unsuccessfully for mental healthcare.

Just as budget cuts were demanding 40 staff layoffs, the annual federal inspection team noted that OSH needed 12 additional staff for the children and geriatric wards.[31] The children's ward housed 63 patients with 18 registered nurses and four unfilled positions. The geriatric ward housed 137 patients with 34 registered nurses and three unfilled positions.[32] Forty layoffs were scheduled in the forensic wards, where 350 employees worked to supervise 329 patients in nine wards and 150 patients in five corrections treatment programs.[33] With staffing already dangerously low, cutting additional employees created serious problems.

Even after a series of dangerous offenders escaped from the forensic wards, the legislature failed to allocate additional money to increase staffing or alleviate overcrowding. "Little, if any, money was spent to increase staffing levels or install new security equipment."[34] Many of the problems were caused by years of underfinancing by the legislature.

A few months later Governor Roberts announced that she was rescinding her recommendation to close the sex-offender program in ward 47B for men convicted of sex

Barbara Roberts was Oregon governor from 1991 to 1995. *Oregon State Archives.*

crimes and on probation. It was the largest sex-offender treatment program at OSH. She and her staff had made the recommendation in the mistaken belief the offenders would be sent back to prison, not released into the community. Instead only the six criminally insane offenders could be transferred to other OSH wards. The other twenty-seven patients had been admitted through the parole system and would be released if the program closed. Locked behind a steel door, many were pedophiles with extensive histories of offenses.

Although the largest at OSH, the program has a relatively low completion rate. Kevin Concannon, director of the state's Human Resources Department, stated, "Of 137 sex offenders who were admitted to ward 47B since the program was started in 1982, 30 completed treatment."[35] Roger Little, director of ward 47B, refuted the assertion by stating that only "10 percent of the 137 patients had committed new crimes compared to the recidivism rates of 60 percent to 80 percent of untreated sex offenders."[36] It was recognized that while the $700,000 a year program was a low-budget priority, it was a high priority to the potential victims in the community.[37]

Because of the increased publicity, ward 47B and medium-security ward 50F were able to stay open temporarily with an emergency infusion of money from the legislature for another year. The twenty-seven patients in ward 47B remained in treatment, and an additional eleven offenders on the waiting list were allowed to enter the program. Permission was also given to begin remodeling the five-story 50 building, which needed the outside walls and plumbing repaired so the top floor could be used.[38]

Forensic program director Richard Vohs gave a summary in July 1991 of needed staff improvements: "The larger problem is even getting close to the national level for staffing and treatment. It would take millions of dollars of additional facility improvements, staffing and training."[39] He admitted feeling embarrassed to take anyone on a tour of the nine dilapidated forensic wards. "For a modern psychiatry facility, I can definitely say that in my 20 years of working in public mental health, I don't think I have ever seen anything as bad."[40] After staff levels were cut again in October 1991, a fight in maximum-security ward 50B put two of the employees in the hospital.[41] Superintendent Stan Mazur-Hart attributed chronic underfinancing for problems afflicting the hospital.

In January 1994, Governor Roberts began the process of closing Dammasch and moving patients to OSH.[42] She justified the closure based on the death of five patients in 1993 and the outdated condition of facilities.[43] The transfer of nearly two hundred civilly committed patients from Dammasch to community mental health facilities with the use of Medicaid funds also

spelled the demise of the facility. The State Mental Health Division and members Richard Lippencott, Barry Kast, Dan Barker, and Dave Edwards used the Medicaid leverage to fund better living conditions for these patients and reduce the strain on Oregon's budget shortfall.

In the ongoing battle for federal financing, OSH was again disqualified by federal inspectors from receiving $302,000 per month in Medicare funds on April 16, 1996. Complicating the problem was a lack of two physicians required to fulfill requirements in the geriatric program.[44] Another infusion of money from the legislature provided a solution, and funds were again reinstated.

Overcrowding continued to plague the forensic program at OSH. In November 1998 a legislative emergency board committee approved $921,234 to open a new ward.[45] The appropriation would cover the remodeling needed to create a ward in part of the J building and twenty-eight staff positions needed to supervise it. There were two maximum-security units already in a section of the J building identified as building 48 and six medium-security units in the 50 building. The first building was erected before the turn of the century, and the second was in danger of collapsing. Improperly constructed, the 50 building had failing metal connections holding the walls together, which put the whole exterior in danger of falling off.[46] Money allocated back

This portion of the J building was abandoned and judged too expensive to repair. *Photo by Tom Green, National Register of Historic Places.*

in 1991 still had not been used to repair the building, and the entire top floor still could not be occupied because of faulty plumbing.

The Oregon Advocacy Center, a federally funded watchdog group for the disabled, filed a lawsuit against OSH in 2000. In 2004 the lawsuit was settled when the state "agreed to create 75 community-based mental-health beds by July 1, 2005 and spend $1.5 million for other outside services for hard-to-place patients, including those with major medical conditions, traumatic brain injuries, histories of substance abuse or serious behavioral problems."[47]

The state also agreed that patients ready for release must be discharged within ninety days. A total of thirty-one of the sixty-nine patients now ready for discharge were to be placed in community housing before July 1, 2005. The rest were to be placed after the 2005–6 state budget was released. The settlement affected all civilly committed individuals who had been waiting for release since December 1, 2003. Forensic patients weren't included in the lawsuit.

In April 1991, the *Statesman Journal* revealed how some of the forensic patients were able to accrue substantial bank accounts while in OSH. According to state statistics, "About half of Oregon's mental patients turned over some of their own money to offset the cost of their care."[48] Few of those patients were in the forensic program. About 135 patients in the program received federal tax-free benefits ranging from $80 to $1,911 a month. In the 1970s the federal courts ruled that the state could not confiscate such benefits. Few of the forensic patients volunteered to help pay for the $131 a day it cost in 1991 to provide care for them at OSH, and the state could not force them.[49]

Fines and settlements continued to add up. OSH was fined $10,200 in July 2006 for not warning a contractor repairing a water line that asbestos-containing materials were wrapped around the old pipes.[50] According to a 1990 study at OSH all asbestos-containing materials on the campus were identified and mapped so appropriate procedures could be taken anytime work was done at the hospital. The Department of Environmental Quality inspectors discovered asbestos insulation in a pile of dirt and debris next to the work site in January.

Financial and staff shortages continued to cause problems at the hospital. The Psychiatric Geriatric Outpatient Consultation Clinic at OSH was closed in September 2007.[51] Administrators cited staffing shortages as the cause. It was decided that the hospital needed to focus its limited resources on immediate and critical psychiatric problems. Part of the problem involved hiring psychiatrists with geriatric qualifications, who were especially difficult

to find in and out of the hospital. OSH also stopped taking new patients in its adolescent outpatient program and reduced the number of psychiatric inpatient admissions. The adolescent program was dissolved when the last patient was discharged.

As of June 2008, OSH was still desperately understaffed. National standards generally indicated there should be 1 nurse for every 5 or 6 patients. At OSH there was 1 nurse for every 18 to 42 patients.[52] As a consequence all variety of assaults continued to increase. "There were 333 patient-to-patient assaults in 2006 and 497 in 2007. In the first four months of this year [2008], there were 241. Patient-to-staff assaults increased from 209 in 2006 to 320 in 2007, with 218 from January through April."[53] Part of the increase could be attributed to better reporting since computers were introduced in 2005 and a group of particularly violent patients was admitted. However, the major cause involved overcrowded wards and an overtired staff. A more competitive pay scale had made it easier to attract better-qualified staff. Even though the legislature allocated money to hire physicians, nurses, therapists, and other staff in 2006, 2007, and February 2008, the hospital was still short 194 people.[54]

In 2011 OSH staff staged a protest rally after furloughs and massive amounts of mandatory overtime increased. Organized by leaders of the Service Employees International Union Local 503, frontline employees protested unprecedented amounts of overtime imposed on staff, which contributed to dangerous working conditions, employee fatigue, and plummeting morale. State-mandated furlough days were making the overtime even worse. Streamlined hiring procedures had helped decrease the nursing shortage, but not in the number of mental health therapists (MHT), previously known as psychiatric aides. Presently there were 42 vacant MHT positions, and the legislature had allocated funding in the 2009–11 budget for an additional 130 positions. Those positions were part of more than 500 new positions authorized by state legislators in a $36 million package aimed at fixing severe understaffing.[55] Between January and March 2011, workers logged 9,294 hours of mandatory overtime in the forensic program, or a monthly average of 3,098 hours. The previous highest monthly total had been 1,761 hours in 2009.[56] Reasons cited for soaring overtime costs included mandated furlough days, an upsurge in staff sick leave, and increased staffing needed to deal with patients who could no longer be put in restraints and seclusion.

Line staff was exposed to unprecedented amounts of violence in the first three months of 2011. Employees in the forensic program related how staff members were being kicked in the head, punched, spit on, and

battered.[57] "In the first three months of this year, the hospital recorded 267 patient assaults on staff, 89 per month on average—a jump from 55 per month in 2009."[58]

An interviewer asked Senate President Peter Courtney why he thought the situation had gotten so bad at OSH in 2010. He answered, "The only thing I've ever been able to conclude was that it took decades and decades to get there in terms of deterioration of facilities, treatment issues and staffing issues. It's not that no one cared before, but there were always other priorities that came forward."[59]

Forensic Failures

Financial failures were particularly devastating for the forensic program. Federal payments helped bolster the other programs at OSH, but the state supported the forensic patients. Whenever the state budget needed to be cut, it seemed that the forensic security program suffered the first cuts. In 1991 an *Oregonian* article described the maximum-security wards at OSH: "Tall barred windows puncture the chipped, yellow brick walls of the J building, giving the hospital the look of an old fort. It is indeed a citadel of last resort."[60] There were no circulating fans or air conditioning in the two maximum-security wards in the J building. Ward 48C was located on the third floor behind seven sets of locked gates and sally ports and housed the state's most dangerous psychiatric patients. In ward 48C the electricity was turned off at night and patients were locked in their rooms. Each room would then be unlocked individually in the morning. The heating often failed, plunging the ward down to near-freezing temperatures. There were no janitors, and ward staff was responsible for whatever cleaning was done in addition to all their other duties, creating a dirty and unsanitary environment.

The State of Oregon had been admitting the criminally insane since Dr. James Hawthorne first accepted Charity Lamb. It began with just a few, but gradually over the years, the number of patients needing special security precautions grew. A formal program was instituted in 1966 under the direction of Superintendent Dean Brooks.[61] By 1980 the forensic population outnumbered the general psychiatric, geriatric, and children's treatment sections put together. Unfortunately the financial problems afflicting the hospital in the 1980s and 1990s made it difficult to provide security and treatment for the forensic wards. OSH spent an average of only $131 a day

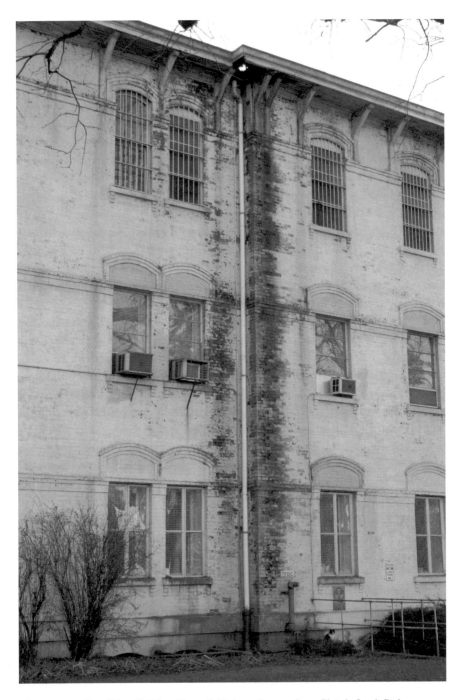

The northern side of the third-floor Forensic Unit can be seen here. *Photo by Laurie Burke.*

on forensic patients while comparable programs spent $220 a day. A forensic patient was a person confined to the hospital because a court has found him "guilty except for insanity" or because the court needed an evaluation to determine if he could aid in his own defense at trial.

Many patients were interned in the hospital because they were suicidal and needed treatment until they could be stabilized. OSH had a particularly desperate group of 330 men confined to its forensic program between 1978 and 1987 when 12 men committed suicide.[62] Five suicides occurred in 1983 alone.[63] Only four suicides had occurred in the same time frame in the 3,330 patients outside the forensic program. This compared to eight suicides over the same time span in the Oregon State Penitentiary and the Oregon State Correctional Institute that together housed 2,700 inmates. Overcrowding contributed to the epidemic of hopelessness and despair.

On August 8, 1989, a suicide occurred while ten men from the ward were locked in their rooms and the rest were exercising in the yard. Only one attendant was on maximum-security ward 48B at the time. During the ten minutes the attendant was out of sight, a patient looped a sheet around his neck and tied it to the iron window screen. Unable to lift the heavier man free of the sheet, the attendant struggled to release the tension until help could arrive. The patient was dead on arrival at Salem Hospital.

John A. Knudson, age twenty-six, committed suicide on November 15, 1994, by tying a bedsheet to the handle of a cupboard above his head in a laundry room. He had been living in a minimum-security ward with forty other patients since June 1990, when he was found "guilty except for insanity" on charges of theft and unauthorized use of a motor vehicle.[64] While he had exhibited suicidal tendencies in the past, staff had not seen any recent warning signs.

Authorities believed an impulse led Paul H. Omans, age twenty-one, to commit suicide in April 1998. He looped a noose around his neck and tied it to a soap dispenser in a shower room. He had been committed to the hospital in 1996 after being diagnosed with a drug-induced mental disorder characterized by paranoid delusions, hallucinations, and hearing imaginary voices.[65] This was the first suicide since Knudson had died.

On October 28, 2008, David Morse was discovered unconscious after a suicide by hanging attempt when he used a piece of cloth tied to a tilted metal bed frame. Morse died a few days later on November 10, 2008.[66]

On December 26, 2010, another forensic patient, Elisabeth Sellers, was found dead after she committed suicide by hanging. She had been living in a medium-security co-ed ward.[67] Sellers had a long history of suicide attempts

and had recently been given a private room after going for an extended period of time without any problems.

Escapes of dangerous patients from the forensic program were even more common than suicides. As they accumulated, they drew more and more attention from the newspapers. Stories included that of Shawn K. McGinnis, who used a wrench and a hacksaw to cut through a screen and one of the bars on the window of his cell to escape on April 14, 1986.[68] Using torn bedsheets, he lowered himself to the ground and, after throwing clothing over the barbed-wire fence, fled the hospital.

Two escape attempts in the summer of 1988 helped identify security problems in maximum-security ward 48C. The first attempt took place on the weekend of July 24 by two roommates who chipped away a one-and-a-half- by two-foot hole penetrating a four-layered brick wall. When authorities responded by imposing a two-day lockdown, a minor riot resulted and three toilets were yanked from the floor. When maintenance workers reported to fix the damage, two patients stole some of their tools. The tools were discovered on August 3. Ward attendants prevented the escape after finding a file, a pair of wire cutters, a flashlight, a broom handle, and a rope made from knotted sheets hidden on the ward.[69]

A similar riot resulted on August 29, 1988, when authorities ordered a lockdown as attendants searched for part of a broken table knife.[70] Patients broke water pipes, flooding three floors in the building. During the ensuing lockdown the men were confined to their rooms at all times, even for meals, and smoking was restricted.

Another flaw in the forensic program regulations was revealed later that month when Roger Merle Martin filed an appeal with the Oregon Court of Appeals asking to be released from OSH. He had been diagnosed with a borderline personality disorder and committed to the hospital for a term of twenty-five years in 1985. However, if the appeal were granted, Martin would be set free, as no mechanism existed to transfer him from the hospital to the prison. Jerry McGee, director of the forensic unit, estimated that there were eight to ten patients in the hospital diagnosed with borderline personality disorders. When Martin's appeal was denied, he decided to leave anyway. While taking out the trash on November 17, 1989, he escaped from OSH. He was discovered in Sacramento, California, five months later after he and an accomplice beat a man to death.[71]

Another highly publicized escape of a very dangerous man occurred in 1989. The escape involved Robert Langley, who entered the Corrections Treatment Program at OSH in November 1986. This was a program designed

to help convicts nearing parole status transition successfully into society. He had been serving a twenty-year sentence at the Oregon State Prison after being convicted of assault and robbery in 1980.[72] He was assigned to ward 41A and within a few months was granted almost unlimited off-campus passes anytime of the day or night. Unknown to hospital authorities, he killed Anne Gray on December 10, 1987, and buried her body in a muddy hole he had dug in his aunt's backyard. Gray was an acquaintance Langley had met through a girlfriend. In the fall of 1988 he was assigned to Cottage 18 on the OSH campus, which served as another steppingstone for inmates who were scheduled to be released. On April 14, 1988, he killed Larry Rockenbrant because Langley was afraid he knew about the Gray murder and would turn him in to the authorities. Langley buried the body in the backyard of Cottage 18.[73] A security guard noticed the grave-shaped hole and reported it. A subsequent investigation revealed Rockenbrant's and Gray's bodies. Langley escaped and was later recaptured in Arizona. He was convicted of both murders and sentenced to death. In December 1989 Gray's sister sued the program and three of the administrators, charging them with negligence in supervising Langley. She settled out of court for $40,000. A year later Rockenbrant's family also sued the program.[74]

In 1990 there were twenty-three patient escapes from the forensic wards. None of the escapes were reported by the state Mental Health Division to the news media. "They included two murderers, two rapists, two sodomists, three arsonists, four burglars, three robbers, two car thieves, one other thief and one man convicted of criminal mischief. Three other escapees had no listed criminal history."[75] All were eventually recaptured within hours to a few months.

By 1991 the Psychiatric Security Review Board supervised about 470 patients.[76] Most had psychotic illnesses including schizophrenia complicated by the usage of illegal drugs and alcohol.

Security was finally increased in the forensic unit in 1991 after a series of highly publicized escapes made headlines. Between 1974 and 1991 criminal patients who either escaped or were freed had murdered at least sixteen people.[77] Other forensic patients set fires in Salem, abducted children in Nebraska, and hijacked a jetliner bound for Los Angeles from Portland.

Forensic patients had to show increased responsibility and positive accountability to earn passes out of the hospital. As part of their treatment the passes prepared them to return to mainstream society.[78] Outings could be a shopping trip to the mall, a research trip to the library, or a trip home to visit family and friends. The trips started with a patient being accompanied

by a hospital chaperone, gradually increased patient responsibility, and worked up to letting the patients take trips alone.

In the spring of 1991 the Michael P. McCormack case hit the newspapers and remained in the headlines for three months. Unfortunately OSH authorities did not notify the news media of his escape until after an anonymous caller revealed it to the *Salem Statesman Journal* five days later. McCormack, age forty-four, had been arrested in 1978 and convicted of murdering his girlfriend and her son. In his first trial he was found guilty of murdering Cherry Baumgardner, and in the second he was found "guilty except for insanity" of killing eleven-year-old Dennis Baumgardner. He served nine years in prison for the first conviction and was sent to OSH on September 11, 1987, for the second.[79] In the four years he'd been at OSH he was allowed to leave at least sixty-five times.[80] Psychiatrists diagnosed him as a manic-depressive, a condition characterized by extreme changes in mood, temperament, and personality. At the time of his escape, on March 14, 1991, he was living in ward 48C, part of the maximum-security unit. During a supervised outing to the Supreme Court law library he slipped away and disappeared.

After his escape, authorities discovered a "hit list" on the personal computer he had left at the hospital, and OSH staff rescinded the "model prisoner" label administrators had used to describe McCormack.[81] Back in April 1990, McCormack and another patient had chartered a plane to fly to Portland while out on an unsupervised pass. It wasn't until staff heard him bragging about his trip that they confirmed his story with Buswell Aviation. That was when he was moved from a medium-security ward to maximum-security ward 48C. Between May 1990 and his escape in March 1991, McCormack was able to regain his pass privileges despite being in a maximum-security ward.

Shortly after his escape, hospital authorities imposed a restriction on passes for criminal patients and vowed to improve security in the forensic program.[82] Superintendent George Bachik promised to provide additional staff and impose increased security measures for McCormack when he was returned.[83] Twenty days after he disappeared, the FBI arrested McCormack in Ohio. Ohio authorities complained that the OSH patient was giving them a headache after he tore up the bedding in his cell. During his escape he had traveled through California, Texas, Illinois, New York, and Ohio.[84] Part of the time he traveled disguised as a woman.

Eventually hospital officials "attributed the escape to lax security and poor clinical judgment."[85] Besides excessive pass privileges, other security problems were revealed in a program holding "300 of the most dangerous people in the

state of Oregon," of whom 60 were convicted murderers.[86] It was reported that when patients returned from unsupervised passes they weren't checked for weapons or other contraband even though procedures indicated they should be. When patients were discovered in lies about where they had gone or broke the ward rules, very few steps were taken to impose discipline or punishment.

The McCormack incident spotlighted security lapses and concerns and initiated substantial changes in security procedures. On April 16, 1991, OSH announced a new security plan. It eliminated all passes for maximum-security patients, put in place a more thorough screening process for other forensic patients, established a seventeen-member security department using current employees, installed metal detectors and video equipment to search and monitor patients and their visitors, initiated an improved reporting system for escapes, and introduced a new photo-identification process.[87]

When selective pass privileges were reinstated after McCormack's escape, it took much longer than the original ten days authorities had initially estimated to thoroughly reevaluate patients and reissue passes. Pass privileges were reinstated on June 3 for five wards and on June 17 for another five wards. Maximum-security patients were not eligible for passes. Administration hoped this would encourage patients to become involved in treatment to earn their way into medium- and minimum-security wards.

Even with heightened security awareness, Alan Shelby, who had only been at the hospital for twelve hours, escaped on April 6, 1991. He was the twenty-second patient to escape within the previous year. Shelby was able to blend in with a group of visitors and leave when they did. He had been transferred from the Oregon State Correctional Institution to attend Cornerstone, a minimum-security drug and alcohol treatment program at OSH.[88] Shelby was recaptured on April 30, 1991, as he tried to escape from a drug lab near Bend, Oregon. He was also charged in connection with an assault, kidnapping, and burglary that took place on April 19. Shelby and another man entered the victims' home, tied them up, and stole nearly $12,000 in property, including a loaded shotgun.[89]

Cornerstone had another two patients escape in 1994. While the program had only a few escapes, five inmates were involved in a drug smuggling scheme earlier in the year. The program treated hard-core drug offenders nearing their release dates. Staffing levels at Cornerstone were lower than anywhere else in the hospital, especially at night.

Another forensic patient, David Ball, walked away from a work detail in 1995. Ball had stabbed to death his stepdaughter's boyfriend in July 1993.[90] Diagnosed with bipolar disease, he had progressed to working outside OSH

at the Salem Rehabilitation facility making wooden pallets. Bipolar disease was characterized by dramatic mood swings and controlled with the drug lithium. Despondent after listening to testimony against him at a May hearing of the Psychiatric Security Review Board, Ball impulsively decided to leave. He turned himself in three days later.

Security measures came under intense scrutiny again in March 1999 after the escape of Christopher Crawford, age thirty-three.[91] Committed to OSH in 1993 after being found "guilty except for insanity" of attempted rape and sex abuse, he took off running while being escorted on hospital grounds. A week later he was recaptured in Portland and returned to OSH, where he was placed in maximum-security.

After Crawford's escape, walking privileges were immediately suspended for ninety patients in the forensic program. The biggest question was how Crawford managed to get a check for $700 issued to him just before he escaped. Generally, patients were only allowed to withdraw $25 at a time, and the money was used to pay for cigarettes and other incidentals. Larger amounts were supposed to be drawn from patient trust accounts only to purchase items such as clothes and electronic equipment by mail order.

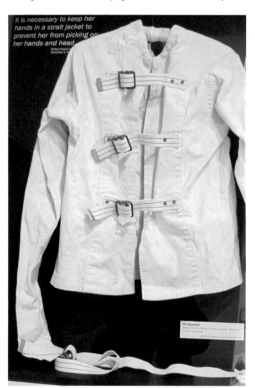

This straitjacket was used to restrain violent patients. *Photo by author, Museum of Mental Health.*

Michael Marks, age twenty-three, escaped on July 3, 2003, after scaling a twelve-foot fence topped with four feet of coiled razor wire. He was being evaluated to stand trial after holding a family hostage at gunpoint. When recaptured in Washington he had two guns, a television, and other stolen items stuffed in pillowcases. It was determined Marks had been faking his mental illness, and after being found guilty, he was sentenced to twenty-three years in prison.[92]

Escapes weren't the only symptom of problems at OSH. Patient violence increased dramatically, not only against each other but against staff members as well. In 1993 Jack Alison, a veteran staff member and former union leader, suffered twenty-one stab, slash, and puncture wounds after going to check on a patient who had been put in time-out. He blamed low staffing levels for the assault that required numerous stitches to deep gashes in his head and across his nose. "If there had been adequate staffing, I would not have gone down to that room alone. If we had one more staff on the ward, two people could check on time-outs."[93] Superintendent Stan Mazur-Hart refuted Allison's claim, labeling the assault an unpredictable outburst.

With so few staff and overcrowded conditions, the men in the two maximum-security wards 48B and 48C ended up spending most of their time either playing cards, watching television, or sleeping. Because so many refused to participate in therapy and staffing levels were so low, treatment was minimal. A small outside recreation area surrounded by fencing and topped with razor wire offered the only privilege available. Patients complained about the use of tranquilizers and antipsychotic drugs. Drug side effects included slurred speech, blurred vision, and involuntary muscle twitching.[94]

Overcrowding was partially caused by the cautious and limited number of patients released from the forensic program. The PSRB approved and supervised the release of every forensic patient. Richard Laing's case raised a number of questions about how the PSRB handled patient cases. Laing arrived at OSH in 2002 after he pled "guilty except for insanity" to assaulting his landlord while drunk. Even after several therapists evaluated Laing and said he did not have a mental illness, the PSRB declined to release him. After another hearing in November 2004 when the PSRB again refused to release him, he escaped and stayed free for two years. It's estimated that it cost the state $300,000 for the two years he was in OSH.[95] He was recaptured in October 2006 and sent to prison until March 18, 2010, when his term expired. Instead of going free he was again sent back to OSH. Within eight days of his return another patient in ward 50C attacked him.

No matter how carefully the Oregon PSRB evaluated and monitored cases, occasionally a released patient committed a crime again. Kim Shing Chan had been a patient at OSH from 1989 to 1996 after drowning his five-year-old daughter and being judged "guilty except for insanity." After being released he successfully lived and worked in Salem for the next eleven years without a problem. In 2006 he was arrested for setting multiple fires at Peoples Church in Salem. The fire injured two people attending a crowded Wednesday night service.

A spokesperson for the board noted that the recidivism rate for PSRB clients was only 1.5 percent compared with a rate of about 30 percent for convicts exiting the prison.[96] (In 2011 PSRB reported that since 1997 only 2.2 percent of its clients committed a new felony while 25 percent of those released from prison committed a new felony.)[97]

After Superintendent Marvin Fickle resigned on October 1, 2007, newspaper reports noted how many escapes had occurred while he was superintendent. Before his arrival OSH had a remarkably low percentage of "elopements," as the hospital designated patient escapes. Between 2004 and 2007, eleven out of the twenty-eight recorded mental hospital escapes occurred at OSH. Five of the Salem patients were from the forensic ward, four were part of the civil commitment program, and two were from the recently closed adolescent ward.

Two of the more notorious escapes took place in 2007. Gino Puglisi, age thirty-eight, escaped on February 14, 2007, after using bolt cutters given him by a former hospital employee and scaling an eight-foot fence outside the gymnasium. Three staff members were supervising ten other patients when Puglisi slipped out an open door.[98] He had been admitted to OSH three years earlier after stealing a car and trying to elude police. He was captured nine days after his escape and returned to the hospital. While in the hospital Puglisi continued to cause problems and "used pay phones to run up sports-gambling debts and to enlist conspirators to help him escape." Staff eventually intercepted a cell phone, $1,000 in cash, and hacksaw blades mailed to him by friends.

On November 21, 2007, murderer Christopher Walker disappeared while on a supervised visitation to his mother's nursing home.[99] Police captured Walker the next morning. He had been sent to the hospital nearly twenty years earlier for killing his girlfriend. Released in 1996, he was returned to the hospital in 2003 after he tried to blow up a propane tank at a business in Portland while aiming the flame at police officers.

Another forensic patient, David Anderson, escaped from the hospital on August 15, 2009, while in the exercise yard with other patients. He had been in the hospital for four years after being accused of criminal mischief, theft, burglary, and a probation violation.[100] Two employees were found negligent after an investigation by the state Office of Investigations and Training. The employees were seated 260 feet away from the patient they were assigned to supervise while he cut the fence with bolt cutters.[101]

Several procedures were initiated after Anderson's escape. Patients were forbidden to go within two feet of the fence; staff was required to count patients every fifteen minutes; staff was required to use a metal detector to

scan patients entering and leaving the recreation area; and staff could not sit together in the yards.[102]

In 2009 patient violence escalated in the women's portion of the forensic program. Dr. Bruce Goldberg, state human services director, stated that "nine people, most of them women, accounted for 45 percent of the violence last year."[103] In response OSH opened its first maximum-security ward for women in February 2009. Employees felt that the decrease of 83 percent in patient seclusion and 60 percent decrease in hours of patient restraint were also instrumental in increased patient violence. OSH administration responded by increasing safety training for in-line staff.

A serious patient-against-staff attack took place on November 22, 2010, in the Harbors section of the new hospital. Rich Dean, a security staff employee, suffered a broken ankle, a torn rotator cuff, a fractured eye socket, and other injuries when he was attacked by Samuel Lehtinen, who was undergoing an examination to determine if he was "mentally competent to aid and assist in his legal defense on pending criminal charges."[104] The patient was wearing belly chains and leg irons when the attack occurred. OSHA investigated the incident and found no violations of workplace safety regulations during its review of the assault.

In 2011 several negative incidents at OSH made newspaper headlines across the state. A highly publicized incident took place on January 19, 2011, when the PSRB's executive director, Mary Claire Buckley, verbally abused a patient at OSH.[105] As the patient jogged with a staff member, Buckley rolled down the window of the car she was riding in and addressed the patient in a derogatory manner for resisting a board decision to place him in a community-based secure residential treatment facility. Investigators labeled her remarks "coercing" and "disrespectful." Buckley had been board director for over twenty years, head of the board that daily made life-altering decisions for hundreds of patients who came under the supervision of the Psychiatric Security Review Board.

On May 14, 2012, a patient in the new admission and stabilization unit caused severe damage to the ceiling of the room where he was being held. He reportedly "jumped up by using the wall as a springboard, punched through an acoustic tile and pulled down a portion of the metal grid. He pulled on some wires and pulled down a small hot water pipe used for heating."[106] Patients in the unit had to move to another portion of the building as a result of the damage. Plans were made to repair the ceiling and improve the security issues presented by the removable tiles. A hospital spokesman noted that every time they had an incident like this they learned from it and worked to prevent a reoccurrence.

High-profile patients were often committed to OSH and housed in maximum security while they awaited court-ordered evaluations. Two high-profile defendants were transferred to OSH in 2011 for evaluations to determine if they could aid in their own defense. They joined 104 other "treat-until-fit" patients housed at OSH. Cheryl Kidd from Lane County was accused of fatally shooting Eugene police officer Chris Kilcullen on May 22, 2011. The judge ordered her treated until she could assist in her own defense or until the end of three years. She was diagnosed with paranoid schizophrenia and had a long history of mental illness. She had stopped taking her medication.

Lane County also committed Miguel Chavel in April 2011 for killing his landlord and burying her body in her backyard.[107] If a patient couldn't be tried within three years, he must return to court and be issued a treat-until-fit order. A civil commitment order can be issued if the patient is a danger to himself or others and held up to three years or until he is fit to stand trial.[108]

Most of the patients at OSH needing evaluations were not violent. Only nine were accused of violent crimes as of May 2011: four were accused of murder, three for attempted murder, one for rape, and one for kidnapping. The wait for an evaluation could be up to eight months. Superintendent Greg Roberts agreed that a backlog of evaluations had been a problem at the hospital. When he arrived to start his new job in September 2010 he found 140 substance abuse evaluations ordered but not completed.[109] Evaluations prepared by psychiatrists and psychologists and used to determine the sanity of accused criminals could vary from two pages to more than twenty-two pages.

Another problem was the incarceration for extended stays of people to OSH who had committed misdemeanors or low-level felonies. The question remained: should these people be locked up in a high-security hospital costing $17,000 per month, or should they be sent to community outpatient clinics?[110]

Today in 2012, the new facilities have increased security with locked doors, while the stairs and elevators require security keys. The only way outside is through two sets of locked gates.

Medicaid and the federal government still do not help pay the $17,661 monthly cost of keeping a forensic patient. The patient count continues to rise and represents the majority of patients living at OSH. In 2009 there were 89 persons committed, and in 2010 there were 63 committed under the "guilty except for insanity" umbrella. Of the 344 patients (out of a total 503 in the hospital) in the forensic unit on February 1, 2011, there were 156 who had committed an A felony, 72 who had committed a B felony, 12 who had committed a misdemeanor, and 28 who were accused of murder and/ or inmate in possession of a weapon.

Notes

1. Bob Nikkel, "A Short History of the Public Mental Health System in Oregon," Office of Mental Health Services, February 2000.

2. Michelle Roberts, "Oregon's High-Priced Hospital of Hurt: The State Mental Hospital Survives on Legislative Inertia, Thwarting Patient's Recovery While Costing Taxpayers Dearly," *Oregonian*, October 24, 2004.

3. John Hayes, "Report Details State Hospital Irregularities," *Oregonian*, January 17, 1984.

4. John Hayes, "Hospital Probe Stuns Officials," *Oregonian*, January 12, 1984.

5. Alan K. Ota, "State Hospital to Lose Medicare Certification," *Oregonian*, February 26, 1986.

6. Ibid.

7. Alan K. Ota, "State Hires Nurses in Effort to Retain Funds for Hospital," *Oregonian*, March 1, 1986.

8. Ibid.

9. Sarah B. Ames, "State Hospital Given 45 Days to Fix Problems," *Oregonian*, December 10, 1987.

10. Alan K. Ota, "State Hospital Receives Favorable Review," *Oregonian*, February 20, 1987.

11. Ames, "State Hospital Given 45 Days."

12. Alan K. Ota, "For These Oregonians, Home Is an Unsafe Asylum," *Oregonian*, October 25, 1987.

13. Ibid.

14. Ibid.

15. Ibid.

16. Alan Gustafson, "Staffing Shortages, Poor Conditions Keep Mentally Ill from Getting Better," *Statesman Journal*, August 14, 1988.

17. Alan Gustafson, "The Sad Legacy of Experiment," *Statesman Journal*, August 14, 1988.

18. Alan K. Ota, "Broken Homes," *Oregonian*, October 27, 1987.

19. Alan K. Ota, "Deinstitutionalization: Long Word for Disgrace," *Oregonian*, October 27, 1987.

20. Ibid.

21. Alan Gustafson, "A System in Search of a Cure," *Statesman Journal*, August 14, 1988.

22. Ota, "For These Oregonians."

23. Alan K. Ota, "Inmates Using Murder, Suicide to Escape the Terror of the Deadliest Ward," *Oregonian*, October 28, 1987.

24. Alan Gustafson, "Overcrowding Creates a Time Bomb," *Statesman Journal*, August 14, 1988.

25. Ibid.

26. Alan Gustafson, "Violence Takes Toll at Hospital," *Statesman Journal*, August 14, 1988.

27. Alan Gustafson, "Oregon Needs Cure for Care," *Statesman Journal*, August 17, 1988.

28. *Oregonian*, February 2, 1989.

29. Kathryn Rospond, "Public Expresses Worry That Budget Cuts Will Limit Mental Health Programs," *Statesman Journal*, April 5, 1991.

30. Alan Gustafson, "Budget Cuts Loom for Mental Hospital," *Statesman Journal*, January 21, 1991.

31. David Steves, "Feds Cite Hospital Staffing," *Statesman Journal*, March 6, 1991.

32. Ibid.

33. Alan Gustafson, "State Hospital Plans 40 Layoffs," *Statesman Journal*, April 9, 1991.

34. Alan Gustafson, "Employee Predicts Disaster," *Statesman Journal*, September 28, 1991.

35. Alan Gustafson, "Sex Unit Closure Averted," *Statesman Journal*, April 18, 1991.

36. Ibid.

37. Alan Gustafson, "Staff: State Falters on Sex Therapy," *Statesman Journal*, July 17, 1991.

38. Alan Gustafson, "Oregon's Forensic Program Suffers," *Statesman Journal*, July 7, 1991.

39. Ibid.

40. *Oregonian*, May 19, 1991.

41. Alan Gustafson, "Workers Decry Cuts at Hospital," *Statesman Journal*, October 22, 1991.

42. Alan Gustafson, "Roberts Plans Hospital Closure," *Statesman Journal*, January 4, 1994.

43. John Henrikson, "More Patients Will Come to State Hospital," *Statesman Journal*, May 26, 1994.

44. John Hayes, "State Asks Federal Re-Inspection of Mental Hospital," *Oregonian*, May 25, 1996.

45. Craig Harris, "E-Board Poised to OK New Staff," *Statesman Journal*, November 20, 1998.

46. Alan Gustafson, "Hospital's Forensic Unit Suffers," *Statesman Journal*, March 30, 1991.

47. Michelle Roberts, "Deal Reached in State Hospital Patients' Suit," *Oregonian*, March 9, 2004.

48. Alan Gustafson, "Criminal Patients Live Well on Tax-Free Incomes," *Statesman Journal*, April 21, 1991.

49. Ibid.

50. Alan Gustafson, "Hospital Fined for Asbestos Violations," *Statesman Journal*, July 29, 2006.

51. Michael Rose, "Hospital to End Psychiatric Program," *Statesman Journal*, August 2, 2007.

52. Michelle Cole, "Overworked, Understaffed at Oregon State Hospital," *Oregonian*, June 8, 2008.

53. Ibid.

54. Ibid.

55. Alan Gustafson, "New Hires Enter a Fast-Changing, Stressful Workplace," *Statesman Journal*, April 24, 2010.

56. Alan Gustafson, "Mandatory Overtime Soars in Past Year," *Statesman Journal*, May 23, 2010.

57. Alan Gustafson, "Stress, Long Hours Are 'Almost Not Worth It,'" *Statesman Journal*, April 24, 2010.

58. Gustafson, "Mandatory Overtime Soars."

59. Alan Gustafson, "OSH Worries Persist for Senate President," *Statesman Journal*, May 23, 2010.

60. *Oregonian*, May 19, 1991.

61. Cheryl Martinis, "Criminally Insane Population Grows," *Oregonian*, September 12, 1986.

62. Ota, "Inmates Using Murder."

63. *Oregonian*, May 19, 1991.

64. *Statesman Journal*, November 16, 1994.

65. Alan Gustafson, "Patient Kills Self at State Hospital," *Statesman Journal*, April 7, 1998.

66. Michelle Cole, "Oregon State Hospital Patient Committed Suicide on Same Ward As Moises Perez," *Oregonian*, April 9, 2010.

67. Ryan Kost, "Patient Found Dead in Her Room at Oregon State Hospital," *Oregonian*, December 28, 2010.

68. *Oregonian*, April 14, 1986.

69. Theresa Novak, "Patients Try to Flee," *Statesman Journal*, August 4, 1988.

70. *Oregonian*, August 30, 1988.

71. Alan Gustafson, "Escaped Patient Convicted in Killing," *Statesman Journal*, April 3, 1991.

72. Eric Mason, "Con Man," *Oregonian*, October 22, 1989.

73. Dave Berns, "Trial Opens in Killing at Hospital," *Statesman Journal*, May 24, 1989.

74. *Statesman Journal*, December 8, 1990.

75. Alan Gustafson, "Escapees Often Not Reported," *Statesman Journal*, April 7, 1991.

76. *Oregonian*, May 19, 1991.

77. Alan Gustafson, "Some State Patients Get Out and Kill," *Statesman Journal*, May 26, 1991.

78. *Oregonian*, May 11, 1988.

79. Grace Shimanoto, "Killer Flees State Hospital Program," *Statesman Journal*, March 20, 1991.

80. Alan Gustafson, "Chagrined Oregon Officials Say Escaped Murderer Was Model Patient," *Statesman Journal*, March 21, 1991.

81. Alan Gustafson, "Hospital Staff: Killer Had Hit List," *Statesman Journal*, March 22, 1991.

82. Alan Gustafson, "Escaped Murderer Calls In," *Statesman Journal*, March 27, 1991.

83. Alan Gustafson, "FBI Nabs Escaper in Ohio," *Statesman Journal*, April 4, 1991.

84. Ibid.

85. Gail Kinsey Hill, "Hospital Ends Gaps in Security," *Oregonian*, April 16, 1991.

86. Alan Gustafson, "Legislature: Fix Security at Hospital," *Statesman Journal*, March 28, 1991.

87. Hill, "Hospital Ends Gaps."

88. Gordon Oliver, "Hospital Tightens Rules After Inmate Escapes," *Oregonian*, April 7, 1991.

89. *Oregonian*, April 20, 1991.

90. Alan Gustafson, "Killer Walks Away from State Hospital," *Statesman Journal*, June 10, 1995.

91. David Kravets, "Offender Flees from Hospital," *Statesman Journal*, March 21, 1999.

92. Alan Gustafson, "Patient Outings a Tradeoff," *Statesman Journal*, March 19, 2006.

93. Alan Gustafson, "Hospital Worker Blames Assault on Short Staffing," *Statesman Journal*, February 13, 1993.

94. Alan Gustafson, "Some Doubt Hospital's New Security," *Statesman Journal*, July 7, 1991.

95. Alan Gustafson, "Hearing to Decide Fate of Patient at Hospital," *Statesman Journal*, March 31, 2010.

96. Alan Gustafson, "Church-Fire Suspect Was a Model Patient," *Statesman Journal*, October 29, 2006.

97. Michelle Cole, "The High Price of Oregon's Insanity Plea; Patients Sent to the State Mental Hospital Cost Millions," *Oregonian*, February 12, 2011.

98. Ruth Liao, "Hospital Patient Hops Fence to Escape," *Statesman Journal*, February 16, 2007.

99. Michelle Cole, "Security Slips at Hospital Still a Problem," *Statesman Journal*, October 9, 2007.

100. Suzanne Pardington, "Psychiatric Patient Escapes from State Hospital," *Oregonian*, August 15, 2009.

101. Alan Gustafson, "Errors Led to Escape at Hospital," *Statesman Journal*, January 16, 2010.

102. Ibid.

103. Editorial, "Safety First at the Oregon State Hospital," *Oregonian*, January 27, 2009.

104. Alan Gustafson, "Workplace Safety Inquiry Doesn't Fault Oregon State Hospital," *Statesman Journal*, May 5, 2011.

105. *Statesman Journal*, March 1, 2011.

106. Emily Gillespie, "Patient Causes Damage at State Hospital," *Statesman Journal*, May 15, 2012.

107. Karen McCowan, "Kidd Joins Defendant Patients," *Register Guard* (Eugene, Oregon), June 12, 2011.

108. Ibid.

109. Cole, "The High Price of Oregon's Insanity Plea."

110. Editorial, "Building a Better Mental Health System," *Oregonian*, February 23, 2011.

Chapter 14

FINDING THE CREMAINS AND EARNING A PULITZER

In 1910 Superintendent R.E. Lee Steiner had a crematorium installed at Oregon State Hospital to dispose of infectious waste products. Three years later the Oregon legislature passed Senate Bill 109 that mandated the state build a crematory or incinerator at OSH. It also directed the authorities at OSH to exhume and cremate any unclaimed bodies buried in the Asylum Cemetery. Since OSH already had a crematorium built, work began immediately. Between 1913 and 1914 the hospital exhumed 1,539 bodies from the Asylum Cemetery so buildings could be erected on the land.[1] The cemetery was located approximately where building 35 stood just east of the Dome building.

The Asylum Cemetery had served the hospital for thirty years by 1913 and was often the final resting place for persons no longer wanted by their families. The first person buried in the cemetery was Frank Holdridge from Illinois, who died in November 1883. The hospital's Daily Log Books record the many deaths at the hospital, how the relatives were notified, and how the bodies were returned to their families or buried in the cemetery. Death Book "G" records each death and the cause of that death from 1883 through 1912. Of particular interest is "The Asylum Cemetery," a pamphlet written by Susan N. Bell in 1991, which gives a history of the cemetery and includes a list of 1,600 patients who were buried there from 1883 to 1913.

In 1959 the twenty-eight headstones, dating from 1884 to 1909, that were removed from the cemetery were discovered in some trees southeast of the hospital. The state was beginning excavation for the new Santiam

Correctional Institute. At first it was thought to be a lost pioneer cemetery, but after an investigation revealed there were no bodies in the "cemetery," the gravestones were finally traced to the hospital. The area had once been part of the Cottage Farm, and the stones had been carted there and forgotten.

There are burial records for the patients who died between 1883, when the hospital opened, and 1913, when the cemetery bodies were exhumed, but no record remains of where those cremains were stored.[2] The current cremains (ashes from the cremations) are of unclaimed patient bodies that died between 1914 and 1971 at Columbia Park Hospital, Dammasch State Hospital, Fairview Training Center, Oregon State Hospital, Oregon State Penitentiary, and Oregon State Tuberculosis Hospital.[3] They were sealed in copper urns about the size of soup cans and warehoused in the basement of building 40. The cans appear to have been sealed by hand, and many look as if they were beaten and dented by trauma. Many have mineral corrosion leaking from the seams, creating a varied and intensely colored patina covering portions of the cans. The last hospital cremation took place in 1971 before the hospital contracted with local mortuaries to take care of patient remains.

In 1976 there were over 5,132 cans removed from the basement of building 40 and packed into twelve underground storage chambers located in the southwest corner of the hospital property as a modest memorial to the deceased patients.[4] The former fishpond was renamed Memorial Circle and made into a columbarium, a vault for the cremains.[5] In 1984 a small headstone for the dead was placed at Memorial Circle. However, over the next twenty years water seeped into the columbarium, destroying many of the paper labels identifying the individuals in the canisters. For many canisters the only identification is the numbers embedded on their lids. The consecutive numbers begin with "01" and continue to "5,118."

After it was discovered that water had seeped into the storage chambers, authorities decided to move the cremains. The copper canisters were placed on shelves in the Cremains Room in building 75, next to the crematorium where the bodies were originally incinerated. At that time the cremains were inventoried with the ultimate goal of trying to unite them with family members. After a wave of publicity reunited 500 canisters with family members, dented cans holding the unclaimed remains of 3,490 people remained.[6]

The *Salem Statesman Journal* publicized the cremains in a story early in 2004, but not many people paid attention.

On November 1, 2004, Peter Courtney, a Democrat and president of the Oregon State Senate, was part of a tour group that included several

VAULT No.	CONTENTS
1	Containers No.1 to No.291.
2	Containers No. 292 to No.787
3	Containers No. 788 to No.1305
4	Containers No. 1307 to No.1845
5	Containers No.1846 to No.2388
6	Containers No. 2389 to No.2942
7	Containers No. 2943 to No.3480
8	Containers No.3483 to No.4112
9	Containers No. 4114 to No.4752
10	Containers No. 4756 to No.5132 & Misc.
11	Empty
12	Empty

Above: Map of the cremains in the columbarium. *Oregon State Archives*.

Left: Senator Peter Courtney was a major advocate for the hospital. *Peter Courtney's Office*.

other legislators and two *Oregonian* editors, Rick Attig and Doug Bates.[7] They opened the locked storage room for the first time since 2000.[8] An individual accompanying the tour labeled the room "The Room of Forgotten Souls." In an interview Senator Courtney gave several months later he recalled that day: "It was such a stark situation. I remember the day I asked for the key, we were in a tour group and I had heard this room existed. It was an overcast, eerie day, and all of a sudden you're in this little room and there they are."[9]

Dr. Marvin Fickle, who became superintendent on April 26, 2004, had this to say: "The story about the cremains is in large part a metaphor of what has happened here in terms of the mental health system...It is, of course, ironic that people, in essence, seem more concerned about the dead than the living."[10] Dr. Fickle opened up the back wards of the hospital to inspection by legislatures and reporters.

In 2005 photographer David Maisel was allowed to enter the storage room housing the cremains. His remarkable photographs were made into a memorable book, *Library of Dust*. He recalled his first visit and a young Oregon State Penitentiary prisoner who was cleaning outside the room. The young man leaned into the room and whispered to Maisel, "The library of dust," thus creating the title for his book. Maisel believed the copper canisters evoked the evidence of trauma and displayed the evolution our bodies go through when we die and the souls that once occupied them.

On May 27, 2005, Peter Courtney announced the newly created Oregon State Hospital Memorial Fund to "establish a memorial for the dignified, perpetual care of the unclaimed cremated remains and to collect and archive historical documents, photos and other data to preserve hospital history." Individuals wanting to contribute donations to the fund were asked to contact the governor's advocacy office.[11]

Senator Courtney spearheaded the introduction of Senate Bill 1097 on July 18, 2005, to permit disclosure of the names and dates of births and deaths of people who died in a state institution, were unclaimed after death, and whose remains were stored at the hospital.[12] The disclosure released the information for the purpose of internment or creation of a memorial for the deceased. The law amended the current medical privacy laws, making it easier to reunite the cremains with family descendants. It passed the senate by a vote of 28-0 on July 29, 2005, and the House of Representatives by a vote of 59-0 on August 1. Governor Ted Kulongoski signed the law into effect a few days later.

On March 30, 2007, Governor Ted Kulongoski signed into law Senate Bill 32, allowing the Oregon Department of Human Services to publicize

the names of the deceased patients. Otherwise federal confidentiality laws would not permit the hospital to release the names. The legislation passed unanimously by both the Senate and the House and went into effect immediately after it was signed off by the Oregon attorney general's office.

In a further effort to publicize the cremains and reunite them with their families, the Oregon State Hospital posted on January 28, 2011, on the Internet the names of approximately 3,500 persons. The names are listed alphabetically and include the date of birth and death.[13] The first name on the list is Marie Abner, and the last is Mary Helen Zucher. The web address to view the names and get instructions on how to claim remains is: http://www.oregon.gov/OHA/amh/osh/cremains.shtml.

These are some of the cremains stored in copper cans for persons who died between 1914 and 1956. *Photo by Rob Finch,* Oregonian.

Officials of the hospital were able to identify all but four of the canisters. Unfortunately, about 25 percent of the hospital's list had incorrect or misspelled names. OSH medical records staff and one part-time temporary staff member worked on the list in their spare time for two years. They received no additional compensation or time to compile the list. In addition it was very difficult to read the handwritten records and spelling was never a primary consideration when patient records were made. The state registrar for vital records at the Oregon Public Health Department offered to assist the hospital in verifying names on the list but warned it could take some time.[14]

In a surprise five to one vote, the Salem Historic Landmarks Commission approved a proposal to house the cremains in a historic 1896 structure labeled building 60. It was originally constructed as an infirmary and later used as a paint shop.[15] The memorial, estimated to cost $500,000, will be funded by the state's Percent for Art in Public Places program as part of the Oregon State Hospital Replacement Project. The law requires 1 percent of direct construction funds of new and renovated state buildings with construction budgets of $100,000 or more to go toward acquiring works of art.[16] Hopefully the "Room of Lost Souls" will have a permanent and respectful home and Oregon will finally honor the symbol of so many years of neglect toward the mentally ill.

By January 2012, family members had claimed more than 1,600 of the 5,118 urns.[17] The discovery of the remains was one of the catalysts for the approval of a new state mental hospital.[18]

THE 2006 PULITZER PRIZE

There is no doubt the discovery and publicity of the cremains accelerated the hospital's efforts at renovation and rehabilitation. Coupled with the cremains discovery was an influential series of fifteen editorials featured in the Portland *Oregonian* beginning on January 9, 2005, and ending on September 18, 2005. Robert Caldwell had been chairman of the editorial board since November 1995 and helped supervise the series. He died in 2012. For him and the rest of the *Oregonian* staff, the series represented a huge commitment in resources, time, and effort. Two of the major writers were Rick Attig and Doug Bates. Robert E. Nikkel, Oregon mental health and addictions commissioner between 2003 and 2008, served as a resource.[19] Nikkel was assistant to the director of the Department of Human Services. The stories covered the history of the

hospital but focused primarily on present problems and possible solutions. In proposing solutions, the writers recognized the complexity of the issues facing the mental health system and the difficulty involved in solving them. The titles and dates of the editorials were as follows:

1. All the Lonely People, January 9, 2005
2. One Flew Out of the Cuckoo's Nest, January 30, 2005
3. A Mad and Mindless Health Policy, February 13, 2005
4. All Dressed Up and No Where to Go, March 13, 2005
5. Long Hallways, Hard Steps, March 20, 2005
6. Oregon's Enlightened Neighbor, April 24, 2005
7. Where Sanity Doesn't Prevail, April 30, 2005
8. A Delusional State, May 8, 2005
9. What About Bob, May 15, 2005
10. Hospital Time, May 20, 2005
11. Elda's Ashes, May 31, 2005
12. Fifteen Days to Find Sanity, June 13, 2005
13. A Word from Nurse Ratched, June 25, 2005
14. A New State of Mind, July 29, 2005
15. There's No Turning Back Now, September 18, 2005

Included were thirteen photos taken by Rob Finch that focused on the hospital's condition. They were eerie and sobering. They showed the decrepit state of wards so dilapidated they had been condemned, including the visiting area and the cremains room. Even in the occupied wards, five-gallon buckets caught rainfall coming through cracks in the ceiling. The newest building on the 144-acre campus was built in 1955, making it over fifty years old. The editorial reported that rooms designed for two now often contained three or more patients.

The first editorial covered the actions of Senate President Peter Courtney, who introduced an emergency proposal in 2005 to relieve overcrowding and find solutions to the problems at OSH. The emergency board approved a $467,000 appropriation, and a blueprint for change was drawn up.[20]

One of the first modifications required altering Oregon's laws regarding insurance coverage of the mentally ill. At that time insurance companies were not required to provide coverage for mental healthcare at the same level as they covered physical illnesses. This lack of mental health parity in Oregon was a fundamental problem, sending families who were trying to pay for mental healthcare into bankruptcy. When insurance and family

finances could no longer pay for services, the patient's only recourse was admittance to OSH, where the state paid the bill.

Finally, on March 21, 2005, the Oregon Senate passed Senate Bill 1 by a vote of 23-6 ensuring financial parity by prohibiting insurance companies from discriminating against the mentally ill.[21] The law required insurance to cover mental health and chemical dependency at the same level it covered medical issues. It passed the Oregon House of Representatives on July 30.[22] The editorial reported that after months of Republican filibuster and the second-longest legislative session in Oregon history, the bill sponsored by Peter Courtney was finally signed into law by Governor Ted Kulongoski.[23]

Things seemed to be improving at OSH. In a guest opinion column featured in the *Salem Statesman Journal* of June 22, 2005, Ted Ficken, director of quality improvement at Oregon State Hospital, justified his reasons for taking a job at OSH: "Inspectors who come to the hospital agree that the hospital is overcrowded and understaffed and that our buildings need to be replaced, but they also comment on the excellent work being done by the staff."[24] He believed staff efforts had reduced falls in the geriatric wards and patients were being encouraged to participate in treatment decisions to prepare them for life in the community. The use of restraints was now below the level of national standards, and "36 quality improvement projects [were] underway, involving virtually every patient care unit and clinical discipline in the hospital."[25]

The *Oregonian* recognized that it was to the state's and the hospital's financial advantage to move patients into smaller community settings. The *Oregonian* reported that it cost the state an average of $11,000 a month to house a patient at OSH, while it cost $3,375 (with Medicaid covering 62 percent of that) to house a patient at a community-based treatment center.[26] Cora Burnell had been a forensic patient at OSH for twelve years, from 1983 to 1995. Diagnosed with a schizoaffective disorder, she was sent to OSH after stabbing a man in Portland.[27] She moved to Homestreet, a community-based treatment center in Hillsboro, in 1995, where she was much happier and believed the more intimate setting had greatly increased her rate of progress.

In 2005, other patients like Cora were still housed in the OSH forensic program and made up the majority of patients in the hospital. The Oregon Psychiatric Security Review Board, created in 1978 and the first of its kind in the country, supervised the patients sent to OSH by the various county courts.[28] These patients were housed in the forensic wards at OSH. The *Oregonian* reported that since 1992, its recidivism rate was almost zero. Over the decades these wards had grown from a patient count of 67 in 1937 to 450 in 2005. According to the editorial most patients in the forensic wards were very violent

and should never be released. The Psychiatric Security Review Board's mandate was to keep the public safe, not to do what's best for the patient.[29]

Many of the patients, like Steve Gonzales, were sent to OSH after committing crimes while addicted to drugs or alcohol.[30] Experts at the time maintained that such patients did not necessarily have a mental illness but a personality disorder. According to Oregon law, alcohol and drug addiction could no longer be used to send people to OSH. The *Oregonian* editorial believed that instead of being allowed to plead "guilty except for insanity" they should pay for their crimes unless they had a true mental illness. Rod Tharp, a patient in the forensic program since 2000, had five treatment teams rule that he had no mental illness, yet he remained a patient in the hospital.[31] In April 2005 the "Oregon Supreme Court ruled in his favor and ordered the state Psychiatric Security Review Board, which has custody of the criminally insane, to either determine that he has a mental disease or discharge him." As a result of his ordeal the statute was named the *Tharp* ruling.[32]

The series went on to state that Oregon's state penitentiary and county prisons "house more than four times as many severely mentally ill people as the hospital."[33] Only 72 beds were available in various prison facilities throughout Oregon outside of OSH for the 2,700 inmates suffering from severe mental illness. "Oregon ranks 49th, next to last, among the states in providing beds for its acutely ill inmates."[34] The editorial writer believed inmates faced a choice of sitting in isolation twenty-three hours a day in prison or attempting suicide to gain a bed in the crowded state hospital. Oregon law mandated that patients found guilty except for insanity were to be treated, not punished. With a limited 72 slots available at the Oregon prison, the remaining inmates needing treatment could only wait and hope.

The editorial lamented the decrepit state of the hospital. For example, on May 20, 2005, a bathroom pipe burst at OSH, sending water cascading down the walls in ward 41 housing forensic patients. A hospital team reported the building "riddled with seismic, fire and electrical problems that could come crashing down on the heads of patients and staff at any time."[35]

By the end of the series Oregon had successfully addressed many of the problems plaguing the mental health system. Authorities had closed the hospital's adolescent wing, shutting down the facility long known for its abuse of vulnerable teenagers. The legislature changed the law so insurers could no longer dictate unreasonable terms of care for the mentally ill. The Oregon legislature had funded 250 beds in community settings like Homestreet, where Cora Burnell lived. But most of all, Oregon was now committed to erecting a modern hospital to house the criminally insane.[36]

Rick Attig and Doug Bates were awarded the Pulitzer Prize for Editorial Reporting in 2006. They were cited for "clearness of style, moral purpose, sound reasoning and power to influence public opinion in what the writer conceives to be the right direction." The prize was $10,000 for their persuasive, richly reported editorials inside Oregon State Hospital.

On September 3, 2008, Senate President Peter Courtney was a member of the group breaking ground for the new mental hospital to replace the decrepit buildings at OSH. Finally, after years of advocating for the mentally ill in Oregon, he was part of a new beginning.[37]

NOTES

1. Michelle Roberts, "Long Lost Face Found in State's Dark Corner," *Oregonian*, March 13, 2005.
2. DHS News Release by Jim Sellers, "Oregon Families Obtaining Relatives' Ashes from Oregon State Hospital," June 27, 2005.
3. News Release by the Office of the Senate President, "Senate Bill Permits Identifying Cremated Remains for Burial, Memorial," July 18, 2005.
4. *Oregonian*, February 11, 2005.
5. Editorial, "Oregon's Forgotten Hospital—Elda's Ashes," *Oregonian*, May 31, 2005.
6. Roberts, "Long Lost Face Found."
7. Rick Attig, "Cremains: Images of Oregon's Neglect," *Oregonian*, October 25, 2008.
8. Sarah Kershaw, "Long-Forgotten Reminders of Oregon's Mentally Ill," *The Times* (New York), March 14, 2005.
9. Ibid.
10. Ibid.
11. News Release by the Office of the Senate President, "Memorial Fund Created for State Hospital," May 27, 2005.
12. News Release by the Office of the Senate President, "Senate Bill Permits Identifying Cremated Remains for Burial, Memorial," July 18, 2005.
13. DHS News Release, "Oregon State Hospital Hopes to Unite Families with Cremated Remains of Past Patients," January 28, 2011.
14. Michelle Cole, "Oregon State Hospital Tries to Reunite Families with Cremated Remains of Past Patients, but Errors on List May Make It Difficult," *Oregonian*, March 31, 2011.

15. Queenie Wong, "Plan for State Hospital's Cremains Hits a Snag," *Statesman Journal*, April 22, 2012.

16. Ibid.

17. "Cremains Chronology," Oregon State Hospital, Salem, Oregon, January 2012.

18. Jonathan J. Cooper, "Mental Hospital Matching Ashes with Families," *Bend Bulletin*, February 1, 2011.

19. Per interview with Robert Nikkel in 2012.

20. Editorial, "Oregon's Forgotten Hospital—All the Lonely People," *Oregonian*, January 9, 2005.

21. News Release by the Senate Majority Office, "Senate Approves Insurance Parity for Mental Health Care," March 21, 2005.

22. News Release by the Office of the Senate President, "Senate President Applauds Passage of Mental Health Parity," July 30, 2005.

23. Editorial, "Oregon's Forgotten Hospital—A New State of Mind," *Oregonian*, July 29, 2005.

24. Ted Ficken, "Superb Staff Drives Success at the Ever-Improving State Hospital," *Statesman Journal*, June 22, 2005.

25. Ibid.

26. Editorial, "Oregon's Forgotten Hospital—One Flew Over the Cuckoo's Nest," *Oregonian*, January 30, 2005.

27. Ibid.

28. Editorial, "Oregon's Forgotten Hospital—All Dressed Up and Nowhere to Go," *Oregonian*, March 13, 2005.

29. Ibid.

30. Ibid.

31. Editorial, "Oregon's Forgotten Hospital—Where Sanity Doesn't Prevail," *Oregonian*, April 30, 2005.

32. Ibid.

33. Editorial, "Oregon's Forgotten Hospital—A Delusional State," *Oregonian*, May 8, 2005.

34. Ibid.

35. Editorial, "Oregon's Forgotten Hospital—Hospital Time," *Oregonian*, May 20, 2005.

36. Editorial, "Oregon's Forgotten Hospital—There's No Turning Back Now," *Oregonian*, September 18, 2005.

37. Rick Attig, "For Oregon's Mentally Ill, Finally a Day in the Sun," *Oregonian*, September 3, 2008.

Chapter 15
A NEW BEGINNING

After Dammasch Hospital was closed in 1995, the state promised to increase community services to make up for its loss. Over the years budget cuts progressively halted, downsized, or closed many of those facilities and programs. In 2004 the Lane County Psychiatric Hospital closed for lack of funds.[1] Hundreds of people in need of mental health services "languish in jail cells, charged with minor crimes, clogging the criminal justice system while not getting the care they need in the mental health system."[2]

Major changes in Oregon's mental health system began in 2004 when Oregon Governor Ted Kulongoski set up the Mental Health Task Force. Its subsequent report called for an overhaul of procedures at OSH and a change in purpose for the hospital. In order to make room for patients who were remaining far too long in community hospitals, the committee recommended the following:

1. Change the admission and discharge protocols at OSH.
2. Use the Oregon State Hospital only to "provide secure housing for individuals who pose a large danger to society or to themselves."[3]
3. Find a dedicated funding source to pay for mental health facilities in Oregon.

As of 2004 it was estimated to cost $110,000 a year to keep one of the seven hundred patients then housed at OSH in one of the two separate types of psychiatric programs available.[4] The larger was the Forensic Psychiatric Services (FPS) and the smaller was the Psychiatric Recovery Services (PRS).

The FPS consisted of 334 beds in ten units and 100 residential-level beds on three units. Patients were admitted to the program through criminal court proceedings, as criminals found "guilty except for insanity," or as persons needing psychiatric evaluations to determine if they were competent to proceed to face criminal charges.[5]

The PRS served non-forensic patients who had been civilly committed due to serious and persistent mental illness and consisted of 195 beds at OSH-Salem and 54 beds in OSH-Portland. These were divided into nine wards: five wards for adults with severe and persistent mental illness, two wards for geriatric patients, one ward for patients with brain damage, and one ward as a medical facility.

In an effort to preserve and improve mental health services at OSH, Senate President Peter Courtney engineered an emergency appropriation of $467,000 in 2005 to study the replacement of OSH and awarded the contract to the San Francisco consulting firm KMD Architects. Its report declared the oldest structure, called the J building, unsafe for staff and patients, mostly due to earthquake dangers. It also determined that the layout of the patient wards was inefficient, lacked appropriate program space, and did not comply with Oregon's Psychiatric Patient Care Rules. Exposed pipes, glass windows, and hidden alcoves posed threats and hazards to both patients and staff. Nearly 40 percent of the 500,000 square feet in the building was unusable due to age and neglect.[6] Wards meant to hold thirty-two held more than forty-four patients. Asbestos and lead paint would require expensive precautions before nearly fifty-two thousand dump trucks of material could be hauled off.[7] The report determined that the most financially advantageous solution was to demolish the existing structures and build new.

In March 2006, KMD Architects suggested three different plans to Oregon officials to replace the aging OSH facilities. In addition they stated that 419 community-based residential beds would be needed by 2011. Besides the J building another eleven structures were recommended for demolition.

After the governor and his team considered the results, a second report was requested, at a cost of $350,000, to determine where the new facilities should be located, what those facilities should look like, who should be housed there, and how much it would cost.

The governor approved the suggested plan in 2007, which called for a 620-bed facility in Salem and a 360-bed hospital in Junction City. The selection "sites were judged by their acreage, acquisition costs, zoning, accessibility to community services, proximity to the patient population centers and availability of hospital staff."[8] A major consideration supporting

the Salem site was the 1,250 employees already living in the Salem vicinity. Besides providing beds for patients currently in Salem, the plan delivered enough beds for 150 patients from the soon-to-be-closed site in Portland. It also took into account the patients to be transferred from the Blue Mountain Recovery Center in Pendleton, due to be closed in 2015.[9]

The Salem facility was scheduled to open in 2011 and the Junction City facility in 2013.[10] The facility in Salem would cost as much as $360 million.[11] Altogether the project, including the Junction City hospital, would cost about $458.1 million. SRG Partnership, based in Portland, and Hellmuth, Obata and Kassabaum, based in San Francisco, were jointly awarded the design contract.[12] CH2M-Hill was awarded a $10 million contract to oversee the construction of the two hospitals.[13]

The proposal presented a conceptualized drawing of the Junction City hospital showing a 420,000-square-foot building with one- and two-story buildings connected by corridors. The report advocated housing up to 40 civilly committed patients and up to 320 forensic patients. Inside the complex would be vocational and education departments, an infirmary, a secured outdoor recreation yard, two soccer pitches, two softball fields, and six basketball courts. The estimated cost would be between $117 million and $120 million and would employ 640 staff.[14] It was also suggested the hospital be built using the land previously purchased for a medium-security prison.

From November 13 to 15, 2006, the U.S. Department of Justice conducted an on-site review of both the Portland and Salem campuses. Triggered by a letter sent to the agency in 2004 by Senator Avel Gordly, the inspection exposed severe problems at OSH. Under the Civil Rights of Institutionalized Person Act (CRIPA), 42 U.S.C. passed in 1997, the justice department had the right to investigate conditions and practices at OSH as they affected the patients who lived there. It issued a scathing report on January 8, 2008, criticizing nearly every aspect of patient care.[15] It emphasized the same issues that KMD Architects had reported in March 2006. "Federal reviewers documented widespread problems that include patient-to-patient assault, repeated suicide attempts by patients who were supposed to receive one-to-one monitoring, and questionable use of restraint and seclusion to control violent or suicidal behavior."[16] The report noted five specific deficiencies at OSH:

(1) fails to adequately protect its patients from harm; (2) fails to provide appropriate psychiatric and psychological care and treatment; (3) fails to use seclusion and restraints in a manner consistent with generally accepted

professional standards; (4) fails to provide adequate nursing care; and (5) fails to provide discharge planning and to ensure placement in the most integrated setting.[17]

The report noted 392 patient-against-patient assaults between January and December 2005.[18] In the first ten months of 2006 OSH had already recorded 410 such assaults, showing a 25 percent increase over the previous year.[19]

Incidents of patients deliberately hurting themselves were also common, even during 1:1 observation, indicating a single staff member was assigned to watch a patient at all times. One patient's record reported twenty-six suicide attempts, and during seven of those events a staff member was supposed to be doing 1:1 surveillance. The report noted, "OSH fails to use systemic behavioral (social learning) strategies to eliminate dangerous behaviors and teach patients more adaptive ways to behave."[20]

Staff recorded 654 patient falls between January and November 2006. One patient fell 25 times in three months, and nothing was done to ascertain the cause or enact prevention.

There was no uniform method of reporting patient abuse or neglect at OSH. Even when policy directed reporting procedures, they were often ignored. Of the 161 incidents of alleged abuse and neglect that took place during September 2006, only 4 were flagged for investigation.

The review committee criticized OSH for using restraints and seclusion far too often without clear treatment goals. "The hospital logged 1,172 restraints and 1,773 seclusions in the 18 months ending in December 2005. During the following 18 months, restraints rose to 1,205 and seclusions grew to 1,248."[21] Between January and June 2006, patients were placed in seclusion and/or restraints 393 times; 83 of those were in prone restraints, a very dangerous action. It was determined that OSH violated the law by using restraints as punishment and for the convenience of the staff in too many instances. Some patients had been in isolation for over a year. In other cases, staff had developed the use of non-authorized restraints variously termed a "suicide suit," a punitive program of "safety status," restriction to certain parts in the living unit called "east end restriction," or placing patients in a "security hold." The report went on to state, "The facility's reliance on seclusion and restraint as treatment strategies is inappropriate, ineffective, extraordinarily detrimental, and at times, life-threatening."[22]

Interim superintendent Maynard Hammer defended the hospital's practices: "We know they're not good, and we don't like to use them. A lot

of the patients in lockdown, I hate to say it, but it's for their own good. It's hard to control 28 patients on a unit with only nine or ten staff."[23]

The deteriorating buildings were severely criticized. They were labeled unsafe for both patients and staff. In addition "the mental health services at OSH substantially depart from generally accepted professional standards."

Medication errors were far too numerous and dangerous. Instead of prescribing antipsychotic medications and benzodiazepines over short periods of time for their primary purposes, they were used to sedate and reduce aggression in patients over long periods of time, an action the report labeled "chemical restraint."[24]

The CRIPA report also identified "improper medication and disease control procedures and inadequate planning that delayed patients' recovery and discharge." Infection control was determined to be inadequate. "Of the 28 patient deaths in the hospital between January 2005, and August 2006, 15 were from pneumonia, an infection-related condition."[25] In addition to an outbreak of norovirus, problems with mice in rooms, outbreaks of scabies, and staff failures to clean up messes in seclusion rooms plagued the hospital.[26] All were considered preventable problems.

The chronic shortage of nurses was "exacerbated by the lack of adequate staffing, support, training and supervision." The committee criticized the systematic use of overtime to staff the units. Staff members routinely cited overwork as a cause of errors and mistakes. Administrative leadership also faltered after 2003 as the hospital experienced three new superintendents within seven years.

The report concluded with thirteen pages of detailed recommendations regarding each deficiency and was publicly posted on the Civil Rights Division website. Copies were sent to the Oregon attorney general, OSH interim superintendent, director of Oregon Department of Human Services, and the United States attorney, district of Oregon.

Senate President Peter Courtney stated, "What this shows is that we're not even close to being there when it comes to the care we're providing right now." The state "got lulled into thinking it was all about the bricks and mortar of a new hospital."[27] Courtney continued to be the leading and most influential OSH benefactor. "His clout proved instrumental in boosting the hospital's 2009–11 budget to $324 million, a 31 percent increase" needed to hire 525 new employees.[28]

In 2009 a community advisory board was created to give Salem residents and state mental health advocates a greater voice in hospital operations. "The advisory board was established to help improve the safety, security and

care of Oregon State Hospital patients."[29] It included various neighborhood residents, hospital patients, and advocates led by Salem City Councilor Bruce Rogers.

An additional federal probe began in 2010 after the U.S. Department of Justice's Special Litigation Section received a letter accusing the state of reducing the amount of money allocated to community-based services just as the state increased funding for the new state hospital building program. The probe would determine whether OSH "fails to serve individuals with mental illness, both those confined to and discharged from OSH, as well as those at risk of being institutionalized, in the most integrated setting appropriate to those individuals' needs."[30]

A report costing $175,000 by Liberty Healthcare in 2009 highlighted conflicts and finger pointing between hospital managers and human resource officials.[31] It was asserted that vague accountability and blurred responsibilities created apathy and inability to discipline noncompliant employees. Kaufman Global, an Indiana firm, was hired to examine the hospital's culture in 2010 at a cost of $1.99 million. Its goal was to produce a written blueprint to spur cultural change and other improvements at OSH by June 30, 2011.[32]

Newly hired superintendent Greg Roberts pointed out recent improvements made to address the problem:

1. Stepped up employee performance evaluations.
2. Speeded up OIT investigations into allegations of patient abuse or neglect.
3. Quick dismissals of new employees who failed to meet expectations during their probationary periods.
4. Additional training for managers, to help them work in concert with HR.[33]

Kaufman was hired to produce solutions to the problems identified by Liberty Healthcare. In addition the state paid $252,000 in 2009 for a sixteen-page report from Judge James Hargreaves, who was hired by Governor Ted Kulongoski. That report basically emphasized the lack of urgency on behalf of hospital management, undefined goals, poor planning, and reiterated problems the CRIPA report had already covered.[34]

In addition to paying outside consultants, local businesses benefited from the transformation. A dozen Salem firms secured lucrative contracts providing landscapers, electricians, plumbers, and painters. Cherry City Electric, Oregon Cascade Plumbing and Heating, Dallas Glass, and Davidson's Masonry were named as some of those companies. The reddish brown paint color was

selected to reproduce the color of brick and closely matched the original look and character of the façade in 1883.[35] Wooden window frames were painted eggshell white to provide contrast with the brick-colored paint.

The reconstruction project was committed to salvaging and recycling as much of the material as possible. An office was set up where residents and contractors could apply for whatever was reclaimable. Linda Hammond, administrator of the OSH Replacement Project, stated that the event further solidified "Oregon's commitment to protecting and preserving valued historic and cultural resources for generations to come."[36]

By retaining the Salem site for the larger part of the hospital, authorities were able to keep the workforce already in place and take advantage of the land currently owned by the state. The new hospital would be on the south side of Center Street on a ninety-acre section of the campus, preserving many of the trees and landscaping presently in place. In the process twenty-five buildings and structures were demolished to make way for the new OSH.

It was decided in 2008 to preserve the oldest portion of the J building (now called the Kirkbride U, referring to the originator of the building and its new shape) including the tower and cupola. Two wings of the J building were demolished, leaving a little more than half of the structure to be remodeled and rebuilt. The plan to preserve the Kirkbride U was a compromise with the City of Salem's Historic Landmarks Commission after the 144-acre campus was added to the National Register of Historic Places.[37] In addition, building 60, the physical plant, and all but one cottage were also preserved.

Authorities were unable to preserve the two magnificent murals painted inside the top floors of the J building. "Little is known about the origins of the colorful, landscape-depicting murals that became unveiled in recent days as state-hired contractors began to take down Building 43—a 60-feet wide section of the fortress-like J Building."[38] In 1961 patient Obie Eatherly had sketched an outdoor lake scene—one of two he painted on the walls of the recreation rooms.[39] A volunteer group had donated paint. It took approximately a week in June 2009 to dismantle the north portion of the J building. The south wing was dismantled in April.

On April 11, 2009, the demolition of the J building began when a track hoe with a 195-foot arm pulled down a section of brick wall.[40] Workers needed to wear breathing masks to avoid inhaling asbestos dust as walls tumbled down and the ceiling fell in on the south wing. Totaling nearly 34,120 square feet, the south wing had three floors and a basement. The south wing of the building was first separated from the remaining part, the roof detached, and subsequent floors removed. Demolition was completed in 2010.

This shows one of the two murals that could not be saved when the J building walls were separated. *Photo by Laurie Burke.*

This photo, taken on December 8, 2009, shows the scaffolding put in place as renovation begins on the old entrance to the J building. *Photo by Laurie Burke.*

It took twelve minutes to lower the twenty-thousand-pound, 124-foot cupola to the ground from the top of the J building in 2009.[41] It was returned to its position on top of the new Kirkbride U on September 24, 2010. The distinctive tower had been repaired, refurbished, and reinforced before being raised from its scaffold-covered spot. The remaining 110,000 square feet of the historic structure was remodeled and incorporated into a new 870,000-square-foot complex.[42] The portion of the 126-year-old structure being preserved received a new roof and extensive structural remodeling.

The outside remodeling was completed in August 2011 after the cupola was replaced and all the scaffolding was removed.[43] Superintendent Roy Orr declared in 2009 that razing the creaking structure was symbolic of tangible and visible progress.[44]

The renovated century-old fountain so prominent in old photos of the hospital regained an honored place between the Kirkbride U and the landscaped park that extends across the west section of the campus. Besides the hospital museum, the Kirkbride U contains the offices for hospital administration, health administration, nursing administration, risk management, and communications.

Hospital representatives traveled to Virginia, North Carolina, New York, and Canada to observe current treatment programs to implement at OSH. A new hospital built in Topeka, Kansas, was used as a good example of the most modern forensic building and treatment design, particularly in the hub-and-spoke layout of the living areas. The philosophy established by Thomas Kirkbride that the building was to be part of the treatment continues today just as it did in 1883.[45] This design complemented the state-of-the-art treatment mall approach replacing the ward system used for the past century. "This approach calls for patients to leave their living areas and go to specialized malls within the complex for group therapy, education classes, work, recreation, and other activities."[46]

The treatment mall care model has as its primary focus the concepts of house, neighborhoods, and downtown with a centralized medical facility. Emphasis remains on the individual instead of the group and facilitates the implementation of individualized treatment plans. Patients are required to spend a minimum of twenty hours in active treatment per week. Patients live in their house, which includes where they sleep, a multipurpose room similar to a living room, a kitchenette, a laundry room, and a clinical support space. The neighborhood is adjacent to the house and includes the cafeteria, treatment rooms, and recreation facilities. The downtown includes other kinds of treatment spaces such as the gymnasium, a hair salon, and art therapy rooms.

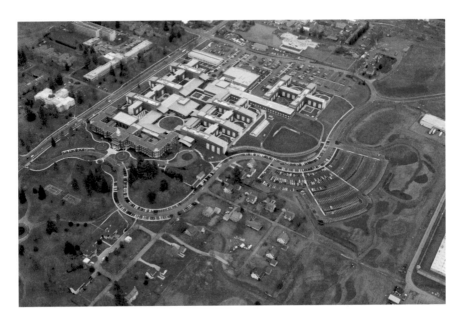

A 2012 aerial photo of the completed renovation of Salem Oregon State Hospital. *Oregon State Hospital.*

Patients must earn the privilege of going "downtown." Patients exit the living area at the same time every day, leaving behind television and other distractions to enter the neighborhood. This approximates a more normal approach to life and encourages patient responsibility, positive choices, and independence.

Inside the neighborhood portion of the building "there's a gymnasium with a stage, dining halls that allow patients to share meals and motivate them to better care for and dress themselves for dinner, just as they would, and will, outside the hospital walls. There's a convenience store, a bank, and a hairdresser."[47]

The treatment mall care model also dictates the design necessary to provide security for staff and patients. Four distinct patient groups are served: transitional and transitional secure; psychosocial rehabilitation (PSR); admission, behavioral, corrections (ABC); and neuro-psych.[48] The downtown portion of the treatment model is located in the first floor of the Kirkbride U and the adjacent new structure. Visually the Kirkbride U still remains the entrance to OSH. In actuality the entrance is in the new building attached to the Kirkbride U on the south side.

A new seventeen-thousand-square-foot kitchen serves the facility. "Steam kettles as big as an eight-person hot tub, a pot washing machine that six people could stand in; ovens that four people could walk into and comfortably

This is the new entrance to OSH. *Photo by Laurie Burke.*

stand" will no longer be used.[49] Food will no longer be cooked, hauled though tunnels to the wards, reheated, and served on trays to waiting patients. The new plan calls for food to be prepared cafeteria style with patients able to choose what they want to eat. The new OSH Food and Nutrition Service provides sixty thousand meals per month, twenty-five thousand snacks per month, and seven hundred sandwiches per day at an average cost of $3.75 per meal. The 2009–11 budget for food and kitchen supplies was $5.84 million and $7 million for payroll to employ seventy-nine full-time staff.[50]

Included in the cost of the new buildings was a $25 million state-of-the-art computer software system specially designed to keep patients' records and facilitate communication between staff. Prior to its implementation, OSH relied primarily on paper files. The hospital had at least twenty thousand cubic feet of stored paper records, enough to "create a paper trail stretching from the state hospital along Center Street NE to the Capitol Mall and back three times."[51] It is officially known as the Behavioral Health Integration Project, or BHIP. Employees of Netsmart Technologies, the firm awarded the computer contract, were contracted to work at OSH until the system is completely integrated and operational.

When finished the new hospital configuration with 620 beds contained four units: Harbors, a facility for maximum security; Trails, a facility for

medium security; Bridges, a facility for minimum security and transition to community care; and Springs, a facility for geriatric services.

The first portion of the hospital put into operation was the Admissions, Behavior and Corrections (ABC) building, otherwise called Harbors. It is the most secure portion of the new facility. It has beds for 104 patients separated into five residential units and opened on January 10, 2011. In addition a 20-bed unit was slated to house prison inmates needing short-term care before returning to prison. It's estimated it will eventually have 323 staff members working there.[52] It serves patients entering the hospital for the first time and those needing a safe place to be evaluated and begin treatment. Modern, shatterproof windows have replaced the metal bars that once protected glass windows. No barbed-wire or chain-link fencing creates a prison-like atmosphere around the three-story brick exterior.[53] Public tours were offered, beginning on November 18, 2010, which emphasized the increased ability of patients to procure appropriate treatment in a safe and secure setting.[54] Tour managers also pointed out increased safety measures for staff.

For the 104 high-security patients transferred into the newly opened wing of the ABC building, each now had a private bedroom and access to flat-screen televisions in nearby activity rooms. Included were sensory rooms designed to provide a quiet safe retreat for overwhelmed patients, a new gymnasium, several fitness rooms, and secure inner courtyards where patients could play basketball or volleyball.[55] The building was divided into five residential units occupying 114,300 square feet. The most important feature was improved safety and security features for both the patients and the increased number of staff members.[56] Forensic patients, about 455 in 2010, made up 75 percent of the total patient population at OSH

The Trails wing was opened in August 2011. It houses primarily forensic patients needing a medium-security level of care. Superintendent Greg Roberts announced, "As you know, today was the big move to Trails—the second in a series of three patient moves into the new facility."[57] He went on to reassure the hospital advisory board that the new space would provide increased and improved therapeutic treatment options for patients. The new wing houses 174 patients previously housed in the crowded 50 building. As of January 9, 2013, OSH had 579 patients and 1,769 employees, and it cost about $176,366,261 a year to operate.[58]

Daniel Smith, a psychologist at OSH, credited Superintendent Roberts with the success of the new hospital. "Greg Roberts is persistent. He is working with both unions here at the hospital and with the management

staff to bring about change. In 18 months, he has brought more change than occurred here for quite some time."[59]

Criticism will always be part of OSH history. However, even the critics were expressing cautious optimism in 2012. Chris Bouneff, executive director of the National Alliance on Mental Illness, wrote this to the *Statesman Journal* in 2012:

> *The Salem Campus is not ideal. Congregate care for 620 people is never ideal. But without the reconstruction of the state hospital, providing any care would have remained impossible. You cannot heal when the physical environment is in shambles, nor can you provide proper care if your physical workplace is in such disrepair that it works against you.*[60]

When interviewed in January 2013, Superintendent Roberts identified the greatest obstacle still facing OSH: "The problem is the ability to move people to a less restrictive setting when they are ready to move. Right now if you are a patient in this hospital, especially if you're a forensic patient and you no longer need to be at this level of care, it will be months before we can move you to a community setting."[61] While recognizing the problem is a beginning, the solution involved increasing capacity in the communities, solving internal hospital problems, and getting approval from the PSRB. He anticipates spending at least three and a half more years in Oregon at OSH.

The Museum of Mental Health is a 501(c)(3) tax-exempt organization and opened on October 6, 2012.

This is the Kirkbride U and the entrance to the Museum of Mental Health. *Photo by Laurie Burke.*

It occupies twenty-five thousand square feet of the front section of the Kirkbride U. Using hundreds of salvaged hospital artifacts, the museum illustrates and emphasizes the history of mental healthcare in Oregon and particularly the history of OSH. No other institution or structure in Oregon, except for possibly the Oregon State Penitentiary, contains "more history, more tragedy, more human misery, than the J building at the State Hospital."[62] The museum was established to preserve this history.

Today the Kirkbride U has been totally revamped. As a historic monument the outside architecture has been preserved and reflects the grandeur of its original design. Inside, a modern mall allows patients to practice returning home in a safe, secure, and supervised manner. New wards provide safety for staff and patients. Patients have access to twenty-two secure outside yards with grass, sunshine, and exercise.

For the first time since 1883, Oregon has a mental health facility comparable to the finest in the United States. Drive down Center Street in Salem, visit the museum, and feel the pride every Oregonian should feel at this marvelous achievement. At last Oregon has recognized that a therapeutic environment is necessary to create a climate of hope and optimism—not only for the patients inside OSH walls but also for the people who work there. Oregon has moved several steps closer to treating its mentally ill population with respect, integrity, and human decency.

NOTES

1. Gary Cornelius and Joe Eaton, "Moving Beyond Broken Promises," *Register Guard*, March 13, 2005.
2. Ibid.
3. *Obesity, Fitness & Wellness Week*, September 18, 2004.
4. Ibid.
5. Grace Chung Becker, acting assistant attorney general, U.S. Department of Justice, Civil Rights Division, CRIPA Investigation of the Oregon State Hospital, to the Honorable Theodore R. Kulongoski, U.S. Department of Justice, Civil Rights Division, Washington, D.C., January 9, 2008.
6. Jonathan J. Cooper, "State Hospital Rebuilt Following Abuses," *The Bulletin* (Portland, Oregon), November 19, 2010.
7. Cornelius, "Moving Beyond Broken Promises."
8. Don Colburn, "Kulongoski Picks Hospital Sites," *Oregonian*, March 1, 2007.

9. Alan Gustafson, "Secondary State Hospital Site Called into Question," *Statesman Journal*, February 17, 2011.

10. Colburn, "Kulongoski Picks Hospital Sites."

11. *Daily Journal of Commerce* (Portland, Oregon), October 24, 2007.

12. *U.S. Fed News Service*, November 19, 2007.

13. Ibid.

14. David Steves, "Psychiatric Hospital Needs a Site," *Register Guard*, June 23, 2006.

15. Alan Gustafson, "Feds: Hospital Failures Alarming," *Statesman Journal*, October 24, 2010.

16. Dee Lane, "Feds: Conditions at Oregon State Hospital Violate Patients' Safety, Rights," *Oregonian*, January 16, 2008.

17. Becker, CRIPA Investigation, 1.

18. Michelle Roberts and Brent Walth, "Patients Lose in Push for State Hospital," *Oregonian*, January 21, 2008.

19. Becker, CRIPA Investigation, 6.

20. Ibid., 15.

21. Ibid., 22.

22. Ibid., 23.

23. Roberts, "Patients Lose in Push."

24. Becker, CRIPA Investigation, 18.

25. Ibid., 29.

26. Ibid., 30.

27. Roberts, "Patients Lose in Push."

28. Alan Gustafson, "OSH Worries Persist for Senate President," *Statesman Journal*, May 23, 2010.

29. Peter Courtney, "Politics Must Be Put Aside to Improve Mental Health Care," *Statesman Journal*, August 25, 2010.

30. *News Review* (Roseburg, Oregon), November 21, 2010.

31. Alan Gustafson, "State to Pay for Review of Oregon State Hospital," *Statesman Journal*, June 27, 2010.

32. Alan Gustafson, "OSH Invests $1.99 Million in Consultants," *Statesman Journal*, December 2, 2010.

33. Alan Gustafson, "Bad Apples Hinder Reform Efforts at Oregon State Hospital," *Statesman Journal*, May 8, 2011.

34. Alan Gustafson, "Are Oregon State Hospital Consultants Worth It?" *Statesman Journal*, February 28, 2011. Judge Hargreaves was a former Lane County Circuit Court judge.

35. Alan Gustafson, "Fresh Paint Retains Historical Character," *Statesman Journal*, August 30, 2010.

36. "OSH Cupola Removed for Restoration," December 5, 2009, www. oregon.gov/DHS/features/cupola-restoration.shtml.

37. Alan Gustafson, "Plan Spares Tower on Old Site," *Statesman Journal*, April 10, 2008.

38. Alan Gustafson, "State Hospital Murals Won't Be Saved," *Statesman Journal*, June 10, 2009.

39. Ann Sullivan, "OSU Opens Long Locked Doors of Wards," *Oregonian*, March 5, 1961.

40. *Statesman Journal*, April 7, 2008.

41. "OSH Cupola Removed for Restoration."

42. Alan Gustafson, "Is the Oregon State Hospital No Longer Mired in Misery?" *Statesman Journal*, March 18, 2012.

43. oshmuseum.wordpress.com/page/3.

44. *Statesman Journal*, April 7, 2009.

45. Editorial, "Oregon's Forgotten Hospital: What About Bob?" *Oregonian*, May 15, 2005.

46. Gustafson, "Plan Spares Tower."

47. Editorial, "New Hallways, Big Steps," *Oregonian*, March 18, 2012.

48. Steven V. Riley, "Building a Treatment Mall: Oregon State Hospital's New Campus in Salem Will Employ This Care Model," *Behavioral Healthcare*, September 1, 2009.

49. Allan Gustafson, "A Fresh Start," *Statesman Journal*, August 23, 2010.

50. Ibid.

51. Alan Gustafson, "For the Records, State Hospital Is Revamping Its Filing System," *Statesman Journal*, January 23, 2010.

52. Alan Gustafson, "Modern to the Core," *Statesman Journal*, November 15, 2010.

53. Cooper, "State Hospital Rebuilt."

54. Editorial, "New State Hospital Building Is Just a Start," *Statesman Journal*, November 18, 2010.

55. Gustafson, "Modern to the Core."

56. Alan Gustafson, "Some Fear Old Woes Will Move to New Facility," *Statesman Journal*, November 14, 2010.

57. Alan Gustafson, "Patients Move into Second Oregon State Hospital Wing," *Statesman Journal*, August 17, 2011.

58. Addictions and Mental Health Division of OSH, per Rebeka Gipson-King, communications officer, dated December 31, 2012.

59. Gustafson, "Is the Oregon State Hospital."

60. Ibid.

61. Interview of Greg Roberts by author at OSH on January 22, 2013.

62. Rick Attig, "Ashes to Ashes, Dust to Dust," *Oregonian*, April 11, 2009.

EPILOGUE

For so many years legislators and citizens ignored the rat-infested, crumbling buildings that made up Oregon's major mental hospital. Today there is a beautiful state-of-the-art facility on OSH grounds. In addition to the new building, there is also a sense of optimism and hope inside the walls. Staff and patients walk the halls with smiles on their faces and purpose in their strides. For the first time in over one hundred years, Oregonians can feel pride when they look at the Oregon State Hospital.

There remains a great deal to do, but after accomplishing this much, a positive future now has a chance. We need additional safe and comfortable community housing for patients ready to leave the hospital. We need more easily accessible mental health facilities in our towns and cities. And we continue to need a better understanding of what we can do to help those with mental illness. The road is long, but at last we have a vision and a map.

As Dr. Jack R. Ewalt observed almost fifty years ago as chair of the Joint Commission on Mental Illness and Health: "The state hospital has been investigated, inspected, reorganized, converted, divided, dispersed, and even abolished, in fact or in theory, by countless imaginative persons motivated by a variety of urges. The state hospital survives, however, and is an amazingly tough and resilient social institution."[1]

NOTES

1. Jeffrey L. Geller, "The Last Half-Century of Psychiatric Services as Reflected in *Psychiatric Services*," *Psychiatric Services* (January 2000), 48.

Appendix I

OFFICIAL STATISTICS FOR OSH, 1884–1956

B y law, every two years superintendents of public institutions were required to submit a report to the Oregon legislature. The following numbers are from those official Oregon State Hospital biennial reports. In order to fit the statistics on the graph, numbers were taken at four-year increments.

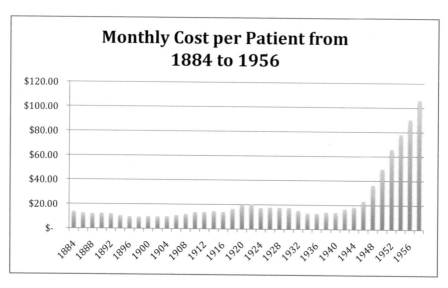

Monthly cost for OSH, 1883–1958. *Analysis by author.*

The initial cost per patient was $13.86 rising to $78.14 in 1956. As the chart shows, the cost remained steady until 1948 when it began rising abruptly, coinciding with the end of World War II. It also corresponded with increasing inflation and the end of patient workers in the hospital.

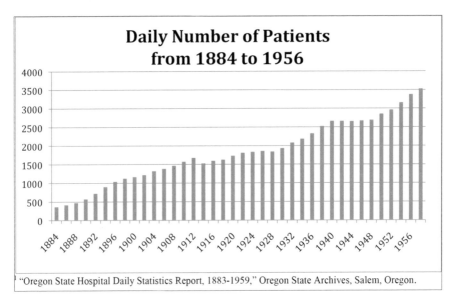

"Oregon State Hospital Daily Statistics Report, 1883-1959," Oregon State Archives, Salem, Oregon.

Number of patients for OSH, 1883–1958. *Analysis by author.*

Even though the costs remained steady during the first fifty years, the number of patients living in the hospital increased drastically after that. Starting with fewer than 500 at the end of 1884, patient numbers increased to nearly 3,500 in seventy-two years, an increase of 700 percent.

Appendix II
POPULATION STATISTICS AT OSH, 1900–1959

In 1959 the Oregon State Hospital published a composite report comparing patient statistics for the month of December for the previous sixty years. It covered the years of greatest growth at OSH. During that time the overall population nearly tripled. The male population doubled, and the female population increased by almost six times.

Comparison of Daily Patient Statistics for the 31 days of December 1900-1959[i]

	Received		Discharged		Died		Eloped		Esc Rtd		Paroled	
	M	F	M	F	M	F	M	F	M	F	M	F
1900	17	16	1	3	6	3	3	0	1	0	0	0
1909	24	6	17	21	3	0	1	0	1	0	0	0
1919	27	21	9	12	8	15	5	0	3	0	0	0
1929	38	35	6	5	11	3	50	0	0	0	13	24
1939	43	38	9	5	18	10	5	0	3	0	31	55
1949	49	40	31	16	16	10	11	0	7	1	55	45
1959	139	126	96	61	18	16	8	4	3	2	45	47

[i] "Oregon State Hospital Daily Statistics Report, 1883-1959," Oregon State Archives, Salem, Oregon.

Patient statistics for December 1900–1959. *Analysis by author.*

The difference between the male and female population growth is even more obvious when represented in graph format. After 1949 and the end of World War II, the female population decreased dramatically while the male population continued to increase. This corresponded with

increased opportunities for women outside the home and expanding roles in society.

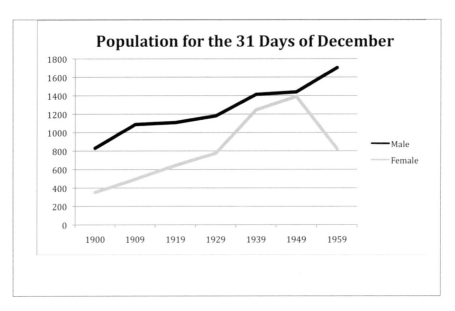

Population numbers for December 1900–1959. *Analysis by author.*

ACTUAL NUMBERS REPORTED

	Male	Female	Average Number of Patients
Dec. 1900	830	352	1176
Dec. 1909	1088	493	1580
Dec. 1919	1109	644	1743
Dec. 1929	1181	775	1943
Dec. 1939	1413	1246	2675
Dec. 1949	1440	1390	2830
Dec. 1959	1704	823	3521

INDEX

X

Y

Z

ABOUT THE AUTHOR

Diane L. Goeres-Gardner is a fifth-generation Oregonian whose ancestors came to Oregon in 1852 and settled in Tillamook County. She is the award-winning author of four books, including *Necktie Parties: Legal Executions in Oregon, 1851–1905* released in 2005 and *Murder, Morality, and Madness: Women Criminals in Early Oregon* released in 2010. Both were published by Caxton Press. She is also the author of *Images of America: Roseburg* and *Images of America: Oregon Asylum*, published by Arcadia Publishing.

Photo by Laurie Burke.

Visit us at
www.historypress.net
..
This title is also available as an e-book